THE INDIANA RAIL ROAD COMPANY

RAILROADS PAST AND PRESENT

George M. Smerk, Editor

THE INDIANA RAIL ROAD COMPANY

America's New
Regional Railroad

CHRISTOPHER RUND

INDIANA UNIVERSITY PRESS
Bloomington & Indianapolis

This book is a publication of

Indiana University Press
601 North Morton Street
Bloomington, IN 47404-3797 USA

http://iupress.indiana.edu

Telephone orders 800-842-6796
Fax orders 812-855-7931
Orders by e-mail iuporder@indiana.edu

Library of Congress Cataloging-in-Publication Data

Rund, Christopher.
 The Indiana Rail Road Company : America's new regional railroad /
Christopher Rund.
 p. cm.—(Railroads past and present)
 Includes bibliographical references and index.
 ISBN 0-253-34692-4 (cloth : alk. paper) 1. Indiana Railroad.
2. Railroads—Indiana—History. I. Title. II. Series.
 TF24.I3R78 2005
 385.5'09772—dc22
 2005019836

 2 3 4 5 11 10 09 08 07 06

To Kyle, Laura, Bridget,
and the little family that could

CONTENTS

Foreword

By all odds, the Indiana Rail Road (INRD) should no longer exist. The Midwest is littered with abandoned rail lines. How the line that is now the INRD escaped a similar fate is a tale of vision and hard work—and a little luck along the way. At many levels, the story of the INRD parallels the rebirth of the railroad industry nationwide. This is the story of how one railroad came back from the brink of extinction. It is also part of a bigger story about how an entire industry reinvented itself.

A generation ago, railroads were a classic failing industry. Much of the country's rail system was overbuilt, overmanned, and poorly managed. Much of it was run down, and the federal government tightly regulated all of it. When trucks began picking off the merchandise traffic, railroads reacted by cutting service and maintenance. As a result, remaining service declined even further and more traffic was lost. Railroading simply was not sustainable as it was then organized and operated.

Railroads in the Northeast failed first. The government essentially took control of the bankrupt rail lines and merged seven carriers into Conrail. Thousands of miles were excluded from the new railroad, and billions were spent on rebuilding what was left. The rail crisis next hit the Midwest. By then, the government had grown tired of massive financial bailouts. If railroading was going to survive, it would have to find a new way of doing business. With their backs to the wall, railroads tried a number of strategies: they shed passenger and commuter services, closed shops, took up multiple tracks, and abandoned lines. Where it was impossible to win an abandonment case, they found ways to sell or lease the lines to other operators.

The modern shortline industry was born from these divestitures. The big railroads viewed lightly trafficked feeder lines as a burden; the quicker they were gone the better. But where the big guys saw problems, a new breed of railroaders saw opportunities and believed that they could reduce costs and increase revenues, succeeding where others had failed. They bet a lot of money and effort on creating a new business model for railroading. They reduced costs by using smaller crews on each train (crews at the

time numbered four or five). Their plan was to eliminate rigid craft lines, which would create efficiencies and savings, and use lower-cost motive power, which would reduce capital investment. But it was not just about reducing cost. To regain traffic, the shortlines had to improve service quality. They would woo customers, even little customers long ignored by the big railroads. Better service would, in turn, bring more traffic and more revenues, restoring profitability.

It was a good business model but no guarantee of success. Creating and then operating a shortline was not for the faint-hearted. These were high-risk ventures, and some of them failed. Others drifted off into economic limbo, eking out a modest profit but never producing any real growth or financial rewards.

Many lines did succeed, and their success had a profound impact on the rest of railroading. The presence of the shortline industry permitted the major railroads to focus on their core routes. Second, shortlines kept traffic on the core lines' rails that would otherwise have been lost. Third, shortlines showed that railroads could be run both safely and efficiently with smaller crews. The work practices of the shortlines were emulated by the major carriers (though only after a lot of push-back by the unions). The result was a dramatic increase in efficiency for the entire industry.

These improvements in labor productivity were at the core of a rejuvenated railroad industry. Without them the industry would have continued to languish, and it is fair to say that without the shortline movement, labor changes would have come much later, if at all. The shortlines were a guiding light in this effort, essential to the recovery of the rail industry.

The Indiana Rail Road is the poster child of how to build a shortline carrier. There are many good business lessons to take from its story, but these deserve to be at the top of anybody's list:

First, choose the right markets. Lots of shortline operators blew this as they rushed to get into operation. Tom Hoback knew that finding the right market was the key to success. The INRD inherited weak track and poor service, but the market potential was always there. A large metropolitan area such as Indianapolis offered the prospect of growth; railroads thrive on volume, and population means freight to move. The line had access to multiple rail carriers, essential for a shortline to avoid falling captive to a single large carrier. And the line had coal traffic, ideal for rail technology (again, railroading is a volume business). Having found the right market, Hoback had the patience to wait until the rail line he needed was available.

Second, stay focused. Many a business, large and small, overextends. By seeking to do too much, it does nothing well.

Hoback focused on building the railroad line he acquired and did so in a methodical way. He also stayed focused on the basics: track, motive power, and people.

Third, never stop innovating. Hoback built a low-cost railroad, cultivated his markets, and was rewarded, in time, with a very good railroad. It would have been easy to sit back and coast at that point, but INRD has never been happy with the status quo. It has been at the forefront of such innovations as one-person crews and transloading services. The world is constantly changing, and today's best practices are soon yesterday's news.

Railroading is no longer in peril. Tracks are well maintained, and traffic is growing. But the challenges are no less daunting than they were a generation ago. Railroads must offer quality service, and here the industry in general still has a long way to go. What should we do to provide service where it is needed? Traffic is growing, and that requires more people, more track, and more equipment. But since everything cannot be done at once, what should be done now and what can be postponed? More capacity means more capital expenditures. Where is all that capital going to come from? Are there ways, through innovative technology, to reduce the need for capital?

The future will be just as challenging as the past. Let's hope that, 20 years from now, an updated edition is telling the story of the INRD's next successes.

Jim McClellan
Virginia Beach, Virginia
March 2005

Acknowledgments

I've said it many times—railroading is a big job. And, as I've discovered in writing this book, documenting a railroad is no small task either. I owe a debt of gratitude to a great many people, and I'd like you to know a little something about each of them:

GEORGE SMERK

As a kid growing up in Lafayette, Indiana, I was surrounded by railroading and railroaders. It was here that I first heard of George Smerk. George is the survivor of a career in Class 1 railroading and, more significantly, professor emeritus of transportation at Indiana University's Kelley School of Business—an expert in the science of moving people by rail in urban environments. I entered Purdue University in the fall of 1983 with hopes of attaining a degree in industrial management and a career in the rail industry. Not long after I started, I realized that I didn't have much of a head for calculus and some of the other important things that prevent train wrecks. So I migrated down the Monon line to Bloomington and pursued studies at the Indiana University School of Music, which led to a career in broadcasting and corporate communications. When I left the thought of professional railroading behind, I never imagined that I would someday be working in consultation with George on a book project. It is George who receives credit for the idea of a book about the history and achievements of the Indiana Rail Road Company, and I consider myself fortunate to have been in the right place at the right time to be considered for the job. It has been gratifying and fulfilling, both personally and professionally, to know and work with George. His vision, enthusiasm, and steady encouragement have kept the firebox stoked.

JENNIFER BORN

As the Indiana Rail Road Company's corporate archivist and historian, Jennifer held the keys to piecing together the story of the earliest days of the railroad, all the way back to its narrow gauge antecedents. She worked very conscientiously on my behalf to acquire many rare

documents, including a volume of correspondence from Illinois Central president Stuyvesant Fish from the IC archives at Chicago's Newberry Library. In addition, Jennifer scoured area newspapers for archival news clippings and did a lot of detective work tracking down oral histories and recollections from people who witnessed the coming of the railroad firsthand in rural Indiana and Illinois.

LEIGH DARBEE

By virtue of her previous career as a historian with the Indiana Historical Society and her second career as a staff member at the Indiana Rail Road Company, Leigh was a liaison between key people at the railroad and me and provided invaluable perspective on assembling a historical account of the company. She helped with many crucial details, including verification of source material and fact-checking.

JOHN CUMMINGS

John's early career on the Illinois Central was spent slinging stone, timbers, and steel. Today on the Indiana Rail Road, he's more concerned with circuit boards. As manager of communications and signals, John has been the point man on many of the railroad's technological initiatives—quite a transition from the old days. John is also an accomplished local historian who has gathered vintage photographs from the earliest days of the IC's Indianapolis line for this book and pointed out the many people and events that have shaped the development of the railroad in southern Indiana. From his days on the IC section crews, John knows the Hi-Dry like the back of his hand, and he has served as a chaperone on many exploratory trips up and down the railroad that have been not only informative but also a lot of fun.

SUSAN FERVERDA

Sue became one of my most helpful go-to people at the INRD. She tirelessly coordinated access to the people who make the railroad work and, as such, was instrumental in helping me to keep my work flowing, even when I was working at a snail's pace. Her responsiveness to my scores of requests, inquiries, and fire alarms was key in pulling all the resources together and keeping this project, if you'll pardon the expression, "on track."

NORM CARLSON

Midway through the development of this book, I was fortunate to meet Norm, an expert in the rail industry and president of Carlson

Consulting International. Before launching his own consulting practice in the fall of 2000, Norm was worldwide managing director of transportation industry practice at Arthur Anderson. In addition to his technical knowledge of railroad operations, Norm is an industry historian and a contributor to numerous publications. Norm generously offered his time to review my manuscript.

TOM HOBACK

Had it not been for Tom Hoback, many communities in southwestern Indiana and southeastern Illinois would very likely not have rail service today. He and a very capable group of railroaders have performed a feat of modern-day magic, taking a crumbling branchline and transforming it into a profitable new model for contemporary regional railroading, all in a span of 20 years.

I first met Tom in the spring of 1998, having been a longtime admirer of his railroad. Our friendship has made it possible for me to have unfettered access to the INRD and the research materials necessary to tell its story. In my career in corporate communications, I've encountered a cross-section of businesspeople, from the brilliant to the boorish. Perhaps what I admire most about Tom Hoback is that he is not only an astute and successful entrepreneur, but he is also a true gentleman, in the classic sense of the word. While these two qualities are not necessarily mutually exclusive, they seem to be too rare a combination. It's one reason that I highly value my association with him and why I'm certain that I'll always consider writing this book one of the high points in my career.

AND A CAST OF THOUSANDS

The list is seemingly endless—Mike Engel, for compiling business data and statistics; John Haselden, for providing engineering data; Ed Wilson, Scott Orman, and John DePaelmelaere, for cab rides, operating information, timetables, and other important operations data; Tom Quigley, for recollections of the early days of INRD operations; John Doeringer, for insight into the corporate workings of the Illinois Central and the regulatory landscape leading up to the Staggers Rail Act of 1980; Brian Banta, an extraordinary historian of the rail industry in Indiana, for his research efforts and assistance; Ed Bowers, for historical information on locomotives; Cathie Carrigan, for preparing the index; Clark Snyder, for insight into the relationship of the railroad and Indianapolis Power & Light; and collectors, for contributing rare photographs—Ralph Bachelor, Joy Fisher, John Fuller, John F. Humiston, Lloyd Kimble, William Millsap, and Eric Powell. In addition, the people of a

number of institutions have also provided rare photos. These include Indiana University's Lilly Library, the Indiana Historical Society, and numerous local historical societies, including those in Sullivan and Bloomington, Indiana, and Palestine, Illinois. I've tried my best to document and give credit where it's due. If there are other names I've neglected to mention here, I hope you'll forgive me.

Finally, please indulge me as I say that for someone who long ago forsook hopes of a railroading career, this book is doubly significant. In many ways for me it represents, after a long and circuitous path, the fulfillment of a personal and professional dream of finding a place—however small—in the fabric of American railroading.

THE
INDIANA
RAIL ROAD
COMPANY

Introduction

To study the Indiana Rail Road is to study contrasts. The railroad is in many ways merely everyday, yet in other aspects truly remarkable. It was conceived and built during the frenzied period of construction that pushed U.S. rail mileage to its peak in the early twentieth century, and it came to be part of one of the most venerable names in the industry, Illinois Central—the "Main Line of Mid-America."

To passionate observers, it's the quintessential American railroad. Between its 155 mileposts, you'll find nearly every aesthetically inspiring feature of American railroading—soaring viaducts and grain elevators, coal mines and oil wells, quaint villages with team tracks, and even a tunnel hidden within the rolling hills.

Yet, for all its engineering marvels and charm, this stretch of railroad, known colloquially as the "Hi-Dry," was never a stellar performer, even though it served Indianapolis, one of the country's most lucrative industrial crossroads. The Hi-Dry never became anything more than a light-density secondary line for IC. Passenger service evaporated at the close of World War II. Merchandise traffic dwindled with the growth of the trucking industry, and by the mid-1970s, the IC's Indianapolis line was sustained

by little more than the flow of southern Indiana coal to Indianapolis Power & Light. Like many other light-density lines across the Midwest, it had deteriorated to a state of near-ruin from lack of maintenance; the railroad industry was in serious decline and didn't have the capital to invest in secondary tracks.

Abandonment looked all but certain for the line, but beginning in the late 1970s, federal legislation incrementally brought long-needed regulatory relief to the rail industry, culminating in the Staggers Rail Act of 1980. Among the benefits of Staggers was the ability for major railroads to sell their properties more easily to small upstart rail companies. And it's here that the real story of the Indiana Rail Road Company begins.

A career railroader and Illinois Central manager, Thomas G. Hoback, spearheaded an effort to acquire a portion of the former Indiana Division. After fighting long and hard to fend off competing interests, Hoback closed the deal in the spring of 1986. With a handful of well-worn locomotives and headquarters that was little more than a shantytown on the edge of the Indianapolis yard, Hoback and his team began the steady, intense process of rebuilding and revitalizing the railroad. The results of their efforts have been truly awe-inspiring. The little railroad Illinois Central was once ready to abandon is on track to yield an increase in carloadings of nearly 1,000 percent by 2006, its twentieth year of independent operation, which also marks the centennial of the line's original completion from Indianapolis to Effingham, Illinois.

The success is owed not just to new crossties and rail but also to entirely new ways of thinking about railroading. Today, the Indiana Rail Road Company is a showcase of innovative technologies and operating techniques brought to bear on the challenges of modern railroading. It's an extraordinary story about solving complex problems—mechanical, financial, and political. Moreover, it's about the commitment and hard work necessary to deliver a level of service that wins business from customers, some of whom had long ago given up on rail transportation.

All of these aspects of doing business involve something seldom heard of in the railroad industry—taking risks. The story of the Indiana Rail Road Company is a story of business risks and rewards, set against a backdrop of the historical richness of the midwestern heartland and one of the most universally romanticized institutions, American railroading. Whether you're a business person, a regional history buff, or simply a rail enthusiast, I'm certain that you'll find interesting stories in the pages that follow. Welcome aboard.

The 1960s were a horror story. It looked like there was no tomorrow.

—John Doeringer, retired IC attorney

The Rise and Rationalization of the Main Line of Mid-America

On July 1, 1999, with the stroke of a pen, over 150 years of history came to a bittersweet close. It was on that day that one of the most venerable names in American railroading became yet another maiden name on the family tree of modern transportation. The Illinois Central Railroad—the "Main Line of Mid-America"—was merged into Canadian National, Canada's successfully privatized flagship rail carrier, which had been developing a voracious appetite for corporate acquisitions. With the new north-south axis gained by absorbing the IC, CN spanned the length and breadth of the North American continent, from Atlantic to Pacific, from the Northwest Territories to the Gulf of Mexico—nearly 19,000 miles of railroad. IC joined the ranks of the great fallen flags. But as emotionally wrenching as that might be, it was actually a happy ending of sorts. Twenty-five years earlier, it had looked as though the company, and indeed much of the U.S. rail industry, might not survive until the end of the twentieth century.

U.S. railroading had been on a slide for decades, suffering in large part from myopic public policy that relentlessly pursued the paving of America. Travelers took to the highways, leading to

years of heavy losses for the railroads, which were required to remain in the passenger business until the Nixon administration finally offered relief by creating Amtrak. Truckers moved aggressively to capture the railroads' freight business, buoyed by cheap fuel, an infrastructure built and maintained by the government, and an artificially low tax burden. Outdated regulatory practices and labor agreements impeded railroads' ability to compete, effectively tying one hand of the industry behind its back. The executive leadership, meanwhile, had shifted its energies to a lot of other interests besides railroading. It all made for an agonizing downhill ride—a slow, ignominious decline for a once heroic industry.

By 1976, the very institution that had made possible our western expansion, industrialization, and economic growth appeared to be on the tracks to perdition. Nearly a quarter of the nation's rail mileage had sunk into bankruptcy. Railroads had endured periods of hardship before; there was hardly a rail company in existence that hadn't experienced at least one bankruptcy. But this was different. This time the threats weren't just economic or political; they were technological, social, and even psychological. Railroads no longer enjoyed a position of preeminence within the life of the nation. They were no longer perceived as having a centricity and immediacy in everyday life. To many Americans, railroads began to seem like relics of a bygone era.

Like the doomsday asteroid that wiped out the dinosaurs, the eastern railroad bankruptcies of the early 1970s signaled a thinning of the herd. With the exception of a handful of healthy carriers, notably those spanning the vastness of the West, the industry was struggling to survive. In Chicago, Illinois Central managers were working on their own corporate survival strategies, trying to engineer a future for the once-great Main Line of Mid-America.

A Different Kind of Railroad

From its very beginnings, Illinois Central was a railroad of distinction. It was America's first land grant railroad, and as such it catalyzed the settlement and development of the Illinois prairie and the colonization of the West. Stretching from northwestern Illinois to the Ohio and Mississippi River confluence, the railroad cut squarely against the grain of cross-country commerce, which was predominantly east-west. The longitudinal nature of the IC would ultimately help open trade in lucrative new markets in Central and South America. But by initial design, the railroad's orientation was principally a function of connecting the waterways that bordered the state of Illinois.

The earliest Illinois settlers logically made their homes near rivers. The Great American Bottom, a Mississippi floodplain extending from Alton to the mouth of the Kaskaskia River, was considered at the time to be the state's most fertile region. However, chronic flooding and prevailing swampy conditions gave rise to serious diseases, including cholera, and by the mid-nineteenth century, southern Illinois was no longer considered a desirable destination. In fact, the state's northerners adopted the moniker "Egypt" to refer to the region.[1] Their persistent disdain eventually gave the Mississippi basin some of the most exotically named cities in the Midwest—Palestine, Cairo, and Memphis, to name a few. Settlers began to push inward, and their numbers were augmented by northeastern immigrants arriving via the Erie Canal after its completion in 1825. Agriculture was the principal livelihood. The fertile prairies, however, with their great undulating oceans of grass, were the last areas to be settled. Their thickly woven grass roots made the soil agonizingly difficult to plow, and the lands were far removed from fresh water and the timber needed for fuel and lumber.

The development of the steamboat industry sparked intense growth in river communities such as Peoria, and it underscored the need for transportation improvements in the interior of the state. The Illinois and Michigan Canal was funded and under construction by the mid-1820s, to the benefit of the inland population in the north. This prodded Illinois residents from other regions to demand their share of government-funded improvements. The state legislature responded with the Internal Improvement Bill of 1837. However, corruption, political infighting, and the Panic of 1837 conspired to kill the program and plunge the state into financial crisis. Not only did the prospects for transportation improvements look bleak, but immigration was also stymied because of the tax hikes that resulted from the fiasco.[2]

Promoters in the important river junction town of Cairo sought to fuel the growth of their city by conceiving a 450-mile railroad to link it with the mining town of Galena in the north. They attempted to stir up support for their plan in Congress, but with Chicago gaining prominence, the Great Western Railway, as it was known, was successfully opposed by U.S. Representative Stephen A. Douglas. Douglas, a young political luminary, was elected to the Senate shortly thereafter. With the support of freshman representative Abraham Lincoln, Douglas retooled the railroad plan geographically and politically to win broad support for a federal land grant. In doing so, he became the chief architect of the Illinois Central Railroad. President Millard Fillmore signed the Central Railroad Bill into law on September 20, 1850. A consortium of eastern businessmen was selected to manage the financing

and construction of the new line, and on February 10, 1851, the Illinois Central Railroad was chartered by the state legislature.

At 705 miles, the proposed Illinois Central would exceed the scope of any other railroad that existed in the United States. As the first land grant railroad, the IC would serve as a model for public policy. During the next two decades, the federal government would make similar land grants to aid the development of railroad lines that became parts of the Union Pacific, Southern Pacific, Chicago & Northwestern, Burlington, Rock Island, and the Santa Fe.[3]

To raise the capital necessary to build and equip this sprawling railroad, the managers turned to European markets. Commencing with a $5 million bond issue in Britain in 1852, European investment in the IC grew so rapidly that European financiers held controlling interest in the railroad for half a century.[4] As construction progressed, more than 2.5 million acres of land were parceled out to the railroad. The Illinois Central Land Department launched an inspiring international marketing campaign to attract immigrants from around the country and overseas to the fertile Illinois heartland.

To build broad support for the congressional land grant, Stephen Douglas had redrawn the IC to expand its ties to the rest of the nation. From the junction of the Ohio and Mississippi rivers at Cairo, the line extended to Dunleith, Iowa, which would be the railroad's gateway to the western frontier. A branchline swung north to Chicago to serve that burgeoning city on the lake and make connections to lines serving eastern states.

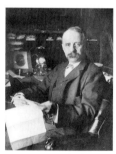

Stuyvesant Fish (*left*) was president of the Illinois Central until E. H. Harriman (*right*), his onetime confidant and fellow IC board member, engineered his ouster in 1906. Illinois Central Archives and public domain

Finally, to win the votes of southern lawmakers, Douglas had written in provisions allowing extension of the railroad to the Gulf of Mexico. This vision was realized in 1877, when IC acquired and renovated connecting broad-gauge lines in the South, converting them to standard gauge in blitzkrieg fashion, as was done often in the late nineteenth century. The dream of a fully extended north-south railroad was finally achieved in 1889 with the opening of the magnificent Cairo Bridge. The great bridge and aggressive acquisition growth into Kentucky and Mississippi and westward to Sioux Falls, Omaha, and St. Louis came about under the leadership of two legendary captains of industry, Stuyvesant Fish and E. H. Harriman. Their partnership was long and fruitful, but it was ultimately undone by a power struggle in which Harriman prevailed in 1906, the year IC reached Indianapolis and Birmingham.

The man at the helm of the Illinois Central during the construction and acquisition of the Indianapolis line was predestined by his lineage to become a captain of industry. Stuyvesant Fish (1851–1923) was born into an aristocratic New York family. His father, Hamilton Fish (named after family friend Alexander Hamilton), served as New York governor and a U.S. congressman before the Civil War. President Ulysses S. Grant later appointed him secretary of state.

Stuyvesant Fish was educated at Columbia University, where he was captain of the 1870 football squad. By 1877 he was a director of the Illinois Central and a member of New York City's inner circle of wealth and power at the dawn of America's Gilded Age. It was only a matter of time before Fish's path crossed that of legendary railroad financier and fellow New Yorker E. H. Harriman. In 1887 Fish assumed the presidency at IC. Harriman also had a seat at the boardroom table as a vice president. Together, they set about renovating the railroad's physical plant and restructuring management and operations to lower transportation costs.

Their success at the IC came with an unfortunate cost. Their professional relationship began to crumble beneath the strain of conflicting visions and strong wills. Harriman was rebuilding the Union Pacific, which, in his grand vision, would absorb the IC and create a circuitous empire from the Pacific to the Great Plains, Chicago, and the Gulf of Mexico. It was a plan squarely opposed to Fish's desire for an independent IC.

In the fall of 1905, Fish was appointed to lead a state committee to investigate alleged improprieties at the Mutual Life Insurance Company of New York. He pursued his duties with a righteous zeal that incensed some IC board members who also held seats on the Mutual Life board. Notable among them was Cornelius Vanderbilt. Fish himself was vulnerable to attack. In 1903 he had begun manipulating IC money to cover personal debts resulting from the ludicrous spending habits of his wife. Harriman helped keep the scandal under wraps and staved off calls for Fish's resignation. However, Fish's conduct in the Mutual Life affair exacerbated hostilities toward him, and his opposition to Harriman's designs on the IC made him a marked man. Harriman became the chief engineer of Fish's ouster from the IC presidency on November 27, 1906, just a few weeks before the completion of the Indianapolis line.

Outside the circles of the railroad history, Mrs. Stuyvesant Fish's legacy overshadows her husband's, for dubious reasons. The daughter of a Staten Island assemblyman and lawyer, Marion Graves Anthon married Fish in 1896. Although she was barely literate, she was highly esteemed among the elite, and she was even regarded by some as the heir apparent to Mrs. Astor herself. The Fishes lived in an urban mansion that sported New York City's largest private ballroom and a specially commissioned Gothic bedroom that Mrs. Fish so adored that she preferred not to disturb it by actually sleeping in it.

Mrs. Fish gained a legendary reputation for her lavish lifestyle and extravagant entertaining. She honored her own dog with a debutante ball, where the pooch appeared wearing a $15,000 diamond-studded collar. And, on an occasion when she was bored with the usual high-society dinner parties, Mrs. Fish invited guests to dine with a mysterious European count. Her friends arrived to find the guest of honor was actually a monkey wearing white tie and tails.

War and Peace

At the dawn of the twentieth century, American railroading was racing toward its zenith. The Main Line of Mid-America was changing lifestyles, from the way people traveled across town and across the country, to the foods they kept in their kitchens. The IC brought Mississippi basin strawberries to Chicago and onward to the East Coast through its connections. Bananas, once an exotic

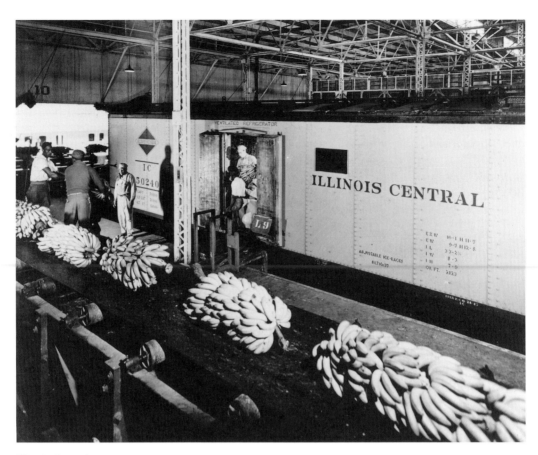

Illinois Central carried fresh bananas north from Gulf ports by the trainload. Bass Photo Company Collection, Indiana Historical Society

delicacy enjoyed only by denizens of the Gulf ports, now streamed northward in ever-longer blocks of refrigerated cars. By the early 1950s, IC was carrying upwards of 1,000 carloads of the golden stalks every week, often in solid trainloads.[5]

The coming of World War I pulled America's railroads together under the auspices of the United States Railroad Administration. Led by President Woodrow Wilson's son-in-law, William Gibbs McAdoo, the USRA took control of nearly every aspect of railroading in the interest of helping the railroads cope with the increased demands placed on them by the war effort. The 1920s brought renewed domestic prosperity and an accompanying building frenzy that resulted in major improvements to all modes of transportation. U.S. rail mileage climbed to its all-time peak, at nearly half a million miles. In Chicago, IC completed electrification of its south side commuter lines in 1926.[6]

When the Great Depression came in the 1930s, the railroads were hit as hard as any industry. Many of the great lines sank into bankruptcy and receivership. IC, however, remained solvent, although encumbered by mounting debt. The 1940s brought recovery, in the form of another war. As part of the nation's great

military-industrial machine, American railroads were run ragged during World War II. Under wartime policy, acquisition of new locomotives or rolling stock was generally out of the question, as was any meaningful renewal of the physical plants. At the same time, record-breaking freight tonnages and passenger-miles hammered the rails into a well-worn state. With plenty of income but no ability to make needed procurements and renovations, IC put its increased wartime revenues to work reducing the debt amassed by the railroad during the Great Depression. The debt reduction program, begun by IC president John L. Beven, was continued in earnest during the administration of Wayne Johnston, who took the helm of the IC in 1945.

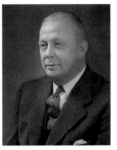

Johnston, the youngest man ever to head the IC, took the company through a period of renewal. Thousands of new freight cars were built in the company shops, worn-out track and bridges were replaced, debt was retired, and dividends were paid to stockholders for the first time since 1931. Revenues, while not at the levels seen during the war, set peacetime records year after year. Johnston presided over the IC for the longest term since Stuyvesant

Wayne Johnston led the IC through postwar transition, the railroad's centennial celebration (*see medal*), the dieselization of its locomotive fleet, and unprecedented debt reduction. A homegrown operations man, Johnston was among the last of the old guard railroad bosses. In contrast, his replacement was a corporate attorney. University of Illinois Archives. IC centennial medal from the Ralph Bachelor Collection

Fish, who had led the railroad from 1887 to 1906. Johnston occupied the famous eighth-floor executive suite in Central Station from early 1945 until his retirement in 1966. He saw the railroad through postwar prosperity, the celebration of its centennial, and the dieselization of its locomotive fleet. His fiscal policy helped IC dramatically increase the value of its stock, while the company met organized labor's demands for sizable wage and benefit increases to offset sharp escalations in postwar cost of living.

Johnston's long tenure had a lasting effect on the IC corporate culture, in some ways perhaps to a fault. Like Beven before him, Johnston fostered a culture of IC people as extended "family"; it is the one word that perhaps appears more than any other in writings about the IC during both men's tenures. While it was an altruistic philosophy, the notion of a large IC family created some expectations of entitlement that would be increasingly at odds with future realities in a threatened industry. On the whole, however, Wayne Johnston's administration represented competent, conservative, shareholder-focused management. IC performance outpaced the industry at large by a number of measures, although in reality this merely meant that IC was in a less steep decline than other railroads.

Like the culture he created, Johnston represented the end of an era. He was the last of a uniquely homegrown corps of railroad executives. He was a dyed-in-the-wool operating man who worked

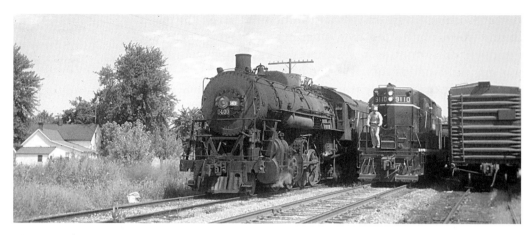

IC steamers began to seem like Rube Goldberg creations when seen next to the boxy form of early diesel hood units. External and internal combustion are pictured cohabitating near Robinson, Illinois (*top*), and on the turntable at the Palestine, Illinois, roundhouse, ca. 1955. William Millsap Collection

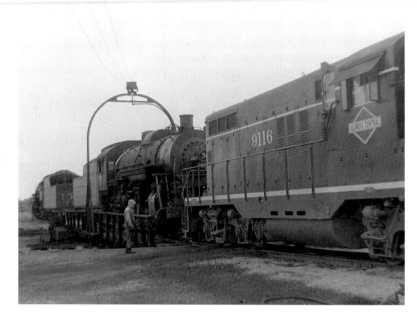

his way up through the ranks in a lifetime of service with the IC. His successor, William Johnson, represented the new guard. Although he was a career railroader with the Pennsy, Johnson was an attorney, not an operations man. This was a clear signal that management problems in the rail industry were taking on new complexities. Indeed, by the mid-1960s, American railroading was in the throes of serious decline.

The Long Road Down

Henry Ford's vision of a motorized America was fulfilled in no small part when Dwight D. Eisenhower signed the Federal-Aid Highway Act in 1956. During his European tour of duty in World

War II, Eisenhower got a firsthand view of Hitler's high-speed national roadway, the Autobahn. Conceived as part of the Third Reich's military infrastructure, the Autobahn ironically served the Allied forces even better as they moved in to occupy Germany at the war's end. During his presidency, Eisenhower became the chief proponent of an Autobahn concept for the United States. The Federal-Aid Highway Act established the financial mechanisms to build and, presumably, fund the upkeep of the system in perpetuity. Eisenhower succeeded in launching what would become the most massive public works project in American history and arguably the largest road-building program ever undertaken by human civilization—the Interstate Highway System.

The project was undertaken in principle as a military solution for rapid troop and equipment movement and rapid evacuation of urban areas in the event of a nuclear attack (a proposition whose absurdity can now be attested to by any urban rush hour commuter). Still, the commercial and societal implications were undeniable. With well over 40,000 miles of four-lane concrete arteries, the Interstate Highway System represented the perfection of Henry Ford's rubber-borne vision, and almost certainly painted a picture of decline for the flanged wheel. Passenger service was the first to feel the impact of postwar letdown. Routes in decline were being pulled from timetables as early as 1948, where the Interstate Commerce Commission would permit. In the 20 years following World War II, IC passenger traffic declined by 40 percent, and the rail industry's cumulative passenger service deficits exceeded $700 million.[7]

Blaming all of the rail industry's woes on Eisenhower's highways, however, would be a gross oversimplification. The highways gave rise to new competition, but there were other factors at work that prevented the railroads from competing effectively. Among them were both an increasingly adversarial relationship between management and labor and onerous government policies and regulations that were divorced from modern realities.

By the 1960s the industry was ready for a shakeout. Since World War II, the market share of freight traffic carried by the railroads had slid from 70 to 40 percent, and what business remained had shifted away from carload merchandise to lower-margin, bulk commodities and intermodal traffic. So, while the share in volume was 40 percent, the share of freight *value* handled by the railroads was far lower—about 4 percent. Gone from the IC were the fresh meats, strawberries, and solid blocks of banana reefers. With business eroding, IC and other rail companies began looking for consolidation partners.

The merger movement produced one pair of especially unlikely bedfellows, the Pennsylvania and New York Central, who joined in an ill-fated marriage as Penn Central. On paper, it looked

like a powerful combination: the two 800-lb. gorillas of eastern railroading, united into a super railroad, poised to lead the industry into better times. But those closest to the action knew there were insidious obstacles to the success of the merger. The two companies had been bitter rivals for generations, and there was deep-seated distrust and suspicion among the power holders in this new, dysfunctional family that proved decisively counterproductive. Diversification, which had become the buzzword in the industry, led management into a tangled web of ancillary ventures, and executives began divorcing their intellects from the core business of railroading. The merger was ill-conceived, poorly executed, and ultimately an unmitigated disaster. On June 22, 1970, after two and a half years and more than $430 million in losses, Penn Central declared bankruptcy. At the time, it was the largest business failure in American history.[8] Yet the worst wasn't over for the railroad industry.

IC president William Johnson was far more successful with his diversification program than were the Penn Central managers. During the last years of the Wayne Johnston administration, Illinois Central Industries was created as the parent company of the railroad. The strategy was to build a conglomerate of companies that would broaden earnings horizons for shareholders and prop up the railroad. As with Penn Central, commercial real estate played a significant role in the program.

Real estate was the low-hanging fruit in many railroads' diversification efforts, chiefly because it was an existing asset that was readily marketable. In IC's case, real estate marketing was an important focus of the company from its earliest days as a land grant railroad. Many of IC's modern land marketing efforts supported industrial development along the railroad, which was good for the transportation business. But IC's property holdings near the Chicago lakefront created uniquely lucrative opportunities to sell "air rights," which allowed developers to build skyscrapers over the tracks. The earliest such customer was Prudential Insurance Company of America, which built its landmark tower over the IC right of way east of downtown Chicago in 1955, during the Wayne Johnston administration, long before the creation of IC Industries.[9]

Wayne Johnston's conservative approach to diversification gave way to decidedly more aggressive plans when the reins were handed to William Johnson. Under Johnson, IC Industries made aggressive acquisitions in an industrial grab bag so diverse that it seemed almost absurd—from hydraulic pumps, to Pepsi Cola, to pantyhose. Some of the new corporate stepsiblings to the railroad included Lincoln Financial, Inc., a Houston-based holding company for insurance and mobile home mortgage services; Benjamin

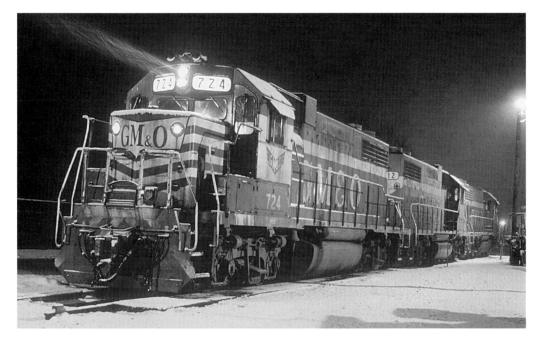

A new corporate name—Illinois Central Gulf—portended the arrival of these foreign visitors at Palestine during the winter of 1973. William Millsap Collection

Franklin Savings, a Houston S&L; Abex Corp., manufacturer of railroad car and track components; Signal-Stat Corp., producer of safety signaling devices for fleet vehicles; Pepsi Cola Bottlers of Chicago, distributors of Pepsi products in IC territory from Chicago to Kansas City to New Orleans; Dad's Root Beer and Bubble-Up soft drinks; Perfect Plus Hosiery; and Midas-International Corp., operator of quick-service automotive muffler and brake shops.

The aggressive augmentation of IC's corporate family under William Johnson drastically transformed the revenue streams of the company, seemingly overnight. In 1966, the last year of Wayne Johnston's presidency, 95 percent of the corporation's revenue was derived from transportation. By 1972 that ratio had fallen to 28 percent, and total revenue was approaching the $1 billion mark.[10] The change in fortunes had begun diverting Johnson's attention from the flagging business of railroading, and in 1969 Florida attorney and former U.S. transportation secretary Alan R. Boyd was hired to assume the role of president of the railroad. Together with Johnson, Boyd would literally make a new name for the railroad.

On August 10, 1972, the Gulf, Mobile & Ohio Railroad and the 121-year-old IC merged to become the Illinois Central Gulf Railroad (ICG). Managers of both companies saw an ideal opportunity to create a consolidated, streamlined north-south railroad, while eliminating their respective chief competitor. Merger talks had begun during the Johnston years, and the application for their corporate marriage license was filed in 1968. Shippers, labor, and

the Interstate Commerce Commission had their say, and the two railroads were joined.

The new company was 9,568 miles of railroad—more than Alfred E. Perlman's New York Central prior to its merger-induced downfall.[11] Among those miles was a proliferation of light-density and secondary lines, including the Columbus & Greenville Railway and the Mississippi Central, two stepchildren that the Interstate Commerce Commission practically forced on the ICG as a condition of the merger. There were some 21,000 people employed in operating the new railroad—more than two employees per mile. Freight tonnage-per-mile analysis showed ICG squarely at the bottom of the industry. Desperate to shake off its burdens, ICG entered a phase of abandonments. Attorney John Doeringer was part of the ICG management team that began the earliest downsizing of the railroad immediately following the GM&O merger. He recalls the flurry of abandonment proceedings that grew out of the merger: "Prior to the GM&O merger, there were no abandonments of any consequence. After the merger took effect, the abandonment program began in earnest. If the IC lines looked bad by that time, the GM&O lines looked far worse. Where would the money ever come from to fix them up? Abandonment was the only answer. We got rid of small pieces—8–10 miles here and there. Then, a big one—very urgent—a GM&O line from Murphysboro south toward Cairo. We had to do that one right away. It was a roller coaster of a line with a long steep grade. It was a bad situation—wreck after wreck. We got rid of some others in the South, too; we sold Columbus & Greenville to Southern, who had owned it years before. We had to start rationalizing quickly. IC stock was hovering around $10 per share."[12]

The railroad was forlorn and getting worse. By some accounts, it was like a rolling junkyard. Freight cars were deteriorating, and IC's bad order ratios were among the worst in the industry. The Paducah shops heroically kept the motive power roster padded with rebuilt early generation GM road switchers. From 1978 to 1982, Paducah craftsmen remanufactured more than 200 locomotives.[13] The "Paducah Geeps" left a distinctive (albeit somewhat homely) imprint on IC men and rail enthusiasts alike.

After the merger, IC's marketing department, led by John Ingram, began developing new service concepts and aggressive pricing tactics, with an emphasis on bulk commodities movements—heavy unit trains with ultra-low rates. Despite an admirable boldness and spirit of innovation uncommon in the industry, these new marketing ideas would only add further strain to the already ailing railroad. One of the most controversial concepts was "Rent-a-Train."

Rent-a-Train was designed primarily for a single, large-volume

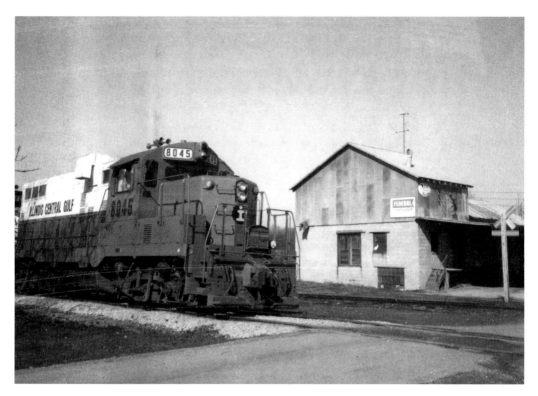

The distinctive Geeps rebuilt in ICG's Paducah, Kentucky, shops were a common sight. This specimen is seen on the Indianapolis line at Solsberry, Indiana. Larry Shute Collection

customer, Cargill. The company had its own barge fleet and did a lot of shipping on the water. Rent-a-Train was designed to move large volumes of export grain out of a landlocked area of eastern Illinois to the Gulf. Rent-a-Train rates were published in such a convoluted way that it would have taken a mathematician to actually discern the rate being charged. Therein lay the gimmick. In essence, Rent-a-Train was nothing more than a rate cut for bulk Cargill business. Curiously, according to Doeringer, the Interstate Commerce Commission—the same regulatory body that stonewalled on Southern Railways' 100-ton "Big John" hopper because small shippers couldn't qualify for its discount rate—approved the Rent-a-Train concept.

Although unit train margins were razor thin, every time a train moved, it seductively put thousands of dollars in the corporate till. Coal from Illinois mines bound for Commonwealth Edison in Joliet was moving for as low as $1.30 per ton. Doeringer observes, "If only we could have gotten closer to $2.00 or $2.25 a ton, we could have lived with it. But some of the managers said, 'Every time this train runs, it's $13,000 in the bank. If it runs twice a week, that could very well cover our payroll.' So we did what we had to do to survive. In the long run, though, all that these marketing ideas did was wear down the railroad very quickly."

On the ICG main line, the slow orders were ominously begin-

ning to spread. The profusion of light-density and secondary lines and branchlines was seriously deteriorating. Maintenance on these lines had been systematically deferred to pare overhead expenses and free up the cash necessary to keep the core of the railroad operable. It wasn't enough. Doeringer recalls a conversation with an IC finance executive that summed up the futility of the situation: "John," he began, "this company is only replacing 1 percent of our rail every year. Do you realize what that means? At this rate, every piece of new rail we lay has to last 100 years!"[14]

New Blood, New Direction

In 1975 John Ingram left ICG to lead the Rock Island through its last years. Upon his departure, Alan Boyd recruited a new marketing vice president, Harry J. Bruce, from the Western Pacific. Bruce had been an understudy to the legendary Alfred E. Perlman, who had gone west to resuscitate the WP following the fall of Penn Central. Six months into Bruce's tenure at IC, Alan Boyd parted ways with IC Industries, and it looked as though Bruce's ICG career would be short-lived. However, he remained under ICG vice president and chief Washington lobbyist Bill Taylor, who was tapped for the presidency. Bruce launched aggressive marketing initiatives that were service-oriented, rather than being focused on lowball rates such as Rent-a-Train. Some ideas were more successful than others. Among the concepts Bruce introduced were high-frequency, quick-turn "Slingshot" trains and TRT (Truck-Rail-Truck) door-to-door delivery for steel producers. Significantly, Bruce also explored new export markets for the high-sulfur southern Illinois coal that could no longer be burned domestically in the volumes previously consumed.[15]

During Bruce's years as ICG marketing chief, the complexion of the entire industry changed dramatically. The Penn Central bankruptcy in 1970 was merely the opening act in an epic industrial tragedy. By 1976 eastern railroading had descended into a state of crisis. Other major carriers, representing nearly 25 percent of the nation's rail mileage, also sank into bankruptcy: Central of New Jersey, Lehigh Valley, Lehigh & Hudson River, Reading, and Erie-Lackawanna. Congress at last responded with legislation that began to remove the artificial impediments to operating and managing railroad companies—the Railroad Revitalization and Regulatory Reform Act of 1976, also known as the Four-R Act.

The Four-R Act capitalized and reorganized the bankrupt eastern railroads into a government-operated system dubbed Consolidated Rail Corporation, or Conrail. Under the provisions of the act, Conrail would remain under government control until it was returned to profitability, at which time it would be reprivatized.

Illinois Central, by virtue of its corporate slim-down plan, became the mother of the regional and shortline movement of the mid-1980s. One of the offspring, the Indiana Rail Road Company (INRD), became a great success. (Had it not, you wouldn't be holding this book in your hands.) Since 1986, INRD has enjoyed management continuity and exponential traffic growth. But originally with 110 miles and a price tag of $5.3 million, this reincarnation of the former Indianapolis line was practically the runt of the litter. INRD had some much bigger brothers and sisters among the IC spin-offs. Some made good; some didn't. Here's how things have panned out for the other IC scions:

Gulf & Mississippi Railroad

G&M became the first fruits of IC's secondary line sales program on July 10, 1985. The company was 715 miles of mostly parallel north-south Gulf, Mobile & Ohio lines in Mississippi. The G&M never found its legs. Chronically ailing, the company was nearly broke when it was purchased by MidSouth Rail Corporation after less than three years. Kansas City Southern acquired MidSouth in 1994, and most of the G&M lines are once again under the corporate umbrella of a Class 1 railroad.

Chicago, Central & Pacific Railroad

The second begotten offspring of IC, the CC&P, originated at Hawthorne Yard in Cicero, Illinois, and ran westward to Council Bluffs, Iowa. It was basically the former Iowa Division of Illinois Central, including a branchline to Sioux City and the former district from Waterloo to Albert Lea, Minnesota, known as the Cedar Valley Railroad. In addition to IC tracks, CC&P adopted its own version of the venerable IC green diamond herald. CC&P built a successful operation, hauling coal, agricultural goods, food products, chemicals, and mixed freight with more than 250 employees. Ironically, CC&P was so successful that Illinois Central repurchased the company in 1996. It continues operating today as part of Canadian National.

MidSouth Rail Corporation

In late March 1986, just two weeks after the Indiana Rail Road Company began operations, newly created MidSouth Rail Corporation purchased 373 miles of IC lines between Meridian, Mississippi, and Shreveport, Louisiana—the Vicksburg route. MidSouth went on to acquire other Louisiana properties, notably some ex–Rock Island lines. It also came to own the ICG Mississippi lines spun off in 1985 as the Gulf & Mississippi. Kansas City Southern bought MidSouth on January 1, 1994.

Paducah & Louisville Railway

IC's Kentucky Division was purchased in August 1986 by CG&T Industries, Inc., a corporation formed by the owners of western Kentucky aggregates and warehousing businesses served by the IC. In 1988, PAL was sold to First Chicago Corporation, and in 1995, the railroad was acquired by current owner Four Rivers Transportation, Inc., a holding company controlled by PAL management and CSX Transportation. Today, with over 270 route miles, some 250 PAL employees serve more than 90 online industries, as well as bulk terminals, reload centers, Ohio River ports, and the U.S. Army installation at Fort Knox. Commodities handled include chemicals, coal, aggregates, lumber, propane, and heavy equipment.

As a footnote to the PAL story: IC's legendary locomotive shops at Paducah have survived under VMV Enterprises, which continues the business of rebuilding and repairing locomotives for customers around the world under the "VMV Paducahbilt" trademark.

Chicago, Missouri & Western

On April 28, 1987, IC sold the Kansas City and East St. Louis lines—the old Chicago & Alton route—to upstart CM&W. A sickly offspring, the 633-mile CM&W suffered a fate similar to the G&M; it was in bankruptcy within a year. The railroad was split up in the fall of 1989 when Southern Pacific bought the East St. Louis line. Pursuant to the bankruptcy proceedings, Santa Fe served as designated operator of the Kansas City portion, the Gateway Western. The East St. Louis line survives today under Union Pacific. Gateway Western was sold to Kansas City Southern in 1997.

More significantly, Four-R made it easier for railroads to get out from under money-losing operations—to liquidate or abandon money-losing properties, enter into cooperative service agreements, and reduce redundancies in their physical plants.

Not least among the benefits of Four-R, the government made cheap capital available to the railroads to rebuild their wretched tracks. During the 1970s, a curious term had been heard with increasing frequency: "standing derailment." It's every bit as ridiculous as it sounds—parked trains simply falling off the rails (or, more precisely, a deteriorated track structure that gives way beneath the weight of a parked train). Standing derailments were a fact of life and a sad commentary on the state of America's rail infrastructure. Derailments of trains in motion were occurring frequently as well and contributing to sharply escalating costs. Through the provisions in the Four-R Act, and with some masterful lobbying by the old Washington hand Bill Taylor, IC qualified for some $167 million in low-interest loans from the Federal Railroad Administration. IC was now mortgaged to the FRA. If management defaulted on the loan, the railroad would be partly owned by the government, a scenario that fortunately never played out.[16]

The Four-R Act also paved the way for more profound changes in the government's relationship with the railroads—the passage of the Staggers Rail Act in 1980. Staggers was a watershed event. It gave railroads new freedom in negotiating confidential price-and-service packages and long-term transportation agreements directly with shippers. The railroads had won new business latitude and a new era of self-determination in managing their affairs. The ink from President Jimmy Carter's pen was barely dry when the ICG became the first railroad to sign a long-term transportation agreement, a coal movement contract with Hoosier Energy in Bloomington, Indiana. The contract was negotiated by ICG coal marketing manager Thomas G. Hoback.

Growing Smaller

On April 15, 1983, ICG experienced a shocking and disheartening event. At an afternoon luncheon engagement, CEO Bill Taylor suddenly collapsed and later died at a Chicago hospital. It was a traumatic moment of crisis for the company. ICG was unexpectedly without leadership or an heir apparent.

Several weeks after Taylor's passing, ICG's board of directors chose Harry Bruce as the company's new chairman and CEO. During his years as marketing chief, Bruce developed the theory that a radically smaller, streamlined ICG would be profitable. Inspired by the manner of his former boss, Perlman, Bruce aggressively pursued hard data to support his case. He appointed a task force to

gather the metrics needed to test his hunch. Bruce ordered a study of 30 years' worth of data on ICG branches and secondaries from 1954 to 1984, essentially the life span to date of the Interstate Highway System.[17] The study revealed without a doubt that traffic and revenue from ICG's branches and secondaries had fallen to mostly unprofitable levels. However, with the growth of Sun Belt industries and export traffic through the Gulf ports, the north-south trunk remained robust. With his theory validated, Bruce and his core rationalization team, including Doug Hagestad, Rick Bessette, Harry Meislahn, and Henry Borgsmiller, began planning rationalization of the Illinois Central Gulf on a massive scale. It was an undertaking that would result in the wholesale liquidation of two-thirds of the company.

Bruce approached his line sales program in the style of a marketing man, with an emphasis on packaging. Working with Hagestad, he bundled ICG's branchlines into turnkey deals that would be attractive to upstart operators, in what would become the early seeds of the post–Staggers Act shortline movement. The deals included various combinations of rights of way, locomotives, rolling stock, structures, equipment, connections, and traffic sharing agreements—everything a new railroad would need to get started. Pricing was determined by the condition of the property, as well as its traffic and revenue prospectus. ICG executives weren't just selling pieces of railroad; they were selling self-contained businesses. It was a creative approach to solving the rationalization problem. However, selling the plan to the ICI board would be another story.

As CEO, Bruce reported to the board of directors of IC Industries, which had its own ideas. They had concluded that the railroad should be sold in its entirety to a single buyer, ideally another Class 1 railroad. Given the newfound regulatory freedoms and strategic flexibility in the industry, coupled with the analysis showing that the north-south main line could be profitable if liberated from the secondaries, the board's insistence that ICG be liquidated as a whole seems puzzling. To many observers, it revealed a desire to exit the railroad business as cleanly and expeditiously as possible.

When Bruce first presented the idea of secondary line sales to the board, it was met with stern disapproval. He would have to wait to sell his plans and advance his agenda. Opportunity just happened to come knocking one evening in late 1984. A business reporter for the *Chicago Tribune* called Bruce's office angling for a story and began questioning him about rumors concerning the sale of IC properties. The answer he gave was at once spontaneous, shrewd, and powerful. It was released like a snap of static electricity, built up by the friction between his designs for IC and the intransigence of the board. Throwing caution to the wind, he

told the reporter that if genuine, viable offers were made for ICG properties, he had a responsibility to shareholders to give those offers serious consideration.[18]

When the story hit the newsstands, the reaction of the board was predictable, to say the least. Bruce was summoned to William Johnson's office, where he was subjected to a blistering diatribe. But while Bruce's ears were ringing, so was his telephone. When he returned to his office, he was greeted with a stack of credible inquiries about the sale of ICG secondary lines. Overnight, the line sales program had taken on a life of its own and was already gathering the momentum of a runaway train.

Within months, the dying limbs began dropping off. In the summer of 1985, the Gulf & Mississippi was born from 715 Mississippi miles of the old GM&O. Price tag: $22.5 million. Next, the eastern 52 miles of the line to Montgomery, Alabama, was sold piecemeal to the Southern Railway and Seaboard Coast Line for

Chairman and CEO Harry J. Bruce changed the railroad's name back to Illinois Central in 1985 and presided over the liquidation of two-thirds of the company's 9,000 miles of track. Courtesy of Harry J. Bruce

$8.5 million. In late December, the Iowa line became the Chicago, Central & Pacific, and another $75 million went into the bank. The following year, the Mid-South Rail Corporation acquired the Vicksburg Route for $123.5 million. A portion of the Indianapolis line—the subject of this book—brought $5.3 million, and the Kentucky Division became start-up Paducah & Louisville for $70 million. The Chicago & Alton lines were next—$81 million—sold to the Chicago, Missouri & Western. And the electrified Chicago commuter lines were transferred to the Metra system for $28 million.[19] Within three years, more than 6,000 miles of track were liquidated and nearly half a billion dollars in cash was deposited in the till. The essential IC had emerged.

Bruce's approach to liquidating the withering limbs of his railroad had proved to be a masterful solution. Getting rid of the entire 9,000-mile ICG, as the IC Industries board so ardently desired, would have been a tougher sale, given the industry environment at the time. For a Class 1 railroad to acquire the IC lock, stock, and barrel—including its many flagging branches and secondaries, labor agreements, high operating ratios, and other baggage—would have been like a python trying to swallow a German shepherd. But the individual pieces were attractive to nonunion start-ups, which could operate those properties with radically different cost structures.

THE INDIANA RAIL ROAD COMPANY

The streamlined IC had a real future now that it was again capable of making good money for shareholders, above and beyond what a wholesale trip to the auction block would have yielded. And the prospects of a revitalized IC were even better with the infusion of the hundreds of millions of dollars in capital that the line sales program generated. Coupled with a program of offering voluntary severance packages to "buy down" employment, the rationalization program drove IC's operating ratios to among the lowest in the industry by 1988. IC Industries voted to spin off the railroad, which in 1985 had dropped "Gulf" and reverted to its original name, Illinois Central. The stock of the new Illinois Central opened on the NYSE on January 3, 1989, at $11 per share. By the end of the month, the price had nearly doubled. On February 20, a small New York–based investment company, Prospect Group, made a tender offer of $20 each for all outstanding shares and acquired control of the company within a month. By mid-March, Harry Bruce's work on the Illinois Central Railroad was done.[20]

The downsizing of the IC was an industry milestone. Never before had a major American railroad undergone such a sweeping, self-directed transformation. The effects of IC's turnaround echoed throughout the industry, as other companies adopted similar strategies. Whether or not he realized it at the time, Harry J. Bruce had become one of the early architects of a movement that both revitalized existing railroads and gave rise to an entirely new generation of start-up companies that would contribute to a grassroots rebirth of the rail industry.

One of those companies pulled its first train on March 18, 1986, over 110 miles of what had been IC's Indianapolis District. With former IC tracks, former IC customers, and a former IC marketing man at the helm, the Indiana Rail Road Company began plying the rails.

A Time to Build

I built the railroad with unlimited gall and a box of cigars.

—E. Pratt Buell, Clark Buell Donahay & Co., contractors

A casual glance down the Indiana Rail Road main line paints a deceptive picture. Or, more correctly, it paints no picture at all. The monotony of the timbers, gray stone, and twin steel ribbons belies the rich fabric upon which the tracks are laid. It's a fabric woven with stories: not stories about a railroad, but stories about people. There were the ordinary people working to carve out lives for themselves in cities and towns and in the isolated countryside of Illinois and Indiana after the Civil War. And there were the extraordinary people, urban men of powerful means, strong wills, and resourcefulness. For both the everyday people and the luminaries, the railroads promised to change life dramatically.

Today, modern transportation and communications technologies are seen as continually shrinking the world. That trend began in earnest with the first transcontinental railroad, in what was arguably the most significant shrinking of the planet since Columbus's voyage to the West. When the golden spike was hammered at Promontory Point in 1869, the sound resonated throughout the country, striking a particularly alluring chord in the ears of entrepreneurs. It was the sound of money. The railroad was far more than a transportation machine; it was a commerce machine. No

other industry held such powerful potential in expanding the economy, generating new wealth, and weaving together far-flung communities in a growing nation. The western frontier was untapped and full of promise. The railroad represented the apex of mankind's technological achievement. (Today, some history teachers even describe the early steam locomotive to their students as the "space shuttle of the nineteenth century.") It was an emotional rush that stirred the nation to a fever pitch. It was a time to build.

Judging by the outcomes of many early railroad ventures, the building frenzy must have been fueled largely by such raw emotion, as opposed to rational business planning. As Elmer Sulzer aptly illustrated in his *Ghost Railroads* books, exuberance often led to a mentality of "ready, fire, aim." Many of the lines constructed during the late nineteenth and early twentieth centuries were poorly conceived or only marginally justifiable from an economic standpoint. Indeed, by World War I, the nation's rail mileage had peaked at well over a quarter of a million miles, much of it overbuilt and layered with redundant routes. Flagging railroads that were lucky merged into bigger trunk lines; the rest were abandoned.

The Indiana Rail Road Company traces its lineage to a patchwork quilt of these early ragtag lines that bisected isolated backwoods and prairies. Individually, these little railroads were too weak to survive, but stitched together with the will and deep pockets of some of the most famous empire builders of the Gilded Age, they would forge a viable link to Indianapolis for the Illinois Central.

Narrow-Minded

Some of the right of way that would become the Indiana Rail Road began as part of an envisioned east-west railway linking St. Louis and Cincinnati.[1] This would be unremarkable in and of itself, but the "Cincinnati & St. Louis Straight Line," as it was known, was different. It was planned as a three-ft. gauge line. Commonly employed in captive settings such as mines, quarries, and timber operations, narrow gauge railroads were now being promoted by some postwar builders as the future of mainstream railroading—a superior, competitive alternative to standard gauge.

The U.S. Civil War was the first conflict in history in which railroads played a decisive role. The Union had the upper hand in most aspects of railroading, including management, engineering, and equipment, but the issue of track gauge also factored significantly in Union superiority. While certainly not universal at the time, standard gauge enjoyed greater prevalence in the North. In 1861, 13 track gauges were used in the northern states, although only 3, including standard gauge, enjoyed prominence.[2]

In contrast, the South was a mixed bag of track gauges, including a number of broad gauge lines—five-foot and five-foot-six-inch gauges, for example. These incompatible railways required cumbersome and inefficient offloading and reloading of freight and created serious logistical problems in mobilization. One might be led to assume that non-standard gauge railroads became extinct after the Civil War, but the opposite was true. In *American Narrow Gauge Railroads,* George W. Hilton writes that the narrow gauge movement was just getting started in earnest in the 1870s, in spite of lessons learned in wartime. Railroad builders were pressing forward with plans for narrow gauge lines even decades after the war's end. Puzzling as it may seem logistically, it made sense financially.

The junior-width railways offered attractive start-up advantages. The right of way was slimmer and easier to clear and grade. The equipment was lighter and less expensive to build, and it could ride on lighter rails, timber, and roadbed. In short, narrow gauge railroads were simply faster and cheaper to build, which was significant in this age when the country was in a hurry to finance and build rail lines, often with help from taxpayers along the routes.

Local governments helped perpetuate the gauge problem by imposing restrictions on where railroad companies could build. In communities served by more than one railroad, ordinances frequently were enacted that prohibited the rail companies from building their depots in close proximity. These peculiar laws served to prop up the livelihoods of local teamsters, who made their fortunes by providing horse-drawn transfer service between rail facilities for passengers and freight. One of the most notorious examples was in Richmond, Virginia, where authorities prevented the intersection or interchange of any of the five railroads serving the city.[3] The notion of a standard track gauge was rendered moot by these early zoning models, which ensured competing rails wouldn't meet.

Another factor that supported early narrow gauge lines was a localization of commerce. Interline movements and multiple interchanges weren't yet necessary to meet the demands of trade and commerce. Early rail lines reflected this localization and served as feeders to urban areas, as opposed to establishing links between them.[4] It was easy to view the local railroad as more or less a closed system, and narrow gauge could certainly be seen as an adequate platform for many proposed developments.

As railroading began to link major commerce centers and expand intercity trade, the narrow gauge movement sought to compete with the standard gauge lines. By connecting adjacent narrow gauge routes, promoters hoped to establish large trunk systems. The Cloverleaf Branch of the Nickel Plate Road, for example, traced its origins to the Toledo, Delphos & Indianapolis, which

was part of an envisioned narrow gauge empire that would have stretched to the Texas Gulf Coast. The Cincinnati & St. Louis Straight Line, the earliest ancestor of the Illinois Central's Indianapolis line, was a similarly conceived entity, itself part of the "East and West R.R."[5] The E&W was a grand plan for a continuum of narrow gauge lines reaching eastward to Washington, D.C. It was a risky venture—not just an investment in the viability of a route, but betting the farm on the viability of the narrow gauge movement itself. The ante was laid down in the middle of the Illinois prairie.

West of the Wabash: Effingham

The history of Effingham, Illinois, dates back to the early nineteenth century, when the first pioneer settlements sprang up along the banks of the Little Wabash River. Farming was the dominant economic activity, and the area was slow to grow until the coming of the railroads in the 1850s, notably the Illinois Central. The first name of the community was Wehunka, a reference to an Indian chief who founded a settlement there. The name was later changed to Ewington and then to Broughton, in honor of John Brough, future governor of Ohio and a railroad land speculator. In 1859, the village of Broughton became the county seat and was renamed Effingham, for the British nobleman Lord Edward Effingham, who refused to fight against the colonies in the American Revolution. Some historians theorize, however, that the name was adopted in deference to a later Lord Effingham who led a group of British investors in bankrolling the IC.[6]

In the late 1800s, Effingham began to emerge as the major transportation junction point it is today. In addition to the Illinois Central, the railroads converging on the city included the St. Louis, Vandalia & Terre Haute; Chicago & Paducah; Springfield & Southeastern; Chicago & Eastern Illinois; and the narrow gauge Springfield, Effingham & Southeastern (SE&SE), the first significant link in the Cincinnati & St. Louis Straight Line.

The SE&SE, or "See & See," was a venture of the Cincinnati, Effingham & Quincy Construction Co. After the railroad's incorporation in 1869, the political process of building the line commenced with the seeking of subsidies and franchises from local governments. As luck would have it, however, it was a bad time to begin building a railroad. On September 18, 1873, Jay Cooke and Company, a prominent New York banking firm, failed and set off the Panic of 1873. The ensuing deep recession stymied plans to start building the SE&SE, and it also led to the railroad's name becoming a misnomer, because construction to Springfield never came to fruition.

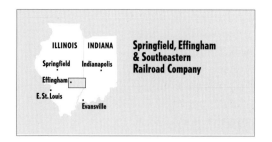

Springfield, Effingham
& Southeastern
Railroad Company

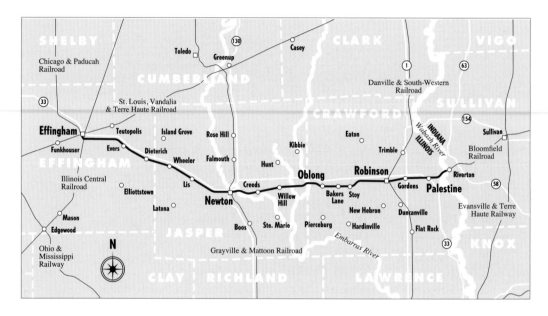

Map by Roy G. Benedict Publishers' Services for the Indiana Rail Road

The plan was to build the line eastward 57 miles from Effingham to the Wabash River and join another 31 miles of track being laid between the Wabash and Switz City, Indiana, the Indiana portion of the line having been incorporated separately as the Bloomfield Railroad Co. From Switz City, the Bloomfield Rail Road Co. (not to be confused with the previously mentioned Bloomfield *Railroad* Co.) had completed six miles of track linking Switz City with Bloomfield in 1874.[7] From there, the line's architects wanted to acquire the Bedford Springville Owensburg & Bloomfield, which had been in operation since 1877, and then build east from Bedford to Madison and Cincinnati.

Firsthand accounts from railroad employees indicate work on the Illinois side began in 1878 or 1879 in Robinson, moving in

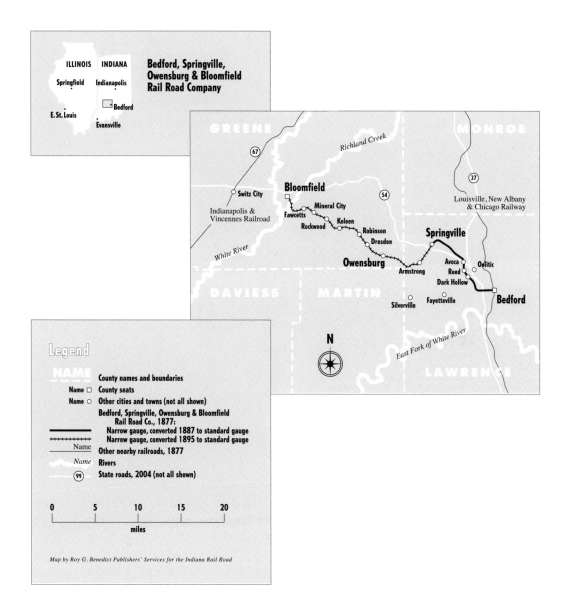

Bedford, Springville, Owensburg & Bloomfield Rail Road Company

Legend

NAME	County names and boundaries
Name □	County seats
Name ○	Other cities and towns (not all shown)
	Bedford, Springville, Owensburg & Bloomfield Rail Road Co., 1877:
————	Narrow gauge, converted 1887 to standard gauge
++++++++	Narrow gauge, converted 1895 to standard gauge
Name	Other nearby railroads, 1877
Name	Rivers
(99)	State roads, 2004 (not all shown)

0 5 10 15 20
miles

Map by Roy G. Benedict Publishers' Services for the Indiana Rail Road

both directions.[8] This supports Elmer Sulzer's assertion that the SE&SE was built between 1878 and 1880.[9] It was at that time that the locals in Robinson first noted the appearance of a flamboyant character by the name of E. Pratt Buell. Buell was a partner in the SE&SE's principal contractor, Clark, Buell, Donahay & Co. He was described as the "head pusher," and he was never without a cache of stogies. He is credited with making the legendary statement, "I built the railroad with unlimited gall and a box of cigars!" Buell's son Ed, incidentally, became a conductor on the road his father built with his temerity and tobacco.

Buell and his crew actually made their appearance in Indiana a couple of years before they began work in Robinson. In July 1875,

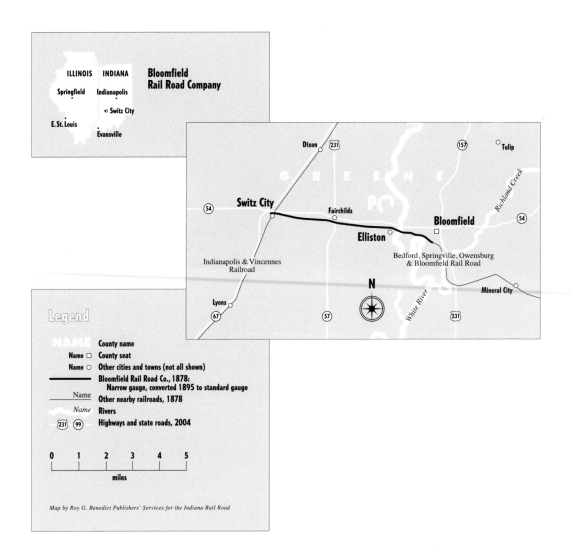

ILLINOIS INDIANA **Bloomfield Rail Road Company**

Springfield Indianapolis

⌐ Switz City

E. St. Louis

Evansville

Dixon 231 157 ○ Tulip

G R E E N E

54 **Switz City** Fairchilds **Bloomfield** 54

Elliston

Indianapolis & Vincennes Railroad

Bedford, Springville, Owensburg & Bloomfield Rail Road

N

Lyons 67 57 231 Mineral City

Richland Creek

White River

Legend

NAME **County name**

Name □ **County seat**

Name ○ **Other cities and towns (not all shown)**

—— **Bloomfield Rail Road Co., 1878:**
 Narrow gauge, converted 1895 to standard gauge

Name **Other nearby railroads, 1878**

Name **Rivers**

231 99 **Highways and state roads, 2004**

0 1 2 3 4 5

miles

Map by Roy G. Benedict Publishers' Services for the Indiana Rail Road

Buell's company signed on as contractor, and work progressed steadily through 1876. In the summer of 1877, the Sullivan *Democrat* reported that the railroad's first locomotive had been delivered and christened the *Joseph W. Wolfe,* in honor of the company president. It was said to be "a very handsome little engine." That statement certainly belied the condition of the company itself, which the *Democrat* also chronicled with accounts of threatened labor strikes and financial tribulations.[10]

By 1878, the Cincinnati, Effingham & Quincy Construction Company fell into bankruptcy and was held in receivership until it was sold in 1882. In the interim, the SE&SE was finally opened for business in 1880. It was a pathetic excuse for a railroad: 35–40 lb. iron rails, laid on untreated ties, and unballasted earthen roadbed that was only lightly graded.[11] There were insufficient funds to build proper stations and structures, so surplus boxcars were used in-

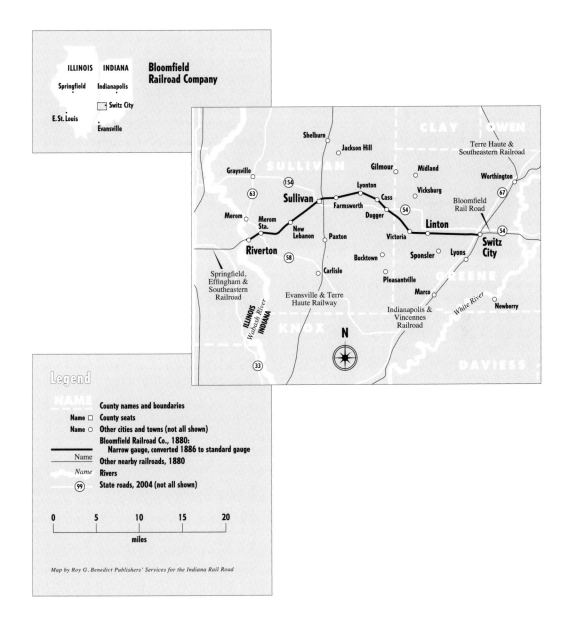

ILLINOIS INDIANA **Bloomfield Railroad Company**

Springfield
Indianapolis

Switz City

E. St. Louis

Evansville

Shelburn
Jackson Hill
Gilmour
Midland
Terre Haute & Southeastern Railroad
Graysville
Worthington
SULLIVAN
Lyonton
Vicksburg
154
Sullivan
Cass
63
Farmsworth
Bloomfield Rail Road
67
Merom
Dugger
54
Merom Sta.
Linton
New Lebanon
Paxton
Victoria
54
Riverton
58
Switz City
Bucktown
Sponsler
Lyons
Springfield, Effingham & Southeastern Railroad
Carlisle
GREENE
Pleasantville
Evansville & Terre Haute Railway
Marco
Indianapolis & Vincennes Railroad
White River
Newberry
ILLINOIS
INDIANA
Wabash River
KNOX
N
DAVIESS
CLAY
OWEN
33

Legend

NAME	
Name ☐	County names and boundaries
Name ○	County seats
	Other cities and towns (not all shown)
Name	Bloomfield Railroad Co., 1880: Narrow gauge, converted 1886 to standard gauge
	Other nearby railroads, 1880
Name	Rivers
99	State roads, 2004 (not all shown)

0 5 10 15 20

miles

Map by Roy G. Benedict Publishers' Services for the Indiana Rail Road

stead. If it sounds like a recipe for disaster, it most certainly was. From its earliest days, the SE&SE was a wretched affair.

The railroad began operations from Effingham to Palestine in the fall of 1880, with the remainder of the line across the Wabash River to Switz City opening in December. Interstate service lasted just over 60 days before the first catastrophe struck. On February 8–10, 1881, high water and ice floes destroyed the Wabash River bridge, severing the railroad at the state line and isolating one of the four locomotives on the east side of the river. Connections with other rail companies at Switz City and Effingham kept each half of the line functioning, but the revenue lost from westbound

The president of the I&IS, Joseph W. Wolfe, was an ordained Baptist minister, making him uniquely qualified to lead a railroad that ostensibly didn't have a prayer in the world. Wolfe was born in 1810 in Virginia and moved to Sullivan with his father at the age of nine. He was a highly respected member of the community, and, in addition to his ministerial duties, he was twice elected clerk of the Sullivan County courts. He was known as a successful investor, which is what led him—unfortunately, for his sake—to enter the railroad business.

As president of the narrow gauge, Wolfe continually attempted to part a Red Sea of woes, not the least of which was trying to make payroll for some 600 employees. Evidence of their tenuous relationship was chronicled in the pages of the Sullivan County Democrat in the summer of 1877, when labor representatives requested that the newspaper publish this open letter to Mr. Wolfe:

Sir:

We, the undersigned, a regularly constituted committee of the employees, including engineers, firemen, brakemen, conductors, and yard hands on your road, demand a fifteen per cent advance on our wages, to take effect from and after July 24, 1877. If our modest request is not promptly complied with we will strike at 12 O'clock M. tonight. We have the assurance of a strong alliance and co-operation of the Crawford and Lockwood Bysickle What-is-it Line. Our language should not be construed as intimidating, but if our wages are not increased, we will tear up the track, ditch the engines, burn your round-house, pull up your piling, and plant your road-bed in sweet potatoes, as productive industries must prevail if the railroads go under. An early reply is respectfully solicited.

Signed,

John Flannagan, Buncomb O'Flint, John Stout, Child Fairweather, Bumpres Hobbs Committee

Do you think they made their point? Apparently they did, for the Democrat soon reported that a strike had been averted. Three months later, it reported that the railroad was bankrupt.

Indiana coal unable to cross the Wabash River to reach Illinois was devastating.

In early 1883, the SE&SE and Bloomfield Railroad (the six-mile connection between Switz City and Bloomfield, Indiana) were merged into the Indiana & Illinois Southern—the I&IS, or "Eye-Nye-Ess." The railroad did its best to operate as a whole, with transfers of freight and passengers across the Wabash River made by boat, but the worst was yet to come. Flooding in November 1883 turned the roadbed into mud and washed out significant portions of the line. The Embarras River bridge at Newton, Illinois, collapsed, further subdividing the already fractured railroad, and other equipment failures caused temporary abandonments of portions of the line. The last straw came on February 10, 1885, when the post office suspended the mail contract. Six weeks later, the I&IS entered receivership.[12]

Bankruptcy was a blessing of sorts for the company, as the receivers made substantial improvements to the railroad with the help of capital from the Boston area. New, heavier bridges were

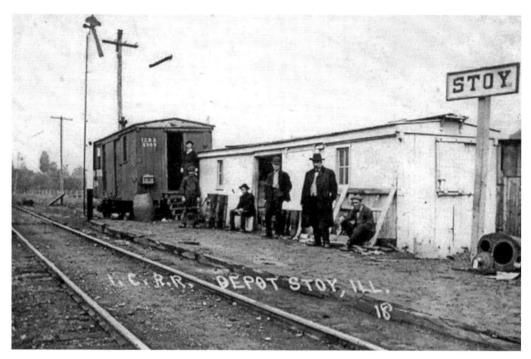

built over the Wabash and Embarras, the general offices were moved to Sullivan, Indiana, new rolling stock was ordered, and through trains were again running on the narrow gauge rails, thanks to the efforts of some 600 employees. The most significant change, however, began in 1886, when the I&IS was converted to a standard gauge railroad. The decision to convert was in lockstep with the narrow gauge trend across the country. Narrow gauge mileage peaked in 1886 and then declined steadily, often due to conversion to standard gauge, as opposed to abandonment. By 1887, the I&IS was standard gauged as far west as Palestine, with completion to Effingham anticipated by year's end.

Alas, like the original construction, the standard gauge conversion was deplorably cheap and ill-performed, achieved by simply realigning the existing rails and spiking them to the same rotting ties. Rolling stock was converted in similar fashion, with existing car bodies refitted with standard gauge trucks. The poor condition of the roadbed, combined with heavier and longer trains (up to 12 cars in length), quickly took a toll on the tracks. The old narrow gauge rails were so light that the flanges of the larger standard gauge wheels wore grooves in the ties. Ironically, the grooves proved beneficial, as they helped provide lateral stability that prevented the rails from spreading.[13]

Still sickly despite the best intentions, the I&IS was a last resort for shippers, and only those who were sufficiently motivated

In the early days of the Hi-Dry, surplus boxcars were often converted to serve as depots at smaller stations along the line, such as the installation at Stoy, Illinois. The scene likely dates from just after the turn of the twentieth century, as evidenced by the standard gauge tracks and the IC reporting marks appearing on the end of the far car. William Millsap Collection

Life on the SE&SE could be downright miserable. The railroad operated in such a fragile state that even a rudimentary problem could bring operations to a standstill. One such story involves a cantankerous locomotive known as the Mother Holmes, one of four steam engines that pulled the earliest trains on the line. The Holmes, often referred to as the "watch charm," "dinky," or "tea kettle," was as unpredictable and stubborn as a pack mule and the source of much consternation and amusement. Some days she could haul half a dozen cars without breathing hard. Other days she could barely move her own frame. On those latter days, she became like an iron nanny goat: firemen were known to feed fence rails, fallen limbs, and other available combustibles into her firebox in desperate attempts to help her steam up.

One fine day during the winter of 1885, when both the Wabash and Embarras River bridges were out, Mother Holmes was working east of Willow Hill and having a tough time of it, barely able to move herself and her caboose in tow. Finally, she simply quit altogether. She came to a halt in a cut and refused to go any further. Her drivers, Lev Hail and J. H. Price, "knocked her fire down, shut up the old caboose, took the mail bags, and hoofed it into Oblong." There they climbed aboard a handcar to complete their run.

The stretch of railroad east of Willow Hill to the Wabash was subsequently abandoned in place, with Mother Holmes and her caboose parked in the cut and rusting to the rails. For three weeks, mail continued to move on handcars until the post office canceled the mail contract. Several months went by before a crew was dispatched to the cut where Mother Holmes rested. They made their way through the vegetation and cattle that had taken over the railroad and proceeded to tow Mother Holmes and her caboose out of the weeds to the shops at Palestine. There the pugnacious locomotive was promoted to an "office job." Machinists mounted her boiler on a stationary frame, and she lived out her days as a steam pump at the roundhouse.

to risk life and limb traveled on the railroad. Owing to the condition of the track, train speed was slow, probably a chief reason that there were no serious injuries. By 1890, the I&IS was in foreclosure. Annual revenues were less than $82,000 and were insufficient to pay even 1 percent interest on debt. Over the next decade, more incarnations of the railroad would come into existence on paper (as many as 13 corporate identities for the SE&SE/I&IS have been discerned in one form or other), and some incremental improvements were made. Notable among these was the installation of heavier rail. Finally, at the turn of the century, with the corporate antecedent of the I&IS in foreclosure and on the auction block, Illinois Central entered the picture. With an eye turned toward Indiana's capital city, IC acquired the line in 1900.

East of the Wabash: Indianapolis

Nineteenth-century Indianapolis was an anomaly of sorts. It was one of the largest cities in the United States not situated on navigable water. The planned 296-mile Indiana Central Canal promised to change that by connecting Indianapolis to the Great Lakes and the Mississippi. It was a trouble-plagued effort, however. Just 24 miles of the Indianapolis Division was excavated, with a mere 10 miles ever becoming operational. The canal project was abandoned in 1839, three years after it was begun, and it fell to the railroads to connect Indianapolis with the rest of the world. The first line to punch into the city was the Madison & Indianapolis in 1847, connecting the Hoosier capital to the railway's other namesake town on the Ohio River. In 1853, the first Union Station was completed, and by 1855 it was served by seven lines

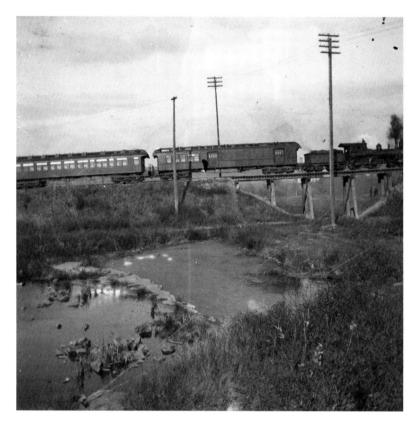

A rare photo of what appears to be an I&IS passenger train near Sullivan, Indiana. Note the oversized look of the trucks below the passenger cars. These cars were likely narrow gauge rolling stock refitted with new trucks when the railroad was converted to standard gauge. William Millsap Collection

that connected Indianapolis to population centers in the Midwest and East.

Railroads brought prosperity to Indianapolis and stitched the city into the fabric of the nation's economy. Through the Civil War era, the city's population began to grow rapidly, as did the business and industrial communities. Indianapolis was evolving into a crossroads of commerce, and soon an assortment of products, from sewing machines to farm implements, was coursing through the city's economic arteries.

This unbridled growth came to a jarring halt when the Panic of 1873 struck. The subsequent recession lasted two years and hit Indiana especially hard. Hundreds of businesses across the state were shuttered, creating a glut of idle industrial properties. Retail businesses sought merger and acquisition partners to weather the storm and, in the process, created new household names, including department store proprietors Lyman S. Ayres and William H. Block. Another familiar institution was born during this time—a small pharmaceutical company with just three employees, known by the name of its founder, Eli Lilly.

To help spur economic recovery, Indianapolis mayor John Caven became the chief proponent of an enterprise incorporated

Indianapolis Union Station and coach yard, sometime before 1917, when the tracks were elevated. Indiana Rail Road Archives

Carriage maker David M. Parry, the chief proponent and president of the Indianapolis Southern Railway. Here is a privately minted coin promoting the "High Grade Buggies and Surreys" of the Parry Manufacturing Company. Jacob Piatt Dunn, *Greater Indianapolis: The History, the Industries, the Institutions, and the People of a City of Homes,* vol. 2 (Chicago: Lewis, 1910).

in June 1873, just before the panic struck—the Indianapolis Belt Railway Company. With Caven's advocacy and tenacity in overcoming legal wrangling and financial issues, the belt was completed on November 12, 1877. It functioned as a connecting line for railroads serving Indianapolis and as the gateway to the stockyards on the city's south side. It was also the portal to the new, expanded Indianapolis Union Station, completed in 1888. By then, the economy had recovered, and Indianapolis was again in the midst of rapid growth that would see the city's population more than double to 169,000 by the end of the nineteenth century. It

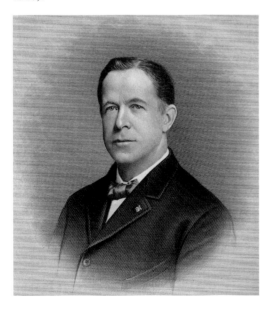

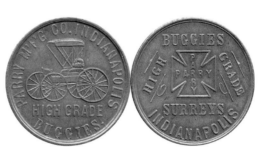

was also around this time that a clique of Indianapolis business-men hatched the idea of building a new rail line southward from the city. The group was led by a highly successful carriage maker, David McLean Parry Sr.

Parry had emerged as a prominent Indianapolis industrialist. He manufactured horse-drawn buggies, and after the turn of the century he entered into partnerships to produce automobiles, no-tably the "Overland" model. Parry was a consummate and tireless capitalist. Not only did he operate his manufacturing plant in In-dianapolis; he was also involved with Texas oil ventures, served as president of the Indianapolis Commercial Club (forerunner of the Chamber of Commerce), and rallied fellow industrialists around the country in staunch opposition to the labor movement. He was one of the country's most outspoken foes of organized labor and regarded unionism as "outright rebellion against the government that must be put down in any manner necessary."[14] Parry would become majority shareholder and president of the Indianapolis Southern Railway (ISRy). He was joined by a board of directors that included William E. Stevenson, Charles E. Barrett, and John McGettigan.

It is reasonable to assume that the founders of the Indianapo-lis Southern envisioned the new railroad benefiting their primary businesses. With his sizable carriage works and dogged demeanor, Parry would have desired tight control over his shipping. While this might be compelling, it certainly wouldn't, in and of itself, justify building 100 or more miles of railroad. The Indianapolis Southern men shared a common denominator in their undertak-ing—a desire for profits.

However, like so many other rail ventures in the nineteenth century, the vision for the Indianapolis Southern had its flaws. The better judgment of the developers was eclipsed by a renewed railroad-building movement that was again rising to a fever pitch. Nationally, rail mileage increased 79 percent during the 1880s, with the United States posting twice the rail mileage per capita as Europe.[15] The economy was robust, and communities were bat-tling one another to attract railroads. Their ammunition was tax money pledged as construction subsidies. The intended route of the ISRy was unclear at the outset, presumably because the pro-moters wanted to leave the door open to more subsidies, in-vestors, and allies.[16] Unfortunately, the noncommittal stance of the line's architects would haunt them when it came time to sell investors on their plan.

Initial survey work for the line commenced in 1892, with an eye toward reaching Evansville and the Ohio River. In contrast to the I&IS, the Indianapolis Southern was always planned as a stan-dard gauge railroad. The narrow gauge movement was in decline

by the time the ISRy was conceived, and the keys to the Indianapolis marketplace—Union Station and the Belt Railway—were standard gauge.

Progress on the ISRy was disastrously short-lived. In May, one of the most actively traded industrial stocks, National Cordage, crashed, sparking the Panic of 1893. Weeks later, changes in currency policy in British India toppled the silver market and devalued the U.S. silver dollar by 50 percent. The economy plunged into a deep recession. Major railroads, wracked by rate wars, overbuilding, and acquisition debts, fell like dominoes: the Erie in July, Northern Pacific in August, Union Pacific in October, and the Atchison, Topeka & Santa Fe in December. Nearly a third of the American rail system was in bankruptcy.[17]

It took three years for the economy to begin its recovery and another three for the Indianapolis Southern Railway to build up a new head of steam. The company was incorporated and chartered late in the summer of 1899. It was around this time that a man by the name of William T. Hicks got involved with the ISRy. Hicks was employed as a financial administrator for Indiana University, his alma mater, in Bloomington, which had become his adopted home town. A member of IU's graduating class of 1873, Hicks was an active, civic-minded citizen who favored construction of another rail line to serve Bloomington. The city's first and only rail connection was the New Albany & Salem, surveyed in 1849, which became part of the Chicago, Indianapolis & Louisville—the Monon Route.[18] The limestone trade flourished with the coming of the railroad, but the Monon served the quarries at the expense of other shippers and passengers. Unless you were a block of limestone, rail service was often insufferable. Having previously voted in favor of public support for competing rail lines that never materialized, Hicks sought out the ISRy developers to volunteer his services in support of their venture. Several years later, he wrote a memoir of his experience. His 1911 manuscript survives in the research collection of Indiana University as the most vivid firsthand account of the building of the Indianapolis Southern.[19]

When the ISRy was chartered in 1899, the loosely planned route ran southward from Indianapolis through Johnson, Morgan, Brown, Lawrence, Orange, Dubois, Warrick, and Vanderburgh counties to Evansville. Two branchlines were on the drawing board, one from Dubois County to the town of Rockport in the far south, and a second from a point in either Johnson, Morgan, or Brown County, through Monroe, Greene, and Sullivan counties to a point near Hymera. Additional surveys were undertaken in Jackson and Washington counties by virtue of lavish subsidy offerings tendered by the local governments.[20]

The proposed route turned out to be a bust. For a number of reasons, the developers were unable to rally investors to finance the line's construction. First, the line, as it was drawn, would traverse an abundance of poor farming country. South of the Lawrence County stone industry, there was scarce industrial activity to generate business for the railroad. This was a tough sell for the promoters.[21] Additionally, as the route continued southward toward Evansville, the terrain became more rugged and would be costly to conquer. Furthermore, there were existing, albeit more circuitous, routes from Indianapolis to Evansville already in operation. It was time to regroup.

In February 1902, the company was reorganized, and two more prominent members of the Indianapolis business community joined the venture: brothers Frank and Cortland Van Camp. Sons of grocer Gilbert Van Camp, the brothers each made significant contributions to Indianapolis commerce. Cortland Van Camp began wholesaling hardware, general store merchandise, and blacksmithing supplies in what would become known as the Van Camp Hardware and Iron Company. Frank developed his father's modest canning business into a major concern, with nine satellite plants from Vermont to California. Frank is credited with inventing a great American staple, a hearty blend of beans, cured pork, and tomato sauce. Still stocked on grocers' shelves today, Van Camp's pork and beans is a connection to Indiana railroad history found in households across America.

Brothers Cortland and Frank Van Camp were among the handful of investors who joined Parry in the Indianapolis Southern Railway venture. Frank had made his fortune in the hardware business, while Cortland operated highly successful canning plants. Among his product offerings was the famous Van Camp's pork and beans. Jacob Piatt Dunn, *Greater Indianapolis: The History, the Industries, the Institutions, and the People of a City of Homes*, vol. 2 (Chicago: Lewis, 1910).

The Mineral Route

In his memoir, William Hicks wrote that, in anticipation of the Evansville route's failure, he had been lobbying the ISRy board for two years to consider a more modest route, from Indianapolis to Bloomington, and then southwest to Worthington and Sullivan. It was essentially the northern branchline originally conceived as part of the Evansville route. The town of Bloomfield later cobbled together a generous subsidy offer and successfully pitched it to the board, swiping the ISRy from their neighbors in Worthington.[22] This route also offered a more tangible hook for investors. The line would bisect country that was rich in buried treasure—limestone, coal, clay, shale, and, it was thought at the time, significant iron ore and oil fields. The 1903 prospectus for the ISRy articulates the newfound positioning of the line as the "Mineral Route."

Hicks's handiwork appears throughout the prospectus. He

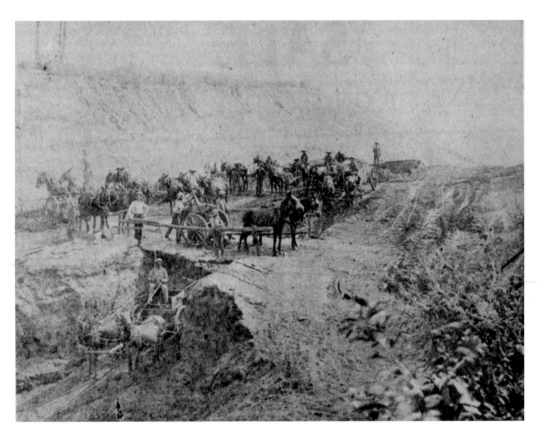

Building the railroad
was a display of
horsepower—literally.
Horses and mules lent
much-needed muscle
for the heavy clearing
and grading work on
the ISRy. Brown
County Historical
Society

worked tirelessly on behalf of the board, canvassing potential cus-
tomers along the route and making revenue projections to buoy
investors. He also played a key role in winning the railroad's fran-
chise in the city of Bloomington in December 1902, which, inci-
dentally, was not the cakewalk one might assume it to have been.
The Monon owned the Bloomington market, and the company
moved aggressively to protect its turf. Some industry leaders and
council members influenced by the incumbent railroad initially
gave a cold shoulder to the ISRy group and their plans.

In the early summer of 1903, money from Wall Street arrived
in the form of Archibald White, a multimillionaire who had made
a killing in the salt industry.[23] White saw great potential in the rail-
road, as well as in the opportunity to apply the techniques he
practiced in the salt business to the local stone trade. He signed on
and became the impresario of the Indianapolis Southern. Property
acquisition commenced, contractors were hired, and work on the
ISRy began in earnest in the fall.

By the following winter, the ISRy was already living on bor-
rowed time. White had ceased making payments to continue con-
struction. To make matters worse, a new alignment was being
sought through Bloomington, and without its Wall Street backer,

the railroad was left in a precarious financial position that threatened to unravel the deal. Parry, Stevenson, and the Van Camp brothers pooled portions of their personal wealth in a war chest to keep construction going. Bank loans were made, contractors carried large portions of the debt, and local merchants extended credit when payroll couldn't be made, all in a valiant effort to keep the ISRy alive.[24] Then, in the summer of 1904, another visitor came to the railroad.

Stuyvesant Fish, president of the Illinois Central, toured the ISRy by horse-drawn carriage. Since the spring, Fish had been the object of overtures from Parry and Stevenson. They had solicited IC backing for completion of the ISRy on an amended alignment to connect with the Illinois & Indiana Railroad (IC-controlled successor to the I&IS) at Switz City. It's hard to imagine that Fish could possibly have turned a deaf ear to the proposition. He had half a rail line to Indianapolis already, and here lay the other half that would connect IC to Indiana's great crossroads of commerce. In fact, Hicks's account and Fish's correspondence with his attorney seem to indicate that the IC president didn't fully realize how desperate the ISRy people were at that point. He noted in a letter to his general counsel in Chicago, "They are willing to give us the control and have acted very nicely in the matter." Fish took great

A bridge crew at work, ca. 1905. Brown County Historical Society

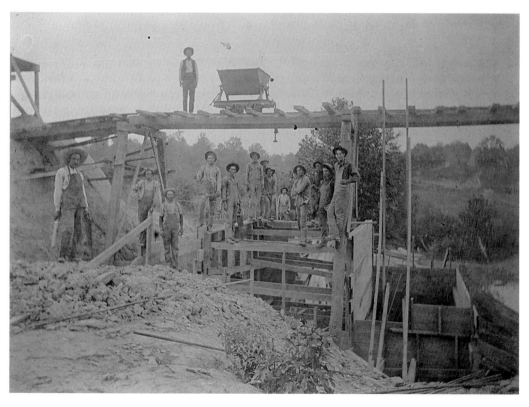

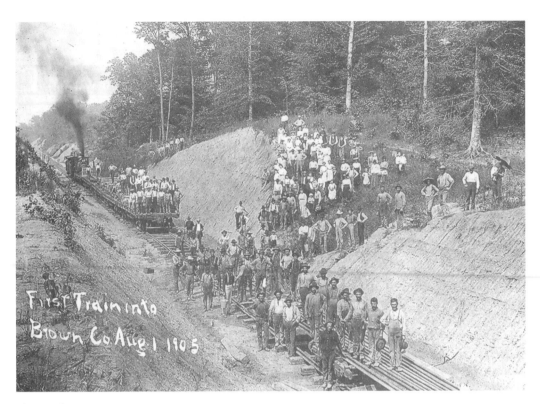

The iron horse arrives in Brown County—the first work train enters in August 1905. Brown County Historical Society

care in treating the ISRy executives with fairness, although the relationship would later prove fruitful to lawyers.

In late June 1904, the Illinois & Indiana Railroad Co. was merged with the ISRy to form the Indianapolis Southern Railroad (IS). Illinois Central controlled 51 percent of the stock, with the remaining 49 percent being apportioned among the ISRy board members. With new management, new money, a new destination, and a new name, the right of way was once again humming with construction activity. But there were significant changes to the original blueprint for the railroad.

Southward from Indianapolis to Unionville, work had progressed far enough that IC engineers decided to leave well enough alone. But the approach to Bloomington and the line westward was fraught with excessive grades and curvatures that were outside the limits of IC engineering standards. The company's chief engineer, A. S. Baldwin, was brought in to correct the deficiencies. New surveys were made from Unionville to Switz City that considerably changed the complexion of the railroad, particularly by eliminating two tunnels in Bloomington and Stanford. An unfortunate side effect of the engineering changes was looming, however. The realigned route required a new franchise agreement with the City of Bloomington.

With the contractors approaching from the east, the city fa-

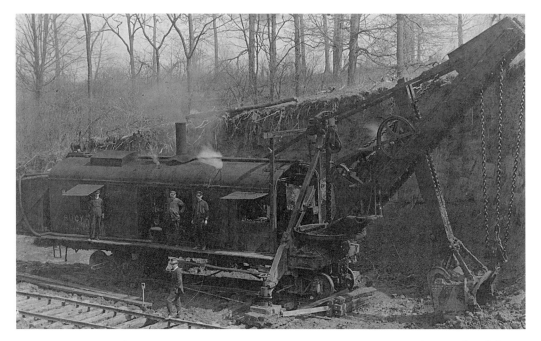

A steam shovel does some heavy earth moving in a Brown County cut. Brown County Historical Society

thers and the railroad began haggling over terms of the franchise. The IC management was unhappy with stipulations on freight rates—coal in particular—from the previous franchise agreement and wanted that subject dropped completely, even implying that they were prepared to bypass the city if the impasse wasn't resolved. Hicks was instrumental in hammering out a compromise that struck freight rates from the franchise in exchange for a refund of the subsidy voted by the city. After some debate, fueled in no small part by Monon loyalists, the franchise was approved in late January 1905.[25]

Through the summer of 1905, work on the line progressed rapidly under the direction of Baldwin and his general contractor, Kenefick & Carter. Baldwin's locating engineer had successfully mapped out a new alignment from Unionville to Switz City that reduced the ruling grade by half a percent, and crews now went to work to carve out his new route for the railroad. Modern grading equipment and teams of men were at work along the entire line from Bloomington to Switz City, where it would join the old I&IS. The original ISRy segment from Switz City to Sullivan was made redundant by the new relationship with Illinois Central and the Illinois & Indiana Railroad. Consequently, that portion of the line was abandoned.

By April 1906, construction of the IS had entered the home stretch, and Bloomington had a new railroad. On April 23, 1906, the first scheduled passenger train from Indianapolis steamed into Bloomington and dropped off passengers at a temporary station

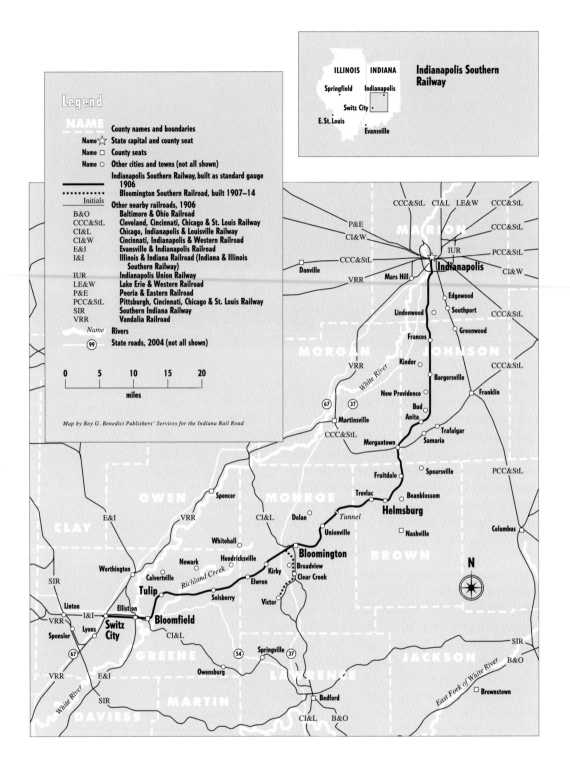

Legend

NAME County names and boundaries

Name ☆ State capital and county seat

Name ▢ County seats

Name ○ Other cities and towns (not all shown)

━━━ Indianapolis Southern Railway, built as standard gauge 1906

•••••••• Bloomington Southern Railroad, built 1907–14

Initials Other nearby railroads, 1906

B&O	Baltimore & Ohio Railroad
CCC&StL	Cleveland, Cincinnati, Chicago & St. Louis Railway
CI&L	Chicago, Indianapolis & Louisville Railway
CI&W	Cincinnati, Indianapolis & Western Railroad
E&I	Evansville & Indianapolis Railroad
I&I	Illinois & Indiana Railroad (Indiana & Illinois Southern Railway)
IUR	Indianapolis Union Railway
LE&W	Lake Erie & Western Railroad
P&E	Peoria & Eastern Railroad
PCC&StL	Pittsburgh, Cincinnati, Chicago & St. Louis Railway
SIR	Southern Indiana Railway
VRR	Vandalia Railroad

Name Rivers

⑨⑨ State roads, 2004 (not all shown)

0 5 10 15 20

miles

Map by Roy G. Benedict Publishers' Services for the Indiana Rail Road

Indianapolis Southern Railway

ILLINOIS INDIANA

Springfield • Indianapolis

Switz City •

E. St. Louis •

Evansville •

on Lincoln Street.[26] In Bloomington, the IS was a railroad ahead of its time, built to surprisingly high standards. Thanks to the work of A. S. Baldwin, in the entire two miles of line built within the city limits there was not a single street crossing at grade. All street traffic passed below the tracks through underpasses built by the railroad.[27]

From Bloomington, the railroad pushed westward into the isolated backwoods of Greene County. Solsberry was also reached in the spring of 1906, and further west, work began on the spectacular link that would complete the IS. One year earlier, a swath had been cut across the Richland Creek valley, between Solsberry and Bloomfield, and concrete footers were poured to support what would become one of the wonders of contemporary railway engineering: the Richland Creek Viaduct, also known as the Tulip Trestle. It was nearly half a mile of railroad in the sky, rising more than 150 feet above the creek bed. In May 1906, construction of the superstructure began at the west end. By that summer, tracks had been laid from Bloomington, and work on the east side began. In December 1906, the viaduct was in place, and the first ceremonial train glided over the towering landmark. The IS main line was complete.

Important work continued on the railroad, however, notably in the form of a branchline known as the Bloomington Southern Railroad. The branchline split off the main with a wye[28] at the southwest corner of the city. It proceeded southward to serve the flourishing stone industry in the vicinity. Construction of the Bloomington Southern began in 1907 and continued in piecemeal fashion. Within seven years, it grew to just over nine miles, extending beyond Clear Creek to the Victor quarry.[29]

Well before that time, however, the IS found itself in trouble. The railroad, encumbered by debt, defaulted on interest payments on its bonds on July 1, 1908. On May 5, 1911, the IS was sold at foreclosure to the Illinois Central.[30] The railroad that would proclaim itself "the Main Line of Mid-America" was now in complete ownership of a main line to Indianapolis.

The Postmodernist Empire Builder

The one thing I remember my dad telling me, probably 40 years ago, was this: If you could just learn to run a railroad like a business, you'd do well.

—Tom Hoback

It seems only fitting that a man who would one day own his own railroad spent the earliest days of his life immersed in railroading. Tom Hoback was born in Peoria, Illinois, in 1947 and grew up in a house between the Illinois River and the Rock Island main line. The house stood halfway between Peoria and Chillicothe, Illinois, where his father worked for the Santa Fe.

Glenn Hoback grew up in Union, Nebraska, where he spent many hours after school befriending the local railway agent and taking in the daily spectacle of railroading in the Great Plains. By the time he was in high school, he had mastered Morse code, and after graduating, he went to work as a telegrapher for the Missouri Pacific. He worked for the Chicago & North Western for a short time, and then in the late 1930s he hired on as a telegrapher with the Santa Fe in Oklahoma. He remained with Santa Fe for the rest of his career, working as an operator and ultimately chief dispatcher on one of the busiest stretches of the railroad, the Illinois Division. From his desk in Chillicothe, Glenn Hoback directed train movements over the two-lane steel expressway from Chicago to Ft. Madison.

Lessons in Railroading

Tom Hoback received a unique apprenticeship in railroading from his father. He recalls being taken on frequent trips to Chillicothe on Glenn's days off, watching the railroad at work, viewing the world from the cabs of locomotives and meeting all the dramatis personae, from trainmen to agents. But Glenn's interest in railroading went well beyond the usual chemistry that attracts people to trains, or what Tom calls the "aesthetics" of the industry—the behemoth machines, the impressive displays of engineering and power, the sights, the sounds, and the smells.

"What made my dad so different," Tom observed in a 2001 interview, "is that he had a real sense of the *business* of railroading. He really enjoyed looking at the industry's financials. He invested in the stock market and always read the *Wall Street Journal* and *Barron's*. He followed a lot of different industries, which gave him a more worldly perspective with which to evaluate the railroad business. The annual reports would come in, and Dad would always show them to me and go through them with me. He recognized that while railroads were capable of moving very large volumes of goods and people, they also suffered from terrible inefficiencies. For example, during the early and mid-1950s I can remember that between Chicago and Kansas City, 451 miles, the Santa Fe would change freight crews—and cabooses—four times! Even after diesel power replaced steam locomotives, they still employed these people called 'firemen' for no apparent reason. Freight trains were running with five- and six-person crews; it was incredible how top-heavy they were.

"And the one thing I remember my dad telling me, more than 40 years ago, was this: If you could just learn to run a railroad like a business, you'd do well. That was what really got me thinking that running a railroad on your own nickel would give you a chance to do some things that you couldn't normally do, especially on a large system. So the idea of someday running a railroad had been with me, really, from a very early age."

Land of Lincoln Meets Haight-Ashbury

When Tom Hoback made plans to leave home for college in the mid-1960s, he knew exactly what he was looking for. Armed with an Association of American Railroads handbook listing schools that offered transportation majors, he began shopping for an education. He settled on Golden Gate University, a small private school in San Francisco. Golden Gate had strong transportation and economics programs, which influenced Hoback's decision, as

did a couple of other factors. First, San Francisco was a major transportation hub, which made it fertile ground for job hunting. Second, San Francisco was the farthest away from home he could travel on his father's Santa Fe pass.

After graduating, Hoback considered going on to graduate school. He was awarded a full-tuition fellowship to pursue his doctorate in economics at the University of Wyoming, but he opted instead to work, save money, and get some experience under his belt. He had a summer job as a traffic analyst for a toy distribution company in the Bay Area and was looking for a railroad position, preferably in marketing. Unfortunately, there were no jobs on the railroad radarscope at that point. Instead, he found a position as a traffic manager for Foremost-McKesson, a food and pharmaceuticals distributor. Although he was with the company for just two years, Hoback ranks it as a significant rung on his career ladder:

"I got involved with all kinds of transportation and distribution: railroads, truck lines, steamship companies. It wasn't something I'd ever planned, but it was an incredible experience. It's where I learned the transportation business from the *customer's* perspective—where I got to know what customers need from transportation companies.

"At the time—and this sounds awful to say—you could always tell the difference between the salesmen that came in from the railroads and those who came in from any other mode. The salesmen from the other companies were generally well dressed, polished, and brought in very specific agendas. The railroad guys were like a bunch of good ol' boys. They'd take you out to lunch or hand you a fifth of bourbon, and that was about the extent of their salesmanship. With only a couple of exceptions—no exaggeration—you could see why the railroads weren't good at getting business.

"Part of it, I think, was because of regulation. There was little rate competition between the railroads; consequently, there was little motivation for a railroad sales agent to be a go-getter. Regulation fostered a culture of mediocrity that was pervasive in the industry. But, having said that, my experience was a good one; it gave me my first glimpse at the industry's underbelly from the shipper's point of view. I never would have guessed how difficult the railroads were to deal with before that time."

He would soon find himself seated at the other side of the table. Western Pacific, also based in San Francisco, had an opening for an economic analyst. By this time, Hoback was far too interested in the working world to go back to school, so he took the job at WP. He ranks it as the most boring job he ever held but also

"It turned out to be a mind-blowing experience." Those are Tom Hoback's words describing not the culture shock of San Francisco during the Haight-Ashbury heyday but the shock of his immersion into the culture of railroad management during an early assignment with Western Pacific's cost and economic analysis department. WP's marketing department wanted to buy 100 new mechanical refrigerator cars to help increase their market share in eastbound perishables coming up the San Joaquin valley. The finance department staff wouldn't approve the expenditure until they could calculate their return on the investment. Tom Hoback was told to analyze WP's existing mechanical reefer fleet and assess its profitability.

"I went down into the bowels of the accounting department," he begins, *"and saw rows of people dressed in old-fashioned clothes, seated behind enormous antique wooden desks with little green lampshades. One guy even wore garter bands around his sleeves—no kidding! It was like a museum. The car records weren't computerized, so I had to go through the dusty old paper ledgers and trace car movements between reporting points. I took a statistical sampling of the cars in the fleet, and I was shocked to find out that the average length of time from the car's loading in, say, Stockton or Modesto until it returned empty from the East Coast was about 30 days! And if cars were out of service for any major repairs, it was even worse."*

Hoback learned that the railroads did a decent job getting the loads interchanged and moved to their Midwest and East Coast destinations. The problem was on the return leg of the journey. Empty cars don't make money for a railroad, and consequently there wasn't a sense of urgency in getting them moved. The railroads would opt to fill out their trains with loads, and the empty reefers would sit in freight yards with their wheels rusting for days on end. The result was that WP's most expensive piece of rolling stock, carrying one of the highest-rated commodities, could generate, at best, a mere dozen carloads per year.

"The capital outlay for that equipment was very high, and maintenance costs on those mechanical refrigerators was far, far higher than typical rolling stock," he says. *"There were also lots of expensive damage claims. For example, say a car's fuel isn't checked before leaving California. It might run out around East St. Louis, and by the time it arrives in New York City, it's been without refrigeration for days, and the whole carload is a total loss. . . . I was able to show the management just how marginal this business really was in the first place."* Speaking facetiously, he adds, *"The marketing department thanked me profusely. They felt that the company was essentially going to be put out of the perishable business. But if we couldn't improve the economics, we really shouldn't have been in the business to begin with."*

After a yearlong stint in the economics department, Hoback moved into a position in the railroad's pricing department. Western Pacific never bought another mechanical refrigerator car.

one of the most instructive. He moved into WP's pricing department later that year, where he saw firsthand how difficult it was for railroads to compete in a regulated environment.

"I served on several different rate committees," he recalled in 2001, "back before the Staggers Act. The railroads had antitrust immunity prior to deregulation, and, interestingly, all the rates were made collectively by the industry and were basically signed into effect by the ICC.

"I'd be sitting in these rate meetings in Chicago with Union Pacific, Southern Pacific, Santa Fe, and the Burlington Northern,

and we'd be talking about what rates we ought to charge U.S. Steel, General Motors, Coors, and other big customers. But there was no strategy behind any of it, and it was invariably all an exercise in futility. The railroads were always afraid to do anything bold because they thought it was too risky—that they might throw their existing business out of equilibrium. They'd let millions of dollars in revenue go straight to the truckers because they were too timid to compete aggressively for it. Consequently, during this time the industry market share just kept dwindling and dwindling.

"Of course, if the railroads did come up with anything new or innovative, the Interstate Commerce Commission (ICC) would often put the kibosh on it because it was deemed unfair for a small shipper somewhere who didn't even load half a dozen rail cars a year. Southern Railways' 'Big John' covered hopper was a classic case. The railroad invested a lot of money to design and build a new high-capacity car, and they weren't allowed to fully realize its advantages. The ICC said it was discriminatory to the customers who couldn't load 100 tons of grain at a time. There were a lot of cases like that when I was with Western Pacific back in the 1970s."

Back to the Midwest

The late 1970s was when the rail industry finally hit rock bottom. By 1976—the bicentennial of a nation that was literally opened up by the railroads—a quarter of the rail mileage in the United States lay in bankruptcy. Spurred on by a desire to return to the Midwest, Hoback entered the shortline business. A professional acquaintance had put together a group to operate and eventually acquire

the former Erie Lackawanna line from Chicago, across northern Indiana with a connection to Lima, Ohio. So Hoback bid farewell to the Bay Area and returned to the Midwest as vice president of marketing for the Erie Western Railroad.

In the wake of the rail industry bankruptcy crisis, the State of Indiana was leasing the tracks from the Erie Lackawanna trustees in order to maintain essential rail services. The physical plant was exceptional. With the right type of signaling, the tracks would have been Class 6, good for speeds up to 110 miles per hour. It was everything you could ask for in a small, independent railroad, except for one problem: it lacked customers.

So Hoback set about developing online business. He posted substantial gains by cultivating trailer-on-flatcar (TOFC) or "piggyback" traffic, bringing imported goods into the Huntington/Fort Wayne area and reloading the trailers with northeastern Indiana commodities bound for West Coast export hubs. Even with online business looking up, however, the Erie Western would never make it out of the woods. The problem lay with acquiring the railroad from the Erie Lackawanna trustees. They put a high price tag on the line—$75,000–80,000 a mile. Despite the fact that financing the purchase would never have been possible with the level of revenue that was being generated, the price remained firm. The railroad was eventually broken up and liquidated by the trustees, an ignominious second demise for an already fallen flag.

Shopping for a Railroad

During the waning days of the Erie Western, Tom Hoback was looking around on his own for a railroad to buy and grow. His search was exhaustive; he had examined 70–80 rail lines when a piece of Illinois Central property captured his attention. In 1977, IC quietly filed for abandonment of a portion of its Effingham–Indianapolis branchline—everything east of Linton, Indiana, including the Indianapolis terminal and the line's biggest customer, Indianapolis Power & Light. Like so many secondaries and branchlines around the country, it was languishing for lack of capital, dying slowly while the railroad squeezed the last bit of revenue from it.

Then, in 1978, this almost-forgotten branchline was catapulted into the headlines. Ten cars of an IC train derailed on the line near Bloomfield, Indiana. It was the latest in a string of at least 40 reportable derailments in a two-year period, and the FRA decided it was time to take action. Inspectors took a walking tour of the railroad and discovered the enormity of the situation. In a 38-mile stretch between Bloomington and Bargersville, just south of Indianapolis, they cited thousands of track defects. They notified the IC that there would be heavy fines levied for each day that trains

IC timetable specimens from 1912 (left) and 1943. The Indiana Division, as the Indianapolis line was originally known, comprised the Effingham and Indianapolis Districts. After July 1, 1933, the two districts were folded into the IC's Illinois Division, where they remained until IC sold the line. Indiana Rail Road Archives

were operated on the substandard tracks. Illinois Central immediately closed the line, a move that opened a new can of worms with the Interstate Commerce Commission, which had ruled against the railroad's abandonment petition earlier in the year.

IC was caught between a rock and a hard place. The FRA was threatening huge fines if they operated the line. The Interstate Commerce Commission demanded the line be kept open. IC president William Taylor cried foul, claiming that overregulation had his company caught in a stalemate of conflicting orders. Ultimately, the ICC approved a plan for Illinois Central—at its own expense—to reroute IP&L coal shipments and other freight to Indianapolis on Conrail via the Milwaukee Road line between Linton and Terre Haute. The trains were rolling, and so was the red ink across Illinois Central ledgers. During the months that their Indianapolis line was shut down, IC not only lost the revenue from its IP&L coal movements but had to pay the utility the added cost of rerouting the shipments—about $1,000 for each train.

Around this time, Hoback was hired as a consultant by an Indiana businessman who wanted to study potential sources of traffic on the IC branchline. The man was from a prominent family with ties to state politics and appeared to be earnest about acquiring the railroad, but he was ultimately unable to put a viable deal together.

Issues of *The Travelers' Official Guide* from 1883 and 1886 show the I&IS mail trains did well to average 17 mph; a 96-mile journey from Effingham to Switz City was advertised as a 6-hour affair. Knowing the fragile state of the railroad, it's safe to say that it probably took considerably longer on most days. (Note that the latter timetable shows a connection to Indianapolis offered on the Indianapolis & Vincennes Railroad.) Indiana Rail Road Archives

Hoback, however, remained intrigued by this Illinois Central branchline, which was known as the "Hi-Dry" or "High-and-Dry." The little railroad appealed to him on several levels. Foremost was its Indianapolis terminal. At that time, Indianapolis was the eleventh largest city in the country and had a heavy manufacturing base. It had exceptional highway access, which was good for warehousing and transload business. It was crisscrossed with Class 1 railroad connections. Moreover, Indianapolis was considered one of the top ten distribution centers in the country. From a business standpoint, Indianapolis was an ideal market to anchor a small railroad. Just as important, the Hi-Dry ran right through the low-sulfur coalfields of southwestern Indiana. The EPA had issued tougher clean air standards in 1977. The impact on the coal industry in Illinois was devastating, but there were sizable amounts of compliance and near-compliance coal to be found in southern Indiana. The mines and the trains were still running, and the Hi-Dry was in the middle of it all.

The railroad was small enough to be manageable, yet there were many contiguous secondary rail lines in the area that would provide growth opportunity as the large carriers continued to downsize. It looked as though the market price for the IC line would be commensurate with the revenue that it could generate, and that price also appeared to be within reach, given reasonable financial backing. Hoback had finally found his railroad. Along with two primary business partners, he began a campaign to acquire the Hi-Dry. One of his first tasks was to initiate talks with IP&L, the railroad's make-or-break customer.

As it turned out, the biggest account would also be the biggest obstacle. IP&L made it clear that they wanted to be served by a Class 1 railroad, even though Illinois Central hadn't invested any substantial resources in the property for years. To IP&L, it made no difference. The utility wanted a big railroad with deep pockets. But any notion of deep pockets at the Illinois Central was an illusion. The railroad was in serious financial trouble at that time and was trying to shed many of its light-density lines. It was largely through the voicings of IP&L that IC received millions in grant money from the FRA to bring the line into serviceable condition. IC then withdrew its abandonment filing. Hoback and his group made an effort to protest the deal, with hope that they might be able to forge their own arrangements with IP&L, but it was to no avail. With his acquisition effort stalled, Hoback decided to return to the world of Class 1 railroading.

Small World

Harry Bruce, who had been Hoback's boss at Western Pacific, had since migrated to the Illinois Central as senior vice president of marketing. He got wind of Hoback's interest in working for a Class 1 railroad and in 1978 offered him a position as director of coal marketing in Chicago. As fate would have it, Hoback came into direct contact not only with the financial executives at Illinois Central but also with the southern Indiana coal shippers the company served. It was the ideal environment and time to begin orchestrating the birth of a new small railroad.

Rumors began to circulate that the IC would be sold to another railroad, but in reality, the major rail companies were frightened away. The IC had a profusion of light-density branchlines that had suffered from years of deferred maintenance. The amount of capital required to rehabilitate these appendages was too large a dowry for a corporate suitor. However, in 1981, in the wake of the Staggers Act, a new strategy emerged. The IC financial department's chief of strategic planning, Harry Meislahn, informed Hoback that the company was preparing to sell a significant number of its secondary lines. On the list was the line from Sullivan, Indiana, to Indianapolis, the Indiana portion of the Hi-Dry.

The IC believed Hoback's plans to acquire part of its property would pose a conflict of interest if he were employed by the company. So, for the second time, Tom Hoback left Class 1 railroading. In 1983, he moved to Tampa, where he worked for TECO Energy, the corporate moniker for Tampa Electric Company. He worked in retooling the utility's coal transportation system to serve additional customers and export markets. Temporarily forsaking rails for rivers, he doubled the utility's barge fleet and cultivated new coal traffic through the Mississippi Delta and Gulf of Mexico. Meanwhile, he continued to work on purchasing a railroad 1,000 miles away.

Back in Indianapolis, IP&L had caught wind of IC's plan to sell, and the utility responded by offering the railroad the possibility of a long-term coal transportation contract. The offer got the attention of IC executives, who froze plans for the sale to evaluate IP&L's proposal. They negotiated for a year and then called it all off in 1984, after suspecting that the offer was really no more than a stalling tactic by IP&L.

Hoback resumed meetings with IC executives to negotiate a sale. Other suitors came forward, including another investment group and even the Milwaukee Road (MILW). (Many, including Tom Hoback, remain puzzled about MILW. At the time, it was certainly in no better position than Illinois Central to acquire, improve, and

STEAM POWER ON THE HI-DRY

The Indianapolis line saw a variety of locomotives in service throughout the steam era, but none rivaled the ubiquitous 2-8-2 wheel arrangement, the Mikado. An abundance of the machines manufactured by Lima and Baldwin during the early 1920s were rebuilt at Illinois Central's massive shops in Paducah, Kentucky, and served through the end of the steam era in the late 1950s.

maintain another marginal property.) To the credit of Harry Bruce and IC, the company remained true to its initial word and pursued a sale with Hoback and his group.

Finally, in Chicago on December 5, 1985, after nearly a decade of searching, analyzing, evaluating, planning, and negotiating, Tom Hoback and his business partners signed a purchase agreement for 110 miles of railroad from Indianapolis to Sullivan, Indiana. The group would officially close the sale on March 17, 1986. Hoback phoned TECO to give advance notice of his resignation and headed for Indianapolis, where he spent the night. The following day, he began search-

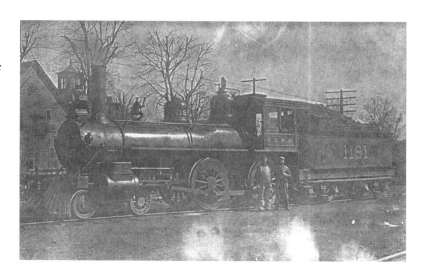

Among the earliest examples of IC steam power on the Indianapolis line were locomotives such as this large American type (*top*) and Mogul no. 1825 on the turntable at Palestine. William Millsap Collection

THE INDIANA RAIL ROAD COMPANY

Machines such as this Consolidation could be seen working at the Lincoln refinery in Robinson. William Millsap Collection

Ten-wheelers such as these specimens were assigned to the passenger trains running between Effingham and Indianapolis. Some of these rugged locomotives saw half a century of service on the IC. William Millsap Collection

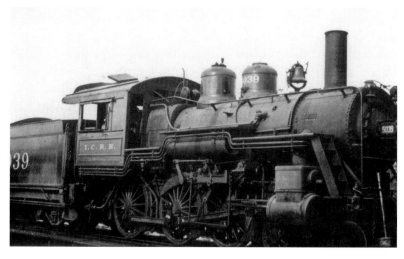

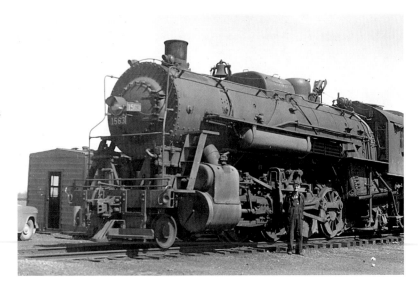

A classic IC Mikado dwarfs a trainman standing next to the drivers. The squared-off sand dome (behind the bell) was a characteristic feature of locomotives shopped at Paducah. William Millsap Collection

ing for an apartment. There was a lot to be done by March 17. First was securing the financing necessary to close the deal.

Writing the Check

Doing something as complicated as buying a railroad is ultimately a test of resolve and relationships. For Tom Hoback's group, getting their names on the purchase agreement was victory in a hard-fought battle, but the war was ultimately won through diplomacy and salesmanship that attracted investors to their project. It was a delicate dance with sophisticated partners, in contrast to the tug-of-war with competing buyers and the entrenched IP&L contingency.

The dance had begun almost a decade earlier, in 1977, when Tom Hoback made the first attempt to acquire the railroad. He met and worked with two executives from the Chicago Corporation who were both keenly interested in railroad deals and were actively seeking opportunities with railroaders. They had experience in the industry and believed that rail investments could be profitable under the right circumstances. They were enthusiastic about the acquisition of the Hi-Dry and were willing not only to back the equity portion of the transaction but to solicit bank financing as well. The deal was scuttled, however, after the IC rescinded its application for abandonment. Still, introductions had been made to a small network of contacts who would be vital when things got serious again in 1985.

Hoback's prior network of business relationships from his days at Illinois Central also proved useful in drumming up financial support. When the Hi-Dry went on the auction block again in

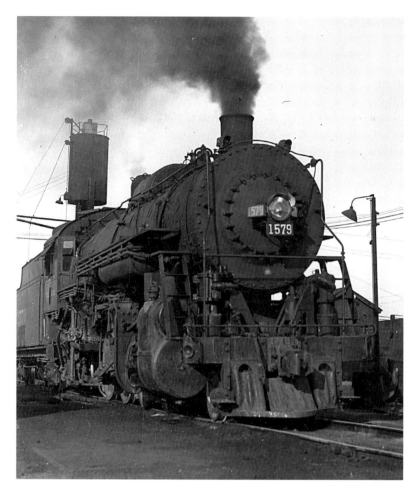

Another signature feature of the IC Mikados was the one-piece forged pilot, clearly visible in these forward-facing views, taken around 1955. William Millsap Collection (*top*) and photo by Ron Stuckey, John Fuller Collection (*bottom*)

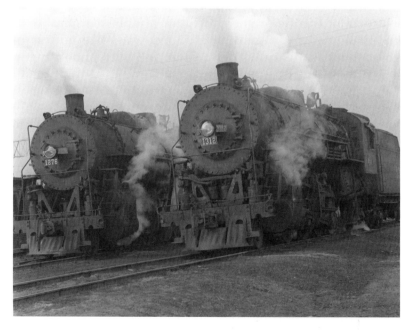

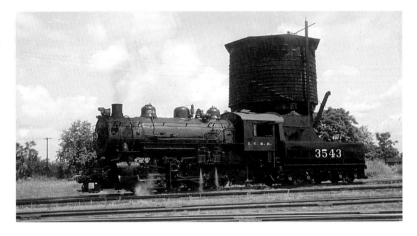

The Palestine yard engine takes a brief respite from switching to take on water. William Millsap Collection

1985, he turned to a senior vice president at one of his IC customers, Old Ben Coal Company in Chicago. Having worked on a number of acquisition projects for Old Ben, this executive seemed a natural source of referrals in banking and venture capital. He found one Chicago investor in particular who would become one of Hoback's most enthusiastic advocates: Rich Lassar.

Lassar had been running his own investments firm in Chicago. Although the acquisition of the Hi-Dry was too large a deal for him to finance alone, he was instrumental in recruiting the two venture capital groups that ultimately provided the down payment. While laying the financial groundwork for the new railroad, Lassar and Hoback formed an exceptional business relationship and personal friendship that endured until Lassar's death in 1995.[1]

One of the firms courted by Lassar and Hoback was the Corporation for Innovation and Development (CID) of Indianapolis; the other was R. W. Alsop of Cedar Rapids. Having an affinity for basic "bricks-and-mortar" transactions, the three firms were in-

A rare sight on the Hi-Dry, this USRA Heavy 2-10-2 was among 125 such machines operated by the IC. This one is seen crossing Lincoln Street in Palestine. Ralph Bachelor Collection

trigued by the proposed deal and helped the entrepreneurs put together a pitch for presentation to banks. Banks tend to have an allergic reaction to railroad transactions, mostly because the collateral is so "slippery." Much of the Indiana Rail Road right of way, for example, is held on reversionary easements. If the rails get pulled up, there is no real estate of any significant value left. This level of risk doesn't appeal to many bankers. Consequently, raising the senior debt for the purchase was more of a challenge. In January 1986, two Indiana institutions came aboard: 1st Source Bank of South Bend and Lincoln National, a Fort Wayne–based insurance company. In retrospect, Hoback acknowledges that it might have been easier to secure financing beyond the boundaries of Indiana.

"I quickly became a lot smarter about the fact that there are banks that specialize in railroad transactions. Had we solicited that type of institution, it would have been much smoother sailing. That's one of the things you learn. When we started the company, I felt it was important to send a signal to everyone that we were a local company—that we had local financing behind us and we were committed to taking good care of our local customers. I didn't want people to think we were going to be another absentee custodian like Illinois Central had become in the latter days. So we tried very hard to develop and emphasize our local relationships."

Lincoln National and 1st Source financed the $4.5 million senior debt on a seven-year mortgage. The two venture capital groups put up 85 percent of the $1.5 million in equity capital, which left Hoback and his two partners to come up with the remaining 15 percent. It was an enormous personal risk. Hoback put virtually every penny he had on the line, including proceeds from the sale of his home, a loan from his mother, and cash from credit cards. Suddenly it was all very real.

The deal was done. The total transaction was $6 million—$5.3 million for the railroad itself, and the remainder for locomotives, materials, equipment, fleet vehicles, and working capital. Hoback and his partners had the cash to buy a railroad that would prove to be either a pig in a poke or a diamond in the rough. They had until March 17, the closing date, to solve a seemingly endless scope of logistical puzzles in transitioning operations. They needed to meet with customers. They needed to recruit operations staff. They needed to buy a fleet of locomotives. There was a lot of work to be done. And now there was a lot at stake.

Life along the Railroad

America's early network of railroads was created not just to move goods and passengers but to move a whole nation into new frontiers and new economic paradigms. That was then. Today railroads exist not because of manifest destiny or blind will but because of demands from industry and society. Where people live and what they do make up the essence of railroading and give trains a reason to move.

In this equation, arguably the greatest factor is *where*. In considering any railroad from both aesthetic and business perspectives, it becomes clear that geography is an overwhelming factor in the railroad's makeup. That is, geography shapes nearly every aspect of the railroad's character. It gives the railroad its twists, turns, crests, sags, bridges, and tunnels. It dictates the motive power needed to get the job done. Moreover, geography shapes the lives of the people, and people shape the life of the railroad. The lay of the land determines how a people will seek their fortunes and what commodities they will load into their trains. The influence of the land is evident in the coal rolling through Appalachia and the Powder River basin, the grain cars crisscrossing the Great Plains, the Thrall cars and bulkhead flats hauling lum-

ber out of the Pacific Northwest, the iron ore trundling from the Dakotas and Minnesota toward the Great Lakes, the juice trains hustling northward from central Florida, the reefers full of fresh California produce gliding across the desert, and the long cuts of chemical cars flowing northward from the Texas Gulf Coast.

It is fair to say that a look at what life was like along Illinois Central's Indiana Division is ultimately a study of geography and how people harnessed its resources to build their economies. It's also a study of change—how people and their enterprises have come and gone, how some communities have flourished, how some have atrophied, and how others have completely faded away. No single aspect of the story has great consequence or earth-shaking drama, but put it all together and you have a portrait with a certain quiet dignity. It's a picture of ordinary people who worked extraordinarily hard for a meager existence in the small, simple worlds they created, which happened to be connected by a little railroad. It's a patchwork quilt of stories, stitched together by two threads of steel.

The Illinois Basin: Liquid Assets

Back in the days of the I&IS, agriculture was the raison d'être for denizens of the eastern Illinois communities along the railroad. Some of the principal commodities they produced were hay, apples, and livestock, much of which headed to Chicago. However, the ground worked by farmers around Palestine and Robinson held an even greater bounty below the fertile soil that would fundamentally change life and the economy in the Illinois basin. The basin is a shallow, teardrop-shaped region of gently sagging rock layers. The seemingly inert prairie blankets a subterranean architecture of domes, pockets, seams, fault systems, and anticlines wherein lie abundant fonts of America's industrial elixir—oil.

Natural gas had been discovered in Crawford County near Palestine before the turn of the century, but the reserves and the markets were anemic, and drilling activity was accordingly modest. However, in 1903, oil was struck in Palestine,[1] and in 1906, the year the Indianapolis line was completed, oil was discovered on a farm in Oblong Township. By 1920, some 7,000 wells had been drilled for primary production in Crawford County, delineating what came to be known as the Main Consolidated field.[2] Some of the first wells initially produced more than 1,000 barrels a day. The Crawford County oil boom was in full swing.

The Main Consolidated field would prove to be the most productive area in the basin, with the most significant reserves lying in an area known as the Robinson Sands. It was here in Robinson

FROM OBLONG TO OBLIVION
THE OIL BELT—ILLINOIS' FORGOTTEN RAILROAD

The growth of the oil industry in southeastern Illinois inspired the building of yet another railroad in the early twentieth century. The Oil Belt Traction Company was incorporated in 1909 and would earn the dubious distinction of being one of the last American narrow gauge railroads ever built. Construction of the three-foot line began in the summer of 1909, just south of Illinois Central's Indiana Division main line in Oblong. By 1913, 25 miles of meandering, wobbly tracks linked Oblong with the towns of Hardinville and Bridgeport to the southeast.

The little railroad operated combination trains with a fleet of secondhand rolling stock that included a dozen freight cars, one coach, and an American type locomotive that was reportedly acquired from the Vandalia Railroad. The trains carried oilmen and their gear, agricultural materials, and people traveling into Oblong from outlying townships. During the warmer months, Sunday excursions were run to Wolfe Park on the banks of the Embarras River, the passengers riding on benches placed atop flatcars. The railroad's spartan facilities offered no place on the line to turn the locomotive, so trains were operated push-pull fashion, making the return trip to Oblong backward. This operating quirk was the cause of many lengthy delays and mishaps, as well as plenty of mockery from the locals.

From the beginning, the Oil Belt suffered the same ills as other undercapitalized railroads—cheap construction, labor strikes, frequent derailments, unreliable equipment, and natural disasters, to name a few. By 1917, the railroad was inoperable, owing to washouts and a collapsed bridge. The banks foreclosed, and in 1918, after less than five years, the rails of the Oil Belt were pulled up and fed into the furnace to support the World War I scrap metal drive.

where the Lincoln Oil Refinery sprung up from the Illinois prairie. In 1924, the Ohio Oil Company, part of the ruthless Standard Oil trust before it was dismantled in 1911, acquired the refinery in a strategy to broaden the scope of the Ohio's operations beyond being essentially a captive crude provider for Standard. Under the new ownership, Lincoln began production and regional distribution of Linco brand gasoline. In the late 1930s, Linco was folded into another Ohio-acquired brand, Marathon. A rendering of an Olympian runner was the brand's visual icon, coupled with the slogan "Best in the Long Run." Coincidentally, the long run was where oilmen hung their hopes for the future, as the oil boom began to taper off. A flood of Texas crude depressed prices between 1930 and 1950, and the oil boom faded, as most new drilling activity in the basin ceased during those years. Following World War II, oilmen turned to a new technology to economize production from existing wells: the waterflood, injecting a cushion of water to push oil out of the reservoirs. The Ohio zealously implemented waterflood operations during the 1950s and 1960s, until deflated crude prices once again put a chill on the industry.

In 1962, the Ohio Oil Company changed its name to Marathon Oil and adopted the now-familiar logo featuring a large letter M on a shield. The Robinson refinery continues to flourish today as part of the seven-refinery system of Marathon Ashland Petroleum, LLC.

The impact of that first oil discovery a century ago can't be overstated. Men turned to new jobs in the oilfields as the economy shifted from agriculture to industry. Generations of men and women have fed their families by toiling in the refinery and oilfields surrounding Robinson, drilling more than 200,000 wells and harvesting hundreds of millions of barrels of crude. And, unlike manufacturing concerns, which can pull up stakes and move

away almost overnight, oil stays put. As long as the nation thirsts for oil, and as long as it can be brought up economically from the Illinois prairie, Robinson's wells and refinery will remain deeply ingrained in the landscape and life of Crawford County.

From Crude to Cocoa

The oil boom of the early twentieth century rippled out into the broader economy, as merchants set up shop to serve the prospering community of oilmen. In 1914, the Heath Brothers opened a soda fountain and candy shop in Robinson. Their store was a hit with both the locals and the traveling businessmen who frequented Robinson during the oil boom.

The story of their success holds that one of their regular customers had a habit of sharing candy recipes with the Heaths. On one occasion, he brought them a formula that he picked up from a family of Greek immigrants in Champaign for a brittle, buttery confection. The Heaths took the recipe, perfected it, and sold the sweets at their counter and on the delivery routes of the family's dairy business. Oil boom travelers took the new candy throughout the re-

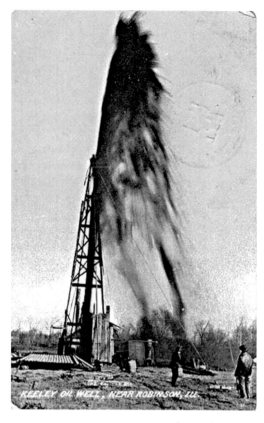

A gusher in the Illinois basin—the Keeley oil well near Robinson. Joy Fisher, USGenWeb Penny Postcard Collection

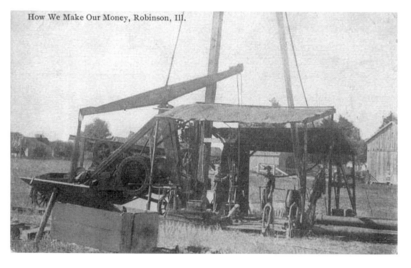

Pumping oil in Crawford County. Oil wells are still a common sight on farms and country home sites today. Joy Fisher, USGenWeb Penny Postcard Collection

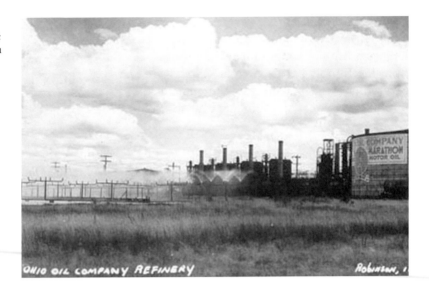

The Lincoln refinery. This photo was made after the introduction of the Marathon brand, as evidenced by the graphics emblazoned on the storage tank. Joy Fisher, USGenWeb Penny Postcard Collection

gion, and by the early 1930s, Heath English Toffee was on store shelves around the country.

After more than a decade of making their toffee bars by hand, the Heaths invested in an automated assembly line for their Robinson plant. By the end of World War II, Heath bars were popular around the world. In 1946, the patriarch of the family, L. S. Heath, incorporated the company and began acquiring other candy brands. In 1967, the company moved into its current Robinson home on West Main Street. Additional investments updated the plant in the 1970s and added a facility for making all of the company's chocolate in-house.

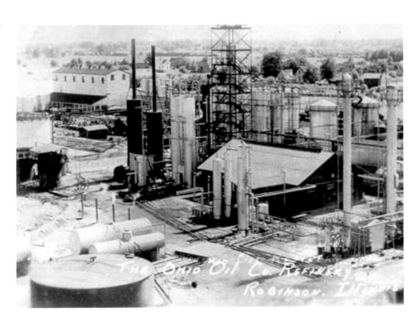

An early aerial view of the Lincoln refinery. Joy Fisher, USGenWeb Penny Postcard Collection

The Heath family sold their esteemed company to Leaf, Inc. of Helsinki, Finland, in 1989. Leaf dramatically augmented the Robinson operation, adding hundreds of employees and new brands to its production line, including Milk Duds, Whoppers malted milk balls, and candy bar favorites Payday and Zero. In 1997, Hershey Foods acquired the company.

The candy factory at Robinson is a stark and delightful contrast to the serious, gritty business of oil refining just a few miles down Highway 33. A good recipe and some tweaking in a candy maker's kitchen almost a century ago have created generations of jobs and wealth and given a unique taste of Robinson, Illinois, to consumers around the world. Life in Robinson wouldn't be the same without candy, which was a frightening thought in 2002, when Hershey's board of directors began making noise about selling the entire corporation to Nestlé. After a particularly loud public outcry from every corner of America, the idea was scuttled. And Robinson is still home to a sweet, generations-old craft.

"Best in the Long Run": The early Marathon brand featured an Olympian runner.

Palestine: Hub of the Wheel

Back in the days of the I&IS, Palestine, Illinois, just west of the Wabash River, was chosen as the location for the little railroad's shops and servicing facilities. Water for the steam locomotives was abundant, and the coal supply was just down the line in Indiana, in the Sullivan County mines. The shops were a welcome addition to the tiny agricultural community, which hadn't yet discovered the first oil reserves in the area. However, the I&IS was a feeble enterprise, and when the line fell into insolvency, the shops were abandoned. When Illinois Central became involved, with an eye toward extending the line to Indianapolis, the town became rapt with hopes and anticipation that the shops might be reborn in Palestine. Other communities had similar aspirations to host the enterprise, namely Sullivan. But by the time

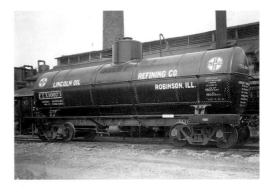

This diminutive riveted oil can is a far cry from the high-capacity cars that serve the refinery today. William Millsap Collection

The consist of this IC train gives a reliable clue to the location—somewhere not far from the Lincoln refinery in Robinson, in the heart of Illinois oil country. William Millsap Collection

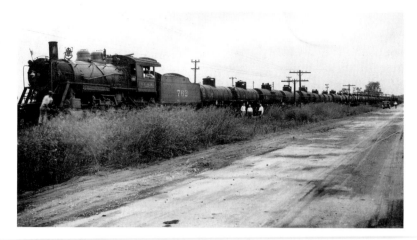

Palestine mechanics pose proudly with one of their machines, 1910. Ralph Bachelor Collection

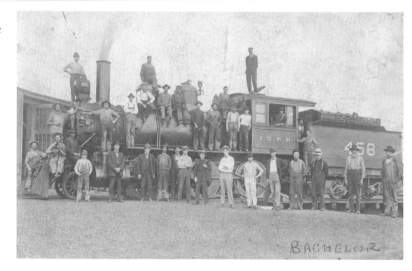

The Palestine roundhouse crew in front of the yard office, 1910. Ralph Bachelor Collection

According to the handwritten notes on this 1922 photo, the ranks of the Palestine roundhouse men had grown to 180. Ralph Bachelor Collection

that town had a delegation assembled to visit IC offices in Chicago, the decision had already been made to build in Palestine.

The first newspaper reports naming Palestine as the winner of the coveted prize were circulating by June 1906. The town was abuzz with talk that IC had optioned the purchase of 102 acres of the Woodworth farm for construction of a switchyard, machine shop, roundhouse, and other facilities. With its division point activities, shops, station, and maintenance section, the IC became one of Crawford County's largest employers. By the 1930s, there were some 200 men sharing an annual payroll of nearly $300,000—roughly $4 million in today's currency—in the sprawling train town that was the IC shops.

After World War II, declining traffic and dieselization sent Palestine and other facilities like it into a period of decline. The 12-stall roundhouse, which had been reduced to six stalls by a fire, was abandoned in 1957 and razed in 1964. The turntable was filled in, and a wye was built to turn locomotives. By that time, only nine trains a day were running the line, although there were still more than 60 trainmen rostered at the station, as well as roughly three dozen car and track maintenance workers, clerks, and other employees.

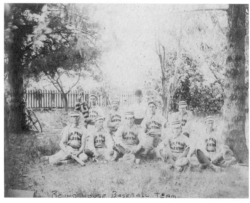

They worked hard, and apparently they played hard, too. The roundhouse baseball team, ca. 1910. Ralph Bachelor Collection

An Illinois Central crew poses with a local freight, ca. 1910. Ralph Bachelor Collection

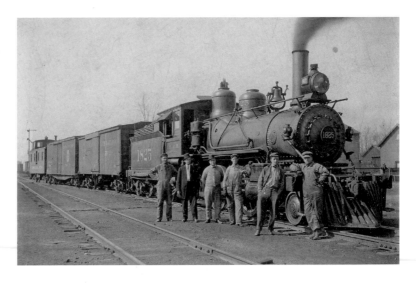

The IC shops at Palestine. The freight yard is out of view to the right. Ralph Bachelor Collection

Under INRD ownership, the Palestine yard has been completely renovated down to the subgrade, with new trackwork and technology to serve the industrial community in Crawford and Jasper counties. The roundhouse and shops are gone forever, but the chugging of the yard engine, the clanging of couplings, and the rumble of long coal trains echo through the streets of Pales-

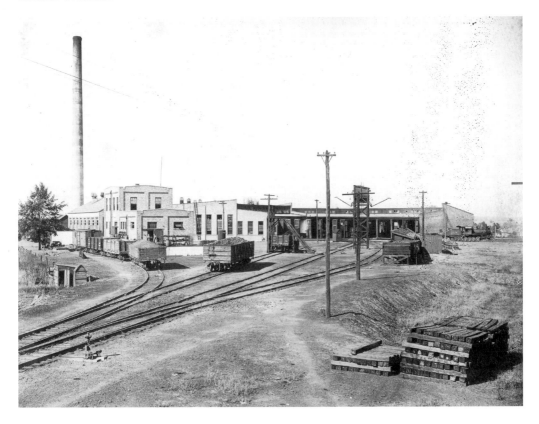

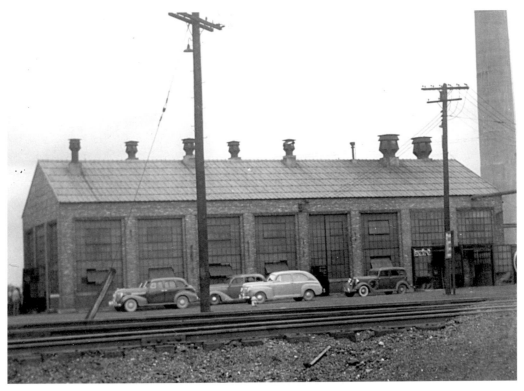

The Palestine car shop, seen here probably in the late 1940s. William Millsap Collection

tine, reassuring the townspeople that their railroad and their economy continue to thrive.

Sullivan to Switz City: Coal Country

Coal is the energy of natural vegetation, conveniently packaged in rock form. Decaying plants and peat bogs between the river valleys in southwestern Indiana sank and congealed into vast re-

The turntable at the Palestine roundhouse, apparently photographed during the May 1943 flooding. Ralph Bachelor Collection

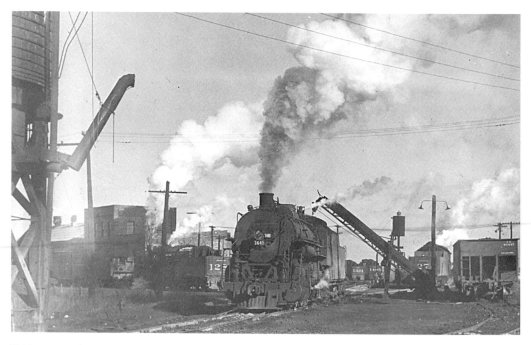

Taking on coal at Palestine, ca. 1955. William Millsap Collection

serves of the ebony gold over thousands of years. Coal was first discovered in Indiana along the Wabash River in 1736. A century later, the rocks were being shipped by flat boat from locations along the White, Wabash, and Ohio rivers. Indiana was producing less than 10,000 tons of coal per year—the capacity of a workaday unit train today. Small-scale surface mining was done at first by pick and shovel and later by horse and scraper. The first underground mine shaft in Indiana was developed in 1850 at Newburgh, and by 1852, both shaft and slope mines became common.[3]

Through the end of the 1800s, Indiana coal production increased rapidly to feed the industrial revolution, and by 1900 the

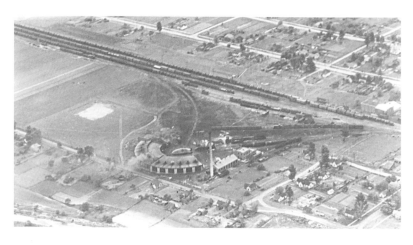

This aerial photo shows the Palestine shops and freight yard, looking south-southeast. Fire destroyed the east half of the roundhouse, leaving the six stalls directly facing the camera. William Millsap Collection

Hoosier state ranked sixth in coal production nationally. The principal reserves were located in the southwestern quadrant of the state, in an area of roughly 7,000 square miles.[4] Workable beds at that time were estimated at 8 billion tons and projected to last at least 300 years. Projected yearly production by 1910 was 10 million tons. At the close of World War I, Indiana was producing more than 30 million tons annually. Sullivan was the top-producing county. Three-quarters of its families made their livings from the coal business.

The significance of coal to the American economy in the early 1900s cannot be overstated. Coal was the primary fuel for indus-

Ghostly and forlorn, the Palestine roundhouse stands abandoned before being torn down in 1964. William Millsap Collection

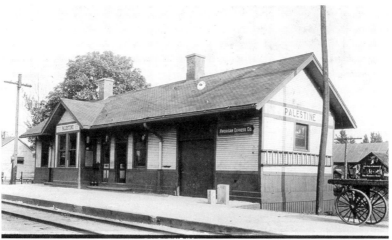

Illinois Central Rail Road Depot, circa 1910.

The Palestine depot, looking peaceful and tidy between trains, 1910. William Millsap Collection

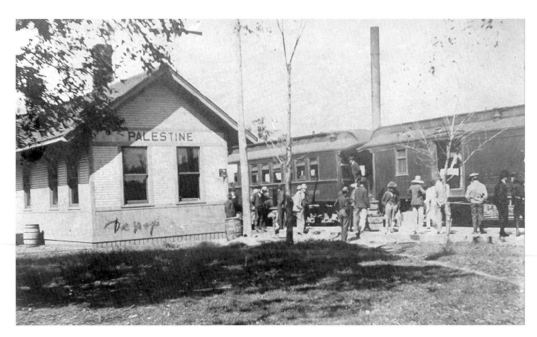

The depot at train time. William Millsap Collection

try, and the railroads were a prime means of conveyance to slake the enormous appetite of manufacturing plants and urban populations. And this being the era of the steam locomotive, the mines and the railroads enjoyed a symbiotic relationship, each representing one of the other's biggest customers. As electric power grew in practicality and prominence, coal consumption became ever more concentrated among the utilities and gave rise to a new term in the railroading lexicon, the "unit train." The cuts of coal-laden, wood-sided gondolas gave way to massive, articulated land barges—steel hoppers in solid blocks by the hundreds, bound for the generating stations that fed the power grid.

In the early days, IC had a solid foothold in the Indiana mining industry, exclusively serving 6 of the 11 mines in operation between the towns of Sullivan, Dugger, Victoria, and Linton. Other lines zigzagged through the coal quadrant as well, including the Monon's Bedford & Bloomfield (B&B) branchline, Pennsy's Indianapolis–Evansville line, and the C&EI Chicago–Evansville line, which crossed the Hi-Dry at grade at Sullivan. Sixteen miles east, at Linton, another diamond carried the Southern Indiana Railroad, later known as the Chicago, Terre Haute & Southeastern Railway, across the IC tracks. The CTH&SE became the Milwaukee Road's Terre Haute Division from Chicago Heights southward to Terre Haute and Bedford, where Louisville was accessed via trackage rights on the Monon. With the fall of Hiawatha's flag, the Soo Line, later absorbed by Canadian Pacific, picked up the line in 1985 and operates it today. The Linton junction was an important

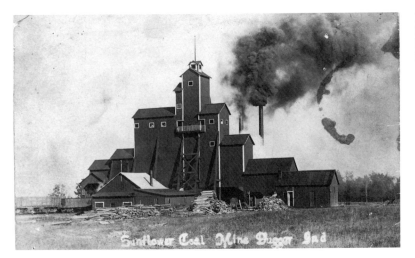

The Sunflower Coal Mine, near Dugger, Indiana. Indiana Rail Road Archives

one on the Hi-Dry for receiving offline coal bound for Indianapolis and Newton, Illinois. Recently, Indiana Rail Road built a new connection to CP that bypassed Linton, much to the relief of motorists who dealt with the aggravation of coal trains being cut and spliced in the middle of town.

Coal fortunes in the region have shifted over the years, particularly where the IC was concerned. The Clean Air Act of 1970 established new, stringent standards for coal sulfur content, and this virtually closed down domestic markets to mines in southern Illinois. Harry Bruce and the marketing team at IC worked, with mixed success, to open conduits to less regulated export markets in order to keep the coal moving on the rails. Much of Indiana's coal reserves were compliant with the low-sulfur regulations,

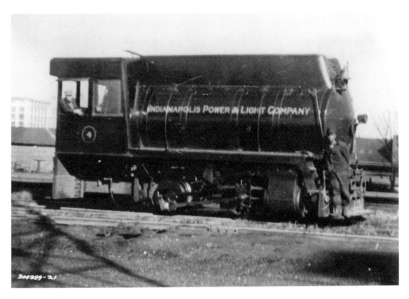

Indianapolis Power & Light has always been one of the largest coal consumers on the line. In days gone by, this interesting little locomotive moved coal cars at the plant. It is a "fireless" engine, powered by a rechargeable steam reservoir. Bass Photo Company Collection, Indiana Historical Society

however, and that is ultimately what kept the IC's Indianapolis District on life support throughout the 1970s. Southern Indiana coal was still burning in the boilers of the massive Indianapolis Power & Light Company's Stout generating plant, as well as the downtown Perry K steam plant. The fuel was hauled in a car fleet owned by the utility, largely on the Hi-Dry and the old Pennsy Evansville line, which, by the end of the decade, was being traversed by the bright blue locomotives of Conrail.

Coal still figures significantly in southern Indiana railroading, but not so much in the livelihoods of the people. Machines have replaced men in the mines, some large operations—notably Peabody Coal's Hawthorn Mine—have been idled, and competing fuels have made inroads into the market. Still, in 2002, Indiana miners harvested some 36 million tons, with some 9 billion tons now estimated to be lying in wait beneath the Hoosier loam.

Bloomfield: Indiana's Other Brickyard

Rolling eastward, the Hi-Dry leaves coal country behind and enters the gently rolling farmland of central Greene County. Ap-

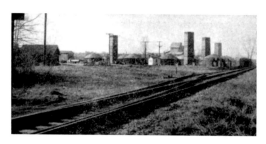

The brickyard and kilns at Bloomfield. Bloomfield Historical Society

proaching the White River, the Hi-Dry pulls within sight of the Monon's Bedford & Bloomfield branchline, passing over it and the New York Central's Terre Haute–Evansville line at the famous Elliston triple crossing. The Monon swung eastward and remained within sight of the Hi-Dry to the town of Bloomfield, the county seat. Apple orchards were common in the area, the early settlers having brought seeds with them from the Carolinas. Owing to suitable iron ore deposits nearby, there was a small foundry and iron fence post factory when the railroad arrived.[5] More significantly, Bloomfield was home to high-quality clay beds, giving rise to a sizable brickyard that did a fair amount of shipping by rail.

The most tragic event in the history of the Indianapolis line occurred in Bloomfield. On August 25, 1951, a 10-year-old boy was playing on the tracks in the middle of town, at a level crossing with the Monon line. The lad placed a three-quarter-inch diameter, 10-inch long steel bolt between the live rail and the guard rail at the diamond. An approaching IC train struck the bolt. The pilot wheels derailed and sent the locomotive into a boxcar parked on a lumber company siding, where workers were busy unloading it. One by one, 19 cars of the 49-car train piled up. In the ensuing chaos, a broken rail punctured the firebox and breached the boiler,

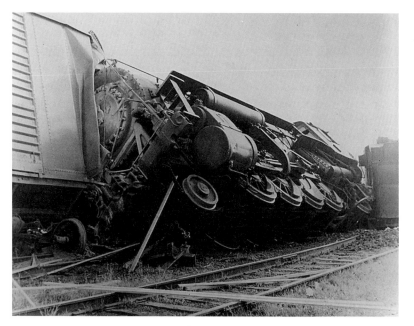

The aftermath of the derailment at Bloomfield, August 25, 1951. Larry Shute Collection

scalding three crewmen. Engineer G.E. Dean, fireman W.E. Reynolds, and brakeman H.V. Sparks all died from serious burns after being transported to Greene County Hospital in Linton. It was, and hopefully will remain, the darkest day in the history of the Hi-Dry.

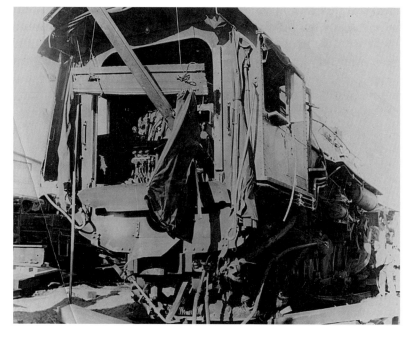

The locomotive cab, showing the protruding rail that breached the boiler and released a fatal torrent of steam on the three IC crewmen inside. Larry Shute Collection

Tulip: Railroad in the Sky

East of Bloomfield, the terrain becomes considerably tougher, and the railroading becomes more spectacular, especially near a rural village known as Tulip. Today, Tulip no longer exists as the town it once was. It is only a loose grouping of family homes and farmland, home to about three dozen people. The one thing that has remained unchanged about Tulip is the giant Richland Creek Viaduct, a half-mile of railroad elevated more than 150 feet above the creek bed and surrounding valley. Decades ago, however, Tulip was a bucolic, albeit impoverished whistle stop on the Illinois Central. In fact, it was the daughter of an IC man who left one of the most lucid descriptions of life in Tulip during the early 1930s, in the depths of the Great Depression.

Avis Hamilton Stalcup penned a brief but intimate and charming memoir of her youth in Tulip. Her father, Lebert Hamilton, was in many ways the envy of the townspeople. Unlike many of the men in Tulip, he had a good job, operating the pump station that filled the trackside water tank from a spring-fed pond at the base of the viaduct. She recalls that the spring never ran dry, even in the most scorching summers.

The Hamilton family was furnished a house by the IC, a fact that practically made them royalty in the eyes of their neighbors, especially since the viaduct was the focal point of the entire community. The townspeople would gather for Sunday picnics, baseball games, and ice cream socials in the valley beneath the looming landmark.

Even with a company house and a good job, though, times were lean for the family. There was no electricity or running water. Baths were taken once a week in the warm water at the pump station. The family's house was heated with wood and lit with

A postcard depicting an early trip across the Tulip trestle. Indiana Rail Road Archives

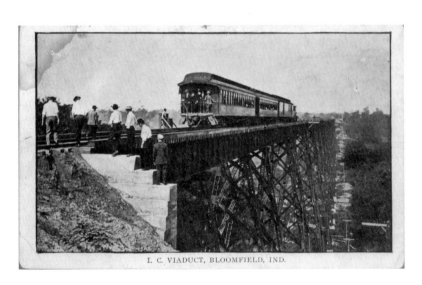

I. C. VIADUCT, BLOOMFIELD, IND.

THE INDIANA RAIL ROAD COMPANY

kerosene lamps. The summers were too hot, and the winters were too cold. But Tulip was a lovely town, with people who were peaceful and content with simple pleasures—horseshoes, hunting mushrooms, and hulling walnuts. The Depression brought another group of less-contented people to Tulip: hobos who rode the IC rails. Driven by hunger and desperation, they could occasionally behave violently, but some wild blackberries and yeast bread usually bought a lot of goodwill.[6]

Solsberry: Spirit of Independence

Local chronicles contend that the name of this country hamlet is derived both from its founding father, Sol Wilkerson, and from the abundance of berry patches surrounding the town. In fact, fresh berries were shipped by the gallon from Solsberry to Indianapolis on the early trains, sharing a berth with fresh eggs and "hoop poles," bands used in barrel-making, accounted for in economic reports of the time under the category of "cooperage."[7] As with many other rural stations along the line, timber and livestock were also principal commodities. Early photos of Solsberry clearly show the livestock pens and log yard, practically atop one another. Most timber from Solsberry was only on the rails a short time,

The livestock pens and log yard at Solsberry were a hub of local commerce, as seen here ca. 1920. Courtesy of Donny Lavon Yoho

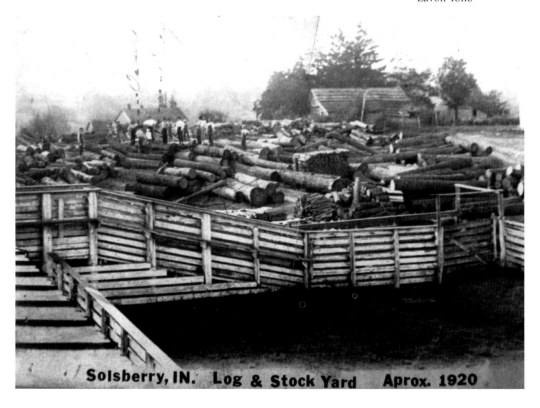

Solsberry, IN. Log & Stock Yard Aprox. 1920

The Solsberry depot, ca. 1917. Rounding the corner of the station at the extreme right is Cotton Yoho, grandson of Frank Yoho. Larry Shute Collection

ending its journey just a few mileposts east, in the mills of Bloomington's furniture factories.

In addition to its economic impact, the railroad changed the social lives of county residents as well. In its most basic effect, the railroad simply gathered people together. Train time was an occasion for coming out, sharing fresh berries, serving a hearty meal to the trainmen, and greeting the passengers, wherever they might be going. More significantly, people living in rural Greene County had newfound mobility. They could visit relatives miles away whenever they desired. They could, on a whim, spend a Saturday in Bloomington, shopping downtown or seeing the circus. The railroad even changed the way people cooked and heated their homes. No longer did they simply feed cordwood into their stoves; now they could burn coal. Children would scramble to the tops of passing coal cars and kick the oily black rocks to the trackside, where they would scavenge them and bring them home, all while the benevolent trainmen would look the other way.

A section crew poses near Solsberry in the 1950s. Larry Shute Collection

Solsberry was a colorful, industrious village. Then, as now, it attracted people with a certain rugged individualism and spirit of self-determination. One particular Solsberry resident stands out as a gallant figure in the town's history, and his legacy endures to this day. Frank Yoho was patriarch of the Yoho family, a rural dynasty that heartily shaped the character of the tiny community. Frank Yoho was a tall, burly man whose physical presence lived up to— and likely contributed to—his achieving the status of quasi-folk hero. His physical strength served him well as a hog butcher. He

impressed the young boys with his display of muscle, single-handedly hefting generous porkers onto the hooks and whittling them into fresh chops and bacon. Before the trains came, Frank also carried the mail in a horse-drawn carriage over a rural route that originated at the nearest post office, 12 miles away in the town of Freedom. He is especially remembered for his return trips in the evenings, when he would be seen driving his horses as fast and furious as they would run, anxious to get home after a long day's work.

Frank Yoho is best remembered as proprietor of the Yoho General Store. Here, where trains passing just a few feet away have rattled the store's windowpanes for generations, resides the very heart and soul of Solsberry. The spirit of the place permeates every crevice of the ancient structure, whose clapboard siding is so weathered, ghostly, and gray, it almost appears to be carved from Indiana limestone. To step inside is to step back in time, beneath gnarly beehives mounted on the rafters like fishing trophies, above shelves stocked with cornflakes, soda bottles, and mousetraps. The floor beneath the pot-bellied stove and liar's bench is like hallowed ground—a rural Poet's Corner. Fix your gaze on it, and the echoes of animated conversations long past seem almost deafening. The store is a tangible expression of Frank Yoho's spirit, and it's where his reputation for hard work and civic-minded generosity were indelibly imprinted on generations of townspeople.

The Blizzard of '78 deposited a heavy blanket of snow across the Midwest, much of it appearing to have accumulated on the nose of this ICG GP38, chugging along near Solsberry. Larry Shute Collection

Today, there is little economic activity to speak of in Solsberry. It's a sleepy community of modest rural homes, inhabited by people who earn their wages down the road in Bloomington or elsewhere. The Yoho store is still open for business, carried on by Frank's descendants. And the trains still rattle the windowpanes every day.

Stanford Ore Bust

A town not even on the railroad, Stanford deserves mention because of what *didn't* happen there. The official prospectus for the Indianapolis Southern Railway touted the line as "The Mineral Route." This moniker was based in large part on what was thought to be vast, high-quality iron ore deposits near Stanford, in the area

known as American Bottoms. Early surveys showed the railway transecting what was believed to be 200 square miles of ore fields. In 1903, test drillings had been performed that indicated the possible presence of 40–50 million tons of premium ore. A branchline was even conceived to diverge from the main line near Stanford and rejoin it at the west end of the range, about 18 miles to the west. To David Parry and the Indianapolis Southern promoters, the ore looked like pure gold. In correspondence to prospective financiers, Parry wrote self-assuredly and enthusiastically about the lucrative bounty lying in wait. Alas, he counted his chicks too soon. By the time IC was helping to lay tracks for the ISRy, it was clear that the ore deposits had been greatly overestimated.[8] The line was restaked to the north through easier terrain, and Elwren supplanted Stanford as the station serving outlying Monroe County.

Bloomington: Extraordinary City

The county seat and hub of activity in Monroe County was, and remains, Bloomington. The city became home to the first state university, which was chartered by the legislature in 1820 and inaugurated in 1824. By the time the New Albany & Salem was surveyed in Bloomington in 1849, the campus had moved north from its original location to the old Dunn farm, east of the town square. In addition to the university and the array of mills, blacksmith shops, and other basic merchants, Bloomington was home to a handful of truly extraordinary enterprises. The most enduring of these owes its existence to an indigenous commodity that has made Indiana famous throughout the world.

The Hoosier State was blessed with a buried treasure below its midsection unlike any other. Beneath the hilly countryside, in a narrow band 35 miles long and 5 miles wide, almost exclusively in Monroe and Lawrence Counties, lay the most abundant strata of fine-grain limestone to be found on the planet. By the mid-1850s, the stone industry began to blossom, facilitated in no small part by the completion of the New Albany & Salem, which eventually became part of the Monon main line from Louisville to Chicago. At the start of the twentieth century, there were no fewer than 20 quarries and mills in operation in the Bloomington area, harvesting and finishing more than 7 million cubic feet of stone every year. The quarry season was eight months, with mills operating year-round. The market produced more than 150 carloads of stone for the railroads every day.[9]

In addition to being well suited for masonry and construction, Indiana limestone was also ideal for the formulation of Portland cement, which figured into IC president Stuyvesant Fish's hopes

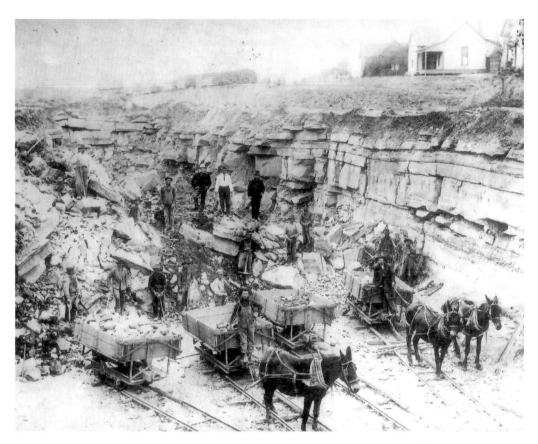

Limestone country: Men and beasts labor at cutting a path for the railroad through an abundance of stone in Bloomington, ca. 1904–1905. Larry Shute Collection

for his mineral route acquisition. In numerous letters to his associates in the Panama Canal Zone, Fish expressed keen interest in the construction of the great waterway, especially the cement requirements.

The stone business gave rise to another little enterprise in Fish's Indianapolis Southern operation, the Bloomington Southern. This branchline, just over nine miles long, was built piecemeal between 1907 and 1914. It departed the main line immediately west of Bloomington, at a point called Floyd. It then proceeded southward, converging on the Monon at McDoel Yard and paralleled that line to Clear Creek and the end-of-track at the Victor quarry. The line fell into gradual disuse as the stone industry waned. By the time the Indiana Rail Road Company took it over, it was in woeful condition. South of Clear Creek, small trees had taken root in the roadbed. Ownership of the south end of the line was transferred to the City of Bloomington for use as a recreational trail. The north end was kept in place to serve a building supply company, the county highway garage, and the sprawling RCA television assembly plant. That right of way was vacated and sold to the City of Bloomington in 1997, when the city cleared the land to create a new truck route to the RCA facility as part of a plan to develop the

site upon RCA's imminent closing. Indiana Rail Road continued to access local industry around the RCA site by means of trackage rights over the former Monon main (by this time owned by CSX Transportation) through downtown Bloomington to the Bloomington Southern connecting track at McDoel Yard. However, these remaining tracks were abandoned, and the property was sold to the City of Bloomington in December 2003 as the city prepared to convert the last remnants of the Monon main and McDoel Yard to urban green space and an alternative transportation corridor. The last remaining feet of the little limestone branch known as the Bloomington Southern were uprooted and stripped away before the summer of 2004, followed closely by the last vestiges of the historic Monon line in downtown Bloomington.[10]

Although it was dominated by the monochromatic gray and buff stone, Bloomington was also home to more colorful institutions, one of which was intimately connected with the railroad industry: the Gentry Brothers Circus, a highly successful group of traveling companies with headquarters on the Gentry farm on Bloomington's west side. Henry B. Gentry began performing with trained dogs in the early 1880s, and within a few years, he had grown his act into a touring show that traveled in a customized railcar. By the turn of the century, Gentry and three of his brothers were operating four traveling shows of four cars each. In 1902, the show trains converted from all-coach to a combination of flatcars, stockcars, and coaches. A route book was published that year showing a fleet of 72 cars in service.[11] The shows made stops in cities from the Midwest to the Deep South. The years leading up to 1920 proved increasingly challenging for the operation, and by 1915, the company had cut all but one show, which traveled in 15 cars. In 1916, the show was taken over by new management, which sold the company off in 1922. The Gentry brothers tried to revive their original show in the early 1930s, but with the tough times of the Great Depression, it was a bust. Henry Gentry's last known occupation was painting street signs in Bloomington. He died penniless in 1940 at age 75.[12]

Bloomington had leaders in more traditional crafts as well. The Showers brothers originally went into the business of making coffins for fallen Civil War soldiers. Within a couple of years, the brothers moved to property on Morton Street, along the Monon tracks, where they began building what would become an industrial empire—eventually recognized as one of the largest furniture manufacturers in the world. Three sprawling plants eventually covered the near west side of Bloomington, housing what was then state-of-the-art manufacturing facilities. It boasted such features as an overhead fire sprinkler system, a private branch telephone exchange, electric lights and ventilation, and steam heat.

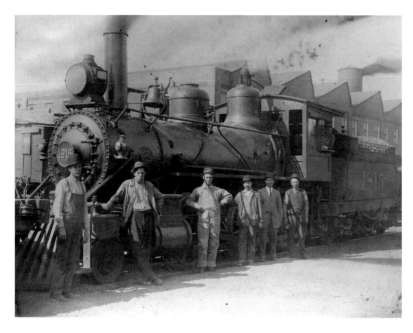

With the unmistakable roofline of the Showers Brothers furniture plant in the background, IC men pause for a photograph with Consolidation no. 1815. Larry Shute Collection

In the early twentieth century, Showers craftsmen were responsible for an enduring innovation, the use of hardwood veneers, which made their pieces lighter and more economical than traditional solid oak furniture. Quality Indiana hardwoods were brought in from southern communities, such as Jasper, as well as from Solsberry, just down the IC line in Greene County.

The area surrounding the plant was a hotbed of railroad activity. The inbound Monon line descended a steep grade, with the ridge-running IC flying over the tracks a few hundred yards

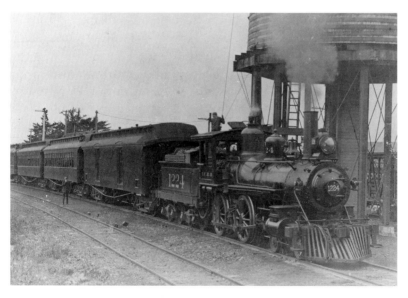

An early IC passenger train, led by an American type locomotive, pauses for a drink at the Bloomington water tower. William Millsap Collection

northwest of the complex. A spur brought IC trains down to the long Showers dock, which was capable of accommodating two dozen rail cars at a time. The IC freight depot was sited at the south end of the complex. IC and Monon traded cars at a small interchange yard west of the flyover, where the lines reached the same grade. A water tower and coal bunker were situated between the IC main and the connecting track, along with a handful of minor structures to accommodate the section crew and their tools.

By 1920, Showers Brothers employed more than 1,000 men in every aspect of making furniture, from milling raw timber to rolling mirror plates. To accommodate production of their popular kitchen cabinets, a fourth plant was built on the south side of town, between the Monon's McDoel Yard and the IC's Bloomington Southern branch. This plant also produced cabinets for RCA, Crosley, and Atwater Kent brand radios, which were entering households from coast to coast. RCA became one of Showers' best and most important customers, which would prove significant in future Bloomington industrial development.

The Great Depression hit the Showers operation particularly hard. Betty Showers-Dillon candidly maintained that the company never really recovered from the impact of those years.[13] Suffering from flagging demand, the company was burdened with excess capacity. Showers executives offered their south side plant for sale to their esteemed customer, RCA, and Bloomington's next record-setting employer entered the community in 1940, manufacturing radios and television sets.

In the decades that followed, Bloomington became the undis-

puted television manufacturing capital of the world. At the peak of its operation, the RCA plant was producing as many as 14,000 televisions every day, marketed under virtually every familiar brand label—Montgomery Ward, Sears, Zenith, and others—as well as the venerable RCA line. Ironically, the cabinets, which had been built on the same production floor in the days of radio, were now shipped in—largely by rail—from a variety of suppliers, from Canada to the Deep South. Many of these cabinet shops were only capable of building enough pieces each day to supply the Bloomington plant an hour or two's worth of production time.

RCA remained in the community until 1998, when French owner Thomson Consumer Electronics moved the production lines to Mexico. Almost 50 years earlier, in 1955, Showers Brothers sold its remaining facilities to Storkline, a Chicago-based manufacturer of juvenile furniture. By 1959, the company's production in Bloomington was phased out. The plants were sold to Indiana University, which used the facilities for craft shops and storage. Two fires in early 1966 destroyed the mill and finishing buildings. One of the near west side plants remained as a university warehouse until 1995, when it was renovated to accommodate Bloomington's city hall, the Indiana University Research Park, and commercial office space. The distinctive sawtooth roofline is once again a vibrant Bloomington landmark. The adjacent furniture showroom building is now home to an advertising agency, and the administrative office building has been occupied for many years by the Indiana University Press, the publisher of this book.

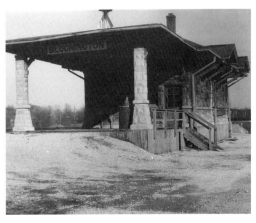

The remnants of the Bloomington Depot, shown sometime after 1962, when the main portion of the station was razed. The surviving structure shown here is the baggage house, which served as business quarters for IC section crews and the Bloomington agent-yardmaster. It was later sold and converted to a Japanese restaurant. Photo by Ron Stuckey, John Fuller Collection

The presence of a major state university figured significantly in the Bloomington railroad business, creating an augmented demand for rail passenger service to carry traveling students, faculty, and administrators. These and other local riders appreciated the direct link to Indianapolis, something the Monon wasn't able to offer. Throughout the early 1940s, students and townspeople enjoyed weekend rides on the IC to Brown County for hiking excursions and day trips to Indianapolis for shopping outings and business errands.[14]

In the earliest days of the Indianapolis Southern, the IU student body on the Bloomington campus numbered only about 1,500, compared with more than 30,000 today. The greatest swelling of the ranks came after World War II, when returning soldiers took advantage of the GI Bill to study. But by the time most

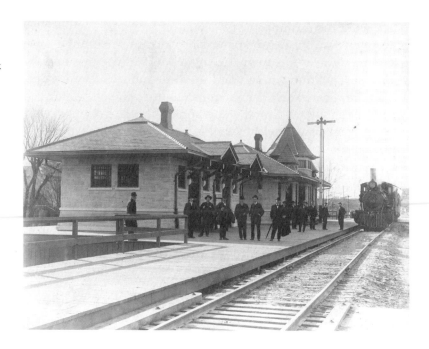

of these new students were on campus, it was already too late to ride an IC passenger train.

The depths of World War II and subsequent government-directed curtailment of underutilized trains spelled the end of passenger service on the Hi-Dry. (The Monon, however, held out for two more decades. Its last passenger train pulled out of Bloomington on October 3, 1967.) The stately limestone IC depot above College Avenue and Walnut Street in Bloomington stood empty for several years after the last ticket was punched. Some sources indicate it was razed in the late 1950s. Bloomington city directories indicate its demise probably occurred in 1961. The baggage and express house was left standing, serving as home for IC's yard master and agent and later as a Japanese restaurant called Ekimae, which translates to "train station."

Coal also had a part in the railroad's relationship to the university. The university's own heating plant was located on the IC main line, which inconspicuously bisected the campus on a mostly grade-separated path. However, much of the coal that was burned at the plant originated off-line, so IC's stake in the movements was minimal, only a local switch. Consequently, the level of service delivered by the IC was usually minimal as well and was plagued by annoyances such as frozen payloads in the winter months. IU transportation professor George Smerk helped devise a plan to build a warming shed for the coal hoppers that would thaw the loads with the abundant steam generated by the plant, but the IC wasn't interested. Such was the nature of the relation-

ship which eventually drove campus administrators to prefer pounding the overcrowded campus streets with heavy trucks to feed the coal stockpile rather than deal with an uncooperative railroad.[15]

Indiana Rail Road made a number of unsuccessful attempts to once again move IU's coal by rail. The university administration was rail-friendly and worked closely with INRD to create a new solution. However, the boilers in the old steam plant were configured to burn a modified stoker coal that wasn't available from mines directly served by INRD, and the economics of a two-line haul were prohibitive. Additionally, the plant's unloading and conveyance systems were designed to accommodate 50-ton cars, half the capacity of a modern hopper. The university converted several of the plant's boilers to burn natural gas, but sharp escalation in gas prices has shifted the preference to coal as the main fuel. Plans are on the drawing board for a new coal-fired power plant to be built alongside the railroad just west of the existing facility by 2007. The new plant will receive Indiana compliance coal as well as crushed limestone for the emission control systems. After two decades of trying, INRD will finally move coal to the IU campus.

Brown County: A Toehold for the IC

Up the line from Bloomington, the IC just barely nicked the northwest corner of Brown County, but those scant eight miles of track were the backdrop for some of the most colorful history recorded along the railroad. The scenic hills of Brown County have always been off the beaten path. The isolated woods attracted people with a characteristic peaceful self-reliance, the lifestyle of old-fashioned mountaineers.[16] Many of them lived by subsistence farming; others tended fruit orchards or made their livings as craftspeople and artisans. Their existence was a world apart, and when it came to the issue of a railroad in Brown County, their attitude was not surprising.

When the Indianapolis Southern was carving out its territory southward, it was proposed that the line pass through the county seat of Nashville before turning westward to Bloomington. The local population was vehemently opposed, saying that the railroad would corrupt the quality of life with noise, smoke, soot, danger to children, and all sorts of tramps and undesirables arriving on the trains. To this day, Nashville is one of only four Indiana county seats that have never been directly served by a railroad. A proposal to link Nashville with Indianapolis and points south on an electric interurban line was well received, but the line was never built. A privately built and operated turnpike was also proposed to serve Brown County with two 12-passenger buses and two 12-ton

freight trucks. However, the idea was trumped by the coming of the first state roads, which finally brought Nashville "out of the wilderness" around 1920.[17]

Not everyone was so dead set against a real railroad, however, namely, a handful of ambitious people in Jackson Township, in the northwest corner of the county. Chief among them was John Helms, a major landowner who donated a parcel of his property to the railroad for construction of a station, which became known as Helmsburg. The railroad gave rise to a variety of businesses there, including timber, canned goods, and the Cullum Broom & Mop Company, which was operated by the son of IC's Helmsburg agent, Jack Cullum. Helmsburg was also the jumping-off point for Nashville passengers, who rode into town with freight and mail in horse-drawn hacks. Train time at Helmsburg was a minor spectacle, the depot bustling with activity and the hack drivers calling out like carnival barkers. The dirt roads that carried their wobbling rigs were primitive and deeply rutted, crossing creek beds and falling prey to the deteriorating effects of unpredictable Indiana weather. Although it was only about six miles, the trip to Nashville could easily take longer than the rail journey from Indianapolis when less-than-ideal conditions prevailed.[18]

With the railroad, Brown County began to attract more and more visiting artists seeking refuge and inspiration in the isolated hill country, many of whom eventually settled there and gave rise to the area's renown as an artists' colony. They arrived on one of the four daily trains running between Indianapolis and Effingham, which had become known among travelers as the "Abe Martin Specials," after cartoonist Kin Hubbard's popular country bumpkin character who hailed from the "Hills o' Brown County." Area

Train time at Helmsburg, Indiana. Hacks greeted the train to vie for business, usually to take passengers and freight into Nashville. Courtesy Lilly Library, Indiana University, Bloomington, Indiana, Hohenberger Manuscripts

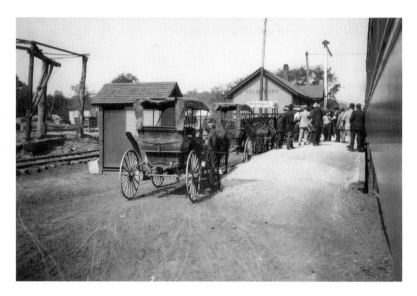

THE INDIANA RAIL ROAD COMPANY

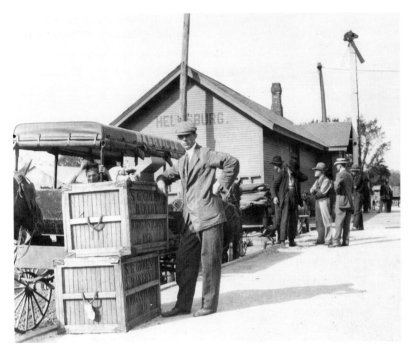

tourists also enjoyed weekend excursion trains to the picturesque destination, spending entire afternoons in the tranquil woods.

T. C. Steele and Adolph Schulz were among the most celebrated artists to step off the trains at Helmsburg. In 1907, Steele built his home and studio, known as "House of the Singing Winds" and began spending summers in Brown County with his wife. Schulz also began summering in Brown County with his artist wife, Ada, and their son during the same year. By 1917, the Schulzes had made Brown County their permanent home.[19] Also among the noted artists to settle there were Will Vawter, illustrator of many of James Whitcomb Riley's poems, and photographer and journalist Frank Hohenberger, whose writings and photography indicate more than a passing interest in the railroad.

The Brown County station at Helmsburg was served by a number of structures during its history. The first burned to the ground on an April afternoon in 1942 after a store of wet coal smoldered and caught fire spontaneously as the agent was enjoying a peaceful lunch at home, just a stone's throw away. An interim shanty was put up for the station agent, not significantly larger than a telephone booth. The slightly larger structure that replaced

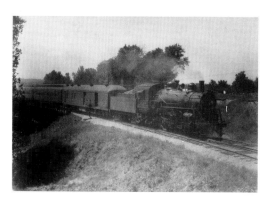

An IC passenger train glides into Morgantown, Indiana. At its peak, passenger service saw two daily round-trips between Indianapolis and Effingham, Illinois. Courtesy Lilly Library, Indiana University, Bloomington, Indiana, Hohenberger Manuscripts

the original depot met a more embarrassing fate: it simply collapsed. The third and final structure was the dormant depot from Trevlac, which was picked up and moved down the line to Helmsburg. How Trevlac gained and lost its little station is another good story.

Two miles up the line from Helmsburg, near the town of Needmore, lived Colonel and Mrs. Cecil A. Calvert. The Calverts raised many eyebrows among the locals; it was said that they spent money like kindling, and the Colonel was known to have a penchant for spinning some real whoppers. He claimed to be a relative of Admiral Farragut, under whom he supposedly served in the Civil War, and he also claimed to have been a member of the Cincinnati Red Stockings baseball team. The Calverts had transplanted themselves from Cleveland to rural Brown County to escape city trappings and invest their mysterious fortune in building a health spa and resort. They proceeded to construct a small community, complete with several houses, a hotel, a livery stable, a dance hall, mills, and other buildings. Naturally, Colonel Calvert saw the railroad as a boon to his enterprise. When IC president Stuyvesant Fish made an inspection trip during the construction of the ISRy, he was invited to stay with the Calverts, and he and the opportunistic Colonel apparently became fast friends. Newspaper accounts told of the emboldened Colonel subsequently marching into Fish's New York office and persuading him to place a station on the line to serve his resort property. In the spirit of shameless

An IC passenger train leans into a curve in Butler Cut, Brown County. Folks called the IC trains "Abe Martin Specials" in honor of cartoonist Kin Hubbard's Brown County bumpkin character. Brown County Historical Society

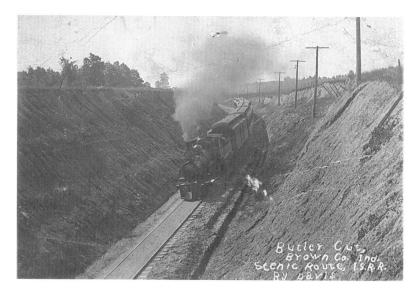

self-promotion, the Colonel wanted to name the village and station after himself. Much to his chagrin, it was discovered that another IC station in Kentucky already bore the name Calvert. Not to be discouraged, the Colonel simply chose to spell his name backwards, and Trevlac, Indiana, was put on the map.

University students in Bloomington discovered the Calverts' retreat and were filling the hotel regularly on the weekends.

Artist T. C. Steele (*right*) arrived on an IC train when he came to settle in Brown County. Courtesy Lilly Library, Indiana University, Bloomington, Indiana, Hohenberger Manuscripts

The flamboyant Colonel loved entertaining guests, especially, it was said, those of the opposite sex. Popular rumor has it that on one occasion, the Colonel's appetites got the better of him. In 1909, Mrs. Calvert abruptly packed up their possessions and moved the family back to Cleveland, where they declared bankruptcy in 1916. Trevlac became a virtual ghost town. Today, it's little more than a wide spot in the highway, bearing the curious legacy of the Calverts' eponym in retrograde.[20]

The northernmost station in Brown County was Fruitdale, a name that reflects the importance of the orchard business in the area, although there was no significant commercial orchard near the station. Fruitdale was originally known simply as Doubling Track (owing to the existence of a siding for that purpose) and then, for a short time, Pomona. There were no scheduled stops at the little station; the mail was handled toss-and-hook fashion, unless the train was flagged to pick up passengers or freight. The typ-

A smoldering coal bin claimed the Helmsburg depot on April 14, 1942. Courtesy Lilly Library, Indiana University, Bloomington, Indiana, Hohenberger Manuscripts

Stationmaster Jack Cullum poses with his new temporary depot, a considerably more "efficient" structure than the one it replaced. Courtesy Lilly Library, Indiana University, Bloomington, Indiana, Hohenberger Manuscripts

ical array of goods on the platform might include fresh fruit and cream, hogs, crated chickens, fence wire, farm implements, and freshly hewn crossties. In the early 1930s, Fruitdale became a commuter platform of sorts, serving a handful of people who spent the week working in Indianapolis and returning to their country homes on the weekends. They would typically set out for Indianapolis on the Sunday evening northbound. They would signal the engineer to make a station stop by lighting a small fire with newspapers in the middle of the tracks.[21]

All told, the three stations in Brown County—Helmsburg, Trevlac, and Fruitdale—encompassed just eight miles of railroad across the northwest corner of the county. It was barely a toehold, but still Brown County could claim it had a railroad. The Model T, which first arrived in the county around 1913, signaled a growing threat to the railroad's business. With continued improvements to public roads, the passengers, mail, and freight carried by train increasingly shifted to automobiles and trucks. By 1936, the stations at Fruitdale and Trevlac were closed and abandoned.[22] Helmsburg remained open through the late 1940s, but only odd carloads of gravel, coal, and lumber were handled; mail and express traffic were mostly riding on rubber wheels by that time.

Indianapolis: End of the Line

North of Brown County, the railroad slipped through farm country that fed the people of Indianapolis. Morgantown and Bargersville, with their collection of mills, blacksmiths, and stores, were the principal stations south of the capital. Morgantown boasted small

Eventually, the IC relocated the abandoned Trevlac depot down the line to serve Helmsburg. Revenue carloads on the adjacent team track became an increasingly rare sight at the station. William Millsap Collection

THE INDIANA RAIL ROAD COMPANY

World War I recruits pose for a farewell picture on the platform at Helmsburg. Brown County Historical Society

natural springs and a health spa, a convenient retreat for city dwellers. The railroad slipped into the south side of Indianapolis and swelled to multiple tracks at the Wisconsin Street Yard (known today as the Indiana Rail Road's Senate Avenue Terminal).

Like the Emerald City at the end of the yellow brick road, Indianapolis stood as the prize at the end of the IC's Indiana Division. The city was a bustling hub of commerce with a plethora of manufacturing, wholesaling, and distribution activity. The booming automotive industry was the focus of many concerns in the city, notably that of ISRy founder David M. Parry, the carriage

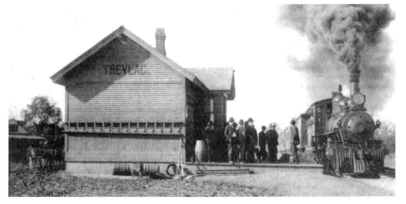

The depot at Trevlac. The ladder mounted on the side of the building was a standard fixture on IC stations. Brown County Historical Society

builder turned carmaker. Other familiar names rose to prominence during the auto boom, including Carl Fisher, a bicycle shop proprietor, and his partner James Allison, who made their early automotive fortunes producing and marketing early sealed-beam gas headlamps. These two were among a handful of players in the industry who built the Indianapolis Motor Speedway on 328 acres of farmland in 1909. The speedway was conceived as a year-round testing facility for the auto industry, as well as a venue to showcase the latest products to consumers. Cutting-edge technology in the very first Indy 500 in 1911 won the race with an average speed of 74.6 mph, taking nearly 7 hours to complete the event.

IC Mikado no. 1549 darkens the sky over Morgantown, ca. 1955. Photo by Ron Stuckey, John Fuller Collection

At the time of the Indianapolis Southern's completion in late 1906, the city's population had reached 200,000, up from some 18,000 at the start of the Civil War. Long before the war commenced, however, the city was already served by multiple rail lines, five of which came together in an entity of true distinction—the nation's first Union Depot, built in 1853.

The Indianapolis & Bellfontaine, the Madison & Indianapolis, the Terre Haute & Indianapolis, the Indianapolis & Cincinnati, and the Indiana Central were five principal railroads associated in

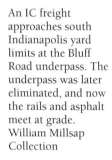

An IC freight approaches south Indianapolis yard limits at the Bluff Road underpass. The underpass was later eliminated, and now the rails and asphalt meet at grade. William Millsap Collection

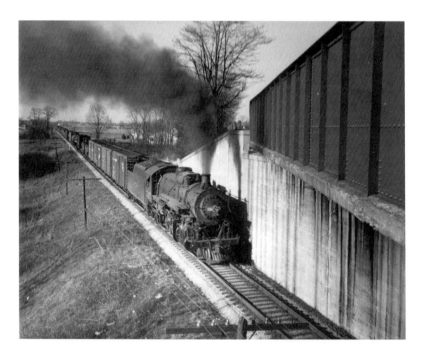

THE INDIANA RAIL ROAD COMPANY

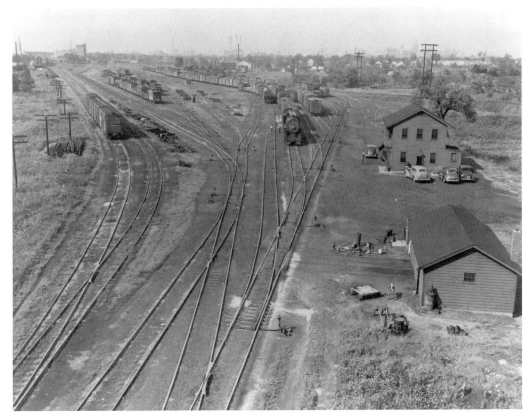

the Indianapolis Union Railway, which operated the tracks and the station. By 1870, the city's population had swelled to some 48,000, and the Union Depot was handling 2 million passengers annually, arriving and departing on 80 trains a day.[23] With more than a dozen railroads now using the facility, congestion and delays were chronic and worsening. The remedy was construction of a brand-new Union Station, which was completed in 1888.

The new station was an architectural gem in the Romanesque Revival style. The 185-ft. clock tower dominated the city skyline and welcomed some 200 trains a day during the zenith of rail travel. The builders' original vision called for a grade separation between the city streets and the train shed. However, funds to elevate the structure weren't available, and a street-level train shed was used until after World War I; a new shed was built on steel legs in 1917. In anticipation of an above-street entry to the station, the original ISRy tracks north of Wisconsin Street Yard were elevated and descended to street level to enter the old train shed. A final concrete overpass was built in 1917 to continue the elevated line to the new, uplifted Union Station.

The first trains on the Hi-Dry to serve Indianapolis boarded and discharged passengers at Wisconsin Street as construction of

Illinois Central's Wisconsin Street Yard (now known as the Indiana Rail Road's Senate Avenue Terminal) in Indianapolis. This view is from the Indianapolis Belt Railway overpass, looking north. Faintly visible on the horizon just right of center is the dome of the State Capitol Building. William Millsap Collection

The turntable and roundhouse at Indianapolis. John Fuller Collection

Cylinder cocks open, Mikado 1549 fogs the turntable at Indianapolis. Photo by Ron Stuckey, John Fuller Collection

the link to Union Station was being completed. The railroad was operational only as far as Bloomington at that point while heavy rock cutting and bridge building were being done further west in Greene County. According to newspaper accounts, the first ISRy customer bought two tickets—one to get a seat on the train, and the second to frame as a keepsake. Riding along with him and the other paying passengers were a handful of railroad managers and dignitaries. Between their coaches and the locomotive were two freight cars bound for Bloomington, carrying brand-new buggies from David Parry's factory and a stock of hardware from Cortland Van Camp's wholesale docks. This inaugural train departed Wisconsin Street on April 23, 1906, generating a front-page story in the press. IC chief engineer A. S. Baldwin promised reporters that the railroad would be serving Union Station by the Fourth of July. Follow-up stories show that he beat that pledge by three weeks. For the next 40 years, passengers rolled into Union Station via the tracks of the Hi-Dry.

The years following World War II saw staggering declines in rail travel, and the number of railroads and trains serving Indi-

anapolis Union Station dwindled. The U.S. Postal Service terminated the mail contracts in 1971, the same year Amtrak was created. The main station structure was sold to the City of Indianapolis to save it from demolition. Following the creation of Conrail, which assumed operation of the Indianapolis Union Railway, as well as the Indianapolis Belt Railway switching district, remaining employees at Union Station were vacated from the building.[24] The noble structure entered a state of suspended animation for the next several years. After a spectacular renovation and short-lived stint as a downtown retail and entertainment center in the 1980s, the station is now a conference center serving an adjacent hotel. The train shed survives as well and still serves an anemic timetable of Amtrak trains, with passengers sharing a ticketing and waiting area with a bus station below, all in the shadow of the behemoth RCA Dome.

The namesake of the INRD was the Indiana Railroad, an electric interurban line that operated intercity passenger service and some of the finest overnight LCL and carload freight service in the industry, provided with cars like the one pictured here. Bass Photo Company Collection, Indiana Historical Society

As grand as Union Station was in its heyday, it wasn't the only hub for rail travel in Indianapolis. At the turn of the century, a new means of conveyance on the rails was growing rapidly—the interurban. Charles L. Henry, owner of the Anderson mule line, is credited with having invented the name "interurban" for electric railways operating between towns and cities. Henry's Union Traction Company ran the first interurban between Anderson and Alexandria, Indiana, on January 1, 1898.[25] Lines began radiating from Indianapolis in all directions by the early twentieth century.

The sleek interurbans were exciting, juiced-up versions of the workaday city trolley car. Trundling clear of the congested city streets, they zipped through the countryside like jackrabbits, giving rural populations unprecedented access to the urban job market, entertainment, education, and state government. Before the era of the automobile, the interurban was perhaps the most advanced, convenient, widely used mode of intercity transportation available to average folks in middle America. To accommodate the booming business being done by the interurbans, the massive Market Street Traction Terminal was opened in the center of downtown Indianapolis in the fall of 1904. Within five years, passenger counts had far exceeded 6 million per year.[26]

The coming of the automobile and subsidized state roads

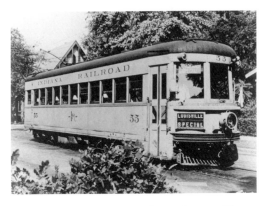

Interurban cars like Indiana Railroad no. 55 provided clean, speedy intercity transportation until state highways pushed them into extinction. Bass Photo Company Collection, Indiana Historical Society

stymied the interurbans and finally killed them off completely. Today, when the average urban commuter spends more than 50 hours each year stuck in traffic jams, the age of the interurban is perhaps most compelling not for what it was but for what it could have become. Within the web of electrified tracks that was the interurban network, it's conceivable that there could have been the genesis of a modern, extensive, high-speed rail network, perhaps superior to any other in the world. Lamentably, we'll never know. Trumped by the automobile, the clean running, speedy interurban seems an invention ahead of its time.

The Last Run to Union Station

An IC train pauses at Sullivan in a classic rural American scene, complete with the ubiquitous Railway Express Agency van. It would appear that by this point in time, the train was utilized more for moving parcels than passengers. Note the wigwag signal at the left, just above the locomotive's cylinder—it remained in service into the twenty-first century. Sullivan County Historical Society

Conventional passenger rail service met essentially the same fate as the interurban, but being operated by solvent, stringently regulated freight railroads, the passenger trains experienced more labored, lingering demises, and, unlike the interurbans, the tracks remained after the trains vanished.

Before World War II, IC dropped two of the four passenger trains running the Indianapolis line from its timetable. Immediately after the start of the war, IC petitioned to drop its remaining trains, Nos. 333 and 334. Public hearings resulted in the trains being kept on, with a consist of one combination express/baggage car and one coach. But in the spring of 1945, a mandate from the Office of Defense Transportation ordered railroads to discontinue passenger trains with less than 35 percent occupancy rates as measured in November 1944. The order suited the IC just fine; it con-

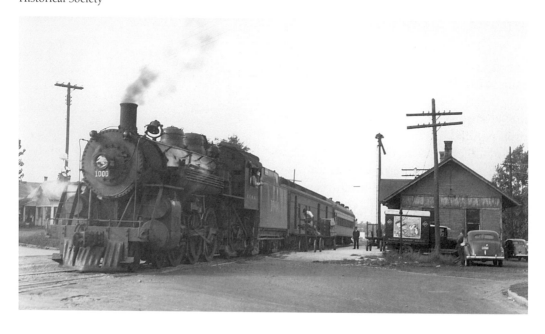

THE INDIANA RAIL ROAD COMPANY

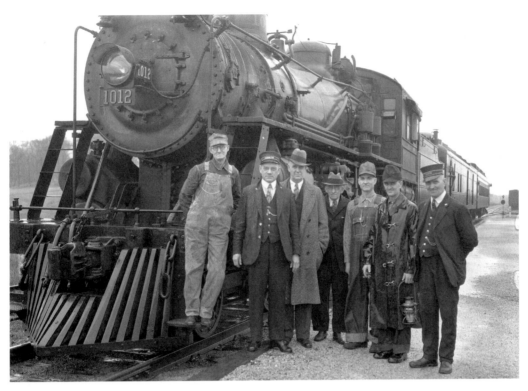

The crew of an IC passenger train. The trains' consists were reduced to one baggage/express car and one coach during the final years of service. Larry Shute Collection

tended the service had been operating at a loss for years. Trains 333 and 334 were terminated.

On March 1, 1945, the last Indianapolis-bound IC passenger stepped off at Union Station, and the little train hobbled back southward to its Illinois home. That summer the war ended, and there was talk of restoring the passenger trains. Public hearings were held, and passionate pleas were heard. In 1948, after two

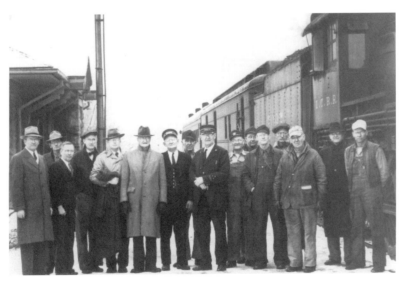

A bittersweet moment at the Bloomington depot on March 1, 1945: Train crew, station agents, and officials pose for a farewell photograph to mark the end of Illinois Central passenger service on the Hi-Dry. Larry Shute Collection

years of numerous court orders, injunctions, appeals, and losses—up to and including the Indiana Supreme Court—IC was directed to reinstate the trains or face a $100 a day fine, but the railroad took the case to federal court and prevailed, and the trains were gone for good. The era of passenger travel on IC's Indiana Division had come to an unceremonious conclusion, making the Effingham–Indianapolis route one of the early casualties in what would eventually become the wholesale decline and fall of intercity train travel.

The years to follow would see the division's freight business slide into decline as well.

Our line is a microcosm of nearly every conceivable engineering challenge and obstacle to railroading you could imagine.

—Tom Hoback

Trestles and Tunnels

The great glaciers of the Ice Age called it quits right around Indiana's midsection. North of Indianapolis, save for the valleys worn down by creeks and rivers, the state is as flat as a pancake. A lush carpet of corn and soybeans thrives in the fertile Canadian soil left behind by the massive ice rivers. South of Indiana's capital, however, the complexion of the land is much the opposite. Here, corn and bean fields are fewer, and they don't sprawl out like a carpet, but are tucked in between rolling hills and stone outcroppings. Traveling from south to north is, in a sense, like traveling through time, before and after the glaciers. Had those frozen bulldozers of long ago made it a few miles further south, the Indiana Rail Road wouldn't be nearly as interesting from an engineering standpoint.

Nor would the railroad have acquired such a colorful nickname. Owing to some 140 bridges—from the miniscule to the mammoth—that span ridges, gullies, creek beds, and peat bogs, the Indiana Rail Road and its antecedents have been known as the "High-and-Dry," or simply the "Hi-Dry." Just who exactly created this enduring moniker remains elusive. It has been suggested that the label came about after the IC helped rebuild some of the low-

A duo from INRD's "red fleet" crosses the Wabash River heading toward Indiana in August 2003. Photo by John Cummings

A pile driver at work in Brown County. If there was ever a railroad that created a demand for these machines, it was certainly the Hi-Dry, with its abundance of trestles and stilts. Brown County Historical Society

lying, soggy portions of the railroad, particularly the I&IS between Switz City and Sullivan, Indiana.

The terrain, coupled with the route's earliest origins as a narrow gauge line, has created a railway that features beautiful scenery and tough operating challenges—from steep, undulating

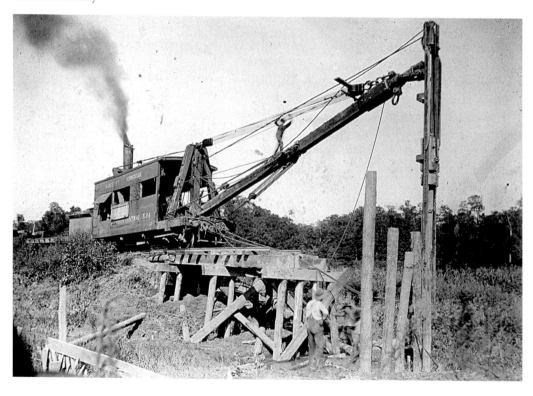

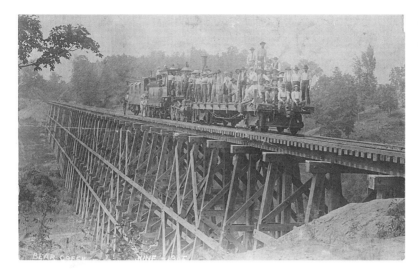

A construction gang tests their handiwork with a trip across the newly completed Bear Creek trestle, June 1905. Brown County Historical Society

rises and sags to flange-eating six-degree curves. There's a lot of drama packed into the railroad's 155 main line miles. Although it's impossible to capture all of that colorful essence in a few gray paragraphs, what follows is a look at a few of the enduring curiosities, listed in ascending order by milepost—"Seven Wonders of the Hi-Dry."

This IC freight is an impressive sight, rolling high above the White River near Bloomfield, Indiana. William Millsap Collection

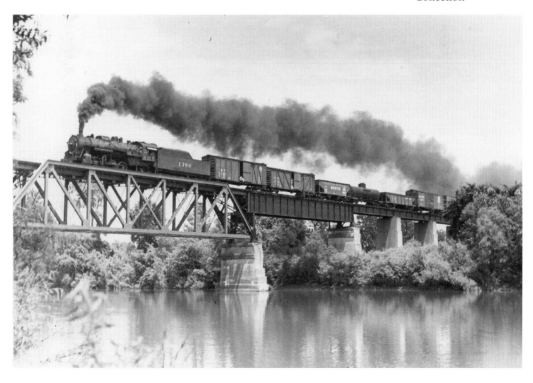

Late on Sunday afternoon, September 10, 2000, Terry Deckard, Indiana Rail Road's supervisor of track in Bloomington, received a phone call from his lead trackman, informing him that the company rain gauge at Palestine showed four inches of rain had fallen in less than an hour. Deckard ordered his trackman to get a track warrant and hi-rail truck and make an emergency track inspection between Palestine and Newton to look for any damage.

At milepost 128.7 in Robinson, he discovered a major washout on the main line, leaving a gaping hole 80 feet long, 40 feet wide, and 20 feet deep. But it wasn't the size of the washout that was the most notable aspect. It was what it revealed—the main line was actually supported on timber stilts

beneath the earth and stone fill! Like so much of this little railroad, this track had apparently also been carried aloft by a low-riding trestle, unceremoniously buried long ago. In fact, the Hi-Dry has a number of known locations where large timber trestles were later replaced with earth.

At the Senate Avenue Terminal, the railroad had possession of a tank car damaged in a derailment. After some quick thinking, the car was decapitated at both ends, fabricated into a suitable culvert and positioned between the timbers still propping up the sagging track. More than 1,300 tons of crushed stone fill was used to once again entomb the old timbers, and crews went to work tamping and surfacing the track. The mainline was back in service within 48 hours.

MP 45.4, Shuffle Creek Viaduct

The surprise revealed by the washout at Robinson, September 10, 2000. Photo by John Cummings

Here stands the first of the landmarks that inspires the moniker "Hi-Dry." Suddenly, the railway steps off onto massive steel legs that carry the tracks over the swampy shallows of Shuffle Creek valley. The creek was first spanned during construction of the In-

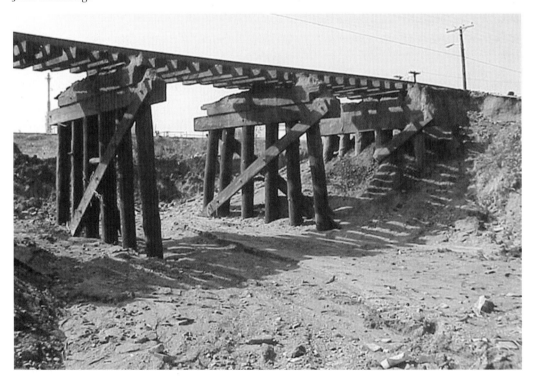

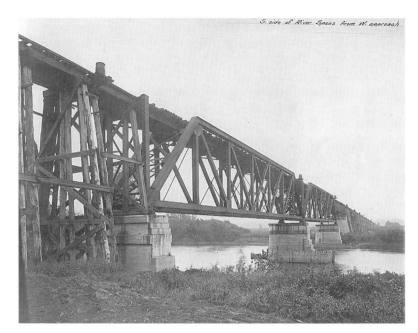

S. side of River Spans from W. approach.

The White River bridge, showing the timber approach sections. Indiana Rail Road Archives

Another view of the White River approach. The half-mile of timber trestle was later filled. Indiana Rail Road Archives

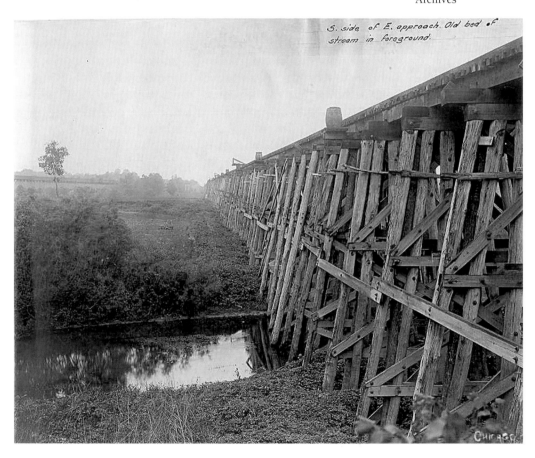

S. side of E. approach. Old bed of stream in foreground.

dianapolis Southern Railway in 1905. The steel giant apparently
had some subsequent work done on the approach sections, for a
glance below the deck reveals the date 1917 inscribed in the con-
crete abutment. The construction features a design typical for the
period: open deck sections supported by steel towers. This stretch
of railroad was part of the original route survey, before IC became
involved and redrew the proposed route from Unionville to Switz

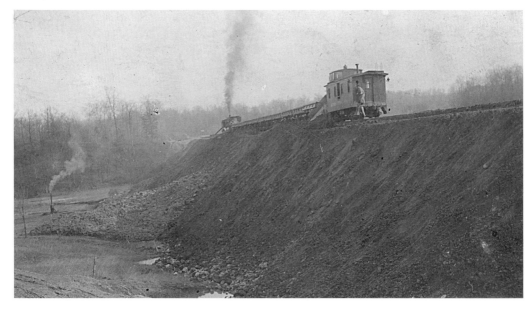

This northbound INRD freight glides over the Shuffle Creek trestle in January 2004. Within moments, the hogger will throttle up for a 1 percent climb to Unionville. Photo by Eric Powell

City. The old ISRy route is shown on IC right of way and track maps diverging from the actual main line at milepost 50, less than five miles beyond the viaduct. It's difficult to second-guess whether IC engineer A. S. Baldwin would have found a gentler, less spectacular route over Shuffle Creek, had he been involved earlier. For the sake of the railroad's aesthetics and character, however, it's a good thing that wasn't the case.

The damming of Beanblossom Creek in 1953 changed the landscape surrounding the viaduct by forming Lake Lemon. Today it is arguably the most scenic spot on the railroad. In autumn, the surrounding hills, blanketed with sugar maples, frame the scene with fiery color as the railroad slips across the sky.

At 75 feet high and 982 feet in length, the Shuffle Creek viaduct is an impressive feat of railway engineering by any measure. However, on the Hi-Dry, it's merely the warm-up act. You'll understand in about 30 miles.

MP 47.5, Unionville Tunnel

Tucked away in a damp, sleepy hollow lies one of the most charming and delightful surprises on the Hi-Dry: the Unionville Tunnel, also known as Peterson Tunnel, in deference to landowner T. J. Peterson. Built in 1905 by the Indianapolis Southern contractors, it's a pigmy of a tunnel, barely 500 feet long. It is, however, a distinc-

A view of the innards of Unionville Tunnel. Shown here with a crude-looking gunite lining, the tunnel was upgraded with a concrete liner and portals in 1917. Indiana Rail Road Archives

Unionville Tunnel

tive landmark that contributes to INRD's image as a microcosm of railway engineering. A miniaturized piece of Rocky Mountain railroading transplanted to southern Indiana, the tunnel is an anachronism. Today a rock pile of this size would simply be daylighted, but at the turn of the twentieth century, engineers elected to bore.

The original tunnel was a crude-looking piece of work, having the appearance of a giant mouse hole. IC brought the tunnel up to higher engineering standards in 1917–18, with construction of a new liner and concrete portals. Surprisingly, this nearly century-old feature of the Hi-Dry isn't the choke point one would expect. The tunnel offers sufficient clearance for modern rolling stock, including double-stack container cars, should those ever find their way onto the railroad. What the little tunnel lacks in length, it makes up for in height.

Unionville Tunnel may be a pipsqueak compared with the

great bores of the mountain railroads, but its teeth are as sharp as any hazard on the iron road. On June 11, 1941, an IC crew was at work relining the tunnel, a project that had been going on for months. A handful of men were working on a heavy timber scaffold built atop a flatcar. At 9:15 a.m., the car was pulled out of the tunnel to clear the main line for the northbound morning passenger train, which was just whistling off at Bloomington. The car, apparently top-heavy with the scaffold, rolled over, crushing two young workmen between the stone walls of the tunnel approach and the cascading timbers. The deaths were front-page news in that evening's *Bloomington Daily Telephone*.

It is worth noting that Bloomington itself would have been the site of another tunnel, had the IC not redrawn the ISRy route. The original plans called for the line to swing north from Unionville and bore through the ridge on the city's near north side that the railroad now rides atop. The former ISRy alignment also called for another tunnel near Stanford, on the way to the phantom iron ore fields that were thought to exist. Unlike Bloomington's never-was tunnel, however, the Stanford bore was actually begun. Workers had begun digging at both ends when the line was rerouted and the tunnel abandoned. The remnants of the old tunnel still exist, albeit overgrown and partially collapsed. It lies on property owned by a relative of a longtime Indiana Rail Road employee.

An SD10 emerges from Unionville Tunnel. The stretch of railroad between the tunnel and Shuffle Creek trestle offers the most picturesque scenery on the railroad. Photo by Chris Burger

MP 55–58, Bloomington's Elevated Railway

Owing to the ridge-running characteristics of the Hi-Dry and the mind of A. S. Baldwin, the IC in Bloomington was a railroad ahead of its time. In and around the most populous areas of town, namely, the Indiana University campus and the city's near north side, the Hi-Dry slips through on a path that is almost entirely grade-separated. At the time of the railroad's completion, ISRy helpmate William Hicks noted in his memoir that there was not a single grade crossing on the railroad. This was in stark contrast to the swath that the Monon cut through the town. Descending a steep grade from the north, the Monon bisected the

The Hi-Dry's high-flying nature carried right through to downtown Indianapolis. To reach Union Station, the line rose out of the Wisconsin Street Yard on an elevated right of way cobbled together from a variety of wooden, steel, and concrete bridgework and hopped over a handful of streets on the city's industrial near south side. The most distinctive of the overpasses was a curved structure built in 1917 that carried the tracks on concrete deck slabs and piers. This bridge directed the northbound line eastward to align it for the connection with the Indianapolis Union Railway and Union Station.

There was also an interesting offshoot wooden trestle that served the old International Harvester plant at McGill Street. Northbound, approaching the curved overpass, a facing point switch gave access to the spur that was held up by the aging bundle of sticks. By the mid-1930s, it had become so badly deteriorated that locomotives were no longer allowed to tread upon it. After Harvester moved, the industries that took over the plant generated only a couple of dozen carloads a year, so the IC offered the customers the opportunity to pony up the money required to renovate the rotting 364-foot-long structure. Not surprisingly, they declined. The switch was spiked, and the cars were relegated to IC's nearby team tracks. The trestle apparently stood dormant for quite a number of years; IC correspondence makes mention of it through the mid-1950s.

Although IC passenger service to Union Station was discontinued in 1945, the elevated connection to the Union Railway remained active for freight interchange, carrying two daily transfer runs and occasional extra trains. By the 1970s, a number of factors began weighing on the old elevated line. The structures were in need of costly maintenance work. However, most of the Indianapolis District had fallen into a state of disrepair and marginal relevance to the railroad by this point. Abandonment appeared to be an eventual certainty, making renovation investments highly unlikely. Furthermore, Interstate 70 had sprouted concrete legs to carry it across the near south side, affecting property values and putting pressure on the city to raise restrictive height clearances on nearby streets to accommodate semitrailers. All of these forces conspired to seal the fate of the old elevated line. By 1978, it had been demolished, save for a 302-foot trestle over Wisconsin Street. It was given a reprieve to provide a tail track for movement of locomotives from the north end of the yard to the service tracks. Today, it too has been erased from existence, and the old main comes to an abrupt halt atop the fill and retaining wall where it once stepped off on its stilted path to Union Station.

Indianapolis Union Station, ca. 1922. The train shed and tracks were originally located at street level but were elevated following World War I. The IC track appears at the lower right, atop concrete piers. The clock tower of the station dominated the Indianapolis skyline. Bass Photo Company Collection, Indiana Historical Society

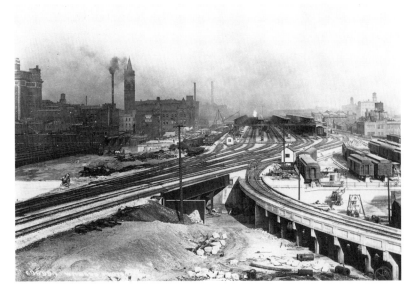

The College Avenue overpass in Bloomington. When the railroad was built, there wasn't a single crossing at grade in the city. Indiana Rail Road Archives

city just a block from the middle of downtown, crossing over a dozen busy streets at grade and snarling traffic on a daily basis for generations.

In modern times, the Monon line in Bloomington, owned and operated by CSX, was merely a switching railroad, shuttling cars between local customers and the Indiana Rail Road connecting track, via McDoel Yard. The south end of the line was abandoned to Bedford as part of a CSX rationalization program in the 1990s. Not long afterward, the north end was KO'd by multiple washouts and CSX suddenly became an island railroad in Bloomington. The Indiana Rail Road Company received an urgent call to keep about two dozen carloads of refrigerators from the GE plant moving out of the city each day, along with smaller quantities of newsprint, lumber, and plastics for the local industries.

Under pressure from the City of Bloomington to relocate its operations away from the downtown area, in December 2003 CSX finally exited the Bloomington market altogether, with the Indiana Rail Road taking over industrial switching operations on the city's west side. The daily switches still drag cars to and from central Bloomington, but only as far as Pigeon Hill and Cavanaugh siding; McDoel Yard has been dismantled, along with the last remnants of the Monon main line in central Bloomington. At the time of this writing, the city of Bloomington was negotiating the purchase of the property from CSX to create urban green space and a new transportation corridor. The work progresses as Indiana Rail Road trains continue to glide above the city streets on a century-old elevated right of way that was well ahead of its time.

Trestles and Tunnels 111

MP 75.4, Richland Creek Viaduct

Appropriately, the last piece of the Hi-Dry to be built was also the most spectacular. The Richland Creek viaduct, referred to colloquially as the Tulip trestle, is an awesome feat of engineering and pure muscle. Nearly half a mile of tracks in the sky, it was the grandest finale a railroad ever had. Although it is among the world's great railroad landmarks, its location in sleepy Greene County on a secondary line has kept it one of the secret marvels of the steel roads. The viaduct, known clinically to the IC engineering department as Bridge X75-6, measures 2,295 feet long and 157 feet above the valley at its highest point. Some 2,700 tons of steel were used to fabricate the airborne railway. Between the approach sections, 18 steel towers support 40-ft. spans, with 75-ft. spans hung between them, so the whole length of the viaduct is like a string of Morse code—alternating dots and dashes written in steel.

The Tulip trestle had an interesting little sister, also dating to

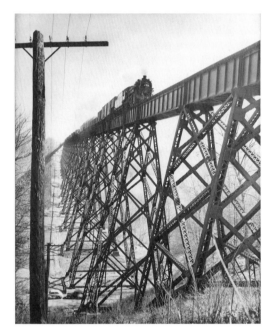

An IC freight rumbling across the Tulip trestle is a majestic sight. Note the cars parked below, no doubt having brought sightseers to visit the great viaduct. Indiana Rail Road Archives

1906, located on the IC's Birmingham line. The Brush Creek viaduct was built on a portion of the line known as the Alabama Western Railroad. Design and construction were similar to Tulip, with a series of deck spans supported by steel towers. In photographs, the two structures can be virtually indistinguishable from one another. However, the Brush Creek viaduct checked in at roughly half the length of Tulip, at 1,230 feet.[1]

Tulip was built to last. Today, owing to the early twentieth-century tendency of "over-engineering," the massive structure is just as capable of carrying 10,000-ton coal trains as it was of supporting the welterweight IC Moguls and wood-side coaches that crossed over the Richland Creek valley a century ago. Construction on the leviathan began in September 1905 with the initial clearing and pouring of the concrete footers by the Collier Bridge Company. The steel for the structure was fabricated by the American Bridge Company and erected by Strobel Steel Construction.

To the east, the approach to the viaduct would be particularly challenging, owing to a thick limestone ridge. Contractor Bruce Head and his crew began blasting and hammering away at the rock, creating what became known as "Head's Cut." The cut was 1,000 feet long and 75 feet deep, yielding more than 140,000

In the hearts and minds of people in southern Indiana, and in the world of contemporary short-line and regional railroading, the Tulip trestle represents a mark of distinction. There have long been varying degrees of interest and opinions on Tulip's place among the world's awe-inspiring railway bridges. Newspaper and magazine reports through the years have mistakenly listed it as the second or third largest structure in the world, claims that can be discounted with a little digging for facts. In actuality, Tulip was the third-largest railroad bridge in the United States, at the time of its construction. In terms of size, architecture, age, or any number of other yardsticks, there always seems to be a structure to be found somewhere in the world that trumps Tulip. Here's how it measures up with its cousins around the world:

Kinzua Viaduct

This celebrated landmark in McKean County, Pennsylvania, was owned and operated by the Erie Railroad until 1958, when it was abandoned and sold to a scrapper for $76,000. The iron man didn't have the heart to destroy the structure, and it was later acquired by the State of Pennsylvania and made into the centerpiece of a small state park. Originally erected in 1882 and rebuilt in 1900, Kinzua was a leviathan at 301.5 feet high and 2,053 feet long—nearly twice as tall as Tulip. "Was" is the operative word, however; an inspection in the summer of 2002 uncovered structural defects that closed Kinzua to the excursion trains and later even pedestrian traffic until strengthening work could be completed. In July 2003, a tornado blew through the river valley and toppled the massive landmark while repair work was in progress. Only the portion that had been reinforced was left intact.

Lethbridge Viaduct

This imposing structure was built between 1907 and 1909, placing it in the same era as Tulip. The bridge spans the Belly River in Crowsnest Pass, which lies on the borders of Alberta and British Columbia in the Canadian Rockies. A Canadian Pacific branchline was built through the pass in 1898, chiefly to develop the area's large coalfields.

A large wooden trestle was the precursor to the steel structure. Fabricated by the Canadian Bridge Company of Walkerville, Ontario, the material for the bridge was moved to the site in more than 600 railcar shipments. At 5,327 feet long and 314 feet above the river, the Lethbridge viaduct is one of Canada's largest railroad structures and is still in use today by the Canadian Pacific.

The Pecos High Bridge

Southern Pacific's Sunset Route carried trains over the Pecos River in southern Texas on three different structures between 1883 and 1944. The most celebrated of these engineering marvels was the 1892 Pecos High Bridge, which for generations held the title of highest railroad bridge in North America. The high bridge was conceived to shorten the main line between San Antonio and El Paso by 11 twisting, looping miles. It was built between November 1891 and February 1892 by the Phoenix Bridge Company of Phoenixville, Pennsylvania, the same contractor that erected the original 1882 Kinzua viaduct. It featured a span of cantilever sections 2,180 feet long, hefted 321 feet above the river by 24 steel towers. The bridge was reconfigured with a partial fill and twice reinforced by 1929. With the boom in rail traffic in World War II, a new, beefier bridge was built within a stone's throw of the old high bridge.

The new bridge, completed in 1944, is 1,390 feet long and originally carried the rails 322 feet above the river on towering concrete piers. Today, the rails rise only 265 feet above the water—the Pecos River has risen more than 50 feet due to the construction of the Amistad Reservoir. Pecos was originally recognized as the highest railroad bridge in North America and the third highest in the world, exceeded only by the 336-foot Loa viaduct in Bolivia, built in 1889, and by another mega-structure built by a legendary French engineer—

Garabit Viaduct, Massif Central, France

This awe-inspiring wrought iron bridge was built in 1884 by none other than Gustave Eiffel. Its massive arch spans 1,853 feet and soars 401 feet above the Truyere River. For years, engineers tried to devise a way to bridge the windy valley

(continued next page)

that prevented the railroads from reaching southern France. Eiffel offered an elegant and spectacular solution. His lightweight, open truss arch was impervious to the strong gusts in the valley, and the weight of passing trains created counteracting compression and tension forces within the structure that created remarkable stability and strength. A sight to behold, the Garabit viaduct is half the height of another of his landmarks, the Eiffel Tower.

The Forth Rail Bridge

In Scotland in 1879, construction began on a railway suspension bridge linking Edinburgh to Perth. It was designed by Thomas Bouch, who built the Tay Railway bridge the year before. However, the Tay bridge collapsed on December 28, 1879, with a staggering loss of life. Consequently, work on Bouch's Edinburgh–Perth bridge, known as the Forth bridge, was halted. Construction on a new design for Forth bridge commenced in 1883, and Edward, Prince of Wales, inaugurated the structure on March 4, 1890. The massive rail bridge is a surreal sight, with three giant double cantilevers spanning more than 8,000 feet and rising 361 feet above the water, with the rails at 158 feet—almost exactly the height of Tulip. Forth bridge was opened in March 1890, at a cost of £3.2 million and 57 lives lost during construction.

Mala Rijeka Viaduct, Montenegro

The prize for tallest railway bridge in the modern world goes to the Mala Rijeka viaduct, which lies between Kolasin and Podgorica in the Yugoslav Republic of Montenegro. Completed in 1976, the viaduct carries the tracks of Yugoslav Railways' Belgrade–Bar line an astonishing 650 feet above the river gorge on four massive concrete piers, the tallest towering as high as a 50-story skyscraper.

The Seto-Ohashi Road/Rail Bridge, Japan

Six bridge sections hop between the stepping-stone islands that separate the cities of Honshu and Shikoku. The structure features double-decker construction, with a motorway above and the railway below. Seto-Ohashi holds the distinction of being the largest combined road and rail bridge system in the world, spanning 5.8 miles. Construction began in October 1978 and was completed 10 years later, in April 1988. Conventional trains are in use along the route now, but the bridge is also designed to accommodate Shinkansen "bullet" trains in the future.

cubic yards of limestone, shale, and earth that had to be removed.[2] Among the most challenging terrain reformation projects on the railroad, it would also be one of the deadliest.

Working in the camps near the viaduct were immigrants from practically every corner of the earth, including many Italians. The language barrier between the men was problematic. Among other mishaps, it contributed to a serious blasting accident on June 26, 1906, six months before the completion of the viaduct. Several cans of powder exploded, severely burning several workers. Laborer Angelo Sacchetti died the following morning and was laid to rest in Solsberry.

The labor camps themselves weren't known to promote a long life expectancy. Bad food (there are a number of accounts of Italian workers sickened after they cooked and devoured a turkey vulture), boredom, and a boiling pot of tensions contributed to bad behavior and violence. In his memoir, William Hicks offers undoubtedly the most vivid literary rendering of the men who came

to work on the railroad: "a variegated assortment of the genus homo, from the Congo, and from the shores of the Mediterranean . . . covering the whole group from Rome to Constantinople. Scandinavia furnished a few, but Hibernia contributed none, except the bosses." The labor camps were ethnically segregated, the principal groups being Italians and African Americans. There was a penchant for gambling and drinking that occasionally brought out the worst in human nature. The Italian workers were reputed to be slightly more frugal with their money, on account of providing for the needs of family back home. Hicks continues: "Among and a part of this mottled crowd, was the 'hobo,' who travels the continent from sunrise to sunset, also the boastful bad man from Bitter Creek; and the gunfighter with record notches cut on the stock of his shooting iron; also the strong arm man, ready for any adventure."[3]

Hicks paints a picture of a motley crew, and both his account and others recall that, while the local communities weren't the scene of many disruptive incidents due to the laborers, the camps themselves saw episodes ranging from mere mischief to murder. Oral histories seem to reinforce this account, although they tend to arouse suspicions of exaggeration.

The 2,700+ tons of steel that make up the Richland Creek viaduct (the Tulip trestle) received a fresh coat of paint in the mid-1960s. Indiana Rail Road Archives

Hidden away in the hills of rural Greene County, Indiana, the Richland Creek viaduct is half a mile of railroad in the sky. Indiana Rail Road Archives

Any landmark as imposing and impressive as the Tulip trestle is bound to have inspired stories that are every bit as sensational. In the case of Tulip, there are seemingly as many tales propping up the folklore of the viaduct as there are rivets holding up the structure itself. Here are a few of the most popular legends:

"Gummy Shoes"

This tall tale dates back to the earliest days of the viaduct. As the story goes, a bridge worker wearing gum-soled shoes took an unfortunate step off the bridge and fell to the ground. His springy shoes, however, kept bouncing him back skyward, ad infinitum. The story has two endings. In the more pleasant version, a hungry dog comes along and nips at the soles of the man's shoes until he stops bouncing. The other version has another bridge worker shooting the poor fellow out of pity, before he starved to death while bouncing uncontrollably.

"Bottomless Pit"

Summertime in southern Indiana is a parade of hot, oppressively humid days. The dripping sultriness frequently yields to saturated nights of uncanny stillness and fog that thickens with each cooling hour before dawn. It was just such a deep summer night that became the setting for one of the most oft-told legends of the Tulip trestle.

It seems that an Illinois Central freight was creeping through the backwoods of Greene County in the pitch-blackness and fog when the train went into emergency and stuttered to a halt. After unsuccessful attempts to recharge and release the brakes, it was time for the crew to walk the train and try to locate the problem.

At the caboose, in eerie silence and completely enveloped in dense fog, the rear brakeman grudgingly prepared to do his duty. He took one last, long drag on his cigarette, rolled the glowing butt between his thumb and middle finger, and flicked it off the caboose porch. His eyes must have grown as big as saucers as he watched the orange spot trace a perfect arc and then, instead of shattering into a shower of sparks on the rock ballast, continue descending, vanishing into the soup and alighting upon the banks of Richland Creek, 160 feet below. Imagine unwittingly stepping off a 16-story building, and you'll understand how lucky said brakeman was that summer night. Who says smoking kills?

An interesting variation on the "Bottomless Pit" story says the trainman, unsure of his whereabouts in the dense fog, decides to light a fuse to shed some light on the situation. He tosses the fuse overboard, to the same effect as the cigarette butt in the other version of the story. The cigarette version, however, is the accurate tale. The brakeman's name was Joseph Young, and his harrowing brush with gravity was chronicled in the pages of the IC company newsletter.

"Coitus Interruptus"

The marvel of Tulip trestle attracts all kinds of people for a variety of reasons, but most people probably wouldn't put it on their short list of places for outdoor lovemaking. Then again, this legendary tale isn't about most people. It's about two Indiana University students who appropriated the viaduct as a makeshift penthouse for a romantic interlude.

Achieving physical intimacy on a bed of railroad ties doesn't exactly sound enticing, but something persuaded the young couple to journey out across the narrow skyway, presumably with sleeping bags or blankets, to build their love nest. Perhaps it was the solitude or an amazing view of the starry sky. Whatever it was, it was abruptly punctuated by the sound of a five-chime air horn.

The startled lovers had no time to make a run for it. Somehow they mustered the presence of mind to lie lengthwise along the outermost edge of the ties as the train loomed over them. Two and a half INRD locomotives growled inches above them before the brake shoes dug in and stopped the train. A crewman walked gingerly down the locomotive catwalks and pulled the naked pair aboard the train and took them to safety.

The moral of the story: Next time, find a place with a siding.

A hogger's eye view of Tulip, 1942. Photo by John F. Humiston

Tales have been passed down through the years about workers fighting and murdering one another in the camps and numerous bodies being buried in the fill.[4] A pair of killings was officially recorded: "Jack the Bear," a well-known troublemaker from the Kenefick camp on the west side of the viaduct, was killed in a fight and buried in the Poor Farm cemetery, and foreman William

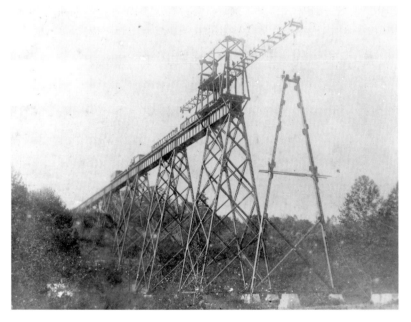

Construction of the Tulip trestle in the fall of 1906. Note the worker standing on the horizontal beam, halfway up the tower legs. Larry Shute Collection

Another view of Tulip under construction.
Larry Shute Collection

Italian laborer Angelo Sacchetti was laid to rest in Solsberry after he was burned in a blasting accident at Head's Cut in 1906. Photo by John Cummings

THE INDIANA RAIL ROAD COMPANY

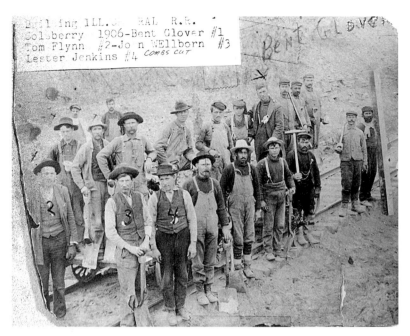

Building ILL. ... RAL R.R.
Solsberry 1906-Bent Glover #1
Tom Flynn #2-John WEllborn #3
Lester Jenkins #4 *COMBS CUT*

Men from divergent backgrounds came together to build the railroad. This collection of faces was recorded in 1906 at Comb's Cut near Solsberry. Larry Shute Collection

Lewis of the Head camp was murdered by another Head foreman.[5] Other acts of foul play are a matter of speculation.

All of the mayhem finally yielded to celebration on December 14, 1906, when the first train glided over the viaduct and marked the opening of the railroad from Indianapolis to Effingham. A

This railroad builder apparently made a home for his entire family in the labor camp. His manner of dress suggests he may have been an Italian immigrant. Bloomfield Historical Society

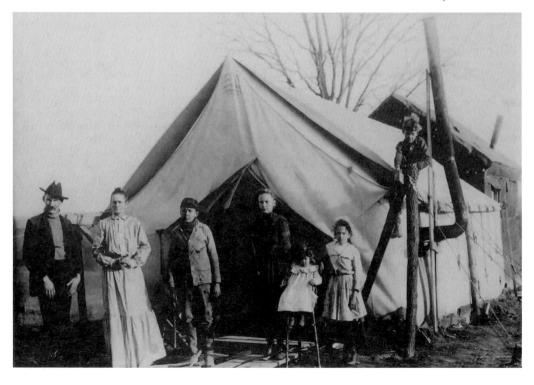

There aren't many places where a steam locomotive could be mistaken for a skywriter. Tulip trestle was one of them. William Millsap Collection

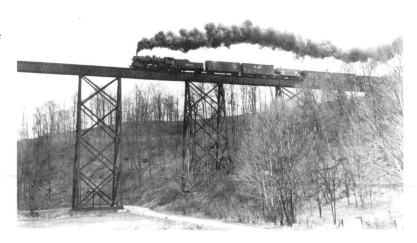

brass band and great crowds of people gathered to meet the eastbound train at the Bloomfield depot long before dawn, some hoping to be among the first to traverse the great viaduct, which stood looming over a blanket of fresh snow that had fallen the night before. Those lucky ones who made the journey may have been luckier than they realized. At the time, half of the riveting work on the great structure was still unfinished.

MP 84.9, Elliston Triple Crossing

Although no longer existing in its original form, the remnants of a wonderful railroad oddity are visible here, just a stone's throw from Highway 54. Here at the station of Elliston, the tracks of

The famous "Triple Crossing" at Elliston, Indiana. Today, the elevated tracks of the Hi-Dry are the only ones that remain. David Grounds Collection

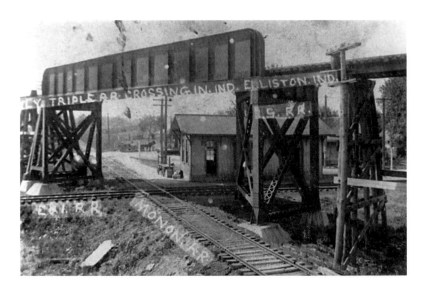

three railroads converged in a web of steel and timber known only as the "Triple Crossing," a congested anomaly in the otherwise sparse Indiana countryside. The quaint little depot was overshadowed by columns of steel and timber that carried the skyborne Hi-Dry. The line flew over a diamond crossing of the New York Central's Evansville & Terre Haute line and the Monon's Bedford & Bloomfield coal branch, which was rolled back eastward to the limestone quarries of Lawrence County in an abandonment filed in the fall of 1935.[6] Today, no crossing exists at all. The Hi-Dry still hovers on iron stilts, but the rails below it are long gone. However, the little station still stands below, visible from the highway, forlorn and boarded up, used for the undignified task of storage in a contractor's equipment yard.

MP 149.3, Razorback

The undulating grades of the Hi-Dry are normally contained within the range of 1 percent, but in the woods near Newton, there's a big bump in the road known as "Razorback." Here, the railroad pitches up at an incline that rivals Cajon Pass or any big mountain railroad—but only for a few hundred feet. Razorback checks in at a whopping 2.01 percent, the maximum grade encountered on the Hi-Dry. Because of its short run, however, Razorback isn't the *ruling* grade—that is, the grade that dictates power assignments and represents a choke point for train performance. Because of Razorback's brevity, longer trains have enough kinetic energy to carry themselves over the big hump with no problems. Ironically, it's the shorter trains that feel the strain on Razorback. A short local freight or a special carrying only a couple of business cars, for example, will find its entire length on the big slope all at once. Without an extended string of rolling tonnage on the rear to push the train through the grade, it takes every notch of throttle to scale this mountainous molehill.

THE SWING ERA

Where the Hi-Dry hops over the Wabash River between Illinois and Indiana has also been the site of some interesting bridgework and, at times, an awkward absence thereof. The earliest bridge was swept away by ice floes in the winter of 1881. By 1886, the I&IS, which had entered receivership, had built a sturdier iron structure. Finally, after Illinois Central gained control of the line, a modern steel truss bridge was erected in 1910, complete with a center span that pivoted on its own pylon, allowing it to swing open to accommodate river traffic during periods of high water. The 223-foot rotating section was actually constructed two decades earlier, in 1890, by the Louisville Bridge Company. The span was originally installed on an IC bridge over the Cumberland River in Kuttawa, Kentucky, and was reconfigured for use at Riverton. In the early years of the twentieth century, the bridge was swung open for river traffic an average of 10 times a year. The last record of it being rotated was July 7, 1938. When the aging swing span began to deteriorate in the mid-1950s, the IC sought approval to replace it with a stationary span. Indiana Senators Birch Bayh and Vance Hartke, who hoped to develop the Wabash as a viable commercial waterway between the Ohio River and the Great Lakes, protested the petition. IC subsequently agreed to a design provision allowing the structure to be easily converted back to a swing bridge if necessary, and the aging span was replaced with a plate girder section in 1965. The concrete pylon at the center of the former swing span is still equipped with a massive orbital gear, thoroughly seasoned to a rusty brown.

The railroad brought competition to the ferry operations that served people near the Wabash River. Taylor's ferry is making the crossing beneath a passing Indianapolis Southern train at Riverton, 1907. Ralph Bachelor Collection

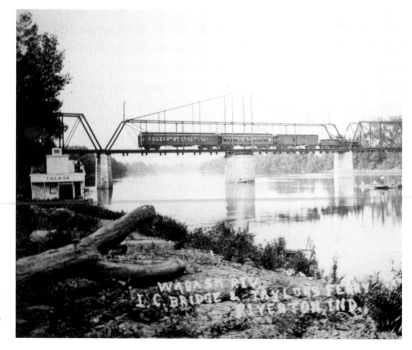

Another view of the bridge at Riverton, with a ferry traversing the river beneath. The center swing span was replaced in 1965. Ralph Bachelor Collection

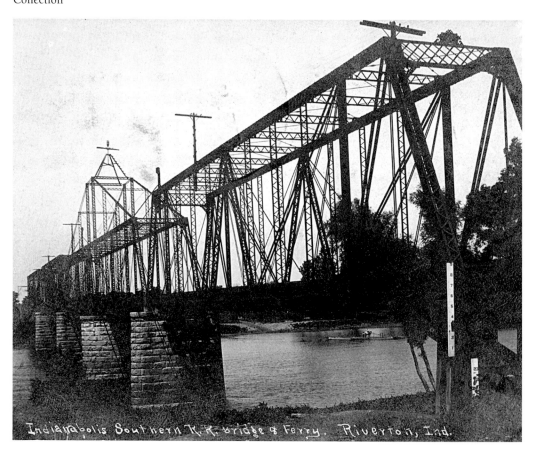

MP 123.9, the Route 33 Roller-Coaster

West of the Palestine Yard, the Hi-Dry makes an impression on motorists that could conceivably induce seasickness. Rolling out of Palestine, the railroad joins up with Illinois Highway 33. For a handful of country miles, the railroad and highway run shoulder-to-shoulder in a most peculiar way—sharing not just the same lateral twists and turns but the same grade as well! Across the Illinois prairie, the highway and the railroad rise and fall together. Imagine pacing a 110-car unit coal train up and down this gentle roller-coaster in your automobile, and you can easily picture what a bizarre sensation it creates.

The Hi-Dry reveals its heritage as lightly graded narrow gauge line along Illinois Highway 33, where the railroad and highway roll over the same undulating grades. Photo by the author

It's here where the Hi-Dry reveals its past life as the old narrow gauge. The Springfield, Effingham & Southeastern line was built years before best practices in railway engineering were consistently employed, especially in the cost-cutting narrow gauge movement. Recall how the IC redrew much of the Hi-Dry's northern route to mitigate the grades proposed by the Indianapolis Southern builders. By the time IC was involved in the line, the SE&SE had been lightly graded, built, and standard-gauged. On top of tons of crushed rock and 115-lb. ribbon rail, Indiana Rail Road trains glide up and down the undulating path long ago carved out for the SE&SE.

Run It Like a Business

It took an extraordinary leap of faith for a customer to take a chance on a brand-new shortline railroad.

—Tom Hoback

R est assured that the business of shortline railroading is not for the faint of heart. An enterprise the size of the Indiana Rail Road Company falls within the accepted definition of a small business. But how many small businesses maintain a physical plant covering 155 miles of territory, including some 140 bridges, scores of public hazards with expensive signaling systems, and a fleet of company vehicles that weigh 160 tons apiece? And how many proprietors of small businesses are forced to carry liability insurance sufficient to cover a hazmat disaster? Railroading is a big job. And railroading as a small business is, in many ways, an even bigger job. No one knows this better than a man who gambled all that he owned to finance the start-up of his own railroad.

Tom Hoback had everything on the line on March 17, 1986, when the first Indiana Rail Road train prepared to depart Palestine, Illinois. He had sold his home, borrowed money from his mother, and was even relying on credit cards for his living expenses in order to secure his share of the down payment for the Indianapolis line. He felt confident that his railroad had a bright, profitable future. All the necessary ingredients seemed to be present, not the least of which was a terminal in Indianapolis, a city

with a rich history as a transportation and distribution center. And with a price tag of less than $6 million, the property was a bargain compared with other secondary lines that were being liquidated by Class 1 carriers at the time.

Still, it was anything but a certainty. One major customer, Indianapolis Power & Light, held the power to make or break the railroad. Delivering coal to IP&L was 90 percent of the business. If the big utility so much as hiccupped, it had the potential to send the railroad into a tailspin. Furthermore, the line's previous owner had run the property ragged. Serious derailments were not uncommon in the Illinois Central days. This venture carried risks, to be certain.

Before worrying about running trains, however, it was time to start running a business. The purchase agreement with IC was signed the first week in December 1985. That gave Hoback roughly 90 days to accomplish a minor miracle. In addition to pulling the financing together to close the deal, he was faced with the challenge of finding the right people and equipment to make the railroad work. The first person he needed was a highly competent and dedicated operations man. The search for the top candidate landed him, quite literally, at the bottom of the map, in Brownsville, Texas.

Hoback found Tom Quigley, who was working for the Brownsville & Rio Grande, a start-up switching and terminal railroad operating on former Missouri Pacific tracks. The railroad had connections to the MoP and Southern Pacific, but its primary purpose was serving the Port of Brownsville. Quigley had relocated to Brownsville from Minneapolis two years earlier, where he had worked for the Minneapolis Northfield & Southern until it was purchased by the Soo Line.

Quigley was a well-rounded railroader. He had spent time in the mechanical department in locomotive maintenance and had experience in engineering and train service as well. He was also proficient with track maintenance equipment. What's more, Quigley had a shortline start-up under his belt with the B&RG, and he had supervised sizeable construction and track renovation projects. In short, he was an ideal match for the job.

Tom Quigley, former INRD chief of operations. Photo by the author

The Hunt for Horsepower

Quigley relocated in February, leaving his family in Brownsville until the end of the school year in June. With the clock rapidly ticking, one of his first tasks was to find locomotives. Six-axle units, with their higher weight, longer wheelbases, and higher

AN F IN GEEP'S CLOTHING

In 1969, the Santa Fe shops in Cleburne, Texas, launched a history-making program of rebuilding more than 200 of the railroad's aging "covered wagon" F-units. To provide improved visibility for yard and branchline service, the railroad wanted to convert the covered wagons into hood units. It was a concept so far-fetched that EMD and GE turned it down when the railroad offered them the job. It was indeed a labor-intensive transformation, from both an engineering and a mechanical perspective. EMD had designed the F-unit car body as an integral structural component of the locomotive. To convert one to a hood unit required fabricating an entire frame in addition to the hood and portions of the cab. Prime movers, trucks, and traction motors were all rebuilt, the latter shipped to ATSF's San Bernardino shops for the task. The whole process took six weeks and produced a funny-looking but endearing stepsibling of EMD's hood units, having the appearance of a pug-nosed GP7. What's more, the Cleburne craftsmen were able to produce a CF7 for one-third the cost of a new road switcher. These distinctive machines are still in service on short lines throughout the country, and a number have found their way to rails outside the United States. The last CF7 remaining in service on the Indiana Rail Road, no. 2543, is configured for remote control operation, coupled to a caboose control car. Having served as the perpetual yard engine for the Senate Avenue Terminal, the little engine was reassigned to Bloomington when CSX turned its operations there over to INRD in early 2004. It now pulls appliance cars in and out of the GE refrigerator plant on the city's west side. No. 2543 sports one curious add-on feature not found on any of its Cleburne sisters: a genuine Mack bulldog hood ornament.

tractive effort would have overstressed the track in its fragile condition, so plans called for four-axle power. Fortunately, it was a buyer's market. There was a plethora of rebuilt GP7s and GP9s being culled from Class 1's fleets as a result of industrywide downsizing. The IC had offered surplus power from the ranks of its Paducah rebuilds, but the better units had already been spoken for. As the search wore on, Quigley found himself headed back to Texas, to the shops of a certain railroad in Cleburne.

Tom Hoback had received a tip that there was good power for sale on the Santa Fe, specifically, from the fleet of its one-of-a-kind CF7 locomotives. Sure enough, Quigley found an army of the little engines parked at Cleburne— roughly 100 of them. Slowly and methodically, he began choosing locomotives by process of elimination. On the first pass, units that didn't have two-inch wheels were scratched; smaller wheels would have required immediate replacement. He continued, using new criteria on each subsequent walkthrough until he had eliminated all but the best. Then it was time to talk price.

The original operating plan had provided enough capital for seven units—six in service with one spare. However, when Santa Fe officials discovered that Mr. Quigley would be paying in cash, they sweetened the deal considerably. He departed Cleburne with title to eleven CF7s purchased for $20,000 each, less than the cost of a traction motor. And that figure even included transportation to Chicago! At that price, the Indiana Rail Road could almost treat the units as disposable. They could run them until they failed, take usable parts, sell the rest for scrap, and still have earned an acceptable return on the investment.

And fail they did. It's not an easy proposition to take a locomotive out of mothballs and transplant it into a foreign climate and terrain. The old CF7s sometimes seemed like fish out of

water. Lugging coal was torturous work for these little engines, which had spent their second lease on life running up and down branchlines on the flat prairie. They had large radiators to handle the Texas heat, but the shutter systems were too small for Indiana winters, and the units were notoriously cold-running. Cold weather also brought problems caused by non-winterized traction motor leads. For warm weather operation, the CF7s sported air conditioners—but not for long. Santa Fe maintenance records revealed that more than three-quarters of CF7 road failures were due to air conditioner faults; the auxiliary electrical systems simply couldn't handle the job. Indiana Rail Road crews enjoyed the air-conditioning while it lasted, but once the spare parts supply was exhausted, they weren't repaired. These quirks were small stuff, however; the most common failures occurred in main generators, a locomotive's equivalent of heart failure.

People Who Need People

Once the company had succeeded in procuring its locomotive fleet, trainmen needed to be recruited to operate the machines. Hoback believed that for INRD to be successful, its employees needed to have a fresh outlook, unencumbered by predispositions about how the job should be done. In the end, Indiana Rail Road hired a half-dozen trainmen with experience on a variety of Class 1 railroads. The new employees shipped out to an ICG training center in St. Louis for familiarization with their new territory and practice sessions on a locomotive simulator.

In contrast to the train and engine service personnel, the new track department was made up entirely of IC people. One of them was John Cummings, a track foreman with a wealth of institutional knowledge of the line's track and maintenance. Cummings had worked on the

NO WAY TO RUN A RAILROAD

In the waning days of the Class 1 secondaries, being a branchline railroader was like having a berth on the Titanic. *Every day on the job, each man was left to fend for himself, and at times it seemed as though the entire ship was kept afloat only by dime-store ingenuity and whatever useful items could be salvaged out of a scrap heap.*

When Tom Hoback was interviewing trackmen in Indianapolis in December 1985, he saw three ICG workers tinkering with a small, one-cylinder reciprocating saw—the only implement they had to cut out and repair broken rail. It needed a spark plug, but they had none, and the management wouldn't provide one. So three men—the Hi-Dry's entire track department—were huddled over a bench with a penknife performing surgery on a worn-out sparkplug, trying to get their rail saw working. It spoke volumes about the absurdities facing railroaders on ICG's secondary lines.

On another occasion, Hoback visited ICG's Indianapolis agent and saw an unfamiliar face in the office. The man was changing lightbulbs. When he asked the agent about the worker, Hoback was informed that it was an ICG electrician from Champaign, Illinois. The lightbulbs in the office were burned out, but if the agent took the initiative to replace them himself and union workers found out, they would turn in time slips and claim a full day's pay for repairing the fixtures. So the agent called his supervisor, who sent an IC electrician on a four-hour round-trip from Champaign to Indianapolis to replace burned-out bulbs. Simply illuminating.

As a railroader who experienced the skinflint ways of ICG management firsthand, John Cummings recalls from his days with the track department that when the crew replaced a section of rail, they had to procure spikes from a scrap pile in the yard. They would fish out a dozen or so and, using an old rail head as a makeshift anvil, do their best to straighten the bent ones.

Hi-Dry and other IC lines in Kentucky, Illinois, and Missouri. He had come to the attention of Tom Hoback in a most peculiar and mysterious way.

In the weeks leading up to the purchase of the line from IC, while Hoback was living and working in Tampa, he received an

unsolicited letter from Cummings, whom he had never met. The handwritten pages were a comprehensive dossier of every mile of track on the Hi-Dry, with detailed notes on each idiosyncrasy and troublesome spot. To this day, Hoback doesn't know exactly how Cummings—from 1,000 miles away—managed to track him down and identify him as the would-be buyer of the line. Nearly two decades have passed since, and Cummings still isn't talking.

Former IC track man John Cummings knew every inch of the Hi-Dry when he joined the upstart Indiana Rail Road in 1986. Photo by the author

Joining Cummings from the IC were Terry Deckard, another veteran of the track department, and car knocker Dick Finley, who headed up the mechanical department. Together, they were a handful of key employees who prepared to take over operations between Indianapolis and Sullivan, Indiana, on St. Patrick's Day, 1986.

False Start

Meanwhile, in Palestine, IC trainmen were skeptical that the deal would actually go through. Most of them had heard scant news through the rumor mill, and when it came to getting reliable, detailed information from their company or their union, they were left in the dark. The atmosphere before March 17 was one of low-key animosity, but when the IC men finally saw notices of their job annulments posted on the yard office board, the situation became electrified. When six CF7s, still in Santa Fe paint, arrived in the Palestine yard from Chicago via Effingham, reality sank in: the transfer of ownership was really happening. As the time drew near for the first Indiana Rail Road train to depart northbound with a short cut of mixed freight, Tom Quigley spent most of the day trading phone calls with Tom Hoback, who was in Chicago closing the sale with IC. Quigley received continual updates on the transfer of the property and the track conditions, trying to determine if and when the train could depart. One section of track near Tulip had already been slow-ordered by INRD's consulting engineer, Harold Meeker (formerly with the Western Pacific), due to a section of badly twisted rail at a rural crossing. This incident caused a flap with the IC trainmaster, who took it as a personal in-

Fish out of water: These Santa Fe CF7s turned heads when they reported for duty at Palestine on March 16, 1986. INRD purchased 11 engines for the rigorous work of pulling unit coal trains up and down 1 percent grades. William Millsap Collection

sult that his judgment had been bested—one more angry IC man. Surrounded by railroaders seething with resentment, Quigley was eager to get his own trainmen aboard and release the brakes before hostilities boiled over. Unfortunately, about 70 mileposts north, the clerk of Monroe County, Indiana, had managed to tacitly scuttle anyone's hopes for an orderly inauguration of service.

The county clerk had simply shrugged off the reported sale of IC property within the county as some sort of hoax or mistake. After all, weren't railroads just a permanent part of the landscape? Such an extraordinary thing as the buying and selling of a railroad seemed far-fetched, so the transfer of the deed wasn't recorded. This made for some interesting phone calls between the IC boardroom and the Monroe County Courthouse. Meanwhile, IC officials were hinting at denying Tom Hoback the right to operate his first train, to which he responded, in carefully chosen words, that this was a revenue train, and if Indiana Rail Road wasn't going to run it, IC most assuredly wasn't going to, either. That evening, a sedan of attorneys headed to Bloomington to unscramble the mess caused by the skeptical clerk. The train would have to remain under security in Palestine overnight, adding even greater anxiety to the already tense situation. There were plenty of disgruntled trainmen around, any of whom knew how to disable a locomotive quite handily. Sabotage is a tactic not beyond the bounds of some irate union workers. It would be a long night.

The morning of March 18 arrived without incident, and the

choreography started anew, although this time eyes and ears were focused on Bloomington rather than on Chicago. At long last, the final piece of the puzzle was snapped into place, and Tom Hoback owned one entire railroad instead of two disjointed halves. The trainmen at Palestine released the brakes, and the string of CF7s tugged its burden across the Wabash River. The little train stopped at Linton to pick up IP&L loads from Soo. There were half a dozen locomotives on the point. The train needed four under power to get the loads to Indianapolis. And four there were: two locomotives went down due to minor failures en route. The coal arrived in Indianapolis, and the Indiana Rail Road Company lived to fight another day.

And there would definitely be some battles in store. With a marginal physical plant and a fleet of overburdened, secondhand locomotives, the little company had its work cut out for it. The first improvement efforts were divided among things that could be readily fixed and those that were urgent. There was a long punch list, but without much cash to work with in the early days, the company had to choose its battles carefully. Broken rails were by far the biggest problem. Most of the rail in place was 90-lb. non-controlled cooled sections, rolled in the 1920s. The rail was 65 or more years old and only designed to carry 50-ton cars. Putting 100-ton cars on the tracks induced rail breaks. Compounding the problem of aged rails was the fact that IC had a nasty habit of installing short rails whenever a break occurred. Their repairs were made by two workers in a pickup truck or a motorcar; they had no equipment to carry full sections of rail to the job site. If a section of rail broke six feet from a joint, the IC men would cut and splice an 8-ft. section to repair it, instead of replacing the entire section. There were some instances where adjoining sections were as short as four feet! As a result, the Hi-Dry was riddled with what some employees boasted were more rail sections per mile than any other line. But the short sticks posed a serious threat and exacerbated the risks already inherent to running high tonnages on the worn-out rails. Track speed was set at 25 mph—Class 2—with occasional 10 mph slow orders.

From the beginning, the intention was to use two-man crews on over-the-road trains. However, concerns about track conditions were sufficient to merit the purchase of a pair of surplus IC cabooses to allow a third crewman to keep a close watch on things from the rear end. It paid off in one case, when a carload of acetone derailed, and the crewman on the caboose radioed the head end and got the train stopped safely.

By late summer, the cabooses were pulled off and replaced by rear-end telemetry devices, also known as "FRED," an acronym for "flashing rear end device." Around this time, the railroad tried

to optimize its crew utilization by running turns on the three weekly IP&L trains. With a three-train-per-week schedule, there was one crew working the yard and one crew working the road, six days a week, a tidy arrangement. Then IP&L, as they would prove wont to do, threw a curve ball: instead of three 75-car trains each week, they ordered four 50-car trains. With the track speeds and available power, a four-train weekly schedule was considerably more difficult to operate.

Even with these heavy-duty challenges of railroading on a shoestring, sometimes it was the little things that caused the biggest problems. Something as seemingly innocuous as fallen leaves, for example, could bring the railroad to a standstill. It was a problem no one had considered—until the first autumn. IC had stopped clearing brush from the right of way years earlier, and when rain-soaked leaves fell, it created a slimy blanket that covered virtually everything. When the southbound leg of an IP&L turn ran empties to Switz City, the train pulverized the mess into an organic sheen with a consistency akin to Teflon. The northbound, returning with loads, then encountered severe wheelslip problems. The turns were consistently requiring re-crews at best. At worst they were suffering mechanical failures. A number of traction motors were fried because of wet leaves in the fall of 1986.

To the experienced railroaders who were doing their best to make this upstart company flourish, the troubles sometimes made it feel as though they were starring in a Keystone Cops movie. Even well-seasoned trainmen could feel like novices with new territory, new equipment, and a new way of doing business that was decidedly different than that to which most of them were accustomed. Tom Quigley, adding road foreman to his list of roles, spent the bulk of his long hours riding with crews, studying the line from the trainmen's perspective and trying to solve problems on the move. Other managers spent more time closer to the offices at Senate Avenue Terminal: Dick Finley ran the mechanical shop; Marvin Wisemore, formerly of Amtrak, was the controller; and John Cox was trainmaster. Cox, an IC holdover, knew the customers and their needs intimately, but his position carried limited responsibility, because traffic was light and highly concentrated among a customer base that could be counted on one hand with fingers to spare. IP&L coal amounted to some 90 percent of the railroad's business; K&F, an Indianapolis scrap metal operation, accounted for another 8 percent. The remaining business was generally scattered among small customers such as lumber yards and grain elevators along the route. Trying his best to counterbalance the dominance of coal, Tom Hoback, in addition to serving as president, was the railroad's one-man marketing department.

Everything was presided over by a board of directors, which included Hoback and two partners, who had put up part of the down payment for the line, and three representatives from the institutions and capital groups who had funded the balance of the financing.

The Good: Beating the Drum

At the IC, Hoback had a large department, interns to do market studies, and a full library of research materials and he was able to approach marketing situations as the incumbent carrier in most cases. IC had a long-established presence in Midwest markets, and even though the railroad was in decline, at the very least it had a recognized place in the minds of customers. In going into business for himself, Hoback went from having a department of a dozen people focused exclusively on coal, to being the sole marketing employee for an entire railroad. More significantly, he went from being an incumbent to being an outsider. Most of the general merchandise shippers along the Hi-Dry had soured on rail service during their relationship with IC and had given their business to truckers long ago. But being a new independent shortline didn't make it any easier to knock on their doors. Many of the startup railroads that were born out of the Class 1 spin-offs of the 1980s had proved to be bad news for shippers, suffering from insufficient capitalization, mediocre management, and marginal operations. As Tom Hoback points out, "It took an extraordinary leap of faith for a customer to take a chance with a new shortline railroad." But Hoback had a leg up when it came to the commodity his railroad hauled the most—black diamonds.

"I was at an advantage because I had extensive knowledge of the various types and grades of indigenous coal in the area, and I knew where and how it could be used. I also had good relationships with people at the Milwaukee Road, which was later absorbed by the Soo Line, and I knew that working together, we'd be able to find markets for that coal. IC had 9,000+ miles of route structure, and they wanted to maximize the long-haul business over their system. A movement from Switz City to Linton wouldn't even get you the time of day. But suddenly the mine operators and the connecting Soo Line had Indiana Rail Road as an infinitely more enthusiastic and engaged marketing partner than the IC had ever been. The mine operators were all acquainted with me from my days at the IC, and they had confidence in me and trusted that I would deliver what I promised."

One of the notable breakthroughs came when the Central Illinois Public Service plant on the IC near Newton, Illinois, wanted to buy coal from an AMAX mine located on the Soo. Indiana Rail

Road worked with Soo and IC on a three-line haul that amounted to less than 80 miles. Conventional wisdom says a movement like that can't be profitable. However, IC already had crews and power in the area, as did INRD. It was just a matter of the Soo switching the mine. Because it was short-haul business, it was never on IC's radar screen before the Indiana Rail Road Company came into existence. Through the efforts of the little upstart line, a respectably large coal contract was drafted, and the three railroads pitched in to move about 750,000 tons a year

Hauling coal used to generate electricity was profitable, but the real quality business in railroading was merchandise, including appliances that consume all of that coal-fired electricity. In Bloomington, there happened to be a very large, very dormant customer who churned out a lot of such highly rated merchandise. Hoback made an appointment to visit RCA.

As he recalls, the traffic managers he met there must have joined RCA before televisions were invented. They were old-school thinkers and very set in their ways. When Hoback first met with them to discuss moving TVs by rail, they were highly skeptical. Although they never said it explicitly, Hoback sensed from their demeanor that they thought the idea was crazy. They told him that if he was still in business in six months, he should come back and they'd talk. It had been 15 years since the last loaded railcar had left the RCA dock in the early 1970s. At that point, it was taking Illinois Central 7–10 days to get cars as far west as St. Louis or Kansas City for connections to the West Coast. RCA managers never knew what to expect or where their cars were going to end up and when, so they pulled the plug. There were two tracks remaining in place at the plant, which was located along the Bloomington Southern branchline, although there was no rail traffic inbound or outbound. Some product was shipped in intermodal trailers, which were trucked to St. Louis to avoid the lazy haul provided by IC. RCA's trucking operation was so reliable and speedy that they could load trailers on Monday and sell the inventory that was still in transit and scheduled for delivery in City of Industry, California, four days later. They couldn't dream of doing such a thing with rail.

Hoback persisted. He reached an operating agreement with Conrail and UP to provide a target range of delivery times, and RCA was willing to ship some of their inventory by rail during the middle of the month, when they weren't trying to fill last-minute orders. With good cooperation from the Class 1s, especially UP, it was a successful venture. Hoback cultivated the business into nearly 1,000 cars a year and even started moving some shipments to their eastern distribution center in Harrisburg, Pennsylvania. It took a year or two for RCA to reach a sufficient comfort level with

rail shipping. They used only 50-ft. boxcars with no load dividers or internal equipment, because they needed internal capacity to fit their large premium line televisions. In all the thousands of carloads handled, not a single damage claim was filed.

RCA was a good customer for the railroad, but a difficult one to win back to rail because of the negative experiences they'd had in the past. With the Indiana Rail Road Company onboard as a capable, creative problem solver, RCA was able to benefit from a more flexible, balanced transportation strategy, with trucks handling hot inventory and rail providing a money-saving alternative for product that didn't need to move as urgently. The cost of keeping extra product in the pipeline was more than offset by the savings in transportation costs.

In Indianapolis, one particular customer that always interested Hoback was Merchandise Warehouse, a large dry and refrigerated warehouse in central Indianapolis. Not only was the operation sited in one of the prime distribution centers in the country, but it had one of the best locations in the city, between Interstates 65, 70, and 74 and the Senate Avenue Terminal. The management has always been enthusiastic about finding rail business, but multiple changes in ownership stifled the progress to develop them into the kind of major shipper that Hoback believed they could become. Some of the commodities INRD has delivered for them are newsprint, building materials, and food-related products, including carloads of frozen corn on the cob for distribution to KFC franchises and frozen shrimp from New Orleans for Red Lobster restaurants.

Another early customer brought both rail business and the opportunity for the railroad to squeeze some added utility from its property around the Senate Avenue Terminal. Liquid fertilizer manufacturer Arcadian wanted to develop a distribution hub in Indianapolis. Indiana Rail Road managers acquired a small fleet of 8,000–10,000 gallon surplus tank cars, generally unsuitable for revenue service. The cars were parked at the terminal accessible from the street and were used as a makeshift tank farm. Rail shipments of liquid fertilizer would arrive at the Senate Avenue terminal from New Orleans and Omaha and would be pumped into the storage cars. Later, the contents would be transloaded into trucks for delivery to local co-ops, distribution centers, and farms.

Arcadian eventually outgrew the operation. Tom Hoback worked on a plan to construct a permanent bulk liquid storage facility with significantly higher capacity, but he was unable to secure the additional customers necessary to achieve viability. The Arcadian business had been very good for the railroad, having grown to several hundred carloads a year and requiring no special permitting or extraordinary costs. Although Hoback was sad to

see the business leave, Arcadian planted the seed for an even more significant development at the Senate Avenue Terminal.

Buoyed by the early success of the Arcadian reload business, Hoback had began talking to large lumber companies about building a commercial reload center at the Senate Avenue Terminal. After conducting talks with Georgia Pacific, Weyerhaeuser, and other lumber products distributors, he was successful in getting contracts signed for lumber storage, and the Indiana Reload Center was born. By 2001, more than 700 carloads of lumber, rubber products, and other building materials arrived for unloading at Senate Avenue. Another center was operated for a time in Bloomington, and further west, in Greene County, an additional dedicated transload operation was undertaken for a unique customer drawn to the clay beds in Bloomfield.

Ceramic tile manufacturer KPT began operations at about the same time the Indiana Rail Road took over operations of the Hi-Dry. KPT was especially notable because it represented the first Taiwanese investment in Indiana. One of the primary reasons for choosing to site their plant in Bloomfield was to be close to a source of clay for their product. In fact, their plant was built on a bluff overlooking the old brickyard on the east side of Bloomfield. However, after the plant was operational, it was discovered that the clay was unsuitable. KPT had to import clay from Georgia and eventually from Ontario. Because the plant was perched high above the railroad, building a siding wasn't feasible. So Indiana Rail Road set up a transload operation at Bloomfield, just two miles down the road. KPT was a very good piece of business for the railroad. Within four years, the plant had doubled in size and was receiving several hundred carloads of powdered clay and binding agent annually. The success wasn't sustained, however. KPT, Inc. went bankrupt and ceased operations June 15, 2001.

The Bad: Conrail

One of the valuable assets Indiana Rail Road had in Indianapolis was access to shippers on the Belt Railway, which was founded and operated by the predecessors of the New York Central and Pennsylvania railroads and wound up in the hands of Conrail following the fall of Penn Central. The Belt had been built specifically as a railroad to facilitate movement of cars between carriers with nominal switching fees. Conrail, however, charged nearly $400 per car to originate or terminate freight movements on its Indianapolis trackage, a rate that often exceeded the gross revenue Indiana Rail Road would have been able to collect for an entire shipment in many cases, making it a challenge to originate carloads in the switching district.

Still, the Belt provided exciting opportunities for INRD to search for new markets for Indianapolis products and develop new line haul agreements that led to profitable business. National Starch and Illinois Cereal Mills were among the best. INRD was able to quote two-line hauls with the IC to move grain by-products for cereals and animal feeds to more lucrative markets in Memphis and New Orleans. National Starch generated inbound grain loads as well as outbound starch products going south via the IC.

However, it was when Indiana Rail Road began moving blast furnace and foundry coke from Citizens Gas in Indianapolis to a number of markets in the upper Midwest in conjunction with Soo that Tom Hoback felt some backlash in the Indianapolis market.

"The traffic manager at Citizens Gas, regrettably, took a typical approach; he looked for the lowest rate and nothing else. Conrail had this market locked up, and they weren't interested in quoting rates to Chicago or to the west, because it was short-haul business for them. But there was a real demand to move the traffic, and shippers were very frustrated. In many cases, they had simply given up hope of ever reaching the western gateways by rail. Then we came to town and started to shake things up by aggressively marketing to these bulk-commodity customers. We started to move some product for Citizens Gas, and we quoted a significant amount of business to northern Indiana for them. I was absolutely certain we were going to win it, but then their traffic manager informed me that Conrail came in with a lower rate. He said, 'Tom, I just don't understand Conrail. It's like someone lit a fire under them.' He never understood that it was our presence and aggressive marketing that lit that fire under Conrail in Indianapolis. There were some shippers like that who just couldn't see the forest for the trees. They couldn't see beyond the rate quoted on a piece of paper to understand the long-term benefits of a more competitive market. Those were the kinds of attitudes we had to overcome, and it made our job back in the early days very frustrating."

The Ugly: IP&L

Every railroad (indeed every service industry) has an 800-lb. gorilla—a big customer that likes to throw its weight around. Tom Hoback's 800-lb. gorilla was Indianapolis Power & Light.

That the utility held the keys to success for the new railroad was one issue, and it could have been merely a footnote to the story, had there been a spirit of cooperation and mutual cultivation. But IP&L's fuel boss, Don Knight, set a tenor that made it a precarious relationship and kept the railroad off-balance and second-guessing for its first decade of operation.

Knight, vice president of fuel supply, wielded enormous

power. Fuel accounts for more than half of an electric utility's costs, and fortunes are made and lost on the buyer's ability to drive down expenses in every category, including transportation. Knight was notoriously aggressive and confrontational with vendors on issues of pricing. A Kentucky native, he came from a family with a long history in the coal industry. He knew the business inside and out, and he knew exactly where the costs were and how to hammer them out. He was hired by IP&L in the 1970s in an era of runaway inflation and unprecedented pricing pressures, and he presided over fuel procurement during some of the most challenging times for the energy industry.

Knight's approach was highly tactical, and his game plan was always in intricate motion. He played all of his vendors—mines, gas suppliers, railroads, trucking companies—like an orchestra conductor, often pitting one against the other and never giving any of them a beat to rest. His apparent objective was to impart a sense of flux

THE BUSINESS END

For well over a century, railroads have operated fleets of specially outfitted business cars designed to be mobile offices for railroad executives to inspect track, observe railroad operations, conduct business, and entertain railroad customers and other guests. After many years of using a historic private car owned by an Indianapolis attorney for business, Tom Hoback acquired another classic gem—car no. 56 from the Atchison, Topeka & Santa Fe Railway business car fleet.

Santa Fe operated 12 heavyweight business cars built by the Pullman Company between 1918 and 1928 for use by its senior executives. Originally delivered as car no. 34, the 56 was one of three identical cars received by the Santa Fe in 1923 under builder's lot no. 4727. The car is 81 feet 6 inches long, and it weighs 178,000 pounds. In 1928 it was assigned to the Santa Fe's vice president of operations, and in 1966 it was assigned to the assistant general manager for the Santa Fe's eastern lines.

The car has undergone extensive modification during its long life. A Waukesha air-conditioning system was added between 1947 and 1953, changing the appearance of the roofline from the classic heavyweight shape. High-speed roller-bearing trucks designed for Santa Fe's heavyweight dining cars were in-stalled between 1950 and 1956. These unique six-wheel trucks feature modern shock absorbers that ensure a smooth ride at speeds in excess of 90 mph.

Around 1953, no. 34's interior was updated by the Santa Fe's Topeka shops, which were renowned for excellent workmanship. The original white oak paneling was replaced with blond laminate, which at the time was a state-of-the-art finish. A glass-enclosed shower was added, and the kitchen was modernized with stainless steel fittings. To harmonize with the rest of its stainless steel passenger fleet, Santa Fe repainted the Pullman green exterior bright silver and meticulously created feathered horizontal striping to create the illusion of fluted stainless steel siding. In early 1973, the car was completely shopped again at Fort Worth, this time to outfit the car for operation without a steam generator.

Car 56 and two sister cars were sold in the 1980s, after nearly 60 years and more than a million miles of service on the Santa Fe. Car 56 was eventually purchased by Conrail and moved to Altoona, Pennsylvania, for use as a track geometry car. In 1990, it was sold to a private owner who moved the car to Oakdale via a connecting ride on the Indiana Rail Road. Car 56 was stored at Oakdale until it was purchased by Tom Hoback in June 2004.

Santa Fe car no. 56, seen in Bloomington in July of 2005, following its restoration and return to service as a business car for INRD president Tom Hoback. Photo by the author

and apparent instability, so that no supplier would become complacent or able to predict his next move. His orders could seem completely arbitrary—change the weekly rail schedule from three 75-car trains to four 50-car trains; shift *x* number of tons over to trucks, even if it was more expensive; increase output from this mine; cut from the other. He would order car ladings to be inspected for debris and demand invoice reductions if any was found. He would have shipments tested for BTU content and demand discounts from the mines if there was a variance from his contract specifications. Every ex parte rate increase proposed by the railroads was challenged with the ICC. It was an intensive effort, but the results were dramatic. For at least 15 years during Knight's tenure, IP&L posted some of the lowest fuel costs east of the Mississippi.[1]

The tenuous relationship with IP&L continued for years. Perhaps the most frustrating tactic from Tom Hoback's standpoint was Knight's resistance to giving the railroad a long-term transportation contract. The word *long-term* simply wasn't in Knight's business lexicon. His orchestration depended on keeping all the players on their toes and keeping his own options as open as possible. Consequently, Indiana Rail Road managers were never able to confidently plan their capital expenditures and authorize improvements and renovation of the railroad as briskly as they desired, because the revenue stream from IP&L was continually punctuated with an ominous question mark.

Tom Hoback felt the pressure from IP&L before he even

closed the sale of the Indianapolis line. The utility pursued numerous avenues to delay and block the transfer of the Hi-Dry for years. When Illinois Central was hinting at abandonment of the line, Knight was instrumental in coordinating a successful intervention effort with the ICC, rallying south side Indianapolis industries to oppose the IC's proposal and testify at hearings. The post–Staggers rationalization and shortline movement was no more palatable to him. Like many other shippers, he was highly distrusting of upstart independent railroads, and wanted to be certain that IP&L would never be served by one. Ironically, the IP&L fuel department's hard-driving tactics contributed to the rise of the shortlines. IP&L kept the Class 1 railroads operating on razor-thin margins and eventually drove them out of the business of serving the utility. Conrail sold off its Petersburg secondary, and after years of flirting with abandonment, IC got out from under the burden of the Hi-Dry. Within five years, every major IP&L plant in operation was served by a shortline railroad.

During Indiana Rail Road's first year of operation, IP&L burned more coal than projected, due to increased demand and the fact that a new generating plant in southern Indiana had not yet come online. This was good news for the young railroad, which welcomed the end of a successful inaugural year with more cash in the bank than anticipated. What's more, the railroad had seen a year free of costly mishaps. All the trains had stayed on the rails, and the Indiana Rail Road Company had managed to establish reliable service on the old Hi-Dry. Tom Hoback visited customers to convey his appreciation and share the good news. But, unfortunately, the celebration would be cruelly cut short.

Beware the Ides of March

On March 16, 1987, Tom Hoback's fledgling company took the first blow of a combination punch that almost KO'd the little railroad. Hoback had been in Chicago on business and returned to Indianapolis late that night. The following morning, he got an early start, but when he arrived at the yard office at Senate Avenue, it was empty, save for the company receptionist and a vendor who had come to call. The salesman said, "Tom, I'm very sorry to hear about the derailment."

After a pregnant pause came the hushed reply, "What derailment?"

After noting the milepost number, Hoback made an abrupt U-turn, jumped into his Chevy, and drove south. This being an age when mobile phones were rare, he had no communication or inkling of how bad the situation truly was. He arrived to find a disheartening scene. Sleep-deprived railroad employees were stack-

After a year of reliable service and exceeding revenue projections, INRD suffered back-to-back derailments that placed the company's future in jeopardy. Trailing CF7 no. 2845 left the rails and rolled over, along with cars of lumber and IP&L coal loads, near Bargersville. Four days later, another train derailed in Bloomfield. Both incidents were caused by broken rails. Indiana Rail Road Archives

IP&L coal hoppers compacted like a giant accordion at Bargersville. One car was so badly crushed that it couldn't be seen until crews pulled the wreckage apart. Indiana Rail Road Archives

Unit no. 2485 was parted out and scrapped after the Bargersville derailment. Indiana Rail Road Archives

ing loose lumber that had been scattered like pickup sticks, knee-deep. In the distance, two of the railroad's CF7s were toppled onto their sides like children's toys, perfuming the air with the heavy scent of diesel fuel. Number 2485 was mortally wounded. The two other units, including the lead with two crewmen aboard, were derailed but mercifully upright. Behind the locomotives, more than a dozen loaded IP&L coal cars had cascaded downgrade, pushed by the momentum of the trailing tons. They folded together accordion-style into a twisted wreckage surrounded by spilled coal, all concentrated within 400 feet of track.

The first call had come in around midnight. Veteran hogger Warren Thompson was easing down a 1 percent grade at MP 23, near Bargersville. As the train entered a four-degree curve, he watched helplessly in the glare of the headlights two car lengths ahead as a section of broken rail sprang up, a condition known as a "snakehead." It's every bit as menacing as it sounds and can easily impale locomotives and cars. Thompson and his conductor, Ben Padgett, were returning to Indianapolis with lumber and IP&L loads after pulling southbound empties earlier that day. The faulty section of rail likely fractured beneath the empties and lay in wait to bite the northbound. The on-board event recorder showed the train at 19 mph when it left the rails.

DELIVERING MAGIC

Many people find something magical about trains, and the Indiana Rail Road is even more magical in early December. That's when railroad employees volunteer to carry on a treasured company tradition, the annual Santa Train. The railroad hitches up its business cars, bedecked in yuletide livery, and takes a cast of costumed North Pole characters, headed by Santa himself, to visit children and families in the small towns along the line. In three days, the train will see more than 5,000 visitors in more than a dozen rural towns. It's harder still to imagine that, with the first Santa Train having taken to the rails back in 1989, some of the earliest young visitors may soon be bringing their own children to see Santa ride into town on his 3,000 horsepower sleigh.

INRD employees volunteer their time each year to bring the Santa Train to rural communities along the line. The man behind the whiskers is John Cummings. William Millsap and Indiana Rail Road Archives

Tom Quigley called Hulcher Services, the industry's leading derailment cleanup contractor, to bring in the heavy equipment and crew to clear the wreckage. Due to the lumber spill, the Hulcher crew couldn't get their machines in place to start the effort. With a value of about $100,000, however, that lumber wasn't going to be bulldozed into a pile of splinters; it would be recovered. And there was only one way to do it—by hand, one two-by-four at a time. Fueled by survival instinct and hot coffee, the railroaders soldiered on, plucking boards from the pile and putting the bundles back together again.

The IP&L cars were so badly mangled that it was difficult to get an accurate corpse count. After trying to determine the figure by matching car numbers to the manifest, it was discovered that one car was so badly crushed it was completely hidden—sandwiched between two others. In the final count, 16 cars owned by the utility were destroyed. Less than a week earlier, Tom Hoback had taken great satisfaction in proclaiming to IP&L executives that the railroad was about to mark the close of its first year of operations without a single incident. Now his company was reeling in the wake of a serious wreck, and a second blow would land just days later.

The Bargersville derailment occurred on a Wednesday. Indiana

Rail Road personnel worked around the clock to get the line back in service by the following Sunday, when the next scheduled IP&L train was due to head north. In response to the catastrophe, the entire line had been slow-ordered to 10 mph in hopes of mitigating damage, should another derailment occur.

Just days after walking away from the Bargersville derailment uninjured, Warren Thompson was back behind the throttle. He pulled the loads out of the Soo Line interchange at Linton and began the slow journey north at restricted speed. Twelve miles later, in the middle of a curve just north of the Seminary Street crossing in Bloomfield, another section of fatigued rail split. Although only eight cars were destroyed in the second derailment, it had a far more devastating effect on morale. In the darkness along the right of way that night beside the silent, spilled train, Tom Quigley gave his boss a briefing on the damage and then asked him a question that hung in the air as heavy as the wreckage beside them: "Should we call Hulcher, or should we all just go home?"

Pick it up, or pack it in? The question succinctly summarized the uncertainties now faced by the company: When would the next rail break? How long could operations continue before a trainman was injured or killed? How many more disasters could the young company survive? After a decade of dreaming, planning, dealing, and sweating, in the span of five days it had come to this. Of course, there could be only one answer. Tom Hoback had worked too hard and had too much riding on the success of the railroad to let it all end this way. The company would do its best to recover. That was not an easy proposition to contemplate while standing amid $1 million worth of property damage.

The nagging question was "how?" The railroad managers had taken nearly every precaution conceivable to avoid an accident of such magnitude. Some even thought the approach was overly cautious. Engineer Warren Thompson was devastated; conductor Padgett, who experienced both derailments with him, left train and engine (T&E) service immediately after the Bloomfield wreck. He met Tom Quigley at the Seminary Street crossing the following day during cleanup and said in a very resolved way that he desired to return to track service. Quigley knew by his demeanor that the issue wasn't open for discussion. But the INRD certainly needed manpower in the track department at that point, so it was an amicable move. (Several years later, he returned to train service and is now an INRD dispatcher at Switz City.)

The NTSB did an onsite survey of the Morgantown derailment. The FRA also came to observe, but with the IC's history of derailments on the Hi-Dry, they were unfazed by the incident. The FRA knew that the line's new management intended to turn the

railroad around, whereas IC never had any intention of rebuilding the line.

As much of a blow as the March 1987 derailments were to the railroad, the insurance carrier was even more stunned. At the time INRD went into business, there were only a couple of insurance companies in the business of underwriting liability insurance for railroads. In early 1987, a new company entered the market, and INRD shifted its business to the upstart firm on March 1. Within three weeks, the railroad filed the first *and* second claim handled by the underwriter, a fact that resulted in a 300 percent increase in premiums for the next five years. Even with the insurance carrier footing the bill, there was still a quarter-million dollar deductible to be funded out of pocket. It was a heavy hit, but the company's financials were tracking well ahead of projection, and there was enough monetary strength to weather the storm. Had the two derailments occurred six months earlier, the outcome might have been very different.

While the track and wrecking crews went to work to put the railroad back together, Hoback worked to mend the business relationships impacted by the derailments. He presented an autopsy report to IP&L, who had lost $750,000 in rolling stock, and to the railroad's financiers, whose confidence was understandably shaken by the turn of events, which echoed the troubles Illinois Central had encountered before the FRA imposed its embargo less than a decade earlier. Then he and Quigley set about developing operations and capital strategies to keep the railroad moving safely while replacing the worn-out sections of rail, each of which now seemed like a ticking time bomb spiked to the crossties.

In retrospect, unionization wasn't the traumatic thing we all had envisioned. Ultimately, it has made us more disciplined managers.

—Susan Ferverda, Indiana Rail Road
vice president of administration

Growing Pains

E very company that experiences transformational growth encounters its share of accompanying pains, and the Indiana Rail Road Company is no exception. From the very beginning, it was clear that the idea of acquiring and resurrecting a dying railroad was going to be anything but a cakewalk. Even before the purchase agreement was signed, the founders of the fledgling railroad—a group of men scattered across the country, from Indiana to Washington, D.C., to Tampa—had collectively undertaken what amounted to a career's worth of work by some standards just to put together the prospectus and take their show on the road to seek financing for the deal. For most of them, the closing months of 1985 brought the equivalent of a second full-time job. But having even gotten that far was miraculous. For all the good intentions of the men trying to rebuild the Hi-Dry, what they got in return was skepticism at best, hostility at worst.

Fight the Power

Ironically, the earliest pangs felt by the new railroad were induced by what would become its largest customer, Indianapolis Power &

Light. With well over a quarter of a billion dollars in fixed costs invested in the Elmer W. Stout generating station on the south side of Indianapolis, IP&L wanted support from what they perceived to be deep pockets at the Illinois Central Gulf, despite the railroad's lackluster history in operating the Indianapolis line. The battle wore on for months, with the utility rallying Indiana businesses to oppose the sale of the Hi-Dry.

The contentious nature of IP&L had been foreshadowed to Tom Hoback during his days as director of coal marketing for the ICG. In the wake of the Staggers Act, Hoback moved to protect ICG's line haul business into Stout by substantially increasing the per-car switch fee that ICG reserved the right to charge for coal shipments IP&L might elect to bring in on other railroads. The move touched off a series of legal actions by IP&L, beginning with state regulators and finally winding up in the hands of the ICC. IP&L successfully argued that ICG was in a position of dominance in the market and won relief from the increased switch charge.

Faced with the reality that they wouldn't be able to block ICG's sale of the Indianapolis line, IP&L finally eased into a neutral stance toward the deal, which likely saved many more months of proceedings, public hearings, and wrangling. But IP&L still proved to be a tough customer throughout the first half of the new railroad's existence. One particularly thorny chapter in the relationship came in the wake of the Conrail breakup.

Following the division of Conrail's assets and route structure between Norfolk Southern and CSX in 1999, the Surface Transportation Board looked at competitive issues that arose from the consolidation. In instances where a shipper had his choice of railroads reduced from two to one, the STB could impose a remedy, such as granting a second carrier competitive access.

When CSX announced the takeover of Conrail's Indianapolis franchise, IP&L asserted that, since INRD was owned in majority by CSX, there was, in effect, no competitive service into the Stout generating plant. IP&L's case was handled by Mike McBride, an experienced Washington attorney who has represented shippers and shipper interests before the ICC and the STB for more than 25 years. The solution he sought on behalf of IP&L was to make arrangements for Indiana Southern to serve as the competitive carrier. ISRR operates the former Conrail Petersburg Secondary, which connects with INRD at Switz City, a significant junction for southern Indiana coal traffic. However, the remedy that the STB finally settled upon was a mandate forcing INRD to grant trackage rights for Norfolk Southern to access the Stout plant. NS still holds this trump card, which could be a very real competitive threat for the INRD, especially if energy economics should ever dictate that Stout be converted to burn western coal.

Dead End at Sullivan

Although coal movements were overwhelmingly the bread and butter of the INRD, they certainly weren't the only source of indigestion. In its earliest days of operation, the company didn't have access to the CSX interchange at Sullivan, Indiana, to move mixed freight. The territory ended at milepost 109, just short of the connecting track. Logic would dictate that Indiana Rail Road run across the Wabash River to IC's Palestine yard via trackage rights to trade cars, but the unions, still smarting from the shortline's mere existence, attempted to block such an arrangement and force interchange of INRD cars at milepost 109.

Although not a model of efficiency, this arrangement wouldn't have caused an impasse. The real problem was that no siding existed for Indiana Rail Road power to back around the train bound for Palestine, so the INRD locomotive would be trapped in front of the cars once it arrived at the IC railhead. IC would have to take the engine into Palestine and bring it back with northbound cars. Union intransigence over the issue continued for nearly two years. The unions took the issue before the ICC and Indiana Rail Road eventually prevailed, although the litigation costs were significant for the company, which in those early days was trying to reinvest every possible dollar into infrastructure rehabilitation.

Grow West, Young Railroad

The issue of working with the IC at Palestine would later grow into entirely new dimensions. When the original purchase agreement for the Indianapolis line was signed with the IC in late 1985, it afforded the Indiana Rail Road Company right of first refusal to purchase the remaining portion of the line into Effingham when the IC decided to sell it. By 1988, INRD had achieved sufficient financial strength to pursue the acquisition. Tom Hoback had conscientiously maintained his key contacts at the IC and taken up the issue with them. The INRD board authorized an offer of $5 million for the remaining track to Effingham, along with a branchline running southward from Newton to Browns. IC agreed to sell, but only up to MP 155 at Newton. They wanted to continue the lucrative businesses of hauling unit coal trains to the large Central Illinois Public Service Company (CIPS) electric generating station there and so retained their connection to the plant just beyond the limits of the sale.

On February 20, 1989, Hoback traveled to Chicago to sign the purchase and sale agreement. He had a 10:00 a.m. meeting scheduled with IC's CFO, Rick Bessette. As he recalled in a 2000 interview, he arrived to find the office bustling with an uncharacteristi-

cally high level of activity, giving the impression that some sort of crisis might be brewing. He waited and observed, and finally Bessette appeared. He greeted Hoback and immediately informed him that a hostile takeover of the IC was unfolding on the floor of the New York Stock Exchange as they spoke. Consequently, he added, there was no way he could execute the sale agreement. Hoback challenged his position, making the case that there was an ethical obligation to make the transaction as planned. Bessette was empathetic and apologized for the circumstances; however, the IC's attorneys would not permit any of the company's assets to be liquidated due to the pending takeover. Hoback went back to Indianapolis empty-handed. He continued to pursue the sale, talking directly with the new IC president, Ed Moyers, about the transaction. But, for whatever reason, it was decidedly not a priority for Moyers. The situation dragged on unresolved for months.

Hoback decided to make a more aggressive move. He had previously worked on some legislative issues with Mark Levin, one of the directors of the Prospect Group, which had acquired the IC in the takeover. Hoback, vacationing in Hawaii at the time, rose at 3:00 a.m. to contact him at his New York office. He explained to Levin that the Indiana Rail Road Company possessed what it believed to be a legally binding agreement to purchase the property and was being stonewalled by the IC management. Levin replied that he'd look into the issue and follow up the next week. Right on schedule, he phoned Hoback and informed him that IC was ready to close the sale.

Some time later, Hoback went to Chicago to see Moyers privately and thank him for moving the deal forward. When the door closed behind him, he received what he characterizes as the most blistering criticism in his professional life. Agitated and animated, Moyers expressed bitter resentment that Hoback had reached beyond his authority as IC president and pressured him through one of his board members. Hoback left the office somewhat dazed but at least comforted by the fact that the deal was done.

The Battle of the Basin

Unlike the original acquisition of the majority of the Indianapolis District in 1985–86, when it seemed unlikely to IC employees in Palestine that the transaction would even occur, this time they took the situation seriously. They launched a guerrilla war against the INRD. Their efforts were aggressive and unyielding. They knew all the shippers in the territory and set about forming their opinions against the new railroad. As local citizens themselves, they had inherent credibility over the outsiders from Indiana Rail Road, whom they portrayed as robber barons having no qualms about wrecking the railroad for their own profit.

Bolstering their claims was a recently failed local shortline known as the Prairie Central, which had run through Robinson to Cairo on former New York Central tracks. In the wake of Prairie Central's demise, the people of Robinson were skittish about trusting another shortline railroad. Further poisoning the well was the fact that the owner of Prairie Central had been Craig Burroughs, Hoback's former associate at the ill-fated Erie Western. The IC union railroaders whose jobs were on the line asserted that Hoback's company intended to milk the line, bankrupt it, and liquidate it, as they claimed had been done with the Erie Western.[1]

The aim of these tactics was to stir the public into an overwhelming groundswell against INRD. Because the acquisition to Newton was considered an end-to-end merger, the ICC had to conduct a formal review, and the presiding administrative law judge determined it to be a significant enough transaction to merit a public hearing in Robinson. Tom Hoback likens that public hearing to a public lynching:

"Anyone, regardless of qualification (or lack thereof) had the right to speak at the hearing. We heard a ludicrous range of fears, opinions, and outright fantasies, none of which had anything to do with the real issue at hand. There were rail enthusiasts who cried out that we were a bunch of scabs out to destroy the great Main Line of Mid-America. They likened me to a robber baron and went so far as to dredge up my involvement with the Erie Western failure and try to suggest that this line would meet the same fate. We couldn't even have lunch in Robinson without being surrounded by whispers and stares. It was as though we were trying intentionally to put the Marathon refinery out of business.

"The union fought us bitterly. They poured a lot of resources into fighting our acquisition. They even went so far as to recruit 35 people from the town of Flat Rock to sign a petition against us. The irony was that Flat Rock isn't even on the railroad, nor was there a single rail customer in Flat Rock!"[2]

A couple of weeks after the hearing, the ICC judge handling the case issued a ruling, finding that the sale of the IC property to the Indiana Rail Road Company was not in the best interest of the public. However, this particular judge had a track record of decisions that had been overruled by the full ICC board, as was this one. Indiana Rail Road management received an administrative order approving the sale, which was executed on August 22, 1990—a year and a half after the date Hoback had originally traveled to Chicago to sign the deal.

The transaction wasn't complete until the sellers, the buyers, and labor reached what is known as an "implementing agreement" to coordinate the transition of operations. The agreement involved four parties: INRD management (who represented their employ-

Thomas G. Hoback, president and chief executive officer, founded the INRD in 1986. He earned a bachelor's degree in economics and transportation from Golden Gate University in 1969. He began his career as a cost analyst for the Western Pacific Railroad in San Francisco before moving into various positions in marketing and pricing. Subsequently, he was appointed director of coal marketing for the Illinois Central Railroad in Chicago, a position he held from 1978 to 1982. He then worked for Teco Energy in Tampa, Florida, developing and implementing a commercial strategy to set up a coal trading company to sell U.S. coal overseas.

John A. Rickoff, executive vice president and chief operating officer, has more than 20 years of experience in the railroad industry. Before joining the INRD in 1997, Rickoff held various senior management positions with the Canadian Pacific Railway and the Soo Line Railroad. During this time, he led the effort that resulted in growth of the U.S. Coal Business Unit, which nearly doubled volume to over 17 million tons per year. This growth was the result of innovative marketing strategies directed at growing highly profitable segments of business. Earlier, he worked in marketing and sales at the Chicago and North Western Transportation Company. He is responsible for the day-to-day operations of the INRD and Central Midland Railway. He earned his BBA degree in marketing from the University of Iowa.

Steven L. Meyer, vice president and chief financial officer, holds his bachelor's degree in finance from Indiana University–Indianapolis and an MBA from Butler University. Before joining the INRD, he spent 19 years with Indianapolis

Power & Light Company, including 7 years as treasurer and 2 as vice president of fuel supply. Meyer is responsible for all accounting, financing, and information services functions.

Susan C. Ferverda, vice president, human resources, and chief administrative officer of the INRD and secretary/treasurer of Central Midland Railway, began her career in accounting, having studied at Taylor University and Indiana Business College. Before working for the INRD, she worked for a private CPA firm in Indianapolis. Having a strong accounting and benefits background, she joined the accounting department at INRD in 1986 and has been responsible for all facets of human resources since 1995.

Larry F. Kaelin, vice president of business development, joined the INRD in 2002 with more than 25 years of experience in sales, transportation, and contract administration with Peabody Coal Company and Marine Coal Sales Company. He is primarily responsible for developing significant new business and overseeing current business from a contract administration and customer relations standpoint. He holds a BS degree in commerce and an MBA from St. Louis University.

David B. Long, vice president of marketing & sales, joined INRD in 2000, and has over 20 years of railroad experience. His recent background includes marketing and sales positions with Twin Cities & Western Railroad and I & M Rail Link. He previously held management positions with the Soo Line and Chicago & North Western railroads. He earned his BS degree in business and an MBA from the University of Nebraska.

ees, as the railroad was nonunion at the time), IC management, the Brotherhood of Locomotive Engineers (BLE), and the United Transportation Union (UTU). After a prolonged struggle to find an acceptable date for all of the parties to meet and work out the implementing agreement, the unions stipulated that the meeting be held in Jackson, Mississippi. To the INRD senior managers, Hoback recalled, it was a sure sign that this ballgame wouldn't end without a fireworks display. Hoback and Tom Quigley boarded an Amtrak train to Jackson and met the IC representatives and union men in a voluminous, dank, and decrepit room above the station,

where they gathered around an expansive old wooden table. The UTU representative was particularly hostile and animated. At one point, enraged, he actually climbed onto the table, crawled to the other side, and pounded his fist to punctuate his heated oratory, reminding the executives that it was indeed 1990 and slavery in this country had been abolished more than a century ago. Had he delivered the performance at a union meeting, he probably would have received a standing ovation, but the people around this table weren't fazed. The INRD already had its legally binding purchase agreement with the IC, so the theatrics unfolding in the room were merely that and nothing more.[3]

After the labor pains finally subsided, Indiana Rail Road took over the Palestine yard and operations to MP 155 on August 22, 1990, and it has continued operations to that territorial limit ever since. The end of the line is marked plainly by a well-worn tag on the milepost that reads "END INRD," accompanied by an abrupt change in the coloration of the rock ballast. Technically, INRD still has the option to purchase the remaining IC line to Effingham, but in the years that have elapsed since the last transaction, the Ameren–CIPS generating station has built a new 4.7-mile connection to the INRD at a cost of $8 million to receive unit trains of western coal—the very prize that first prompted IC to retain ownership west of MP 155. What business remains on the IC is a handful of small, mostly agricultural shippers offering little incentive for Indiana Rail Road to follow through on their option to purchase.

It's a Long Way to Tipton

During that same busy period when Indiana Rail Road was immersed in Act II of its purchase of IC's Indianapolis line, management had been eyeing other avenues of growth. After studying routes that appeared to be likely candidates for sale or abandonment, they began to focus intently on Norfolk Southern's line between Tipton, Peru, Argos, and Michigan City, Indiana. This line would give INRD access to several large power plants in the northern part of the state and possibly some lucrative two-line hauls with the South Shore Line to deliver southern Indiana compliance coal. There was other potential traffic as well, including substantial grain movements.

In order to retain the business of an online auto plant in northern Indiana, Norfolk Southern agreed to lease the line to INRD only as far north as Argos. The entry of Indiana Rail Road onto the scene caught the attention of Kokomo Grain, the line's largest customer, and the company's owner expressed keen interest in becoming an Indiana Rail Road investor. Tom Hoback had

already suffered the effects of ill-fated partnerships numerous times in his quest to acquire and operate a successful independent railroad, and he understandably bristled at the thought of the largest shipper on the line having significant control of the company's direction. He pledged good, attentive service, but politely declined the overture.

Not content to accept no for an answer, Kokomo Grain pressured NS to split the line at Tipton and lease the northern portion of it themselves. The results were disappointing, and that portion of the line was later sold to shortline aggregator RailTex, corporate predecessor of Rail America.[4]

In spite of the truncated line that remained after the intervention of Kokomo Grain, Indiana Rail Road moved forward with its own lease agreement with NS. Immediately, things headed south. It began on the very day the lease agreement was signed. NS had made a daily movement of 18 cars up the line between GM truck plants in Indianapolis and Ft. Wayne. For no apparent reason, NS diverted that movement—a third of the business on the line—to Conrail on the day the lease was executed. Within two weeks came another unwelcome surprise: NS abolished the remaining through-trains on its east-west connecting line at Tipton. Only a triweekly local was left to handle INRD cars, a situation that drastically increased car hire costs and adversely impacted the quality of customer service.

Further clouding the tenuous outlook was the fact that a large number of crossties from an earlier renovation project were reaching the end of their life cycle, and maintenance costs would soon escalate accordingly. Although Indiana Rail Road had been successful in growing some new business on the line, analysis showed that profitability was beyond reach. It was time to get out of the deal.

Because actions taken by NS had apparently undermined the understood terms and service commitment, Indiana Rail Road sought reparation for the losses it incurred operating the Tipton line, a request that NS eventually—and reluctantly—agreed to fulfill. The lease was officially dissolved in 1991, and Indiana Rail Road was made whole in a confidential settlement. INRD continued to haul coal to the Cinergy generating plant at Noblesville under a trackage rights agreement. However, when the plant converted to natural gas in the summer of 2003, that portion of the line was idled for freight operations. Norfolk Southern later sold the property to the Hoosier Heritage Port Authority for preservation as a light rail corridor.

The CSX Connection

The late 1980s and early 1990s were a tense time for the Indiana Rail Road Company. The rehabilitation of the physical plant, the rapid growth in business, and the expansion of the operating territory required a great deal of energy from every person in the company. But behind the scenes, there were money matters that required attention: not just cash flow but the ticking of a fiscal clock, signaling the approaching due dates of some big notes. Recall that the railroad's start-up was funded by a variety of sources, including venture capital firms. These groups look at investments such as Indiana Rail Road as high-risk/high-reward opportunities, and their funds are structured to provide a relatively rapid return on their outlay. In this case, their investments were due to reach maturity in the early 1990s, and they expected a robust payout when the time came.

As both president of the railroad and a principal shareholder, Tom Hoback was in a precarious position. He found himself coming under pressure to put the railroad up for sale to a bidder able to produce the generous sum sought by the venture capital groups, an option that could end his career as Indiana Rail Road president and transfer the company he cherished into new hands. It was a scenario he desperately desired to avoid, so he began to focus his energy on finding an alternate solution. As he would come to reflect years later, as difficult as it was to get the original financing for the railroad done, it was even tougher to get it *undone*.[5]

He began assembling the puzzle, beginning with bank financing and calling on an old friend, Chicago financier Rich Lassar, to solicit a personal loan. But all this still left a considerable gap to be filled. As it turned out, fate provided the missing piece.

In September 1993, heavy storms washed out a large portion of the CSX Monon Subdivision between Gosport and Quincy, just north of Bloomington. Because the line south of Bloomington had already been removed years earlier in a CSX rationalization move, the washout completely isolated Bloomington, including one of CSX's prime customers, General Electric, which shipped two dozen or more carloads of side-by-side refrigerators every day. CSX placed an emergency call to Indiana Rail Road to rescue its Bloomington business by hauling the cars to the interchange on CSX's former Chicago & Eastern Illinois line at Sullivan. Indiana Rail Road responded without missing a beat, adding an evening Bloomington–Sullivan turn to move the merchandise. As a result, CSX didn't lose a single carload of GE business.[6]

Hoback already had a good relationship with CSX chief finan-

cial officer Paul R. Goodwin, which was further strengthened by the INRD's response to the washout crisis. When CSX began making plans to rebuild the line into Bloomington, Hoback challenged the value of the investment, pointing out that INRD could easily forge a long-term continuance of their new operating agreement to serve Bloomington customers and allow CSX to further rationalize its Monon Subdivision. At the invitation of Indiana Rail Road, Goodwin and a group of CSX managers flew to Indianapolis and made a hi-rail trip to observe GE operations at Bloomington. There were two vehicles, one reserved exclusively for Goodwin and Hoback. That afternoon in the hi-rail truck, the two worked out an agreement in principle for CSX not only to continue the haulage agreement but also to make a significant investment in the Indiana Rail Road Company.

In April 1994, after corporate attorneys tweaked and refined the deal reached in the hi-rail truck, the Bloomington haulage agreement became permanent. CSX agreed to build a new interchange yard at Sullivan and lend $2 million to Indiana Rail Road. Hoback used the loan proceeds to finalize the buyout of the remaining INRD shareholders and in the process became 100 percent owner of the Indiana Rail Road Company. For their investment, CSX held a subordinated note with the option to convert it to a 40 percent share of preferred stock in the future.

Paul Goodwin presented the plan to his constituents as a long-term investment for CSX, not as an acquisition or a tactic to exploit the shortline. And with INRD's operating ratio some 20 points lower than that of CSX, Goodwin didn't want anyone meddling in the affairs of INRD.[7] A five-member board of directors was assembled to oversee the company: Hoback, two members appointed by him, and two members appointed by CSX. Other than their approval of the annual budget, CSX has given INRD extraordinary autonomy to manage its own affairs and operate the railroad the way it sees fit. The relationship has remained in that spirit, even long after Paul Goodwin's retirement. INRD people proudly interpret it as a vote of confidence.

In the year following CSX's investment, Hoback, now with virtually all of his personal assets and liabilities tied exclusively to the railroad, wanted to begin gradually liquefying his interest. He once again turned to his friend Paul Goodwin. The two reached an agreement for CSX to acquire the majority of Hoback's stock over a period of several years. At the time of this writing, CSX owned 85 percent of the Indiana Rail Road Company. And it has proved to be a sound investment. CSX officials have described it as one of their best-performing investments; INRD has consistently made a material contribution to CSX's net income.[8]

The Coming of Collective Bargaining

The relationship with CSX brought the Indiana Rail Road Company into a new circle of visibility back in the early 1990s, and as the railroad company grew and became recognized for new innovations, the spotlight began to focus ever more intently. Pursuant to the railroad's experimental operation of remote control locomotive technology, Tom Hoback was asked to testify at an FRA hearing on the subject in Appleton, Wisconsin, in 1997. It was like a debutante ball. Key people from the Class 1 railroads and the labor unions were in attendance, many forming their first impressions of the Indiana Rail Road Company. As a proponent of remote control locomotives, the company had stepped onto the floor holding a lightning rod. Suddenly, the INRD was on the industry radar screen, and organized labor had the company in its sights. In the wake of the CSX investment, many INRD employees were already misguidedly worried about losing their jobs to CSX people, which made the ranks ripe for the unions. Indiana Rail Road leaders left Appleton with the sense that an organizing effort wouldn't be far off.

It was not a thought taken lightly in the company board room. Turning the railroad around and making it viable had taken an intricate and often fragile balance of managing costs and making aggressive capital improvements from cash flow, as well as exercising the freedom and flexibility to pursue new ways of thinking and operating, not the least of which was the application of remote control technologies and one-person train crews. All of this could be placed in imminent jeopardy if the railroad were forced into an onerous collective bargaining agreement.

In early 1997, INRD human resources vice president Susan Ferverda began receiving tips from some employees that the Brotherhood of Locomotive Engineers was initiating canvassing efforts, primarily through the Canadian Pacific, which held INRD's connection to the mines serving IP&L. Green cards began arriving in the mailboxes of rank-and-file INRD employees. In accordance with the Railway Labor Act, only 35 percent of canvassed employees needed to submit a favorable response to clear the way for competing unions to hold elections, with a 51 percent vote required to confirm a union victory. Indiana Rail Road received notice in May 1997 that the canvassing initiative had produced sufficient affirmative responses and that a vote for representation would be held involving anyone qualified to perform train and engine (T&E) service. On the INRD, this included personnel in the mechanical department as well as dispatchers. Railroad management successfully contested this augmented scope of employee representation. This action also bought a two-month

NOTHIN' COULD BE FINER

One of the lamentable casualties of a grow-ing Indiana Rail Road Company was the Indiana Dinner Train. The sleek train, featuring vintage equipment restored and renovated with the help of an architectural firm, made four-hour evening excursions round-trip between Senate Avenue Terminal and Bargersville. A classic E9 locomo-tive provided traction for the relaxed outings, with a pace that seemed only moderately faster than a revolving restaurant. Passengers were treated to a carte du jour and wine list judged on-par or superior to many fashionable area restau-rants. The dinner train proved to be an im-mensely popular Indianapolis attraction and was immediately profitable, carrying some 40,000 guests every year.

However, with the growing railroad becom-ing more pressed for operating and shop capacity, the dinner train became an obstacle to the core transportation business. In the spring of 1993, the Indiana Dinner Train Company was sold to a group of investors who relocated it to Maine. Bon voyage and bon appétit!

cooldown period, which organizers used to aggressively try to sway those employ-ees who were on the fence.

By July, the vote was due. There were 21 employees voting, with 11 votes needed to confirm the union. Only seven votes were received.

INRD managers exhaled, but it was only a brief respite. Two weeks later, the BLE announced that additional votes had turned up in the mail. Management con-tested the election, and a second vote was scheduled. The results were similar, with a deciding margin of votes again showing up after the deadline passed. Indiana Rail Road filed suit on the issue of late votes being counted—a long shot that ulti-mately failed. The Brotherhood of Loco-motive Engineers would now represent Indiana Rail Road T&E employees at the bargaining table. It was the spring of 1999 by the time contract negotiations began. The agreements were drafted over two years by BLE representatives, Ferverda, and Washington attorney Jo De Roche, who observes that she and Ferverda were the first team of women in the railroad industry to negotiate a labor agreement. Their work was signed into effect in July 2001.

In actuality, the transition to a union shop has been far less painful than the psychological trauma that gripped the company during the time leading up to the contract signing. Now managers

The Indiana Dinner Train at Bargersville. The locomotive is an ex–Milwaukee Road E9. Indiana Rail Road Archives

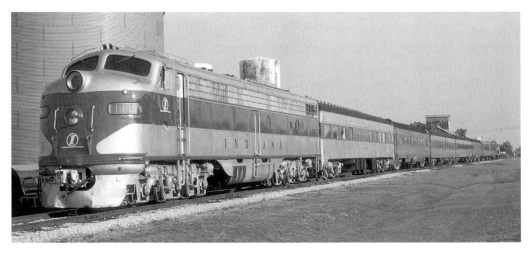

like Susan Ferverda are even sanguine when it comes to the subject:

"When it was all said and done, there were many positives. We had some genuine issues with the way our operations were being managed, and going through the contract negotiation process helped us face those things head-on. I think we, the management, all began to realize that we were going to be far more accountable to our frontline people and we were going to be much better in our own roles than we had been in the past. In retrospect, unionization wasn't the traumatic thing we all had envisioned. Ultimately, it has made us more disciplined managers.

"I also have to say that people on both sides of the table honestly crafted an exceptional agreement for both the employees and for the company. It's a simple plan, yet it's highly effective and easy for everyone to live by, and I believe that it's going to get even better for everyone when we renew the agreement and move it into its second generation."[9]

The fears that had haunted management mercifully turned out to be specters that dissolved with the crafting of the final agreement. The company's labor costs have remained stable, and the railroad has one of the first, if not *the* first, labor agreement to address the use of remote control locomotives and one-person crews, which have been so important to its operations and which will be an increasingly significant aspect of industrywide operations in the coming years.

Parting Ways

One of the most difficult periods in the life of a company is its *adolescence*—the transition to corporate maturity, requiring a far broader scope of vision and capability for management, finance, and strategic planning. Business analysts have observed predictable cycles for these growth and cultural transitions, along with the accompanying churn among the people in positions of leadership. Some are able to bridge the transition and grow into new roles. Others opt out. And yet others must be let go and replaced by those whose greater experience is needed to move the company forward. As unforgiving as it may seem, it is a stark, undeniable reality of growing a company, and success hinges on making the right decisions in hiring the right people at the right time. The Indiana Rail Road Company has lived through such a transition, along with the pains that growth can bring.

In 2001, executive management began identifying the human capital needs to meet the challenges of growing the company into its next phase of development. With great angst, Tom Hoback, in consultation with his senior team, had some difficult decisions to

make—even more so when one considers the history and fraternity that develops between people in such a tightly knit company: "When you're starting a company from scratch, especially one as rundown as this one was, you're working a lot of long, hard hours, shoulder-to-shoulder with good people through extenuating circumstances, and it forges deep bonds between all of you. Then, when you get to a point where you realize that you need a new depth of talent to take the company to the next level, you know in your heart of hearts you have to let them go. But those deep bonds make it extremely difficult."

Hoback had already been in such a place in the earliest days of the railroad's operation. He and his partners worked tirelessly together to orchestrate the purchase of IC's assets and incorporate a new railroad company, but they had disparate approaches to operating the company and taking calculated business risks. Because of pressure from the board members who held the company's venture capital, Hoback was faced with forcing a buyout of his two partners within the first two years of operations. After having worked together passionately toward the shared goal of creating an independent railroad company, there were regrets, feelings of betrayal, and relationships that suffered irreparable damage.

By 2004, the Indiana Rail Road Company emerged from its transition with a new team of senior leaders. Some people were promoted internally, and others were recruited from the top ranks of other large carriers. As painful as such a transition can be, both for those remaining with the company and those who have moved on, the silver lining is that the change is necessary for growth and success. Those who worked through the earliest days of the INRD rebuilt a railroad from the ground up and left behind a company far stronger and more vibrant than anyone would have imagined back in the spring of 1986.

When we located and purchased that large supply of new rail, the company was looking at a future of 50 years instead of 5 years.

—Tom Quigley, former INRD vice president of operations

Rebuilding a Relic

W here do we start?" That surely must have been the question on everyone's mind when the Indiana Rail Road Company was handed the keys to Illinois Central's Indianapolis line. This castoff of the green diamond was itself a diamond in the rough. Despite access to one of the country's prime manufacturing and distribution markets, the Hi-Dry had never become more than a marginalized, light-density line for the IC. It had been severely neglected—especially north of Switz City—and aside from coal haulage to Indianapolis, it was kept alive by the artificial respiration of government grant money and low-interest loans. The line was on the brink of demise when the INRD took over in 1986, and the first area of expertise the new managers had to develop was setting priorities. There were a number of things that could be taken care of handily and inexpensively, but the overwhelming majority of the work needed required significant capital and manpower. With scant equipment and a dearth of financial resources, the INRD team began the slow and steady process of rebuilding the decrepit railroad from the company's cash flow.

1986: First Things First

At the very beginning, the overwhelming task at hand was to just keep the railroad operational. Moving trains without interruption was paramount in guaranteeing the revenue necessary to fund improvements after making the monthly mortgage payment. With the weak track structure posing the greatest threat to the company's solvency, managers immediately undertook simple yet labor-intensive projects in a first line of defense to extend the life of the rail. This included tamping joints, tightening bolts, adding ballast in select locations, and making sure that joint ties were in sound condition.

With a certain degree of stability established, things looked good that first year; the company's operating income was running comfortably ahead of projections. Although it seemed there was cause for celebration, things came crashing down—literally—in mid-March 1987, with the serious back-to-back derailments near Bargersville and in Bloomfield. The broken rails that caused the accidents underscored the urgency of wholesale track and roadbed renovations as quickly as possible—any additional serious incidents had the potential to kill the railroad altogether. Train speeds were cut in half while track rehabilitation was made a top priority. Work priced at $1 million followed within the following year, including installation of seven miles of No. 1 relay rail, 13,000 crossties, and 40,000 tons of ballast.

The ongoing track maintenance had helped to decrease the incidences of broken rails, and over the next two years the company was able to replace 15 miles of rail, mainly on curves and major bridges. Still, with business growing and traffic on the upswing, the effort wasn't enough to make a significant impact and certainly not enough to increase track speeds and operating efficiency. While the portion of the railroad from Sullivan to Newton pur-

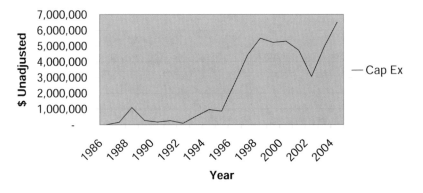

THE INDIANA RAIL ROAD COMPANY

Indiana Rail Road Capital Expenditures History

Year	Expenditure	Significant Projects and Improvements Funded
1986	—	Negligible capital expenditures this year. Does not include approx. $0.3 million for purchase CF7 locomotive fleet and other projects funded with start-up capital.
1987	$0.1 million	
1988	$1.1 million	Install seven miles of new rail; 13,000 crossties; 40,000 tons of ballast.
1989	$0.2 million	Purchase six SD18 locomotives. (INRD also purchased 46 additional mainline miles from IC this year, not reflected in the capital spending budget.)
1990	$0.1 million	
1991	$0.3 million	
1992	$0.1 million	
1993	$0.5 million	
1994	$1.0 million	Replace 8,300 crossties and bridge ties; upgrade warning devices at public grade crossings.
1995	$0.9 million	
1996	$2.6 million	Install 35,000 crossties; 40,000 tons of ballast; align, level, and surface 290,400 track feet; bridge upgrades and improvements; ditching and drainage projects; misc. main line rail replacement projects.
1997	$4.4 million	Lay 40 mainline track miles of heavier rail, including 16 miles of continuous welded rail (CWR); install 17,000 crossties; build new locomotive service facility and management offices in Switz City.
1998	$5.5 million	
1999	$5.2 million	Replace all remaining 90-lb. rail; increase track speeds.
2000	$5.3 million	Relocate corporate offices to downtown Indianapolis.
2001	$4.7 million	Installation of 14 heavy-duty switches on main line; complete work on Midland Subdivision; purchase 6 SD40-2 locomotives and retire 12 older units.
2002	$3.1 million	
2003	$5.0 million	Build new 6,224-ft. "Dixie" siding to stage IP&L trains.
2004	$6.5 million	Purchase four GP-38 locomotives; replace most remaining 110# rail; lay 7.5 track miles of CWR; install 15,000 crossties; increase track speeds to 40 mph; build new yard tracks at Palestine; purchase ditching machinery for drainage projects; install automatic equipment identification readers at select locations; install new computer-aided dispatching system.
2005	$8 million	Build new spur to Bloomington quarry.
2006	$8 million	(Projected)

chased in 1990 was equipped with 115-lb. rail installed by IC less than a decade earlier, the heavy coal trains on the north end were still riding mostly on 90-lb. rail, some of which had been rolled in the 1920s. Ominously, the railroad began to encounter broken rails with increasing frequency, a signal that, without major rehabilitation, the company was living on borrowed time.

1996: Turning the Corner

Rail is the most expensive component in track structure, and the cost precluded any thought of purchasing freshly minted rail from the mill. An intensive search was launched to find a source of heavier secondhand rail that had a substantial service life remaining. Managers found 40 miles of suitable rail and made one of the single most important capital expenditures in the company's history. The new steel was installed over a three-year period, beginning in the summer of 1997.

Replacing the worn-out rail was a watershed event for the company and a sign that the struggles of the past were finally being overcome. For operations vice president Tom Quigley, it was nearly impossible to overstate the significance of the undertaking: "Prior to that time, we didn't think we'd ever be able to fund a significant replacement of our old 90-lb. rail. But we also knew we only had a limited number of years before the rail simply gave out altogether. When we located and purchased that large supply of new rail, suddenly the company was looking at a future of 50 years instead of 5 years."[1]

The entire project put down 23 miles of 127-lb. jointed rail, 16 miles of 130-lb. continuous welded rail, and 1 mile of 112-lb. continuous welded rail. In the process, the INRD also replaced more than 50,000 mainline crossties in 1996 and 1997. The price for the track work exceeded $5.5 million—more than the original purchase price of the railroad in 1986.

The benefits of the renewed rail extended far beyond the basics of track stability and safety. The railroad was finally able to increase track speed to 25 mph for the entire distance between Morgantown and Sullivan. Getting trains over the line faster helped alleviate congestion and ensure better performance to meet customer schedules. Additionally, the more reliable rail freed the track department from the ongoing chores of bolt tightening, joint surfacing, and daily track inspections, allowing them to reprioritize their efforts and move on to other issues. Chief among these was bringing the railroad up to standards for handling newer 286,000-lb. capacity rolling stock over the entire main line.

In 2003, the Indiana Rail Road Company made another rail purchase—just over 3 track miles. While that may not sound sig-

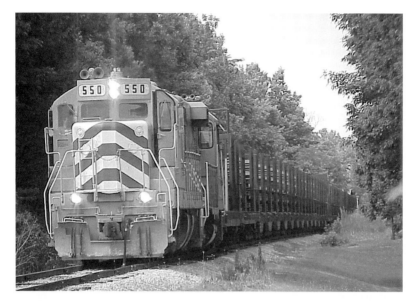

Continuous welded rail makes its way to the worksite. The 1,500-ft. sections of rail travel on specially articulated cars to negotiate curves. The arrival of the newer, heavier rail was a watershed event in the life of the railroad. Indiana Rail Road Archives

nificant compared with the acquisitions of the mid-1990s, it was indeed a special purchase. Although more than 73 track miles of rail were replaced in the company's first 15 years, those projects utilized secondhand rail. Now, for the first time, the INRD purchased brand-new prime rail on a large scale. The new rail, rolled at one of only two rail-producing mills in the United States, was shipped in 80-ft. sections from Steelton, Pennsylvania, near Harrisburg. It was employed in a variety of track projects, including the Shuffle Creek Viaduct, the Midland Subdivision, and a complete renovation of the main line in Linton. The following year, the rail-

In 2003, INRD purchased its first freshly minted rail direct from the rolling mill. The shipment was produced near Harrisburg, Pennsylvania, and transported in 80-ft. sections. Photos by John Cummings

road installed an additional 7.5 miles of new 136-lb. rail between Solsberry and Kirby, eliminating the last remaining 112-lb. rail on the main line and clearing the way for track speeds to increase to 40 mph on welded rail. In the next few years INRD will likely acquire an additional 14–18 track miles of newly rolled continuous welded rail for use in ongoing track rehabilitation programs.

Pour on the Power

Aside from sound track and roadbed, trains cannot move without locomotives. But buying locomotives isn't as simple as waltzing down to the corner used car lot. The power puzzle INRD faced in the early years required a great deal of resourcefulness and a high degree of mechanical skill to solve. In the beginning, INRD turned to Santa Fe for surplus power, in the form of the diminutive and dependable CF7 fleet. But charged with the task of towing heavy

Indiana Rail Road's first six-axle power was half a dozen SD18s. These unique locomotives were originally built by EMD for the C&O and sported trucks from Alco RSD5 trade-ins. Number 7310 is pictured ca. 1998 at Linton, trailing a pair of ex–Milwaukee Road SD10s purchased from Dakota Minnesota & Eastern, one of which still wears DM&E livery. Photo by Shawn Noe

coal trains over the tough terrain on the north end, the days of the first INRD fleet were numbered from the moment they were throttled up.

In 1989, faced with power that was aging rapidly and becoming increasingly unreliable, the INRD picked up a handful of unusual engines—former Chesapeake & Ohio SD18s, riding on trucks from C&O's Alco RSD5 trade-ins. Purchased from CSX, the units were the first six-axle power acquired by INRD. Although they outwardly appeared far better suited to pull the IP&L coal up 1 percent grades, some industry insiders thought that the railroad was foolhardy to purchase them. The locomotives were known to be problematic in curve handling, and numerous engineering studies implicated the trimount trucks, with their asymmetrical axle placement. When CSX put the units up for sale, there were few interested buyers. However, the INRD mechanical department recognized that the trouble with the units was only a factor at higher-speed operation. On the INRD, they would be lugging heavy tonnages at low speeds—track speed on the mainline had been lowered to 12 mph in response to the broken rail accidents in March 1987. As it turned out, the engines worked very well for INRD. The trimount trucks accommodated GE traction motors, which were superior at low speed under the heavy loads. (Later, when track speeds began to increase, their performance suffered somewhat; the units weren't capable of developing sufficient horsepower at higher speeds.)

The next significant power purchase was a group of GP16 rebuilds. The railroad acquired them from CSX in 1998–99, a challenging time for buyers in the locomotive market. There were oddball units along the way, too. The railroad had a single GP9, the only high-nose engine ever rostered on the INRD. Adorned with the early Monon-inspired grey and crimson livery, it was lost in a grade crossing accident in Sullivan in 1991. A lone SDH15 was purchased from CSX, having lived its previous life on the Seaboard Coast Line SD35 before being rebuilt for hump yard service. It was once again

INRD engine no. 600 bore a tribute to the late Rich Lassar, one of the railroad's proponents and financiers. Photo by the author

Seen here in yard service at Senate Avenue Terminal, unit no. 1809 is a GP16 rebuild, equipped for remote control operation. Photo by the author

THE RAINBOW FLEET

Paint was decidedly not a priority for the Indiana Rail Road Company in its earliest days of operation. The fleet of used AT&SF CF7s bore the blue and yellow freight war bonnet scheme, complete with SANTA FE emblazoned on the hoods in letters four feet high. Some southern Indiana residents must have wondered for a moment if a Hoosier tornado had deposited them in Kansas while they were asleep. Although some of the machines finished their days on the INRD without ever receiving a new coat of paint, two units—renumbered 200 and 201—received a wonderful cream and crimson livery inspired by the passenger fleet of the Monon Line, complete with a Monon-esque wheel-on-rail logo crafted by graphic designer Roger Rasor.

A wave of "phase two" power followed the CF7 fleet with an even more colorful array of engines bearing the red and yellow stripes of the Family Lines System, Chessie vermillion, yellow, and blue, and the bright blue and gold of the Dakota, Minnesota & Eastern. Coupled occasionally to leased mates, they made an unpredictable patchwork of head-end color that one INRD customer described as the "rainbow fleet." By the close of 1998, a repainting program had dressed all the units in a monochromatic grey, with high-visibility striping on the noses. In celebration of the railroad's completion of its five-year capital renovation program in 2000, former DM&E SD10 no. 545 was renumbered 2000 and given an experimental red and silver scheme with the "America's New Regional Railroad" slogan on the hood. The railroad later adapted the red and silver look to bear the classic INRD logotype and made it the standard dress for the "phase three" fleet of GP38s and SD40-2s.

an unfavorable time to buy, but the railroad desperately needed power. Investor and company friend Rich Lassar financed the locomotive, no. 600, which was christened in his honor.

By the late 1990s, the railroad again needed more locomotives, and once again the market was unfavorable. Mechanical department chief Dick Finley and operations head Tom Quigley sent letters to every North American railroad soliciting power for sale. They received a promising reply from the Dakota, Minnesota & Eastern, which owned a number of ex–Milwaukee Road SD10 rebuilds. Eight units were bought and bathed in INRD's grey paint (although two were later adorned in early experimental versions of the modern red scheme). Ironically, some of these units were practically returning home; a number had worked the Milwaukee's line between Terre Haute and Bedford that crosses the Hi-Dry at Linton.

In 2001, the time to buy high-quality locomotives was finally right. Class 1 railroads were replacing their fleets with new advanced power, and the secondhand market was consequently flush with good units at remarkable prices. The Indiana Rail Road Company made its most significant power upgrade ever when it acquired half a dozen SD40-2s, GM's popular design, which for three decades was the gold standard in freight locomotives. The INRD units, purchased from Helm Leasing, had each seen about 20 years of service on the BNSF and its antecedents. A handful of the units arrived sporting well-worn coats of cascade green. INRD was able to replace its old six-axle power with SD40-2s at a 2:1 ratio with significant fuel savings. And there were additional operational efficiencies gained as well. For example, the SD40-2s allowed the railroad to pursue run-through power agreements with CP for IP&L empties bound for Black Beauty's Farmersburg mine.

Another significant advantage offered by the new fleet, from both train handling and fuel conservation standpoints, was fully

Indiana Rail Road replaced its existing locomotives at a 2:1 ratio with newer, more efficient SD40-2s. Most of the new engines had seen service on the Burlington Northern Santa Fe. Publicity photo

operational dynamic braking, something the INRD had not employed before, for a number of reasons. First of all, many of the locomotives in the earlier fleets hadn't even been so equipped, rendering the issue largely moot. But when the SD18s came online, the topic became a matter of debate. In the end, a computer simulation revealed that a loaded train at the extreme INRD operating parameters—descending a 1 percent grade into a six-degree curve—would load the head-end to extremes. The lateral force placed on the outside rail would exceed 110,000 pounds, far too much to impose on the old 90-lb. sticks still in use. (The descent into the sharp curve used in the computer model is located at milepost 48.5, near Unionville Tunnel.)

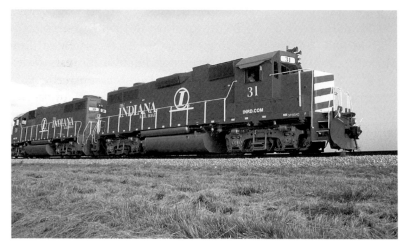

INRD also added a number of versatile GP38ACs and GP38-2s to the "red fleet" and will likely acquire additional units in FY2005–2006. Photo by the author

In addition to the new SD40-2 units for coal movements, INRD also acquired 15 purchased and leased GP38 units to handle general freight and switching duties. Mixed freight business has been growing so robustly that even more power is likely in the railroad's near future.

First Rebuilt, then Transformed

In 1969, three men flew a Saturn V rocket to the moon and back. Yet, for some reason, until the 1980s, it took five to move a freight train. While the rest of the industrial world crossed over into a new universe of advanced technologies, U.S. railroads evolved from the coal-fired, mechanical marvel of the nineteenth century to the redheaded stepchild of a new economy. In the analysis to lay blame, the usual suspects—labor, management, and regulators—each share a common denominator that reveals a shameful truth: American railroading was paralyzed by a resistance to change.

But change is inevitable, even for the railroads. So 1980 brought the Staggers Act, one of the most significant regulatory advances in the history of the industry. Staggers sparked a renaissance in big American railroading, as the Class 1 companies shed themselves of unprofitable business and properties. Given the desperate state of the country's major railroads, this was a remarkable achievement in and of itself, but within these cast-off remnants of the great systems lay the remarkable *echoes* of Staggers. Through the ripple effect of wholesale Class 1 divestitures, there were, for the first time in nearly 100 years, scores of brand-new, independent railroad companies that could rewrite the book on basic railroading. The new companies were, by necessity, lean, unencumbered by long-outdated work rules and driven by their rubber-wheeled competitors to be as efficient and customer-focused as possible. Ironically, some of these upstarts have catalyzed a new generation of improvements in the way railroading is done.

From his early days growing up along the Santa Fe and learning the railroad business from his father, it seemed that Tom Hoback seemed predestined to be involved in transforming the industry. Now, with an independent railroad at his command, a team of capable and creative managers, and an entrepreneurial spirit, he had the platform to push the conceptual and operational envelope and see what a railroad company could do if it were run like a business, not like a railroad.

When the company plunked down more than $5 million for new rail back in 1996, it was only the beginning of an intense $25 million five-year capital plan to reshape the railroad, not just on the outside, but from the inside out. Before it was all said and done, the Indiana Rail Road Company had made significant in-

vestments in new innovations that would enhance operations, customer service, safety, and capacity.

Turning to Technology

By the mid-1990s, the Indiana Rail Road Company had achieved viability, but the low-hanging fruit had now been harvested. Long-term growth, stability, and financial strength would depend on the company's ability to attract new customers to the railroad with improved service and aggressive management of costs.

To find one means of achieving these goals, Tom Hoback went back to the mid-1950s. He vividly remembered reading an edition of *Trains* magazine that featured a remote control locomotive working in a steel mill.[2] The idea was to keep the operator out of harm's way while pulling cars in and out of the most dangerous areas of the plant. At the time, Hoback's father was working on the Santa Fe's busy main line between Chicago and Kansas City, where the railroad made four crew changes—including switching out cabooses—in about 450 miles. The contrast of Santa Fe's top-heavy operations with the productivity of the remote control switch engine made a lasting impression.

The ideas and technologies at work in remote control operations are nothing new or radical. Examples of remote control include such mundane devices as elevators. In industry, remote control is used in all types of heavy equipment, such as overhead cranes, aggregate mixers, and construction apparatus, such as the giant boom of a concrete pumping truck. In the railroad industry, however, objections from organized labor had long relegated the application of remote control to captive operations, such as the steel mill in the magazine story.

The idea of remote control switching had remained with Hoback through the years, and now it appeared that the time had come to make it a reality. He tabled he issue with the INRD management team, and they launched a study of what were, at the time, the only appreciable applications of the technology in North American railroading, on the Canadian National Railway and the Wisconsin Central. CN launched their program in 1989, and it had been remarkably successful, with more than a million hours of safe service logged in some of their busiest classification yards.

In 1995, Quigley, along with equipment manager Finley, attended a conference in Phoenix and visited with representatives from one of the principal manufacturers of the devices. The two left the meeting convinced that remote control would significantly improve safety, and they returned ready to promote adoption of the technology.[3] Upon their return, they discussed the next steps of the project with Hoback. The management team invited a group

of train operators to embark on a fact-finding trip to Wisconsin Central to observe that railroad's eventually ill-fated remote control operations and have face-to-face discussions with trainmen operating the systems without the presence of management. The trainmen were encouraged to develop their own lists of questions and concerns and ask challenging questions during their visit. They videotaped the experience and shared it with the management team upon their return to Indianapolis.

In 1996, Quigley led a second operations team on a similar visit to Canadian National's MacMillan Yard in Toronto, which was the site of the most intensive remote control switching operation in North America. Their observations and hands-on experience aided in the development of a plan to integrate remote control into INRD operations. The railroad proceeded to work with manufacturers of the technology to select the right system and provide training for operators and managers.

During the process of implementing remote control, INRD managers faced a challenge in cultivating buy-in among the trainmen, who perceived it as a threat to their jobs. Tom Hoback addressed the concerns decisively by promising that the railroad would not furlough any employees due to the adoption of remote control technology. And the railroad has never had a problem in living up to that promise. The vigorous growth generated by introducing innovations such as remote control has substantially increased the numbers of train operators employed by the company.

INRD director of road operations Scott Orman moves a locomotive with a remote control beltpack. INRD pioneered the application of remote control switching in the United States. Photo by John Cummings

The pilot program was launched in 1996, and it has been highly successful. Today, INRD has regular remote control assignments in Indianapolis, Bloomington, Switz City, and Palestine/Robinson. The railroad has used the economy of remote control technology to win some cost-sensitive business that required several daily switches at the customer's dock. Without the advantages of remote control, the railroad wouldn't have been a viable choice.

In addition to helping operators to work more productively and provide enhanced levels of service, remote control also offers significant safety benefits. It makes switching operations inherently safer by immediately reducing the risk exposure from two people to one. The railroad switchman working on the ground making cuts and couplings has, historically, had one of the more dangerous jobs in American industry. Even after the advent of the automatic coupler, working between rail cars is a hazardous way

to make a living. With remote control, the man on the ground gains complete control of the train's movements. There's no second-guessing or chance of radio miscommunication or misinterpreted hand signals, and as a result there are far fewer accidents. Statistics compiled by Canadian railroads have reported a remote control accident rate two-thirds lower than that for conventional switching. Safety was no small factor in the INRD's decision to implement remote control.

Today, the entire industry seems to be embracing the idea of remote control, even if only on a limited basis. Virtually every Class 1 carrier now has systems in operation. After initial opposition to the technology, labor has also shifted to a more cooperative stance. There appears to be every reason to believe that remote control, pioneered in the U.S. by the Indiana Rail Road Company, can and will be as successful and widely used among the U.S. railroads as it is in Canada and other parts of the world.

The implementation of remote control also led to additional discussions concerning technology improvements on the Indiana Rail Road and to improvements such as powered switch throws at classification yards. Solar collectors feed storage batteries that power the switch points at the touch of a button or, if so equipped, even with a key command from a two-way radio. Installed throughout a small classification yard, the devices are the ideal complement to a remote control locomotive, allowing a single operator to safely and efficiently switch the yard.

INRD rebuilt the Palestine yard down to the subgrade and outfitted the facility with electrohydraulic switch throws that save time and reduce muscle strain injuries. The units generate their own electrical power with the solar collectors mounted atop the poles. Photo by John Cummings

And Then There Was One

While remote control focuses on moving tasks outside of the locomotive cab, the other significant productivity initiative pursued by INRD involved changing things *inside*. An early adopter of two-person crews in the first year of operation, after continued study of rail operations around the world, Indiana Rail Road was ready to take the next step. When INRD personnel studied remote control switching operations on the Wisconsin Central, they also observed some over-the-road operations using one-person crews. The INRD visitors came home pondering whether one-person crew operations could be successfully employed on Indiana Rail Road.

One-person crews have been the norm for decades in railroad operations in industrialized countries around the world—even in the unionized operations of Switzerland and the United Kingdom. INRD senior managers planned a fact-finding mission and embarked on a tour of New Zealand's Tranz Rail to observe one-person crew operations and interview crewmen and managers. One-person crews proved to be an important productivity tool during a critical time for Tranz Rail, as they were losing significant market share to trucks and undergoing a transition to privatization. A truly unexpected discovery was the favorable reaction from the operators themselves. Surprisingly, one-person crews had been enthusiastically embraced by the Tranz Rail employees for a number of compelling reasons, not the least of which were the elimination of in-cab distractions and the avoidance of personality conflicts and the insidious, low-key hostilities that can result. The New Zealand experience showed that one person in the locomotive cab led to better attention to duty on the part of the train operator, since there was no one else on board to distract him or her—the same reason that over-the-road truckers often prohibit a second person from riding in the truck cab. INRD managers returned home convinced that one-person crews had a place on their own railroad.

One might mistakenly assume that paring down a crew to a single person would be a matter of simply reassigning employees and rewriting the job bid list. Not so. In the interest of safety and best operating practices, Indiana Rail Road set about retooling its entire communications and dispatching system, as well as rewriting the operating rules. In-cab alerters were installed to monitor operator vigilance and initiate automatic train braking if a lapse is detected. New repeaters and phone lines were installed to ensure radio communication availability over every square inch of the property. And dispatching software was upgraded to include global positioning technology and voice-over data communication

to provide a detailed graphical representation of the railroad, with train position and operating data constantly updated.

GPS technology is also used to generate train speed reports for the dispatchers, and the system can be programmed to help manage track warrants as well. For the INRD, global positioning technology provides the benefits of precision, real-time management of train movements in a non-centralized traffic control environment. Train movements can even be recorded and stored. With the click of a mouse, the operations department can analyze train handling and traffic patterns from weeks or months ago. Instant replay has come to regional railroading.

This technology has allowed INRD dispatchers, in effect, to become a virtual second crewperson in the locomotive cab, monitoring train handling and event recorder details. In the event of an emergency, a dispatcher can safely stop a train with a command from the desktop, even if the train is 80 miles away from the Switz City dispatch center. And if a train stops unexpectedly, the dispatcher's map display shows the train location and even allows him to visualize what street crossings are blocked. It is a powerful system that required no hardwiring of the track infrastructure. Everything is contained in the locomotives' on-board systems and the dispatcher's operating software.

There are immediate, tangible benefits of single-person crews on over-the-road trains. It allows regular assignments with more predictable scheduling, better crew utilization, and more responsive customer service. The near future will bring more improvements and enhanced digital technology directly into the locomotive cab. INRD has been moving forward with a plan to replace switch lists and delay reports with onboard laptop computers, with the ultimate goal of having critical business data on everything from payroll to car movement reports entering the company network in real time from the cab.

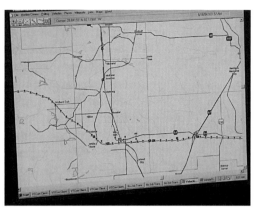

GPS technology gives INRD dispatchers a detailed depiction of train position and performance data, without the hard-wired infrastructure of a CTC system. The GPS technology will operate in conjunction with a second computer-aided dispatching system to create greater efficiency in train movements and to accommodate ever-increasing traffic density. Photo by the author

America's New Regional Railroad

When INRD managers began their most intense phase of rehabilitating the line in the mid-1990s, they weren't simply rebuilding track and equipment; they were setting the bar for a new generation of regional railroads in America. Now, the INRD is enjoying the benefits of remote control locomotives and other technologies to improve operations, management, and cost controls. Customers

get better service. Equipment is better utilized. Employees work more safely. And the INRD realizes greater productivity and a greatly enhanced ability to compete in the marketplace.

Between 1997 and 2004, INRD invested more than $50 million generated entirely from cash revenues to improve infrastructure and capacity in preparation for substantial future traffic growth. The company has created an innovative new model for the American regional railroad—an example of what can be accomplished by creative thinking, wise investment, being bold, and taking well-conceived business risks. These are some things that many people in the railroad industry had long forgotten how to do.

Getting the trains over the road faster will be a key to our future growth.

—John Rickoff, INRD chief operating officer

It's about Results

It seemed like such a no-brainer. In 1986, when the Indiana Rail Road Company took the reins from the Illinois Central, there was nowhere to go but up. During its last year operating the line, IC posted just 12,000 carloads—an average of less than three 85-car trains each week. With a new entrepreneurial spirit and freedom from the cost structures and hemmed-in thinking of a Class 1 operation, INRD was poised to take the railroad to new levels. The extent to which this has happened has exceeded the expectations of even the most optimistic observer. From the very beginning, INRD has pushed the company to new levels of success and found ways to fit more revenue carloads onto a 155-mile single track railroad. In the first year alone, INRD increased carloadings by 3,000 over the IC's final counts and grew revenue to more than $4 million—not a bad start by any measure.

Looking beyond the Tracks

One of the chief reasons that the Hi-Dry was seen as a viable candidate for an independent regional railroad was the potential for the company to develop transportation customers in the area sur-

Revenue Carloadings

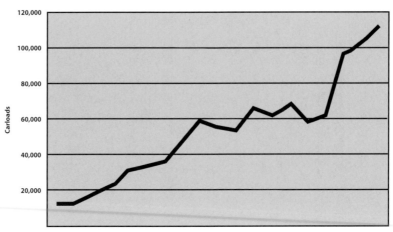

Gross Ton-Miles

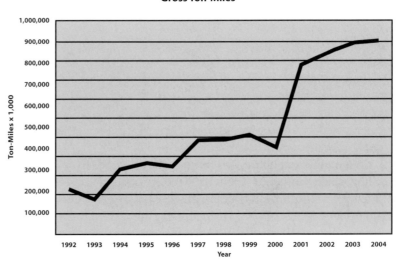

Carloadings, Coal vs. Non-Coal

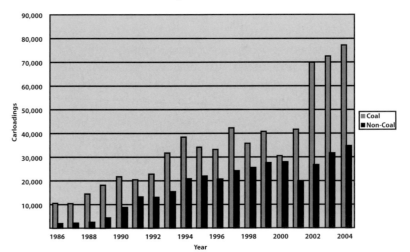

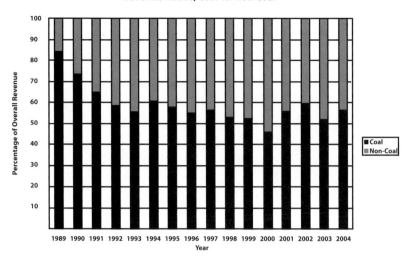

Revenue Ratios, Coal vs. Non-coal

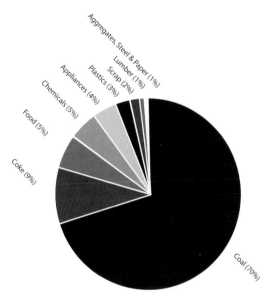

2004 Carloads by Commodity

rounding its principal terminal at Senate Avenue in Indianapolis. Included in the purchase from IC was nearly 60 acres of industrial property around the terminal, just a block south of an on-ramp leading to four Interstate highways—65, 69, 70, and 74. Shortly after INRD began operations in 1986, the company began to explore ways to rehabilitate and develop the terminal.

Indianapolis had a long, distinguished history as one of the Midwest's premier distribution hubs, and here was an underappreciated railroad line that reached right into the heart of it. Again it

Senate Avenue Terminal, 1986. This view, looking north, shows the derelict condition of the property when IC turned it over to Indiana Rail Road. The tank car at the far right is spotted for customer transloading. Lloyd Kimble Collection

seemed like such a no-brainer—adding warehousing and transloading services as a natural extension to the core transportation business. With a modest investment and some well-directed marketing efforts, INRD began making rail customers out of firms that weren't even located near the tracks. The operation was conceived as an independent, adjunct business, christened the Indiana Reload Center.

Throughout its history, INRD has transloaded an array of commodities and manufactured goods at Senate Avenue Terminal, including lumber, liquid fertilizers, plastic resins, rubber prod-

Contrast the earlier view of the terminal with one from 2004. The locomotive tracks are flanked by the Indiana Reload Center and shop facilities. The vacant roundhouse slab now houses a transload operation for a nearby customer. Photo by the author

ucts, and aggregates. In mid-1990, the operation made a major leap when Vancouver, B.C.–based Canadian Forest Products (Canfor), launched a Midwest distribution operation at the terminal receiving some 500 carloads annually. By 2001, the Indiana Reload Center had expanded far beyond its original scope of operation as a break-bulk lumber facility. It now had a handful of newly constructed storage facilities and specialized handling equipment, such as conveyors, cranes, and other devices for transferring material. The reload center's customer base and diversity has grown, as well as the center's geographic reach for truck-to-rail and rail-to-truck services. In 2004, annual carloadings at the reload center surpassed 700. Since then, the number has topped 1,000. The operation handles nearly 100 million board feet of lumber annually and dispatches thousands of trucks to lumber customers in more than a dozen states.

Another early view of the terminal, looking east across the slab of the old roundhouse. The tank cars behind the locomotives are being used for bulk liquid fertilizer storage for Arcadia, an important early customer. Lloyd Kimble Collection

Other significant projects around the Senate Avenue Terminal have included the 1997 sale of a four-acre site to Toledo-based GAC Chemical. The company developed a rail-served plant for the manufacture of chemicals for treatment of municipal drinking water and wastewater and now moves hundreds of carloads of chlorine and sulfuric acid annually. More recently, the railroad sold additional adjacent acreage to Hoosier Concrete for a ready-mix plant. The railroad delivers carloads of bulk sand for the operation and expects to deliver additional aggregate material in the coming years.

Since IC turned over the keys in 1986, Indiana Rail Road has allocated more than $1 million for improvements to the Senate Avenue Terminal, including land acquisition, track upgrades, and environmental projects. The railroad continues strategic acquisition of adjacent properties to pursue industrial development to fuel future growth of the core transportation business.

A THREEPEAT

One important measure of the Indiana Rail Road's record-setting performance came in the form of three silver cups—silver that represents the gold standard in regional railroad safety. In 1994, the INRD was awarded the Jake Jacobson Safety Award for Railroading Excellence. Jacobson, vice president and general manager of the Copper Basin Railroad in Hayden, Arizona, established the award to recognize regional and shortline railroads achieving zero lost-time injuries. (The nation's largest carriers compete for the prestigious Harriman Award, presented annually by the Association of American Railroads.)

Jacobson compiled statistics from regular data submitted to the FRA and awarded seven silver cups to the shortline and regional railroads reporting the most man-hours worked without lost-time injuries. By 1996, INRD was one of only two railroads to win the Jacobson Award three consecutive years. The win distinguished the INRD as one of the safest railroads in the United States.

Balancing Act

By 1995, the Indiana Rail Road Company had turned the Hi-Dry around. The railroad was posting annual carloadings of 60,000, a fivefold increase over the IC's last reported count. As a result, employment and payroll were also growing. The company had lived a wonderful, if hard-fought, success story to this point. But there were significant challenges looming.

In addition to its central Indianapolis location and valuable industrial properties, good coal business had also been a key element in Indiana Rail Road's solvency and growth potential. In fact, if all the railroad ever did was haul coal to IP&L's Stout generating station, it would still have been a viable business. But being top-heavy with coal also presented a threat. The black diamonds still accounted for more than two-thirds of the railroad's carloadings, which pinned the future of Indiana Rail Road to the southern Indiana coal industry. And, as time went on, that future began to show signs of uncertainty. One worrisome force to be reckoned with was the growing tide of western coal from Wyoming's Powder River basin. Although slightly less efficient in terms of energy yield, western coal is relatively clean, abundant, and easy to strip. Consequently, it has become economical enough to transport over long distances. Not surprisingly, western coal was increasingly finding its way into power plant furnaces in the Midwest. There were other enemies, too, including natural gas—already firing power plant boilers around the Indianapolis area that were formerly stoked with coal.

The southern Indiana mining industry, faced by this growing competitive threat, was also suffering ongoing challenges posed by the economics and cost structures of its operations. The fragile state of the industry was illuminated when Peabody Coal announced the closure of its Hawthorn Mine near Carlisle, Indiana, in 2000. Hawthorn's closure sounded an ominous chord throughout the industry, and it resounded in the ears of independent coal-hauling railroads, such as the

TOP 20 SHORTLINE OPERATING COMPANIES BY
ANNUAL CARLOADINGS PER MILE PER YEAR

Owner	Lines	Miles	Annual Carloads	Revenue Carloads per mile
Transtar	4	367	500,000	1,362
Indiana Rail Road	1	155	110,000	710
Paducah & Louisville	1	309	181,000	586
Rail Management Co.	13	309	302,000	411
Washington Group	2	723	285,000	394
Anacostia & Pacific	3	416	97,000	233
Genesee & Wyoming	23	2,778	600,000	216
Pinsley	6	200	43,000	215
Gulf & Ohio Group	9	276	46,000	167
Ohio Central	7	516	71,000	138
North Shore	8	266	35,000	132
RailAmerica	46	8,745	1,140,000	130
Rio Grande Pacific	3	484	57,000	118
Wheeling & Lake Erie	1	769	87,000	113
NA Rail Net	4	1,165	125,000	107
DME	2	2,300	227,000	99
RJCorman	7	222	20,000	90
Pioneer	7	331	25,000	76
Omnitrax	11	1,500	107,000	71
Watco	9	2,834	200,000	71
Totals	167	25,091	4,258,000	170

Source: "The Railroad Week in Review," August 27, 2004, an online publication of the Blanchard Company. Lines owned by Class I carriers, steel and ore companies, municipalities, and government entities are not included.

INRD and Indiana Southern. INRD managers knew it was necessary to grow their non–coal carload business, and they began to develop strategies to counterbalance the 5 million tons of coal that dominated the operation. By working closely with customers, the railroad has been able to open new markets and drive additional traffic to the rails. At the Marathon Ashland refinery, for example, railroad and refinery managers worked together to enhance pipeline capacity by shifting more product to the railroad. Efforts to support the growth of grain customer Mont Eagle Mills have resulted in loading unit grain trains. In Bloomington, INRD provided relief for a storm-battered CSX by taking over movement of GE appliances—with service so reliable that CSX ultimately exited the Bloomington market and turned over the entire operation to INRD.

The growth of these and other business segments tipped the scales. By 1994, coal provided 58 percent of INRD revenue, down significantly from the 90 percent share back in 1986. Additionally, IP&L, which once accounted for 92 percent of INRD revenue, now only represented 30 percent of the company's earnings despite record tonnages moved to the utility. The diversification efforts paid off in more than just balancing the company's business mix; the railroad gained more net business in the process, and the steady increase in carloadings drove traffic density to the highest levels among the country's shortline and regional railroads.

The Big Win

January 6, 2001, was a banner day for the Indiana Rail Road Company—literally. At 3:00 p.m., a 115-car train of coal from Wyoming's Powder River basin broke through a large banner above the rails at the Ameren generating station in Newton, Illinois—the end of a long marketing effort and the beginning of one of the most significant increases in business in the history of the company. The story began, however, almost a decade earlier.

In late 1991, Central Illinois Public Service Company (CIPS) began to seek bids from coal suppliers to furnish large volumes of low-sulfur compliance coal to the Newton generating station. One of the largest contiguous deposits of compliance coal in the Midwest was held by Black Beauty, an independent Indiana mining company. Indiana Rail Road and CP Rail coal marketing representatives entered into extensive negotiations with CIPS fuel procurement officials and traffic supervisors and developed a suitable operating plan and contract proposal that CIPS accepted. Among the principal architects of the plan was John Rickoff of CP, who later joined INRD and is now the company's chief operating officer.

Tom Hoback had long admired Rickoff's marketing skills and worked for a number of years to recruit him. A 13-year transportation contract for movement of 6 million tons of coal was signed by INRD, Canadian Pacific, and CIPS in December 1992. Indiana Rail Road delivered its first train to Newton Station on May 7, 1993. In addition to Indiana compliance coal, the plant also burned coal from Wyoming, which was delivered by Illinois Central.

In March 1999, however, CIPS, which had since been acquired by St. Louis–based Ameren Corporation, converted all of the remaining boilers at Newton to exclusively burn western coal. Indiana Rail Road, which stood to receive a settlement for the cancellation of its contract, instead responded aggressively to compete for the western coal haul in conjunction with Canadian Pacific. The result was the conversion of a loss into the largest single victory the railroad has ever experienced. Indiana Rail Road increased its original annual volume of fewer than 500,000 tons of Indiana coal to some 4 million tons of western coal—pushing the railroad's annual carloadings beyond the 100,000 mark.

As part of the innovative deal, Ameren allocated funds earmarked to settle INRD's original contract to build a brand-new 4.7-mile direct connection to INRD's main line that provides competitive options for their 115-car inbound coal trains from Wyoming. In the summer of 2000, as Ameren began to acquire land for construction of its new INRD connecting track, the railroad began planning construction of its Midland Subdivision to improve its connection with CP. With the new Ameren business, 230 unit trains would be added to the already congested interchange at Linton. INRD identified a dormant track owned by

A unit train of western coal arrives at the Ameren plant near Newton on a hazy Sunday morning in August 2003. Photo by the author

Peabody Coal Co. with a connection to INRD. Peabody had used the line to move coal from its mines to a wash plant, but the track was idled in the early 1980s. The two railroads invested more than $1.5 million to rehabilitate the line with new ties, ballast, rail improvements, and signal upgrades for a highway crossing. INRD crews also realigned the connection to INRD main to mitigate excessive curvature. Not only did the Ameren trains traverse the new Midland Subdivision, but also southbound trains bound for Hoosier Energy's generating station near Merom Station. Following the project, INRD laid a new leg from the Peabody track to accommodate northbound IP&L coal trains as well, allowing all unit trains to bypass the Linton interchange, much to the relief of motorists in the small town, who were delayed for long periods while unit trains were separated and switched onto the INRD.

An outbound train of Ameren empties leans into the south leg of the wye at Midland junction near Dugger, Indiana, while a Palestine–Switz City turn waits on the main. Photo by the author

The Quest for Capacity

More unit coal trains and more time-sensitive high-value shipments drove INRD managers to explore ways of wringing more capacity out of their railroad. Their earliest efforts resulted in restructuring train movements into scheduled operations. INRD managers realized that scheduled operations would not only enhance service and capacity by reducing car transit times from customer docks to interchange points, but also provide additional benefits through better utilization of crews, locomotives, and other resources. In more recent times, the railroad has extended scheduled operations to enhance service for one of its mainstay customers, IP&L. The railroad was faced with the expiration of IP&L's long-term contract and the insidious threat of competition from other railroads stemming from trackage rights mandated by the Surface Transportation Board in the wake of the Conrail breakup. INRD managers tailored their proposal to renew their contract based on enhancing service to IP&L, rather than mere rate negotiations.

Unit train coal shipments are often erratic, delayed by problems at the mine, availability of train crews, interline coordination between railroads, and inefficiencies that result from problems in coordinating all of the players in the supply chain. The objective of INRD's express service for IP&L is to deliver large volumes of coal on a regimented schedule while reducing delays, expenses, and non-value-added processes. With scheduled rail service,

mines can ensure availability of coal for loading, railroads can schedule crews to ensure timely movements, and the customer can reduce handling costs by avoiding unnecessary movement of coal into and out of its stockpile.

To meet the service objective, Indiana Rail Road undertook a program of investments and improvements to improve train routings and cycle times. First, the inefficient Canadian Pacific interchange in Linton was bypassed by constructing a new connecting track to the Midland Subdivision near Dugger, allowing trains to move from one railroad to another without being broken apart and switched in a small interchange yard. INRD's purchase of an upgraded fleet of SD40-2 locomotives facilitated a run-through power agreement with the CP, eliminating the time-consuming step of switching locomotives. The final step was construction of the $1.5 million Dixie Siding near IP&L's Harding Street Station, which made it possible to stage train sets near the plant and eliminate switching out loads and empties at the Senate Avenue Terminal. Not only did these improvements improve service for IP&L and win a renewal of INRD's long-term transportation contract, they also resulted in sharply reduced street congestion in Linton and Indianapolis due to reduced switching operations and blocked crossings. This benefit to the public opened up an important source of funding for the construction of the Dixie Siding—a $500,000 grant from a government air quality improvement fund and from the state's industrial rail service program. Reduced congestion at Senate Avenue Terminal also freed yard trackage for new opportunities. And it wasn't long before a significant new contract was won.

In 2003, INRD was selected by a major plastics producer to receive and stage loads in Indianapolis to help the manufacturer reduce transit times to customers in the Midwest, a concept known as "forward placement." Senate Avenue Terminal tracks now hold 286,000-lb. covered hoppers where IP&L cars were once switched. The plastics contract was large enough that the railroad had to acquire even more property to accommodate the business. Indiana Rail Road leased and rehabilitated a dormant Class 1 facility on the city's east side, the former CSX State Street yard. Since that time, the company has closed additional deals with other plastics shippers to store product, and it is actively pursuing additional trackage to accommodate growing storage needs. By 2006, INRD expects to store and move more than 6,000 carloads of plastics annually.

The Need for Speed

Today, the ongoing increases in business have pushed INRD carloadings to tenfold over what the rails carried under Illinois Central ownership. In 2004, thanks to the robust plastics business and the inauguration of a new ethanol plant in Illinois, the Indiana Rail Road Company posted a year-over-year revenue increase of 15 percent, the best in the company's history. It has been many generations since a railroad achieved the status of a growth company. And with rapid growth comes a certain amount of growing pains. INRD's single-track main line is again feeling the strain caused by explosive growth that has doubled traffic volumes an average of every six years. This time around, management is trying to alleviate the squeeze with a mix of technology and good old-fashioned track speed.

On the technological front, in early 2004, the railroad hired a consultant to create a computer-generated model of INRD traffic patterns. The model allowed managers to experiment with variable inputs and predict the results of various operating and traffic management practices. Ultimately, it will help INRD management to analyze return on investment and impact on customer service for a number of solutions to address growth. Other computerized technologies are being put to work as well, namely, a computer-aided dispatch (CAD) system.

With CAD, dispatchers' routine tasks are organized and automated by the computer, allowing track warrants to be issued more quickly and accurately and freeing dispatchers' time to attend to scheduling and working with customers. The system will also help dispatchers handle additional workloads as the railroad continues to expand beyond its current territorial boundaries, such as the addition of Central Midland Railway. CMR is a Missouri short-line managed by the INRD under contract for its major customer, Ameren. Indiana Rail Road, by virtue of its robust business results, has been at the top of the list for Class 1s and other companies looking to contract railroad operations and management. The INRD had a number of such expansions in planning phases at the time of this writing, and CAD will play an important role in executing such deals.

In future phases, CAD technology will be integrated into systems for both Positive Train Control (PTC) and Electronic Train Management (ETM). Already in limited use on the INRD, ETM tracks train movements with global positioning satellites (GPS). The technology was pioneered in the trucking industry by Schneider National, which used GPS data to keep track of its fleet of thousands of trucks nationwide. On the INRD, the system displays train position for dispatchers on a detailed moving map.

With continuous position data transmitted over the air from locomotives, the system calculates train speeds and can be used to monitor operator performance and ensure safety parameters are met. Onboard event recorders are downloaded and queried automatically, to help identify potential problems in train operation. By combining CAD and ETM, the railroad will have a powerful tool for managing operations, with the capability to track train movements in real time with advanced controls that will allow more trains to operate in proximity with enhanced safety.

While these electronic improvements will greatly advance the efficiency of operations, the factors in the physical world are still just as crucial to improving performance for future growth. In 2004, a record $6.5 million budget for capital expenditures was approved; much of that sum was spent on track projects aimed at increasing speeds across the entire railroad to 40 mph. When trains can move faster, they can get out of each other's way more quickly and reduce conflicts, making the railroad more nimble and better prepared to deliver more than 10 million tons of coal and thousands of carloads of mixed freight that now pour onto INRD rails each year.

How about sometime in January?

—Canadian Pacific's Latta Sub dispatcher,
August 16, 2004, on when he would like
to receive an empty unit train from the
INRD

A Day in the Life of the Indiana Rail Road Company

People who observe railroads from the outside usually have a
deep appreciation for the aesthetics of the industry—the
machines, the sensory experience, the compelling romance of
railroading—but often find the actual *business* of railroading to
be somewhat mysterious, perhaps even mind-boggling. It's al-
most miraculous that across the country, hundreds of trains, car-
rying thousands of cars, each the size of a small house, get
sorted, built, routed, coordinated, received, and delivered every
day (and, for the most part, successfully and profitably). To the
public, the only visible face of railroading is usually the one be-
hind the locomotive cab window, but there is a small legion of
people behind the scenes who orchestrate the daily rhythm of
the railroad. Their work, while mostly invisible to the casual ob-
server, is essential in keeping the trains moving and making the
railroad productive.

Here is a synopsis of the daily drumbeat of the railroad,
spelled out in an around-the-clock narrative as seen from the in-
side out. For an arbitrary 24 hours in late summer of 2004, this is
how the railroad looked, sounded, and functioned—a day in the
life of the Indiana Rail Road Company.

0800

Switz City, Indiana. First-trick dispatcher Wade Deckard has been in the building for ten minutes, hearing a synopsis of what the railroad looks like this morning. Rick Hall, the man he replaces, is about to call it a day, and he gives Deckard the scoop on what's been happening since midnight: A crew on the south end local have exhausted their service hours at Oblong, Illinois and will need a re-crew. Another crew is building a train of coal empties at Hoosier Energy's Merom generating station, but the clock is ticking for them as well. A second unit train of empties is ready for a crew at the Ameren generating plant in Newton, Illinois, and up the line in Palestine, the daily turn to Switz City is building his train and will be calling for his warrant shortly. On top of this, there are four track foremen on duty, supervising crews and moving equipment on nearly every part of the railroad.

After a quick rundown of who's rested, who's not, who's first out, who's marked off, and what cars are parked in what sidings and where they need to go, Hall can go home. Deckard settles in and goes to work. In front of him are half a dozen flat-screen computer monitors with a schematic display of the railroad, color-coded to show warrants and reported locations of crews, trains, and equipment. This is INRD's new computer-aided dispatching (CAD) system, designed and installed by Wabtec. It's fresh out of the box, and the dispatchers, having received their textbook training, are now putting the system to the test in the real-time, workaday world. Their assessment is overwhelmingly favorable; the

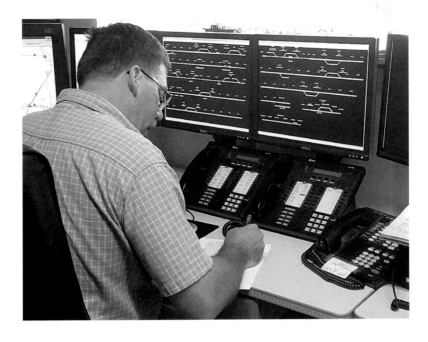

Dispatcher Wade Deckard keeps the railroad moving with the help of INRD's new computer-aided dispatching system. Photo by the author

only complaints are with persistently small but relevant details (e.g., a window opening in an inconvenient screen location, inconsistent alphabetical sorting in some menus, etc.). These minor idiosyncrasies notwithstanding, the potential for this system to enhance efficiency for the INRD is apparent. Especially so when considering the railroad's plan to merge the new CAD system with the existing GPS train management technology using global positioning satellites and its detailed moving maps, graphic depiction of track warrant limits, Form Bs, and other relevant data. With the computer keeping track of all the trains via GPS reporting, the sys-

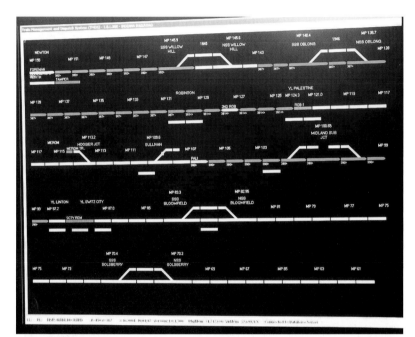

Close-up views of the INRD track schematic as displayed by the computer-aided dispatching system. Photo by the author

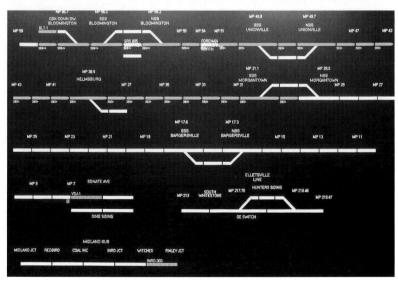

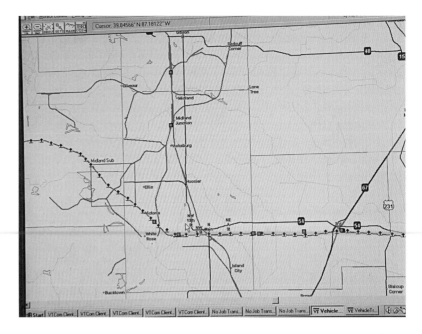

GPS technology gives the dispatcher a detailed map display of the railroad. Photo by the author

tem can cut workload for the dispatcher and train crews by automatically rolling up track behind them when they're in the clear.[1] Additionally, it can help the dispatchers better predict conflicts and optimize train movements to keep things running efficiently. INRD managers hope it will help them squeeze more capacity out of this busy railroad.

Although the weather is unseasonably mild for mid-August, the array of electronic equipment in the dispatcher's room pushes the inside temperature to nearly 80. There's an oscillating fan humming in the background, and the door is left half-open to draw in some cool air from the adjoining clerk's office. A walk-up service window for train crews is adjacent to the dispatcher's desk, and it too is open to help mitigate the stuffiness. The INRD office and shop building at Switz City is a tidy, modern facility. The dispatcher and clerk are on the ground floor, with offices and a conference room upstairs. Based here are managers for operations and customer service, communications and signals, and mechanical and track departments. A separate exterior door opens to an uncarpeted cement floor that bears the brunt of oily, steel-toed boots—a locker room and facilities for train and mechanical personnel. The two floors of offices and crew areas take up half of the building; the other half is occupied by a two-story engine shed with an inspection and repair pit. Like the tracks outside, it's also unusually empty today, save for mechanics working on company automobiles and trucks in a far-off corner of the shop. The emptiness of the shop reveals a spotless interior with freshly painted floors and walls, evidence of recent seasonal maintenance work.

Two locomotives are parked outside the north door—SD10 no. 560, a holdover from the old fleet used for work trains and backup power, and the remote control switch engine, GP16 no. 1813. Both are shut down and silent.

Rick Morris, the Switz City switch engine operator, has been on duty since 0500. He arrives every morning at that time to discover what switching puzzle he'll have to solve to get cars sorted and delivered to Indiana Southern at Switz City and Canadian Pacific at Linton. This morning, there were only half a dozen cars to be positioned—an abnormally light workload. On any given day, Morris would expect to handle 10 times that number or more. The weekly rhythm on the INRD, as with many other railroad divisions, yards, and terminals, starts with lighter volumes on Monday and then builds day by day to a fever pitch at the threshold of the weekend. When things get congested, Morris has precious few places to juggle and stash cars: the main track, a long siding, a connecting track with Indiana Southern, a couple of lead tracks for the locomotive shop (provided they're unoccupied), and whatever portion of a siding at the nearby Triad mining loadout that happens to be available. Morris relates the story of a recent morning when he arrived to find more than 80 cars on the north end of the main, nearly 40 on the south end, and much of his available workspace occupied with other cars.[2] It was a long, hot day, spent constantly in motion getting them all switched. But not today. This Monday is a fluke, and Morris's work is already done until the turn arrives from Palestine, and even that train will have only two cars for him this morning.

Palestine, Illinois. Veteran hogger Warren Thompson is on the PALI job today. PALI is the symbol for the Palestine–Linton turn, which actually turns at Switz City.[3] Thompson formerly handled the road job hauling coal and empties in and out of Indianapolis, but more recently the unpredictable hours and fatigue had gotten the better of him, and he opted for the PALI job instead.[4] With just two cars bound for the CP, he'll have his consist put together and his track warrant in hand in no time.

Linton, Indiana. INRD property here is a beehive of orange-vested workers. This has been an intensely active spot on the railroad this summer. The main track has been rebuilt down to the subgrade, with brand-new rail, all new crossties, and ballast. The siding and house track have also been surfaced and tamped. Track foreman John Fields has been supervising the dramatic transformation, which includes a permanent grade crossing closure and improved warning devices for the remaining crossings. A few months ago, the INRD looked like a branchline here. Now, it looks as good as any Class 1 main line. The contractor's crew is putting down crushed stone around the crossings with front-end loaders, and the

ballast regulator is busy sweeping the tracks, with baseball-size chunks of limestone clattering and ricocheting beneath its apron.

Bloomington, Indiana. There is a sizable rail replacement project going on just south of Bloomington, and a crew from Sperry Rail Services is onsite with their track geometry car to help finish the job. To accommodate this activity and other maintenance on the north end, two trains, SABL (Senate Avenue–Switz City) and LISA (Switz City–Senate Avenue), have been temporarily annulled, giving the section crews an abundance of track time—and some mercifully mild weather. to do their work. The cars normally moved by these jobs are being tacked onto the rear of IP&L coal trains for the time being.

Indianapolis. On the 16th floor of a modern office tower at 101 West Ohio Street, receptionist Gloria Jackson opens the doors for business and turns on the lights. Many of the managers have already arrived, clutching Starbucks coffee cups in one hand and satchels in the other. They file in past walls adorned with dramatic Chris Burger photos of the INRD "red" fleet, framed prints of Mitchell Markovitz paintings and O. Winston Link photos. Staff are busy preparing for a regular INRD ritual, the Monday morning all-staff briefing.

A couple of miles to the south, the daily switching chores at the Senate Avenue Terminal are under way. Marcos Zavala is on duty with the remote control yard engine. Zavala, 56, has been a railroader for nearly half of his life; prior to his 16 years with INRD, he worked on the Missouri Pacific in Texas. The overnight transfer runs between CSX's Avon and Hawthorne yards have brought in plastics loads from the Texas Gulf coast, empties for GE in Bloomington, and a grab bag of mixed freight, all of which needs to be switched. With the temporary annulment of the merchandise freights to and from Switz City, Zavala's to-do list looks somewhat different than usual. Aside from switching the reload center and industries surrounding the terminal, his first order of business is to finish building today's BLLI, which hauls primarily GE empties south to Bloomington and turns with loads. Wearing his remote control beltpack and mirrored sunglasses, he goes to work pulling and shoving cuts of cars in and out of the yard tracks, with the musical pinging and screeching of the wheel flanges filling the air.

0912

Switz City. Dispatcher Deckard is laying plans to relieve the expired crew of ROB2 (the second-trick Robinson, Ill., local). He needs the only rested pair of crewmen on the extra board for the

Merom empties, so he elects to bring on the Sullivan turn crew early. By their normal 1730 report time, another extra board crew will be rested and can take the turn. But Deckard has lingering concerns about the Merom run. With only two train sets serving the plant, a significant delay can instantly throw the operation off balance. The cause for concern is the Canadian Pacific's Latta Subdivision, where the headaches today are in another league altogether. The Indiana Harbor Belt (IHB), CP's Chicago connection, is having signal troubles and won't take any traffic from CP. Meanwhile, the sub is filling up with trains and the railroad is quickly running out of places to put them.

Indianapolis. The Monday morning briefing is under way, with Switz City managers taking a virtual place at the table via the speakerphone. This morning's agenda includes regular reports on train performance, delays, crew starts . . . the list goes on. The meeting begins abruptly with the recitation of two numbers. The first is the number of days worked without a lost-time injury; the second is number of days without a reportable incident. Last week was another good one, and the numbers have been ratcheted up accordingly. The meeting proceeds, starting with a detailed report on INRD grade crossings and the prognosis for closing a number of crossings within the next several years. The briefing proceeds with reports from all the managers and discussion of various issues raised. Conspicuously absent from this morning's meeting are Chief Operating Officer John Rickoff and Director of Industrial Development and Engineering Services John Haselden, who are on their way to Palestine to inspect the yard before launching a construction project. By the time the meeting is under way, they're motoring westbound on I-70, approaching Terre Haute.

0928

Hoosier Junction. The crew building a train of coal empties at the Merom generating station is quickly running out of time, and after the northbound PALI reports clear of the plant lead, they receive orders from the dispatcher to tie up at the first grade crossing north of the switch, where they'll meet their relief crew. The trainmen move toward the switch and get ready to pack it in for the day.

Newton, Illinois. From the extreme south end of the main line, track foreman Bo Hartleroad calls the dispatcher. He has equipment to move over to Willow Hill, where there has been some tamping and surfacing work going on, and he's ready to go. He pauses, waiting for dispatcher Deckard to do some hunt-and-peck

typing, and then his warrant comes over the radio. A quick read-back confirms the order, and the track is all his.

Switz City. This is one of those cartoonlike moments when you can imagine the part of the dispatcher being played by an octopus. If Wade Deckard had eight hands, he could use all of them right now. He's simultaneously attempting to answer two phones and a radio call, while preparing the track warrant for Hartleroad. The pace of the dispatcher's job, while not this insane at all times, remains brisk and hectic throughout the day. The complexities of safely moving trains, predicting events and scheduling crews requires a great deal of thought and concentration, but the available moments for thinking are few and brief, cut short by the ringing of phones and the crackling of the radio. A normal person might be climbing the walls by the middle of a shift, but Deckard, a former trainman, is cool and unfazed through it all. All of his exchanges on the phone, no matter who's on the other end, are punctuated with a warm "you're welcome" and always signed off with a friendly "bah," the southern Indiana contraction for good-bye.

0942

Before Deckard can catch his breath, Warren Thompson chimes in from the cab of northbound PALI. He's at milepost 107, clear of the CSX interchange at Sullivan, and he's calling to roll up track behind him. After voiding Thompson's earlier warrant, Deckard notices a stranger who has appeared at the service window. The lone man, carrying a camera bag, has been waiting patiently for several minutes during the flurry of activity. He's a railfan on a pilgrimage all the way from Cleveland, and he has dropped in to inquire about train position and the prognosis for a good photo op at Tulip Trestle. Deckard treats him with characteristic courtesy, but the prospects for a trophy photo aren't good. It will be twilight at best by the time the big viaduct sees any trains today.

Disappointed, the railfan departs to search for trains at other locales, and Deckard turns immediately to answer another radio call. It's track foreman Jim Bob Carmichael at Bloomington. He needs to lay claim to the turf northward to Morgantown, which Deckard grants. The warrant is issued and confirmed, and his limits appear on the computer's schematic display highlighted in blue, the color reserved for section crews. As the day progresses, an increasing portion of the screen turns that hue as summertime track work continues at a feverish pace. The transaction with Carmichael is barely complete when the chief dispatcher, Randy Blevins, abruptly enters the room. He gives detailed, rapid-fire instructions about crew training slated to take place in Indianapolis

and directs Deckard to call the senior trainmen and get them each scheduled in succession for six-day stints to become qualified for yard transfer jobs on the north end. Despite the quick interchange and the fact that Deckard is intently focused on the computer in front of him, he catches all the details from Blevins and notes the irregular crew scheduling on his mental to-do list. In addition to this scheduling wrinkle, Deckard is also trying to solve the scheduling puzzle of getting as many crew members as possible called to attend one of the company's quarterly breakfast staff meetings, which is taking place in less than 22 hours.

0956

Milepost 104. With PALI's two GP38s and two high-side gondolas making progress toward Switz City, Warren Thompson radios the dispatcher for clearance through Midland Junction, as is required of all trains. The dispatcher has control of the switches, lining them with a radio tone. Lineside indicators use colored lights to display the condition of the switch to approaching trains and broadcast an audio message when successfully actuated. Gapped points or other failed actuation triggers a red indicator light and an audio fault message. The process of lining up an approaching train requires a 10-minute lead, which translates to four miles of track. Thompson calls right on schedule and gets the go-ahead to roll through. These radio-controlled switches are the first application of such devices on any main line railroad. This Indiana Rail Road innovation eliminates the need for a second crewperson on the train to line switches, and it facilitates more widespread use of one-person crews.

Back at Switz City, Gayla Dailey, INRD clerk and office manager, arrives for her 1000–1500 shift. She enters the dispatch office and heads for the fax machine to grab some incoming paperwork and then begins verifying employee time sheets and processing payroll records.

Following PALI's clearance through Midland, Deckard rings up the shipping manager at Hoosier Sand & Gravel up the line in Bloomfield to see if there are any sand loads to be picked up. The reply is not yet, but there will be five cars ready to go within a couple of hours. Rick Morris's afternoon itinerary is now set. Following this exchange, Deckard uses a spare moment to catch up with the situation on the CP. He contacts the planners in Milwaukee to discuss the outlook and try to determine when he can get his Merom and Ameren empties moved up the Midland Sub and off of his rail. But the planner doesn't have room to put anything and is at the mercy of the IHB and its signal maintainers. Deckard replies that he can hold the Ameren train at the plant and will

check back later on the Merom train. After signing off with the CP planner, he immediately phones the Ameren coordinator to inform him that the empties will have to stay put. The next inbound train of loads hasn't yet cleared Chicago, so for now there's enough room at the plant to hold them.

1011

Switz City. Another flurry of activity now unfolds on Deckard's desk. ROB2's relief crew calls to roll up track and get their clearance into the south Palestine yard limit. As Deckard clears them past the finish line, Blevins again abruptly enters the room with another update for the general bulletins. The main line will be closed next Wednesday from 0600 to 1800 for construction of a grade crossing at the new Lincolnland ethanol plant. This will effectively annul ROB1 that day, which will require some coordination with customers. After the update, Blevins announces that he's going to head home. He has been trying to stave off a flu bug for several days and has decided to throw in the towel. The bug has been going around; several railroaders and their families have been struggling with it for a couple of weeks. Meanwhile, still rolling north with PALI, Warren Thompson calls for clearance to enter the Switz City south yard limits.

At 1016, foreman Terry Deckard calls for a Form B to protect additional track from the Bloomington rail project to the Switz City north yard limit. As Deckard finishes issuing the warrant, Thompson calls to roll up track behind PALI.

1100

Palestine. Having arrived at 1045, John Rickoff and John Haselden are beginning their inspection of the Palestine yard. This year's capital plan calls for the addition of two new tracks in the yard to accommodate increased business from the Marathon Ashland refinery and the new ethanol plant. Rickoff and Haselden are here today to make an informal survey of the site and discuss the logistical and engineering issues surrounding the project.

Senate Avenue Terminal. Marcos Zavala has finished building southbound BLLI and has shoved the train headfirst into the staging track (known as the IU track) in preparation for the crew. His next order of business will be to pull scrap loads from K&F Industries next to the yard and replace the cars with empties.

Switz City. The blaring horn approaching Highway 67 announces the arrival of PALI. The train crawls past the Triad coal loadout

and rounds a wooded bend, swinging into view of Rick Morris, who has lined the switch for the siding to cut the two incoming cars. The pin is pulled, Morris steps onto the trailing engine, and half of PALI's switching is already done. Thompson drives 90 car lengths north and out onto the main, pausing for Morris to close the switch behind him. The train noses onto the six southbound cars, which have been parked on the main all morning. Thompson neutralizes the control stand and configures the unit to trail on the return trip. A stroll down the catwalk, and he's quickly seated in the south-facing unit and rolling back toward the engine house. He pauses at the shop track switch, and Morris cuts off the train. Thompson pulls ahead to the fuel rack, the blue flags go up, and he steps off to trade bills with Morris inside while the locomotives are serviced.[5]

1125

Senate Avenue Terminal. The crew of southbound BLLI arrives to conduct their job briefing and organize their paperwork. Their power is on the locomotive track behind the yard office. When it's time, they'll roll out of the yard and pick up their train at the staging track for the trip to Bloomington.

Bloomington. An unusual vehicle is parked at the Kohl's department store on the city's west side. The parking lot and railroad are only two dozen feet apart and nearly on the same grade, giving the impression that someone has driven a CF7 and caboose on a shopping trip. Unit 2543 is the last CF7 from INRD's phase one fleet remaining in operation. It is perpetually coupled and m.u.'d to a caboose carrying remote control equipment.[6] Having served faithfully, lugging coal trains and later serving as the Senate Avenue yard engine, it has now been assigned as the Bloomington yard engine, servicing GE and other nearby industries. It sits near the department store on the old Monon main at Hunter siding, waiting between calls for plant switches, which can number as many as four a day. Later, the little engine will take the day's haul and coast down to the connecting track on Pigeon Hill, where BLLI will swap empties for loads.

Switz City. Hoosier Sand & Gravel in Bloomfield calls with five loads. Rick Morris will first proceed south to Linton with the two coke empties from PALI. He'll set them out at the CP interchange and take whatever freight is waiting there for him before heading back north for the sand loads.

Hoosier Junction. The fresh crew for the Merom empties has arrived to take command of the train and get it moving. CP is still

dealing with problems up north, but will have a crew and power ready to receive the train at Midland Junction.

Palestine. The Sullivan Turn crew has returned ROB2 to the yard and is putting the train away before going off duty.

1212

Indianapolis. The staff briefing is wrapping up, just in time for lunch. Managers retreat to their desks and just as quickly file past the reception desks and into the elevators to head out for a quick bite. The briefing has taken longer than usual today because of the grade crossing presentation, which leaves a lot of tasks to be squeezed into the remaining workday.

Switz City. Three back-to-back warrants are fired off. The first is for Warren Thompson, departing Switz City with the southbound PALI. Thompson is moving for now, but his progress will be stymied at Midland Junction as a result of the next warrant: clearance for the Merom empties to depart northbound from the plant. Finally, the third go-ahead is for an unusually late southbound BLLI to depart Senate Avenue Terminal with mixed freight and GE empties. He's good as far south as Morgantown, where he'll run up against the limits of foreman Carmichael's Form B.

1306

Indianapolis. Activity begins to pick up in the ring of offices on the 16th floor of 101 West Ohio Street as more people return from lunch. In the accounting office, Mike Engel, a longtime member of the INRD management team, is gathering data on CN/IC performance at the Newton interchange. INRD has been experiencing ongoing difficulties, including several missed interchanges. Engel will supply data for the VP of operations to take the case before CN managers for a remedy. Across the hall, vice president of marketing and sales Dave Long is juggling a number of significant projects, including expansion of a large plastics contract signed earlier this year and opening a new market in Indianapolis for products from the Marathon Ashland refinery in Robinson, Illinois. Thanks to the efforts of Long and others in the INRD marketing department, the railroad in 2004 posted a 15 percent increase in revenue over the previous year. the best in recent history and on-par with the company's previous record-setting year.

Switz City. Afternoon desk work is also progressing at INRD's midway outpost. Director of road operations Scott Orman is finishing a posting for a new job at Palestine, a yard switcher to help

locals, particularly ROB2, sort their cars and reduce chronic over-time and re-crewing. In addition, he's scheduling new employee training and checkrides and preparing for a periodic visit from the FRA to review recordkeeping. A few doors down, in an office decorated with vintage Lionel trains, John Cummings manager of communications and signals, is rifling through a stack of paperwork: insurance claims, a police report on a recent crossing accident, and paperwork for an upcoming incident investigation.

Manager of operating practices John DePaemelaere, is also in the building, writing a general bulletin. It's an order imposing a 5 mph restriction on the Ameren lead for the next few days while he measures and installs mileposts. He'll head to the site tomorrow afternoon, but first he'll be making an early morning hi-rail trip on the north end. He'll check the right of way before an inspection train carrying Norfolk Southern executives heads south to observe the Bloomington rail project. DePaelmelaere, a recent addition to INRD management, is an ex-BNSF road foreman who oversaw operations over the famous Cajon Pass, one of the busiest and least-forgiving stretches of railroad anywhere in the world. After distributing his general bulletin, he's out the door with copies of INRD's new rulebook and timetable, which he has been distributing to employees.

Midland Junction. Southbound with two locomotives and a half a dozen cars, Warren Thompson is easing to a stop. His short train is a bonus for the dispatcher today—it will fit comfortably between the two legs of the Midland Sub wye, which will soon be occupied. Within a couple of hours, IP&L loads will be rolling through the north leg and the Merom empties will be coming up the south. For now, however, there's nothing for Thompson to do but wait between the switches.

1400

Senate Avenue Terminal. The second-trick yard engine is now on duty, overlapping the first trick by one hour to provide a two-man team for building the evening's transfer runs. Once those chores are taken care of, the rest of the afternoon and evening will be spent servicing nearby industries and cleaning up the yard to receive inbound cars from the returning transfer trains.

Switz City. Rick Morris is done for the day, having serviced the CP interchange in Linton and pulled the five sand loads in from Bloomfield. It's a rare day when he clocks out with eight hours, and on a beautiful day like today, he'll gladly take it. The northbound cars have been staged for pickup by this evening's IP&L coal train, which will be released from the Farmersburg mine with a CP crew at any minute.

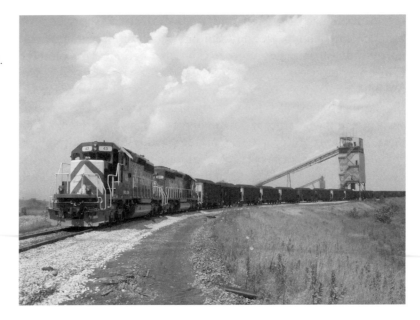

An IP&L train loading at the Black Beauty mine near Farmersburg, Indiana. A Canadian Pacific crew will bring the loaded train onto the INRD at Linton and take it as far as Switz City, where an INRD crew will step on for the remainder of the trip to Indianapolis. Photo by John Cummings

Indianapolis, 101 W. Ohio St. In the president's office, Tom Hoback is trying to return his most urgent phone calls and e-mails before ducking into an afternoon meeting to discuss operations on the Central Midland Railway, the rechristened Missouri Central, owned by Ameren Corporation and operated under contract by the INRD. It's not an easy task managing an additional property two states away. In addition to a fair amount of travel, it requires good lines of communication, which is precisely what the upcoming meeting is all about. VP of marketing Larry Kaelin will be joining the meeting, and he's in his office trying to wrap up a phone call with an executive at Rogers Group, Inc., operators of a major limestone quarry in Bloomington. Kaelin, along with Chief Financial Officer Steve Meyer, has been nurturing a long-standing proposal to build a rail spur and loadout at the site, and Rogers recently signed a letter of intent with Meyer. Rail service will open up long-desired new markets for Rogers and originate significant tonnage for INRD, including ag lime, ballast, and most significantly, scrubber stone for coal-fired power plants. However, the spur requires several miles of new right-of-way, and moving forward with the county council and landowners is a long and delicate process.

At the reception desk, Susan Ferverda, vice president of administration and human resources, is greeting a candidate who has arrived to interview for a mechanical department position. Ferverda has been increasingly busy with interviewing; the net number of INRD trainmen has grown to nearly 40, and attrition has required hiring and training even more. A few feet away in a

conference room, marketing recruits Joe Barbieri and Mike Stickel are comparing notes on a possible new movement. Barbieri and Stickel represent a new generation of railroaders who are bringing a great deal of energy and freshness to the industry. Working for a railroad that also happens to be a small business gives both of them the opportunity to enjoy an environment where their actions have an immediate impact on the company's success, an experience that can be foreign to Class 1 recruits.

1420

Sullivan. Led by a pair of SD40-2s, the train of empties from Merom is clearing the CSX diamond and continuing toward Midland Junction, where Warren Thompson is still in the hole with southbound PALI. Although INRD is fully capable of utilizing one-person crews on moves such as this one, a two-person crew is required due to the fact that the train will be moving onto CP turf, and their work rules require two in the cab.

Morgantown, Indiana. BLLI has progressed southward. With foreman Carmichael's equipment now out of the way, the train receives a track warrant to MP 54, the old Bloomington yard limit.

Senate Avenue Terminal. Midafternoon finds Dick Finley at his desk in the yard office. He's got a full plate of projects in the works. At the south end of the yard, he has a crew changing wheelsets on a leased GP38. The engine's front end is awkwardly truckless, with the pilot resting on wood blocks and the giant cables of the INRD wrecking crane in place to pick up and suspend the unit. It's quite a spectacle, all being performed in the open air. In the two-stall shop, three ex-Amtrak express cars are being painted the signature red and silver of the locomotive fleet and modified to carry a traveling Abraham Lincoln exhibit for the Indiana Historical Society's Indiana History Train. Tom Hoback is a board member of the Society and has committed the railroad's support of the project with equipment and crews. The train rolls out on an aggressive schedule beginning in October, and getting the cars ready in time will be a tall order for Finley's crew. Also on the shop tracks is GP38 no. 30, awaiting repair of its front pilot. It recently suffered a bump caused by a broken knuckle while switching a heavy train. On the next track is a heavyweight observation car owned by an Indianapolis attorney and used for many years as INRD's business car. It's receiving a litany of repairs for its last official outing on a president's special before being moved off the property. Coupled to it is the reason for its exodus. Tom Hoback has purchased a new business car, the former Santa Fe no. 56. It sits with crudely stenciled reporting marks applied for its move from the West Coast and now

awaits a thorough sprucing-up before being inaugurated in service.

Three tracks to the west, mechanical department employee Dennis Wisemore is perched on engine no. 32, changing a headlight bulb in the warm afternoon sun. Slender and blond, he looks as though he should be crouching on a surfboard instead of a locomotive hood. Although his youthful appearance makes him look like a new hire, Wisemore has actually been with the INRD since the very beginning.

Heavy work at Senate Avenue Terminal: While the Indiana Reload Center hums with activity in the background, crews are using the big hook to de-truck a leased GP38 to swap out wheel sets. Photo by the author

1431

Midland Junction. With PALI still parked between the switches, LISA (Midland–Dixie) is cleared onto the Midland Sub northbound. Led by engine 41, the IP&L coal loads squeal their way around the north leg of the wye.

Switz City. Returning from Bloomfield with sand loads, Rick Morris calls to roll up track behind him. He'll park the loads and prepare to call it a day. Dispatcher Deckard receives a slightly heated message from the CP crew caller, who believes that he has kept her crew waiting for the Merom train while the northbound LISA was moved. Deckard explains courteously that the movement was carried out in accordance with the wishes of the CP planners in

On the shop lead, ex-Amtrak express cars are dressed in a new coat of INRD red during their renovation as the Indiana History Train. Photo by the author

Milwaukee. As far as Deckard can guess, the planners had either not notified her or deliberately misinformed her to hide their own mistake. Hang around a dispatcher's desk for any length of time, and you will come to understand that a select few of the voices on the other end of the phone belong to characters who practice their trade like a cat-and-mouse game, spinning untruths to cover their own ineptness and mistakes.

1443

Midland Junction. The northbound train of Merom empties, led by engine 43, crawls past Warren Thompson's train up the south leg of the Midland Sub. It's almost time for him to get back on the throttle.

1518

Robinson, Illinois. ROB1 has been taking care of business at the Marathon Ashland refinery and has some cars to deliver to the Newton interchange. With foreman Hartleroad now in the clear at Willow Hill, ROB1 receives a warrant into Newton.

Midland Junction. Warren Thompson, now looking at a clear track ahead of him, hears the voice of the dispatcher come crackling over the radio, "Are we ready to go home, Mr. Thompson?" A warrant quickly follows, and PALI is headed back to Palestine.

Bloomington. Having arrived at MP 54, BLLI is ready for a work-between warrant to set out the consist and gather the northbound cars for his return to Senate Avenue. After a few false starts, the readback is correct and he's ready to go to work.

1525

Midland Sub. CP calls for permission to bring their power onto the Midland Sub to take the Merom train. Dispatcher Deckard responds with a "look for/talk to" clearance, informing the trainmen to watch out for engine 43 and stay in radio contact with the INRD crew, who will be cutting off the train and moving back down the sub.

1538

Switz City. A welcome sight for Wade Deckard appears in the doorway: relief dispatcher Ben Padgett. He parks his personal effects on a table and begins perusing the day's transfer report. After wrapping up a phone call, Deckard prepares for the changing of

the guard with a briefing on train, track, and crew status. Before turning the railroad over to Padgett, he makes one final call to the CP to see when they might like to receive the empty Ameren train waiting at Newton. The answer from the beleaguered dispatcher sounds back over the speakerphone, "How about sometime in January?"

1614

Bloomington. Track foreman Terry Deckard knows that an IP&L coal train will be headed his way. He calls dispatcher Padgett, who has taken over the helm of the railroad, and inquires about an ETA for the train. Padgett's forecast calls for 2000–2030.

1623

Switz City. Almost within sight through the dispatcher's south-facing picture window, the road job with IP&L loads arrives and holds short of the highway 67 crossing with engine 41 on the point. Its CP crew ties up and jumps into a van for the trip back to Latta.

Senate Avenue Terminal. Trainmen Mike Skora and Terry Hutto arrive at the yard office within minutes of one another to prepare for their nightly transfer run to CSX's Big Four Yard in Avon, with an intermediate switching stop at State Street Yard. They proceed inside to review track bulletins and check their paperwork. On their heels is the crew for the nightly utility job, which switches the IP&L plant and Norfolk Southern cars at Hawthorne Yard. The yard office becomes a lively place as some of Finley's shop men, blackened from their day's work, mill about the place to socialize before hitting the pumice soap and knocking off for the day.

1639

Midland Junction. Heading down the north leg of the Midland wye, the light engines from the Merom train are also bound for Switz City. The crew isn't too pleased to be hemmed in behind the IP&L train, but the dispatcher needs them to assist in switching the northbound sand cars and mixed freight onto the tail end of the coal loads.

Senate Avenue Terminal. The Avon transfer crew is congregated around the fax machine with the utility crew and terminal operations manager Ed Wilson. The group is shooting the bull while waiting for their paperwork, which is being prepared at INRD's downtown offices. The Avon train is ready on the staging track, air tested with power idling.

1700

Riverton, Indiana. With the sun now directly facing him, Warren Thompson has received his clearance into the Palestine north yard limit and approaches the finish line, gliding high above the Wabash River. Once in the yard, he'll put his train away, complete his paperwork and jump in his pickup truck for the long drive home. Meanwhile, in the Palestine yard office, the crew of today's Sullivan turn are coming on duty. They'll put together a train of cars for CSX and bring the inbounds back to Palestine, usually a straightforward job, unless CSX dispatch delays their getting into the interchange.

Senate Avenue Terminal. Still no paperwork for the Avon crew. Hutto changes a battery in his lantern, and the pacing and jawing continues while they wait.

1812

Switz City. The driver of the light engines from Midland Junction informs the dispatcher that they've rolled up to the end of their warrant, behind the IP&L train.[7] The crew isn't called until 1830, and it will be nearly 1900 by the time they're on the throttle. Their engines will have a bit of time to cool their turbochargers.

Senate Avenue Terminal. Finally the fax machine hums and begins spitting out switch lists for the Avon crew. A few more minutes and they'll be hitching a ride with Ed Wilson down to their train.

1836

Senate Avenue Terminal. Aboard the lead engine, Skora releases the brakes, and the Avon transfer train begins its labored ascent up the 3 percent grade of the Indianapolis Belt Railway connecting track. The two GP38s are deafening as they crawl up the hill completely notched out. The ammeter is buried as the traction motor blowers kick up a storm of ballast dust and sand. The engines finally crest the hill and continue throttled up, hefting their burden of 286,000-lb. covered hoppers, scrap loads, and boxcars of GE refrigerators up onto the belt. The bellowing of the engines is reflected into the cab from a string of hi-cube auto parts cars stored on a siding. After what seems like an eternity, the throttle comes down and the train settles into a gentle 10 mph crawl around the southeast side of Indianapolis. Conductor Hutto organizes his grip and lunch cooler, which is topped off with a surplus of Marlboro Lights. After crossing the tracks of the Louisville & Indiana (the

ex–Conrail Jeffersonville Secondary), it's stop-and-go as he climbs off to line switches, one after the other.

1925

Indianapolis, on the Belt Railway. The Avon train slips past Prospect wye and the connection to CSX's Hawthorne Yard. The INRD utility crew will arrive later tonight to interchange with an NS transfer train that services the yard. Looming in the background is the Citizen's Gas & Coke plant, its sprawling coke yard furrowed with cuts of high-cube hoppers. Finally, the GP38s screech around a sharp bend and emerge into the once-dormant CSX State Street Yard, off the former B&O main line to Cincinnati. INRD is leasing the property to provide capacity for a new customer, a major plastics and chemical producer that stages inventory in Indianapolis to reduce transit times. The crew cuts the power from the train east of the yard and proceeds down the ladder to switch cars. They'll trade loads for loads and come out nine cars heavier than when they nosed in.

Senate Avenue Terminal. The second-trick yard job has a southbound cut of cars ready for the utility crew. The temporary annulment of regular merchandise runs to and from Switz City has pushed mixed freight onto the manifest of IP&L trains. With grips and lunch coolers in hand, crew members climb aboard a pair of GP38s and prepare to head to the Harding Street generating station. There, they'll pull coal empties and stage the southbound train in Dixie siding, just inside the Indianapolis yard limit.

Switz City. Brakes are released, the IP&L train eases forward and pulls the rear end clear of the long siding where the northbound sand loads and freight from CP are waiting. The light engines behind them roll into the siding and prepare to shove the sand cars onto the tail end, replace the EOT unit, and wish the crew a good trip.[8] After helping the coal train, they'll roll back south, switch their consist over to an engine shed lead, and tie up.

With his train now assembled, the engineer of the northbound IP&L train releases the brakes and prepares to put power to the rails. Next stop: Dixie siding inside the Indianapolis yard limit.

2000

Sullivan. The Sullivan turn has arrived at the CSX connecting track and is ready to call the dispatcher in Jacksonville for clearance into the interchange. The okay comes in short order, and the train heads onto CSX rail to go to work.

2108

Palestine. ROB2 is finally ready for a warrant out of the yard. The crew has been switching loads in the yard, mostly cars for the Marathon Ashland refinery. The pattern is feedstocks in, slurry oil and refined products out. Petroleum coke is also handled at the plant; empties come in for loading at Marathon and are then pushed south into the Robinson Carbon plant where they're unloaded for cooking in the kilns. Robinson Carbon also receives coke loads from offline sources. After their work at the refinery is done, they'll head down the line to Robinson's Hershey Foods plant to grab an empty sugar hopper on their way to switch the Newton interchange. With any luck, this time they'll make it back to Palestine before their 12 hours are used up.

2215

State Street Yard. The night's switching hasn't gone as smoothly as planned. Cars are jumbled in a different order on the tracks than indicated on paper, and the ones needed are buried. Hutto and Skora keep at it, pulling cuts in and out like a giant, horizontal yoyo. Finally, everything looks ready to go. Skora calls CSX dispatch in Jacksonville for the DTC block he needs to get over the last section of the B&O before entering the IU interlocking in central Indianapolis.[9] But while walking the train during the brake test, Hutto notices two suspicious scrap loads. He recognizes the reporting marks as cars normally routed through the CN/IC interchange in Newton. After cross-checking paperwork, he elects to set them out so they can be towed back to Senate Avenue after the train turns at Avon Yard.

Switz City. CP is slowly beginning to recover from the minor meltdown it suffered today, and INRD dispatcher Ben Padgett can call in a crew to take the Ameren empties out of the plant and get them started north. The inbound loads are working their way south from Chicago and will likely roll onto the INRD railhead at Midland Junction by around 0600. INRD crews handle the northbound empties all the way to Latta yard on the CP, while CP crews run through directly to Ameren. This arrangement is more expeditious, but CP work rules require the INRD to run with a two-person crew, which undercuts the job's efficiency. By the time tonight's crew is ready to roll, Padgett will be on his way home.

Dixie Siding. Things have been going slightly better for the utility crew than for the Avon transfer job tonight. Unlike the State Street Yard plastics loads, IP&L empties always travel together, and the

switching is all done within INRD Indianapolis yard limits. After building the train of coal empties on the siding, along with mixed freight from today's annulled southbound train, the crew positions light engines on the main, ready to receive arriving loads and pull them into the plant.

2256

State Street Yard. At last, brakes are released. Hutto returns to the cab and grabs an aerosol can of hand cleaner. The Avon transfer rolls westward. (Essentially, the train has made a U-turn after running to the east and swinging back northwest to enter State Street Yard.) Progress beyond the DTC block is delayed, however, as a dwarf signal blares a redeye at the crew within a stone's throw of the Indianapolis skyline. Soon the reason is evident as a trio of Dash-9s drags a CSX freight across the interlocking ahead. When the rear end clears, the caution signal lazily comes up, and the Avon train is moving again, creeping past the unoccupied tower and onto the former Big Four/NYC: the "Bee Line" from Cleveland to St. Louis. The train snakes onward, toward the train shed at Union Station. Emerging from the shed, it slowly passes the RCA Dome, Perry K steam plant, and Victory Field. Next, it's the Indianapolis Zoo and botanical gardens, a General Motors plant, and a junction with the Crawfordsville Branch, the former Pennsy line that swings to the south here. Past the junction, Skora notches up. Track speed is 40 on the double-track main, but with the heavy load trailing tonight, it might prove more than the pair of GP38s can muster. Within minutes, the train approaches another home signal and clatters across a familiar set of tracks. It's the belt railway again, directly across town from where this crew entered State Street Yard earlier tonight.

2311

Indianapolis, South High School Rd. The Avon train continues left-hand running toward the Big Four Yard with the locomotives furiously belting out their non-turbocharged chant. In the distance, a CSX freight approaches on the adjacent track. The two trains dim their headlights in a mutual salute and rumble past one another at a closing speed of 75 mph. Skora throttles back and prepares to roll to a brief stop at the signal protecting the South Hunt to the Crawfordsville branch. (The Crawfordsville main again converges with the Bee Line here, flying over it just east of the South and North Hunt connecting tracks.) The INRD train pauses while an inbound CSX descends North Hunt and crosses over into the yard ahead of them. At 2330, precisely seven hours after coming on

duty, Skora and Hutto ease their consist into the 11-track receiving yard. Routed down the runner to the west end, they'll be ordered to double back onto track four, which is already partially occupied. This leg of their shift has gone smoothly. On nights when the yard is plugged, they're held back on the main, sometimes up to two hours or more, while the yardmaster tries to clear up a place to put them among the other CSX arrivals. Tonight, however, their entry is relatively unimpeded. The 55 cars they've brought will be shoved over the hump, sorted, switched into outbound trains in the departure yard, and hauled away by dawn.

IP&L Harding Street Generating Station. The utility crew is dragging coal loads onto IP&L property. Delivery is a fairly easy task here, with only a couple of moves required. Within 45 minutes, the trainmen will be locking the gate behind them.

2342

Avon, Indiana. Skora and Hutto backtrack down the yard runner and cross over into the departure yard to grab the night's outbound take. The engines are coupled to the train, and Hutto cuts out the yard air that has been charging the brake system. With the train already inspected by a CSX "truck man," a clearance from CSX is all that's standing in the way of their heading back to State Street yard and, finally, back to Senate Avenue Terminal to wrap up the day's work.

Newton, Illinois. A pair of Union Pacific SD70MACs are waiting silently in the darkness at the Ameren plant. On duty, the INRD crew prepares to start the behemoths. The giant crankshaft is turned gently, tentatively at first, to clear the cylinders of any moisture condensation that could damage the rods or valves. That seems impossible to comprehend with a brutish engine of this size, which has connecting rods the size of barbells and valves as big as clarinets. Finally the sleeping giant roars to life, sending up a billowing plume of bluish smoke in the moonlight. The second unit follows, and the brakes begin to charge. In terms of holding air, this train set is tight as a drum. It's still packing a good charge, and the big units have it pumped up the rest of the way in no time.

Switz City. Dispatcher Ben Padgett is briefing his relief, Rick Hall, who is ready to take over once again. Padgett's last task of the night is to issue a track warrant for the northbound Ameren train. The Sullivan turn has made it in and out of the CSX interchange with no problems and is already approaching Merom Station, headed back to Palestine. The train will be put away in the yard before the Ameren run poses a conflict. Likewise, ROB2 is work-

ing deep inside the Robinson refinery, creating an open window to get the Ameren empties through. Things don't always work out this well, but it's a welcome occasion when they do.

Indianapolis, Bluff Rd. The crossing gates at Bluff Road descend to mark the arrival of 65 loads of IP&L coal, along with sand and a few cars of miscellaneous freight. The train enters the yard limit and proceeds to the south end of Dixie siding. The pair of SD40-2s cut off, leaving the train on the main, and nose into the siding to join the southbound empties. When the big red engines are clear of the switch, the utility crew eases their GP38s onto the loads and pulls them north on the main toward the IP&L plant. The four-axle, normally aspirated units breathe considerably heavier than their six-axle, turbocharged counterparts, which brought the train in from the mine. The crew of the inbound train now prepare for their journey back south by calling for their track warrant.

0033

Indianapolis, Dixie Siding. With the switch ahead now clear, the IP&L empty train, with track warrant in hand, releases brakes, and the turn is officially made.

0112

Avon, Indiana. After waiting their turn, Skora and Hutto, now aboard the east-facing unit, are released from the departure yard. They pull a 58-car train of plastics loads, GE empties, empty gondolas for K&F scrap loading, lumber, and mixed freight. This time it's easier to make track speed as they head downtown on their way back to State Street yard. Opposing them in the distance is a train led by a pair of GP38s from another foreign road, the Louisville & Indiana. Like Skora and Hutto, the LIRC crew are on their way to make a nightly revolving-door visit to the Big Four yard.

0130

Senate Avenue Terminal. Having delivered 65 coal loads to IP&L, the utility crew is dragging the five sand loads and mixed freight to the Senate Avenue Terminal. There, the yard engine has parked the night's outbound cars for Norfolk Southern on the IU track, where the Avon crew departed some five hours earlier. The crew leaves the inbound cars on the main for the yard engine, backs onto cars on the IU track, and calls for clearance to open up onto the belt.

0148

Palestine. Well on their way, the northbound Ameren empties are rolling into the Palestine yard limit. With the abundance of horsepower on the head end, the train seems to glide effortlessly through the yard and onward toward the Wabash River.

0205

State Street Yard. After weaving their way back through the IU interlocking and into the yard, the Avon crew pauses to shove a cut of plastics-laden covered hoppers into the yard and then grab the two wayward scrap loads that they left behind earlier. It's about 40 minutes worth of work, far more merciful than the three hours they spent earlier.

0231

Hawthorne Yard. The utility crew are easing their train around the bend and onto their arrival track. Getting in and out of this yard is not nearly as complicated and time-consuming as a visit to Avon, and they'll have their cars exchanged and be on their way back to Senate Avenue in short order.

0246

Robinson. Having emerged from the refinery in the wake of the Ameren train, ROB2 is headed through downtown Robinson, on its way to take the single empty from the Hershey plant. Then it's off to switch the Newton interchange and make every effort to return to Palestine before time runs out. It's ROB2 vs. the clock once again.

0314

Newton. ROB2 is crossing the Embarras River bridge. Once over the water, the train will coast down to the Newton interchange. The conductor will gather bills from the trackside office trailer and begin the task of swapping his cars with ones left by a CN/IC local a few hours ago. With the clock ticking and an inbound Ameren train on the horizon, it's imperative that things go smoothly at the interchange.

Dugger, Indiana. The gentle rumble of the empty Ameren cars breaks the silence of the darkened storefronts on Main Street as the big train moves slowly toward the south leg of the Midland wye and prepares to enter the sub, bound for CP railhead. If all contin-

ues to go well, the crew will be off duty in an hour or so, not long before a loaded southbound Ameren train will be getting a crew at Latta to take it on the last leg of its journey from Wyoming.

0329

Senate Avenue Terminal. Mike Skora eases his train down the steep off-ramp from the Belt with brakes set firmly. As the cars progressively roll off the hill, he begins to throttle up gradually and pull them the rest of the way down. The train squeals into the staging track, and Hutto climbs down to cut the power at the south end. The engines will run around the train and pull it into the yard, where Marcos Zavala will begin sorting the cars after dawn. Adjacent tracks hold the inbound cars from Bloomington. The incoming utility crew with Hawthorne cars will soon follow.

0455

Switz City. Rick Morris is ready to begin the day. He leans on the counter at the dispatcher's service window and takes stock of how his chores will be shaping up. It will be off to a quick start. The train of IP&L empties is entering yard limits from the north with mixed freight on the head end. The piercing headlight and ditch lights set the railheads ablaze like two glowing ribbons in the early morning haze. The air is so calm that the whining of the dynamic brakes can be heard clearly from the next milepost up the line, punctuated by the wailing of the horn. The power will cut off at the north end of the siding and head for the fuel rack, while Morris will nose onto the freight and take it off. Another set of light engines rests on the shop lead; a crew will be arriving shortly to take the locomotives onto the Midland Sub to meet an inbound train of loads for the Merom generating station. With luck, the train will be at the plant by noon.

0532

Willow Hill, Illinois. ROB2 is winning the race against the clock. There was a light workload at the Newton interchange, and the crew made their turn in good time. Track speeds on the south end have been increased recently, which will help them along further. There's no more work to do en route this morning, so it looks as though the train will be able to tie up in the Palestine yard before the 12 hours are up and before the Ameren loads pull through.

0601

Midland Junction. The town of Dugger is about to receive a wake-up call. A 115-car train loaded with coal from Wyoming's Powder River basin is easing down the south leg of the Midland wye, bound for Newton. Thirty mileposts away, ROB2 is rolling back toward Palestine, where it will be in the clear by 0630.

0700

Senate Avenue Terminal. Having surveyed the contents of the IU track on his drive to the yard office, Marcos Zavala walks in the door, removes his mirrored shades, and heads for the desk to review the morning's paperwork before getting the yard in motion.

Riverton. The morning hush hanging over the glassy surface of the Wabash River is broken by a pair of armor yellow leviathans as a CP crew drives the Ameren loads across the state line. The lead unit is an imposing SD90MAC, with its long, angular carbody proclaiming, "We Will Deliver." In partnership with the CP and INRD, it will, in less than 90 minutes.

Solsberry, Indiana. Dispatcher Wade Deckard was fast asleep when the southbound train of IP&L empties rumbled through town about 0415. Awake and on the move now, he pulls out of his driveway and starts motoring toward Switz City. Twenty-five miles north of him, the daytime denizens of 101 West Ohio Street are joining employees from across the railroad for the company's breakfast meeting in Bloomington.

Appendix: Up and Down the Line

Note: Milepost numbers are drawn from a number of sources, including the Indiana Rail Road Company Official Timetable no. 12, historical Illinois Central right of way and track maps, and calculations based on cross-referencing sources. Milepost numbers for INRD stations are given, wherever possible, according to the original location of public depots as depicted on IC maps.

MP 1.4—Senate Avenue Terminal, Indianapolis

Known in the days of Illinois Central as the Wisconsin Street Yard, Indiana Rail Road's Senate Avenue Terminal is the north end of the line. (Milepost 0.0 was originally at Indianapolis Union Station, but this portion of the line was dismantled by the IC long ago.) Once home to a roundhouse, two-story yard office, and numerous other structures, Indiana Rail Road development efforts have transformed SAT into a small industrial village. The earliest project was the Indiana Reload Center, which has expanded its scope of operations from lumber to include a wide variety of construction materials, metal, and rubber products. Customers on the east side of the terminal include GAC Chemical, Metalworking Lubricants Company and Superior Solvents and Chemicals, Baja Ready-Mix and Hoosier Sand & Gravel, which receives bulk sand for ready-mix concrete production, transloaded into trucks on the slab of the old roundhouse. On the west side of the yard are an earlier generation of customers. A spur off the old main crosses West Street and ducks into the Merchandise Warehouse dock. And near the south end of the yard is one of Indiana Rail Road's oldest customers, K&F Industries, Indianapolis's largest processor of recycled metals for mills and foundries.

SAT is also home to a portion of INRD's maintenance activities. Locomotive repairs were performed in the great outdoors until the construction of an engine and car shed in 1987. The shed is the dominant structure at the terminal today, overshadowing the squat yard office, which was originally home to each and every

With steam and smoke billowing, an IC Mikado gets a train under way at the Wisconsin Street Yard. Rising steeply in the background is the connection to the Indianapolis Belt Railway, known in later years as "Conrail Hill." Photo by Ron Stuckey, John Fuller Collection

administrative employee. Back in those days, the bosses could hear every hard joint made in the yard right from their desks.

MP 2.1—Indianapolis Belt Railway

The INRD main passes beneath the Belt Railway at the south end of Senate Avenue Terminal, with a connecting track pitching up a steep 3 percent grade to move INRD trains onto the Belt. The Indianapolis Belt Railway Company was founded in 1873 to provide a common rail infrastructure to serve industries around the perimeter of the city. Additionally, the Belt Railway helped facilitate the development of a stockyard near the White River. After initial economic and political obstacles were surmounted, the 14-mile railroad and stockyards opened in November 1877 to brisk traffic—more than 200 freight cars on the first day.[1]

In 1881, the Belt was leased to the Indianapolis Union Railway Company, owner of Indianapolis Union Station, for 999 years. Through bankruptcies and mergers in the rail industry, it is now controlled by CSX Transportation. As for the stockyard, it expanded before World War II, growing to nearly 150 acres and processing 3 million head of livestock annually during its peak. Nationwide consolidation of the meatpacking industry diminished business at the stockyard throughout the 1960s. Today, the original site is occupied by Eli Lilly & Company's Kentucky Avenue campus.

MP 4.1—IP&L Harding Street Generating Station

Nearly 20 percent of the tonnage hauled by INRD is delivered here—some 2 million tons of southern Indiana coal carried in some 18,000 carloads annually. Known for many years as the Elmer W. Stout generating station in honor of a former IP&L board chairman, the plant reverted to its original name of Harding Street generating station in 2001, following IP&L's acquisition by AES Corporation. The facility was first brought online in 1931 with two coal-fired boilers, and by 1973 it had grown to include seven generating units with the capability to burn oil and natural gas as well. The plant has a peak generating capacity of 1,196 megawatts, more than half of which is derived from the coal-fired units. The two natural gas-fired turbines can be brought from cold start to full load in just 25 minutes.[2] IP&L also receives miscellaneous carload shipments by rail at a materials yard adjacent to the plant, comprising mostly utility poles on bulkhead flatcars.

Indianapolis Power & Light's Harding Street generating station. Photo by Chris Burger

MP 4.6—North Dixie

This switch marks the north end of a 6,224-foot siding constructed in 2003, one of the largest single capital projects undertaken by INRD. The long siding at Dixie eliminates the need to stage IP&L coal loads and empties at Senate Avenue—and the hours of switching and blocked grade crossings that ensued. Thousands of motorists who enter Indianapolis via West Street have been afforded considerable relief, and IP&L receives more efficient service at the plant. Two-thirds of the $1.5 million price tag for the project was funded by INRD, with the remaining funds supplied by the Indiana Department of Transportation and the City of Indianapolis.

Dixie was named by the project's chief architect, John E. Haselden, INRD director of industrial development and engineering services, in honor of his wife, Dixie.

MP 5.8—South Dixie

MP 7.0—Indianapolis Yard Limit

MP 8.4—Bluff Road

Just south of this busy crossing is one of Indiana Rail Road's longest-standing customers, Hall & House Lumber, which receives more than 200 carloads of milled lumber and construction

materials annually. To the south, booming residential development has crowded the INRD right of way with upscale housing additions. Once surrounded by forest and farmland, the tracks now slip through a patchwork of patios and swimming pools.

MP 11.6—Frances, Indiana

Between what is now Smith Valley Road and State Road 135 (known long ago as Three Notch Road) lived Charles Edwards, a Civil War veteran and former POW at the notorious Andersonville Confederate prison. The Edwards family's assistance in obtaining the railroad right of way and their hospitality toward the track construction crews prompted the Indianapolis Southern to name the station after them. When Illinois Central took over the railroad, however, Edwards Station lost its moniker due to a duplicate station name on the system in Kentucky. Illinois Central president Charles H. Markham chose the new name in honor of his favorite niece, Frances.

MP 17.4—Bargersville, Indiana

Laid out in 1850, Bargersville was a hub for farmers who shipped their harvests north to Indianapolis. The first established business was a blacksmith's shop, followed soon by a three-story flour mill

The Bargersville depot. John Fuller Collection

and a rough-and-tumble saloon that was eventually run out of town. Some of the enterprises served by the railroad in the early days included numerous mills and the Strum Canning factory. IC made ever-decreasing deliveries of agricultural products through the mid-1970s. Today, Bargersville is home to about 2,100 people. The last remaining rail customer when INRD took over the line was Roy Umbarger & Sons, operators of a farm supply business and grain elevator that dominates the town landscape. The business remains, but the only commodity moved by rail is bulk fertilizer.

MP 24.8—Anita, Indiana

Anita is yet another town along the line bearing the name of a young lady. A member of the ISRy's engineering brigade named the station after his daughter. As the story goes, when the little girl grew up, she had a chance to visit her namesake and was disappointed when she discovered that it wasn't the thriving metropolis she had envisioned. By the 1980s, Anita was almost nonexistent, with just 50 people living within a three-mile radius of where the

station once stood. (After IC closed the station in 1936, the building was converted into a house and moved near the town of Trafalgar.) The state highway department was on the verge of erasing Anita from the map, but proponents of the all-but-forgotten town successfully petitioned to preserve Anita's identity. The town remained acknowledged on paper and was even marked by a commemorative roadside plaque. However, much like the village itself, the plaque later vanished.

MP 30.1—Morgantown, Indiana

Here in Morgan County, the Indiana landscape noticeably begins its transition from the glacier-flattened farmland of the north to the hilly, rocky terrain that challenges Indiana Rail Road trains every day. Reached by construction crews by the spring of 1905, Morgantown was equipped with a passing siding, depot, and tool house on the north side of the right of way and a team track on the south side.[3] The Hi-Dry once crossed a long-removed Big Four branchline here that, ironically, was used by the Indianapolis Southern to transport their materials and crews during the construction of the line.

MP 33.6—Fruitdale, Indiana

A flag stop for Indianapolis commuters, Fruitdale's original name—Doubling Track—was a clue to the punishing nature of the grades laid out by the ISRy. One of three stations originally serving Brown County, Fruitdale was ultimately made obsolete by the automobile and state roads. The depot was closed in 1936.

Fruitdale crossing, Brown County. Courtesy Lilly Library, Indiana University, Bloomington, Hohenberger Manuscripts

Looking north toward the town of Helmsburg, 1906. The depot is at the extreme right. Brown County Historical Society

MP 39.0—Helmsburg, Indiana

Because people in the county seat of Nashville were opposed to a railroad in their town, Helmsburg became the station serving the

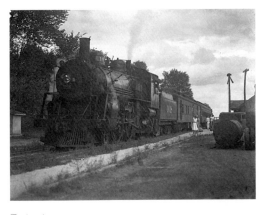

Train time at Helmsburg, early 1940s. Courtesy Lilly Library, Indiana University, Bloomington, Hohenberger Manuscripts

bulk of Brown County's passengers, who made the precarious journey between the station and Nashville in horse-drawn hacks. The coming of the railroad transformed the open farmland into a bustling little community with a flour mill, grocery, post office, farmers market, hardware store, lumber yard, and doctor's office. The local sawmill employed 50 men at its peak, and a canning company employed another 25–35. During the 1920s, Helmsburg was in its heyday and had a population of about 100 people. But beginning in 1924, a series of fires destroyed many buildings and businesses along Main Street, culminating in an April 1942 blaze that claimed the original ISRy depot.

MP 41.3—Trevlac, Indiana

The eccentric and mysteriously wealthy Colonel and Mrs. Calvert simply reversed the letters in their name when they discovered that IC already had a Calvert Station in Kentucky. They developed a popular resort village and had plans to build a castle on a hill overlooking their estate, but Colonel Calvert's philandering led to their abrupt departure, with their village later subdivided and sold off.

MP 45.4—Shuffle Creek

Located 10 miles east of Bloomington in Monroe County, this location curiously appears in early timetables as "Scouffle Creek." The tracks are carried 90 feet above the creek bed by an impressive steel viaduct that provides an extraordinary view of Lake Lemon. Bloomington's preferred venue for sailing, Lake Lemon served as the source of the city's water supply before the construction of Lake Monroe. The vista across the reflective lake when autumn colors are at their most brilliant makes this perhaps the most beautiful location on the line. At the foot of the trestle on the northeast side, barely visible from the tracks, is an ancient cemetery with the interred remains of area settlers, some predating the Civil War. Most of the residents of this shaded, fern-grown resting place are from the Fleener and Brock clans.

MP 47.5—Unionville Tunnel

This landmark is also known as Peterson Tunnel, in deference to the original landowner. A miniature wonder, the little burrow seems almost as tall as it is long. It has been periodically relined and renovated. The portals date from 1917, when extensive concrete work was done across the Indianapolis line. The tracks emerge into a deep, bowl-shaped rock cut on the north side, which is strewn with geodes that fall from the upper layers.

MP 49.7—New Unionville, Indiana

Because the northern portion of the Indianapolis District was laid out and built by the Indianapolis Southern outside the parameters of Illinois Central engineering standards, it became famous for some of the most challenging terrain on the IC. Southbound, the ruling grade was 1 percent, with a handful of sharp curves also complicating matters. At MP 48.5, between Unionville and Peterson Tunnel lies a six-degree curve—the tightest on the entire line. Unionville is the "continental divide" of the district. MP 50.0 marks the point where IC locating engineers abandoned the ISRy right of way and mapped a new alignment for the line, bringing the ISRy's unruly grades and track curvatures under control.

MP 54.0—Old Bloomington North Yard Limit (Removed 2004)

MP 55.0—Indiana University

After crossing Highway 46, the Hi-Dry threads its way between the high-rise student apartments and dormitories on the Indiana University campus. Track speed is restricted, since the area is a beehive of student activity and foot traffic when school is in session. The rails trace a straight line parallel to 10th Street, ducking behind a tree line and into a deep cut beneath Jordan Avenue. The

tracks emerge dramatically on a steel overpass at Fee Lane, between the Kelley School of Business and the university power plant. Remnants of the old power plant siding still exist, buried in the cinders.

MP 55.6—North Cavanaugh

This 2,560-foot siding begins just south of the central IU power plant and continues on steel and concrete overpasses hovering above the city's two major north-south thoroughfares, which straddle the remnants of the old IC station. Once used primarily as a passing track, today the siding is usually stocked with GE appliance cars and other Bloomington traffic moving in and out of town. A few yards to the south once stood an IC "circus ramp" for unloading piggyback cars. The ramp served the RCA plant in its heyday.

MP 56.0—Bloomington, Indiana

The former baggage house is all that remains of what was an exceptionally handsome limestone station at Bloomington. The surviving structure was headquarters for IC track maintenance crews and the local agent/yardmaster at Bloomington. After those jobs left town, the building was sold. It has served as a restaurant and beauty salon. An additional retail building erected next door was designed to harmonize with the architectural features of the old station.

Rail business in Bloomington has changed markedly throughout the years, affected by the closing of the Showers Brothers furniture plant in the mid-1950s, the closing of many limestone quarries served by rail, and the exodus of much of the manufacturing that relocated here from the East in decades past. The dismantling of the remaining Monon tracks pushed a handful of smaller customers to trucks. Remaining rail movements are principally GE refrigerators, bulk plastic pellets for a manufacturer of packaging films, and a handful of refrigerated shipments for US Foods, a distribution center once operated by SuperValu. Occasional outbound loads of crushed limestone are handled at a nearby transload site, but that may dramatically change when the railroad completes construction of a planned spur into the massive Rogers Group Bloomington Quarry, a major producer of crushed stone and construction aggregates.

MP 56.1—South Cavanaugh

MP 56.4—Monon Flyover

True to its moniker, the Hi-Dry rises above West 11th Street on a concrete overpass and then leapfrogs over the former Monon right

of way on a steel structure. So steep was the Monon's incline rising north out of Bloomington that the two lines reached the same grade just a few city blocks from the flyover.

MP 56.6—Pigeon Hill (Former Monon/CSX Interchange)

This area was once the site of miscellaneous maintenance structures, as well as a large wooden water tank to feed IC steam power. In its heyday, the interchange was busy with a plethora of rail traffic, including a daily parade of limestone blocks and boxcars of fine wood furniture from the Showers Brothers dock. Now that the Monon line is gone, the tracks at the old interchange are used only for miscellaneous car storage.

MP 56.8—Floyd

Floyd marks the former location of a wye, where the Bloomington Southern branchline diverged from the main. Less than 10 miles in length, the little line trundled southward past the RCA television plant to the stone quarries that dotted the landscape between Bloomington and Victor. Many of the quarries, most of the former RCA plant, and the old branchline itself have been erased from the landscape.

MP 58.0—Former Bloomington South Yard Limit (Removed 2004)

MP 61.0—Kirby, Indiana (Monroe County Airport)

When the developers of the Indianapolis Southern were hammering out their franchise agreement and right of way in Monroe County, the word *airport* didn't even exist in the common vocabulary. The Wright Brothers were still approaching their maiden flight at Kitty Hawk. The Hi-Dry tracks pass between the instrument approach lights, just a few hundred yards from the threshold of runway 35. Follow the extended centerline of the runway a mile north of the field, and you'll find yourself right in the middle of the Rogers Group Bloomington Quarry.

MP 65.0—Elwren, Indiana

When the hopes of finding big iron ore deposits turned out to be a bust, the railroad was rerouted from its original alignment through Stanford. Taking the names of three nearby families— Eller, Whaley, and Breeden—the station of Elwren became Monroe County's westernmost stop on the Hi-Dry. Today, the little enclave of homes that marks Elwren is barely discernible from the railroad.

MP 70.2—Solsberry, Indiana

This village, named after its founder, Sol Wilkerson, is the eastern-most station in Greene County. The county's name honors General Nathaniel Greene, although the Revolutionary War hero never resided here. It's one of the largest Indiana counties, with more than 540 square miles of land; however, it is also one of the state's least populated. The western half is gently rolling hills and fertile bottomlands, ideal for farming, while the eastern part of the county is rugged and rocky. Coalfields dot the landscape, making Greene County a gateway to southern Indiana's coal industry. The railroad passes through tiny Solsberry next to its most venerable landmark, the ancient, well-worn Yoho General Store. Other than the daily passing of the big red locomotives, there's not too much excitement here, with the exception of a Saturday in early December, when the Indiana Rail Road Santa Train brings St. Nick for his annual visit.

MP 75.6—Richland Creek Viaduct

Nearly a century old, this iron giant hefts heavy coal trains aloft just as capably as it bore lightweight IC steamers during the earliest years of its service. This half mile of railroad in the sky is every bit as awesome to behold today as it was when the last rivet was put in place in 1906. At the time of its inauguration, it was the third largest railroad bridge in the United States, factoring the span and the height. It remains one of Indiana's greatest railroad landmarks and one of the most notable bridge structures in service on a modern railroad.

MP 77.6—Tulip, Indiana

The Tulip Depot was a favorite gathering place of youngsters during the Great Depression. Back in the days of steam, IC maintained a pump house that brought water up from the creek for the locomotives. The post office, established on January 14, 1884, was closed by the summer of 1906, before the railroad even began operation. At the close of the twentieth century, little more than three dozen people called Tulip home. Their houses are mostly tucked away inconspicuously in the shadow of the great viaduct.

MP 83.0—Bloomfield, Indiana

In 1824, due to an unreliable water supply, the seat of government in Greene County was relocated to 62 acres of land donated by distiller Peter C. Van Slyke and named Bloomfield, in recognition of the New York State hometown of a prominent resident.[4] Illinois Central maintained a passing siding and a one-story freight depot here.[5] The old brickyard on the town's outskirts made enterprising

The depot at Bloomfield. Photo by Ron Stuckey, John Fuller Collection

use of the high-quality natural clays found in the area. Today, the aggregates trade has been resurrected in Bloomfield. Indiana Rail Road carries bulk carloads of masonry sand from Bloomfield to Indianapolis for ready-mix concrete production.

MP 84.9—Elliston, Indiana

This diminutive town, with its depot, stores, and a few homes, was never prominent, but it was home to a marvelous railway curiosity, the famous "Triple Crossing"—the Monon and NYC meeting at grade beneath the IC's elevated right of way, with the charming little station tucked in below the trestle. For non-rail traffic, Elliston held the advantage of being next to one of two bridges crossing the White River from Fairplay to Richland Township. When the bridge was replaced and the main road rerouted, however, the village was cut off, and Elliston faded away. The depot (ca. 1877) still stands forlorn, directly beneath the elevated INRD tracks.

MP 89.4—Switz City, Indiana

This Greene County town was once a bustling hub of railroad activity. Switz City, named after German immigrant farmer John Switz, was a crossroads for coal commerce in southwestern Indiana, as well as a junction linking Evansville, Vincennes, and Terre Haute. IC's Indianapolis line crossed Pennsylvania Railroad's Indianapolis & Vincennes Division (later known as the Vincennes secondary) and the Bedford & Bloomfield branch of the Monon. The town once boasted an impressive Union Depot where the two rail-

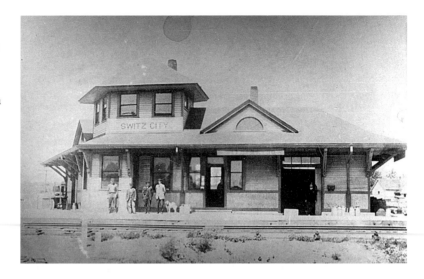

The Greene County hamlet of Switz City once boasted its own Union Depot. I&IS passengers made connections for Indianapolis here, via the tracks of the Indianapolis & Vincennes. David Grounds Collection

roads crossed and a 22-room hotel built in the late nineteenth century, which served as a pied-á-terre for railroaders and itinerant salesmen working the territory.[6]

Today, the railroad crossing the Hi-Dry is the Indiana Southern, which purchased the line from Conrail. The tracks cross between the Triad mining loadout at Highway 67 and the INRD engine house and offices to the east (track north). INRD built the Switz City facility in 1997. The structure itself was in use at another site; the railroad purchased it for $10,000, disassembled it, shipped it by rail to the company's nine-acre tract of land in Switz City, and rebuilt it with suitable modifications to accommodate locomotives. The facility features an interior pit track for locomotive repair, a fueling station with storage capacity for more than 20,000 gallons of diesel fuel, and a sand tower.

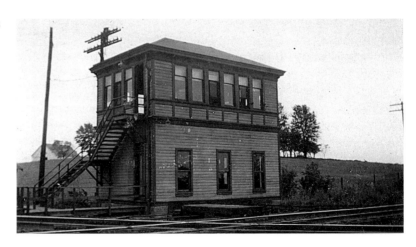

This rare photo shows the stately interlocking tower at Switz City. The tower is long gone, but the junction remains, now serving Indiana Rail Road and shortline Indiana Southern. David Grounds Collection

MP 95.4—Linton, Indiana

This community of roughly 6,000 is the boyhood home of the late Hollywood entertainer Phil Harris. The area was first settled around 1825 by a small group who called their town New Jerusalem. The community soon opened its own post office, which was named in honor of General Linton of nearby Terre Haute, a veteran of the War of 1812 and the Indian Wars.[7] By 1906, the year the Hi-Dry was completed, the town's population had swelled to more than 12,000, owing to the success of the coal industry. In recent years, Linton has suffered harsh economic impact from the loss of several key employers—General Electric, Sunbeam, Peabody Coal, and Winalta USA, a Canadian-owned producer of manufactured housing.

The long-abandoned depot at Linton, 1971. Photo by Ron Stuckey, John Fuller Collection

Linton has always been an important coal junction for the INRD. The coal fed into the IP&L boilers in Indianapolis originates at the Black Beauty mine in Farmersburg, Indiana, on the Canadian Pacific Latta Subdivision (ex-Soo, ex-MILW) that runs between Terre Haute and Bedford. The line crosses INRD at grade in central Linton, with an automatic interlocking. In the summer of 2004, the INRD right of way in Linton, including a 3,500-foot siding, was rebuilt down to the subgrade, with at least one grade crossing permanently closed and improved protection devices installed at remaining crossings.

MP 97.6—Victoria, Indiana

This ghost town was an important crossroads for coal traffic in the first half of the twentieth century. In 1902, the Monon line executed a 25-year agreement to access Victoria on the tracks of the Indianapolis Southern from the connection with Monon's Bedford & Bloomfield branch at Switz City. At Victoria, the Monon built connections to nearby mining operations. Within five years, the Monon constructed its own branchline to Victoria from Wallace Junction, rendering the connection via Switz City superfluous.[8] Coal mining at Victoria dwindled in the mid-1950s, and the village began its transformation into a ghost town. Today, virtually no remnants of Victoria can be discerned, and the only activity is the wildlife working around the peat bogs.

MP 100.4—North Midland Junction

The diverging track here is the north leg of a heavily traveled wye that carries unit coal trains from the CP at Jasonville onto the

INRD. Indiana coal from the Black Beauty mine at Farmersburg rolls north on this track toward Indianapolis and IP&L. From the earliest days of INRD operations, the long coal trains bound for IP&L were painstakingly switched in several cuts from the CP interchange yard at Linton via the connecting track, much to the aggravation of Linton motorists. This time-consuming shuffle continued until the INRD engineering department created a plan to rehabilitate six miles of abandoned track at the idle Peabody mine near Dugger to give the coal trains a run-through connection—INRD's Midland Subdivision. It was completed in 1999 at a cost of nearly $2 million.

MP 100.8—South Midland Junction

Just a few car lengths from the north switch lies the south leg of the Midland Sub wye. Unit coal trains bound for IP&L, Hoosier Energy's Merom generating station, and Ameren's Newton, Illinois, plant made the six-mile Midland Sub the highest-density track on the entire line—averaging more than 20,000 tons of coal each day. However, in early 2005, Ameren trains began making the connection to INRD via CSX in Sullivan, lightening the load over the Midland Sub. In 2003, INRD upgraded the switches at Midland with radio-actuated power throws that can be lined by the dispatcher. This innovation eliminates the safety risk posed by having a trainman step off the locomotive to line a switch by hand and also saves considerable fuel by allowing the trains to pass through the junction without coming to a full stop.

MP 101.1—Dugger, Indiana

The little coal mining community of Dugger is the site of two abandoned IC lines that served the Sunflower and Keely mines.

The depot at Dugger.
Indiana Rail Road
Archives

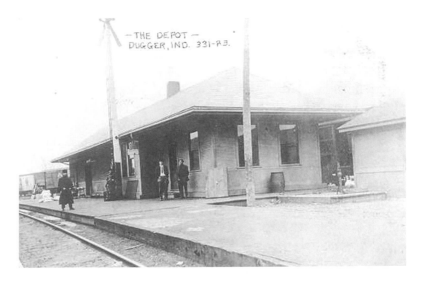

With its old-fashioned lampposts often bedecked with patriotic stars-and-stripes bunting, Dugger's main street is a favorite spot for photographers. Next to the post office is the Coal Museum, where visitors can enjoy a self-guided experience. Just ask the postmaster for the key and let yourself in.

MP 109.0, INRD End of Track, 1986–1989

MP 109.4—CSX Diamond

On the outskirts of Sullivan is the site of a level crossing with the former Evansville & Terre Haute, later part of the Chicago & Eastern Illinois (C&EI) main line from Chicago to Evansville and today owned and operated by CSX. In 1969, as a condition of the Missouri Pacific's acquisition of C&EI, the ICC ordered the line to be sold to the Louisville & Nashville, which was later absorbed into the corporate predecessors of CSX. It's a reasonably busy line, seeing as many as 40 trains a day. The crossing was upgraded to protection by an automated interlocking system in the late 1920s—state of the art for its time. The technological marvel was even featured in the May 19, 1928, edition of *Railway Age*. Today, modern electronics and signaling systems perform essentially the same job as the original interlocking, with its oil-fired approach signals, mechanical semaphores, and smashboards. The first installation eliminated 18,000 train stops a year. And this is a place where trainmen prefer not to lose momentum. Southbound INRD trains have to ascend a steep 1.74 percent grade on the approach!

MP 110.0—Sullivan, Indiana

In 1885, Sullivan became the headquarters of the I&IS during its final days as a narrow gauge railroad. When the IC took over, the town of Sullivan launched a campaign to be selected as home for

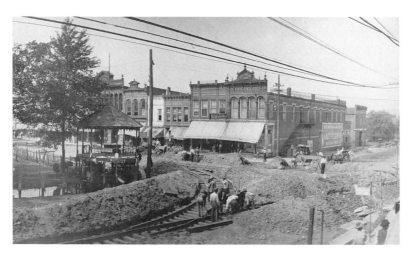

The interurban comes to Sullivan: Laying tracks for the Terre Haute, Indianapolis & Eastern Traction Co., 1906. Sullivan County Historical Society

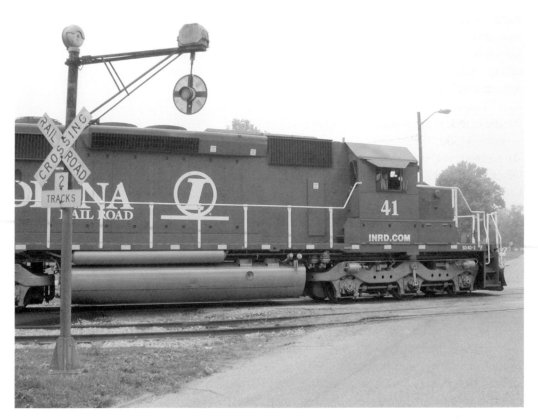

The well-worn wigwag signal on Main Street in Sullivan saw service into the twenty-first century. Photo by the author

the new shops, but it was too little, too late. IC inked a deal to site its shops in Palestine as the Sullivan delegation was on a train, traveling to lobby the railroad.

In 1906, the year the Hi-Dry was completed, Sullivan also inaugurated interurban service to Terre Haute on the Terre Haute, Indianapolis & Eastern Traction Co. Service to Sullivan was abolished in 1931, the same year that bankrupt THI&E was acquired by electric traction operator Indiana Railroad, not to be confused with today's Indiana Rail Road Company.

Indiana Rail Road scholars also know Sullivan for another distinction—home of what was the last remaining wigwag signal in service on the Hi-Dry, which was still protecting the Main Street crossing well into the twenty-first century.

MP 113.2—Hoosier Junction/Hoosier Energy Merom Generating Station
A switch off the main line here marks the lead track to Hoosier Energy's Merom generating station. Hoosier Energy broke ground on the $860 million plant in November 1977. The facility's two coal-fired 500,000-kilowatt generating units began commercial operation in 1982–83. The advanced pollution controls at the Merom plant include an imposing 700-foot stack that is visible for

miles. Nearby, Hoosier Energy has developed the Merom station's 1,550-acre Turtle Creek Reservoir cooling lake for recreational purposes. The reservoir is also home to Hoosier Energy's Environmental Education Center.

In 2003, the 210 employees at the plant burned 3 million tons of Indiana coal—a daily average of nearly 10,000 tons—to generate 6.6 billion kilowatt-hours of power. That's enough electricity to supply 500,000 typical Indiana homes for an entire year. Coal is brought to the stockpile on an internal network of some 14 miles of railroad track.[9]

When Tom Hoback was employed by the IC as director of coal marketing, he negotiated and drafted the industry's first post–Staggers Act long-term rail transportation contract—a coal hauling agreement for the Merom generating station.

MP 114.4—New Lebanon, Indiana

Here is heard the first hint of the exotic city names found in the "Little Egypt" region of Illinois. When Illinois Central took over the old I&IS, it was in horrible condition, with crooked rails, non-existent roadbed, and steep hills. According to an account published in a 1958 IC newsletter, the grade at New Lebanon Hill was one of the worst, and trains frequently had to be "doubled" over the hill in two sections. New Lebanon had a charming little depot that survived into the late 1980s, but it was razed by the IC just before INRD acquired the property.

According to local historians, the tall "stove pipe" hat made famous by Abraham Lincoln during his presidency was first designed and made in New Lebanon. A congressman from Carlisle was said to have worn one of the hats to Washington, D.C., where it was admired by James K. Polk. Polk ordered one of the towering lids for himself and wore it in his inaugural parade in 1845. Two years later, Abe Lincoln was seen sporting one when he was sworn in as a congressman.[10]

MP 118.7—Merom Station, Indiana

The depot that once stood here in the western outskirts of Sullivan County served the town of Merom, which is located two miles to the northwest on a scenic bluff high above the Wabash River. Merom's colorful history is marked by its annual Chautauqua of the Arts. A national movement that flourished in the late nineteenth and early twentieth centuries, the Chautauquas were organized to bring culture and intellectual stimulation to America's rural communities. Merom's religious and educational event featured concerts, debates, plays, and lectures. Among the luminaries of the day who spoke were Carry Nation, William Jennings Bryan, William H. Taft, Warren Harding, and Billy Sunday, the profes-

sional baseball player turned prohibitionist preacher. The tradition of the summer Chautauqua continues in Merom today with a more colloquial summer festival that features a re-created fur trader encampment, hot air balloons, classic cars, crafts, and a bounty of barbecue.

MP 120.4—Riverton, Indiana/Wabash River

The Wabash River was first bridged in late 1880, but not for long. In February 1881, high water and ice floes swept the bridge away. In 1886, a sturdier bridge was finally opened, and the railroad was back in the business of interstate transportation. Riverton was also the site of commercial ferry operations, which understandably thrived while the railroad bridge was out of commission. The steel bridge that stands here today was built in 1910–11, originally with a pivoting center span that could be opened for vessels to pass when the river was high. The swinging span was replaced with a stationary section in 1965 (see chapter 5, "Trestles and Tunnels").

MP 121.0—Palestine Yard Limit North

After stretching across the Wabash, the rails are elevated above the flood plain on heavy timbers. Nearly 1,000 feet of this trestle system was destroyed in 1969 by a fierce fire that took the Palestine and Robinson fire departments five hours to extinguish.

MP 123.1—Palestine, Illinois

In the Illinois Central days, the line from Effingham to Indianapolis was divided into two districts with the Palestine yard and shops at the midpoint. Palestine was the last station on the Effingham District and the last station in Illinois before the line crossed the Wabash River as the Indianapolis District. Palestine had a major yard and was a source of oil, sand, tools, and supplies for IC crews.[11] The public depot was located between North Main and Pike Streets.

The centerpiece of the yard and shops was a six-stall roundhouse. With the advent of the diesel locomotive on the IC in the 1950s, however, the roundhouse gradually fell into disuse and was razed in February 1964. A wye was subsequently installed in the northwest corner of the yard for turning locomotives. By this time, IC payroll at Palestine included about a dozen car and locomotive maintenance men, two dozen track maintenance men, two dozen firemen and engineers, and about 40 conductors, brakemen, and yard clerks.

In 1998, INRD completed an extensive renovation program that rebuilt the Palestine yard down to the subgrade and equipped the yard ladder with solar-powered electrohydraulic switch

throws. Later upgrades to the switches allow them to be actuated via yard crews' handheld communications radios, making it highly efficient for a single operator to work the yard with a remote control locomotive. The railroad's most recent capital plan funded two additional tracks in the yard to accommodate increased business from Marathon Ashland's Robinson refinery and other customers in the area.

MP 123.4—Reinbold & Sons
This grain and ag supply business enjoys the distinction of being the oldest continually operated business in Crawford County, Illinois. Opened in Palestine in 1852 by the Miesenhelder family, the mill was purchased by Walter Daily in 1947 and was acquired by the Reinbold family in 1984. More recently, the operation was sold to another INRD customer, Mont Eagle Mills of Oblong, Illinois.

MP 124.3—Palestine Yard Limit South

MP 123.8—Lincolnland Agri-Energy
In the summer of 2004, INRD inaugurated inbound and outbound rail service to this brand-new ethanol production facility. More than 450 local farmers invested in the $57 million project, which bridges petroleum and agricultural interests in the Illinois basin. Ethanol is a renewable fuel

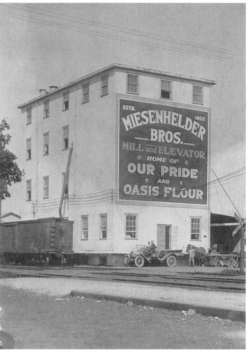

The Miesenhelder Brothers mill and elevator at Palestine. William Millsap Collection

made primarily from corn that is used principally as a gasoline additive to boost octane and provide a cleaner burn. Lincolnland is the sixth ethanol production facility in Illinois and one of fewer than 100 ethanol plants nationwide, with a combined production capacity of more than 3 billion gallons annually. Lincolnland Agri-Energy will annually process nearly 20 million bushels of corn into 50 million gallons of ethanol and 150,000 tons of by-products.

MP 127.1—Gordons, Illinois
This location appears in timetables and highway maps as both "Gordon" and "Gordons." Today, it appears to be just a rural junction of Illinois Highways 1 and 33. However, it does offer a nice location for snapping photos. Point a long telephoto lens down the track, and you'll see the railroad and the highway rolling over the same undulating grade together.

MP 129.0—Marathon Ashland Petroleum, Robinson Refinery

The railroad widens here with sidings to accommodate more than 12,000 carloads of petroleum and by-products produced at the sprawling refinery every year. Marathon Ashland Petroleum's seven-refinery network and its supporting logistics and transportation divisions allow all seven plants to be managed as a single system. Feedstocks can be shuttled among the refineries, taking advantage of processing strengths at individual plants. Marathon Ashland operates a fleet of some 2,000 owned or leased railcars, in addition to hundreds of trucks and 8,000 miles of pipeline. The output at Robinson represents more than 1 percent of the total refining capacity in the United States.[12]

Due south of the refinery is Robinson Carbon. This operation receives inbound petroleum coke from the neighboring refinery as well as other sources. The coke is calcined—cooked in kilns at 1,600 degrees Fahrenheit to reduce hydrocarbon content. The purified coke is a principal ingredient in the carbon anodes used in aluminum smelting.

MP 129.6—Owen (Former Big Four/NYC Interlocking)

A junction of the Big Four line to Cairo at this spot was once guarded by Owen Tower. The tower was demolished in the 1960s, and the Cairo line is now gone, having finished out its days as the Prairie Central Railroad. The Big Four depot north of the site lives on, however, serving as a VFW museum and memorial.

Owen Tower stood guard over the Big Four/NYC junction at Robinson until it was razed in the early 1960s. William Millsap Collection

MP 130.1—Robinson, Illinois

Robinson is the Crawford County seat, with a population of just under 6,400. Its steady, flourishing mix of manufacturing and agriculture is anchored by Marathon Ashland and Hershey Foods. The town is also home to Lincoln Trail College. The old depot between Cross and Franklin streets became a pizzeria, but it was destroyed by fire in 2002.

Robinson's Quail Creek Country Club was a regular stop on the PGA tour from 1966 to 1974.

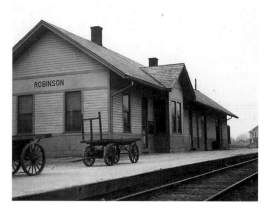

The Robinson depot, 1938. William Millsap Collection

MP 131.1—Hershey Foods, Robinson Plant

What can you make with 100-ton carloads of sugar (besides the world's biggest toothache)? At the Hershey plant in Robinson, the answer is some of the best-selling candy in the world—Heath bars, Payday, Milk Duds, Whoppers, and a delicious grab bag of other treats. INRD delivers bulk loads of sugar and corn syrup to the confectionary, and according to the railroaders who have taken the plant tour, there's nothing yummier than a fresh Payday bar still warm in the wrapper.

MP 135.5—Stoy, Illinois

From the tracks, Stoy appears to be nothing more than a rural grade crossing. However, about 135 people call it home. Long ago the haunt of a local fraternity who dubbed themselves the "Stoy Boys," the community is depicted in early photos with a surplus

A rare photo of the "Stoy Boys," a local fraternity of townsmen on the Illinois prairie. The date of the photo is unknown, but the condition of the tracks in the background may provide a clue. They look suspiciously underballasted, perhaps an indication that this scene was captured during the narrow gauge days. William Millsap Collection

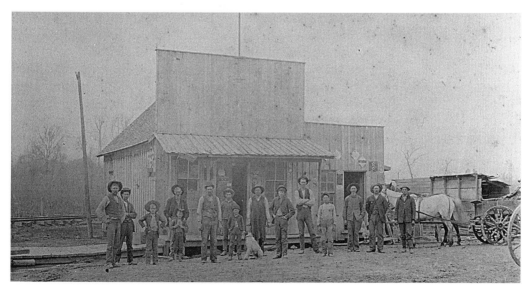

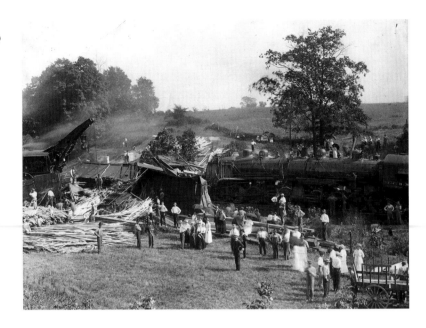

boxcar serving as the I&IS depot. Perhaps the most significant event in railroad history here was the head-on collision of two trains in 1920.

MP 139.5—Oblong, Illinois

Billing itself as "The Only Oblong," this prairie village is home to about 1,500 people and the Illinois Oil Field Museum and Resource Center. The museum houses the petrology reference collection of Lincoln Trail College, as well as permanent exhibits of scale models, oilfield equipment, and other artifacts.

Across Highway 33 from the museum is one of INRD's best customers, Mont Eagle Mills, Inc. Since 1916, the company has been owned and operated by four generations of the Glezen family. The first flour mill was built on the site in 1869 and changed hands several times. Early owners included Captain William Wood and D. Z. Condrey, Civil War heroes of the famous 98th Illinois Regiment of Wilder's Lightning Brigade. The Kirtlands, an expert miller family from New York, operated the mill from 1879 until 1914, when it changed owners a number of times and finally fell into receivership. In 1916, Sam A. Glezen and Charles Bissey, Indiana farmers with no milling experience, bought the mill. By the mid-1920s, Glezen had bought out his partner and was milling as much as 200 bushels of wheat a day. In the decades that followed, the company marketed wheat flour, corn meal, and animal feed ingredients to the towns and farms of southeast Illinois, and in 1953 it was incorporated. Mont Eagle's first grain elevator and retail fertilizer plant were built in 1961, and the business grew commensurate with the rapid increases in grain yields during the

A train of coal from Wyoming's Powder River basin enters the home stretch of its journey on the Indiana Rail Road at Willow Hill, Illinois. Photo by the author

1960s and 1970s.[13] With recent acquisitions, Mont Eagle Mills now operates multiple grain elevators and retail agricultural input businesses across four counties in southeast Illinois. The company puts nearly 4,200 carloads of grain on the rails for INRD every year.

MP 145.6—Willow Hill, Illinois
A population of 250 people resides in Willow Hill. Willow Hill Grain is the principal landmark and railroad customer, one of two grain operations in the area.

MP 149.3—Razorback
The maximum grade on the Hi-Dry—2.01 percent, but only for a few hundred feet.

MP 150.9—Embarras River
You'll be embarrassed if you mispronounce the name of this river around the locals. It's "EM-braw." A tributary of the Wabash River, the Embarras has its origins in small creeks south of the Champaign-Urbana area. Over its length of some 220 miles, it drains more than 1.5 million acres in ten southeastern Illinois counties. Not long after the first Wabash River bridge was swept away by ice and high water in 1881, the Embarras bridge collapsed, breaking the old narrow gauge line into three isolated sections.

MP 153.4—Newton, Illinois
The seat of government in Jasper County, Newton is home to some 3,000 people and was once the junction point for the Illinois

An IC freight crosses the Peoria–Evansville line at Newton, with the old depot standing forlorn. John Fuller Collection

Central's Indianapolis line and its line from Peoria to Evansville, Indiana. By the time INRD was ready to acquire this part of the Indy line, the IC had already abandoned the Peoria line from Newton to Mattoon. To create an additional incentive for the IC to sell, INRD offered to purchase part of the remaining Peoria line from Newton southward to Browns as part of the deal. It was 46 miles of lightweight track in the most deplorable condition. INRD struck a deal with Indiana Hi-Rail Corporation (IHRC), an aggregate of numerous shortlines in the region, to purchase the Browns line. (IHRC was already operating the portion of the line south of Browns to Evansville for its owner, Owensville Terminal Company.)[14] Attracted by the prospect of developing grain business, IHRC purchased the line from Indiana Rail Road for $1 million. It would prove to be a significant factor in the shortline operator's undoing. Not long after the transaction, a major bridge on the line collapsed, setting into motion a series of financial crises that eventually bankrupted the company. IHRC ceased operations in December 1997, and the line was abandoned as far as Poseyville, Indiana. Several hundred yards of the old Browns line owned by Indiana Rail Road still exist south of the old junction in Newton. The track is used for car storage and interchange with CN/IC, which still operates the portion of the line between Peoria and Mattoon.

MP 154.9—Ameren Lead

Here, in the last few feet of INRD's territorial limits, a second track diverges and swings into the distance, where on the horizon looms

one of the railroad's largest customers, Ameren's Newton generating station. This 1,132-megawatt plant brought its first generating unit online in 1977, followed by a second unit in 1982. Originally designed to burn compliance coal found in the region, the station was converted to burn western coal from Wyoming's Powder River basin in 1999. The conversion, undertaken at a cost of $30 million, was designed to reduce sulfur dioxide emissions by nearly half, while producing 15 percent more energy.

The plant typically burns 4.2 million tons of coal annually—the equivalent of nearly an entire 100-car trainload every day. The coal is ground into a fine powder and blown into the boiler furnace. At full generating capacity, the boilers devour 900 tons of coal and produce more than 8 million pounds of steam per hour.[15]

MP 155.0—End of INRD Ownership

Milepost 155 marks the end of the line for INRD, but the rails roll into Effingham under CN/IC ownership. And here at MP 155, an old acquaintance pays a visit each night. Under cover of darkness, the IC local quietly slips back onto its former turf to grab the day's cars from INRD at the Newton interchange track and tug them back to Effingham.

Notes

1. THE RISE AND RATIONALIZATION OF THE MAIN LINE OF MID-AMERICA

1. Paul Wallace Gates, *The Illinois Central Railroad and Its Colonization Work* (Cambridge: Harvard University Press, 1934), 4, 10.

2. Ibid., 21.

3. Wayne A. Johnston, *The Illinois Central Heritage, 1851–1951: A Centenary Address* (New York: Newcomen Society in North America, 1951), 13.

4. Ibid., 15.

5. Carlton J. Corliss, *Main Line of Mid-America* (New York: Creative Age Press, 1950), 407.

6. John E. Stover, *History of the Illinois Central Railroad* (New York: Macmillan, 1975), 297.

7. Ibid., 425.

8. Joseph R. Daughen and Peter Binzen, *The Wreck of the Penn Central* (Frederick, Md.: Beard Books, 1999).

9. Stover, *History of Illinois Central,* 468.

10. Ibid., 483.

11. Harry J. Bruce, *Mentors & Memories: My Forty Years Inside, Outside, and Alongside the Railroad Industry* (Wilmette, Ill.: privately printed, 2003), 109.

12. John Doeringer, retired Illinois Central attorney, interview with the author, February 25, 2002.

13. *Motive Power Review: Diesel Production Statistics,* version 1.82, compiled by Andrew Toppan, March 25, 2000 at http://www.hazegray.org/rail/product.htm.

14. Doeringer interview.

15. Bruce, *Mentors & Memories,* 116–28.

16. Ibid., 116.

17. Ibid., 135.

18. Ibid., 142–43.

19. Ibid., 145.

20. Ibid., 158–60.

2. A TIME TO BUILD

1. E. R. Alexander, comp., "I&IS Old Timers Club: History, Experience, Incidents," 14, in Palestine Public Library clippings file, Palestine, Illinois, 1924.

2. John E. Clark Jr., *Railroads in the Civil War* (Baton Rouge: Louisiana State University Press, 2001), 16.

3. Robert C. Black III, *The Railroads of the Confederacy* (Chapel Hill: University of North Carolina Press, 1952), 9.

4. Thomas Weber, *Northern Railroads in the Civil War* (1952; reprint, Bloomington: Indiana University Press, 1999), 13.

5. Thomas J. Wolfe, ed., *History of Sullivan County, Indiana,* 2 vols. (Chicago: Lewis, 1909), 1:150–53.

6. Illinois State Historical Society.

7. Elmer G. Sulzer, *Ghost Railroads of Indiana* (Bloomington: Indiana University Press, 1970), 158.

8. Alexander, "Old Timers Club," 5–6.

9. Sulzer, *Ghost Railroads of Indiana,* 158.

10. Alexander, "Old Timers Club," 7–8.

11. Wolfe, *Sullivan County,* 156–157.

12. Alan R. Lind, *From the Lakes to the Gulf: The Illinois Central Gulf Story* (Park Forest, Ill.: Transport History Press, 1993), 148.

13. Alexander, "Old Timers Club."

14. *The Encyclopedia of Indianapolis,* ed. David J. Bodenhamer and Robert G. Barrows (Bloomington: Indiana University Press, 1994), s.v. "Parry, David M."

15. Lee Niedringhaus, "The Panic of 1893," exhibit, American Museum of Financial History, 2002.

16. W. T. Hicks, *Indianapolis Southern Railway* (Bloomington: Monroe County Historical Society, 1911), 3.

17. Niedringhaus, "The Panic of 1893."

18. *Monon* [MOE-nahn] is a Native American word that means "swift running."

19. Hicks, *Indianapolis Southern Railway,* 2.

20. Ibid., 3–4.

21. Ibid., 5.

22. Ibid., 5–6.

23. Ibid., 11.

24. Ibid., 17.

25. Ibid., 20–24.

26. Ibid., 25.

27. Ibid., 25.

28. A track junction configured in the shape of a Y, allowing trains to reverse direction in the manner of a three-point turn.

29. Hicks, *Indianapolis Southern Railway,* 23.

30. Interstate Commerce Commission Valuation Docket 387 (Washington, D.C.: GPO, 1934), 322.

3. THE POSTMODERNIST EMPIRE BUILDER

1. Evidence of their friendship was once found stenciled on the cab of now-retired locomotive number

600. Of a handful of christened machines in the Indiana Rail Road fleet, one bore the name *Rich Lassar.*

4. LIFE ALONG THE RAILROAD

1. Emmerson Judd, "Report on the Indianapolis Southern Railway," prepared for the Illinois Central Railroad, July 1904.
2. Source: Maverick Energy, Robinson, Illinois.
3. Source: Indiana Coal Council.
4. Judd, "Report on the Indianapolis Southern Railway."
5. Ibid.
6. Avis Hamilton Stalcup, "Remembering Tulip," from *Tulip, Indiana: One of Greene County's Vanished Villages,* ed. Mildred and Connie Uland (privately published, 1999), 59–61.
7. "Solsberry, Indiana, and the Coming of the Railroad," oral histories compiled by Joseph C. Meredith, 1981.
8. Charles W. Shannon, "Iron Ores of Greene County," from *Biographical Memoirs of Greene County, Indiana, with Reminiscences of Pioneer Days* (Indianapolis: B. F. Bowen, 1908).
9. Judd, "Report on the Indianapolis Southern Railway."
10. Roughly four miles of the Monon main line still exist between Bloomington's west side industrial area and the town of Ellettsville.
11. Tom Parkinson, "Gentry Bros. Dog and Pony Shows," from *The White Tops,* 5–7.
12. Historic Preservation Committee of the Environmental Quality and Conservation Commission.
13. Archival footage from an interview with Prof. John Mee, featured in part 1 of *The Spirit of Monroe County,* WTIU/Indiana University Television, Mickey Klein, producer, 1997.
14. Richard Simons, interview with Jennifer Born, Indiana Rail Road archivist.
15. George M. Smerk, interview with the author, January 30, 2004.
16. Essie Reams, "A Bit of Old Time Middle West," *Illinois Central Magazine,* November 1925
17. Ray Mathis, *A Brown County History* (1936; Bloomington: privately printed, 1993).
18. Frank Hohenberger Manuscripts, Lilly Library Collections, Indiana University, Bloomington.
19. Brown County Convention and Visitors Bureau.
20. Deloris Hamm, "A Birthing: With the Illinois Central Railroad Came the Calverts, Founders of Trevlac," *Brown County Democrat,* September 15, 1982.
21. Hohenberger Manuscripts.
22. Mathis, "Brown County History."
23. James R. Heatherington, *Indianapolis Union Station: Trains, Travelers, and Changing Times* (Carmel: Guild Press of Indiana, 2000), 7.
24. Ibid., 59.
25. Northern Indiana Center for History.
26. George M. Smerk, "The Economic and Social Impact of the Electric Interurban Railways on Indianapolis: A Sketch for a Portrait," lecture presented at 2001 Midwest Rail Research Center symposium, published online by Indiana Historical Society.

5. TRESTLES AND TUNNELS

1. *Railway and Engineering Review,* March 31, 1906.
2. *Indianapolis News,* December 18, 1906, 17.
3. Hicks, *Indianapolis Southern Railway,* 13–14.
4. Olive Raper, interview with Joseph C. Meredith for his oral history, "Solsberry, Indiana and the Coming of the Railroad," 15.
5. "Viaduct in Greene County One of America's Unique Rail Structures," Greene County Historical Landmarks, Greene County Public Library, Bloomfield, Indiana.
6. Elmer G. Sulzer, *Ghost Railroads of Indiana,* 166.

6. RUN IT LIKE A BUSINESS

1. Clark Snyder, IP&L general counsel (retired), interview with the author, January 30, 2004.

7. GROWING PAINS

1. John Doeringer, interview with the author, February 25, 2002.
2. Hoback, interview with the author, May 11, 2004.
3. Thomas J. Quigley, former Indiana Rail Road Company vice president of operations, interview with the author, July 2, 2002.
4. Hoback interview, May 11, 2004.
5. Hoback, interview with the author, January 26, 2001.
6. Susan Ferverda, interview with the author, May 11, 2004.
7. Hoback interview, May 11, 2004.
8. Based on figures provided by the Indiana Rail Road.
9. Ferverda interview, May 11, 2004.

8. REBUILDING A RELIC

1. Quigley interview, July 2, 2002.
2. Hoback, interview with the author, September 16, 2003.
3. Quigley interview, July 2, 2002.

10. A DAY IN THE LIFE OF THE INDIANA RAIL ROAD COMPANY

1. On railroads without lineside signals to control train movements, trains are given authority to move through the issuing of track warrants—a written order transmitted verbally to the train crew from the dispatcher via two-way radio. "Rolling up track" is a railroader's term for voiding a track warrant after the train has cleared the limits of the warrant.
2. Although south of Bloomington the INRD

doglegs to an east-west orientation, locations in this account are described according to the railroad's timetable, which indicates track direction north and south.

3. Many of the INRD trains today bear symbols that have been rendered misnomers by changes in operating patterns.

4. INRD trainmen bid for positions by seniority to fill regularly scheduled jobs. The rest of the operators are grouped in a pool for extra board assignments made at Switz City.

5. While equipment is being serviced by personnel, operating rules require the track to be protected against movements by hanging blue markers or lamps as a warning.

6. M.U. refers to "multiple unit connection," which allows a group of locomotives to be operated in unison by the engineer in the lead cab.

7. LISA was once the symbol for northbound IP&L coal trains (Linton–Senate Avenue Terminal). In the days of 12 mph track speeds, a turn wasn't possible, so a separate southbound job carried the symbol SALI. Today, the two legs are combined as a turn, and most INRD operations people simply refer to it as "the road job."

8. The end-of-train device (EOT) provides rear-end brake pipe pressure information to the crew via radio telemetry. Advanced "two-way" telemetry devices allow an emergency brake application to be made from the rear of the train, reducing adverse slack action.

9. DTC indicates "dark territory control," track without lineside automatic block signals to guide the trainmen.

APPENDIX

1. Source: Indiana Historical Society.

2. Source: IP&L/AES Corporation.

3. Lind, *From the Lakes to the Gulf*, 153.

4. Historical Landmarks Foundation of Indiana, *Greene County Interim Report: Indiana Historic Sites and Structures Inventory*, 60.

5. Ibid., 152.

6. Ibid., 57.

7. Ibid., 44.

8. Sulzer, *Ghost Railroads of Indiana*, 163–65.

9. Source: Hoosier Energy REMC.

10. Source: Sullivan County Historical Society.

11. Lind, *From the Lakes to the Gulf*, 151.

12. Source: Marathon Ashland LLC.

13. Source: Mont Eagle Mills.

14. Surface Transportation Board news release no. 97-63, August 11, 1997.

15. Source: Ameren Corporation.

Index

RAILROADS PAST AND PRESENT

George M. Smerk, Editor

Books in the Railroads Past and Present Series:

CHRISTOPHER RUND is a senior marketing communications writer and creative director with a lifelong interest in railroading and transportation. He was raised in Lafayette, Indiana, home to the Monon Railroad (now the Monon subdivision of CSX Transportation), and moved down the Monon line to Bloomington in 1984 to study music at Indiana University. While a student, he was employed in a variety of capacities with the university transit system and later worked for two commercial bus lines. He began his career in media with Indiana University's National Public Radio affiliate station and in 1993 joined the staff of one of Indiana's largest corporate communications firms. He has developed award-winning marketing and public relations campaigns for clients in a variety of categories, including transportation, national defense, financial services, broadcasting, manufacturing, and social services. In 2001, he contributed to a *TRAINS* magazine feature on Indiana Rail Road Company innovations and technology. Mr. Rund resides in Bloomington, Indiana, with his wife and two children.

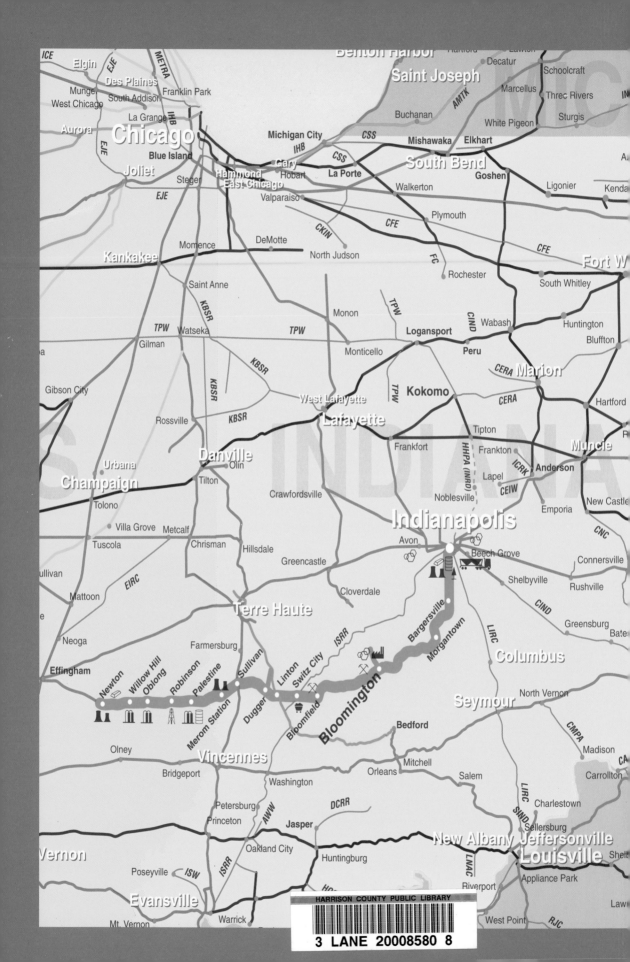